DISCO

Music, Movies, and Mania Under the Mirror Ball

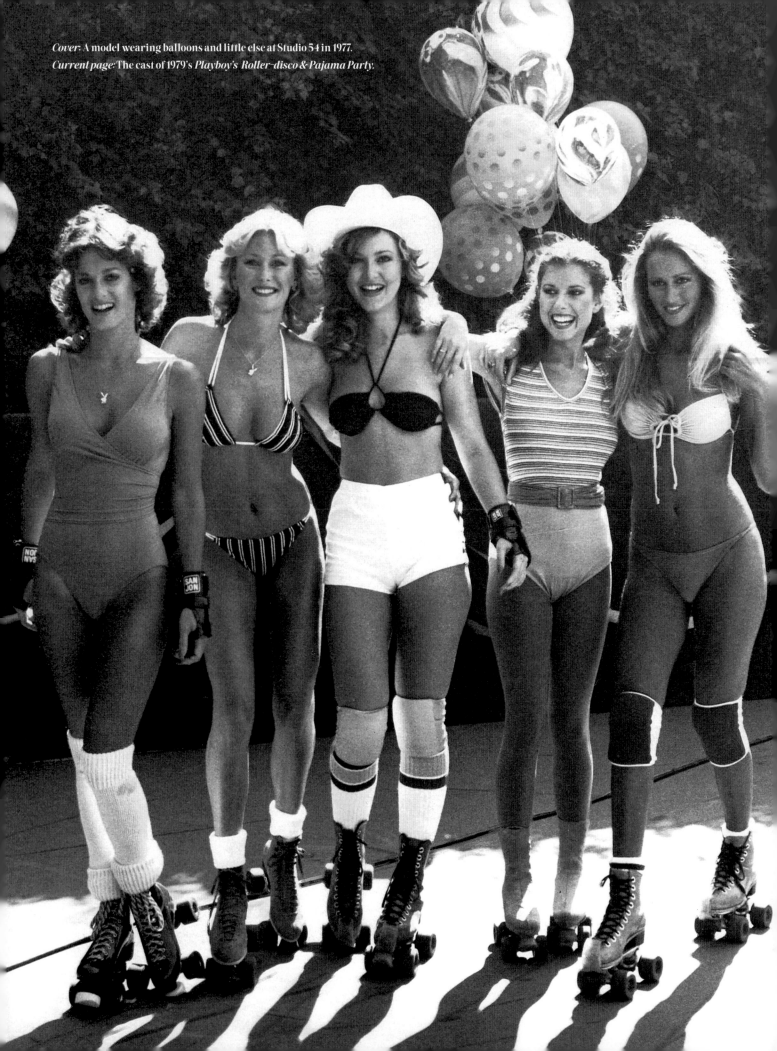

DISCO

Music, Movies, and Mania Under the Mirror Ball

Frank DeCaro

New York Paris London Milan

ENTER TOWER GATE

C 25

338 D 6
SEC. ROW SEAT

2nd PROMENADE $15.00

| THE BEE GEES 8:00 P.M. | TUE. EVE. SEPT. 11 1979 | PERF. 4 |

square garden
ylvania Plaza

JERRY WEINTRAUB

GEES

WITH CONCERTS WEST

ELSENER.

MENADE $15.00

Bee Gees concert ticket stub.

For those who remember to dance, and those who dance to remember.

Contents

Donna Summer being zhuzhed for the *Four Seasons of Love* cover shoot.

INTRODUCTION: GOT A MATCH? • **PAGE 08**

CHAPTER 01: A LOFTY BEGINNING • **PAGE 12**
 Q&A: Nicky Siano
 Must-Hear Disco Playlist: 1970—1974
 Boogie Oogie Boogie Woogie Dancin' Songs
 Q&A: Freda Payne
 Must-Hear Disco Playlist: 1975
 Q&A: Gloria Gaynor

CHAPTER 02: STUDIO 54 • **PAGE 34**
 A Tale of Two Studios
 Q&A: Cory Daye
 Must-Hear Disco Playlist: 1976
 Legendary DJs
 Q&A: Thelma Houston

CHAPTER 03: THE MIRROR BALL ON THE MOVIE SCREEN • **PAGE 56**
 More, More, More
 Q&A: Fran Drescher and Donna Pescow
 Meco and Moroder at the Movies
 Shadow Dancing: Movie Themes Gone Disco
 Q&A: Felipe Rose & David Hodo of Village People
 Must-Hear Disco Playlist: 1977

CHAPTER 04: DANCING ACROSS AMERICA • **PAGE 98**
 Disco for Kids
 Disco Dining
 Teen Discos
 Q&A: France Joli
 Must-Hear Disco Playlist: 1978

CHAPTER 05: HALSTON, GUCCI, FIORUCCI • **PAGE 122**
 Disco Jeans
 The Brotherhood of the Traveling White Suit
 Disco Nightwing
 Q&A: Norma Kamali
 Q&A: Melba Moore

CHAPTER 06: MAKIN' IT ON TV • **PAGE 142**
 Very Special Disco Episodes
 Classic TV Themes Gone Disco
 Q&A: Deney Terrio
 Must-Hear Disco Playlist: 1979

CHAPTER 07: PLAY THAT FUNKY MUSIC, WHITE BOY • **PAGE 162**
 Disc-Originals
 Disco on Broadway
 Broadway Show Tunes Gone Disco
 Something for the Boys: *The Ethel Merman Disco Album*
 Q&A: Linda Clifford
 Discofied Classics

CHAPTER 08: GOTTA HAVE HOUSE • **PAGE 190**
 Q&A: The Ritchie Family
 Legendary DJs
 Must-Hear Disco Playlist: 1980—1983

CHAPTER 09: PETE & JIMMY & MARC & NEIL & CHRIS & ANDY & VINCE & k.d. & SANDRA & SAM • **PAGE 202**
 Q&A: Andy Bell
 Cover Versions of Disco Songs
 Q&A: Chris Frantz
 Must-Hear Disco Playlist: 1984—1999
 Q&A: Pete Bellotte

CHAPTER 10: DISCO FOREVER • **PAGE 222**
 Q&A: Nile Rodgers
 Q&A: Donna Summer
 Must-Hear Disco Playlist: 2000—2024

ACKNOWLEDGEMENTS • **PAGE 239**
PHOTO CREDITS • **PAGE 240**

INTRODUCTION:

GOT
A MATCH?

Sylvester

When the singer, actor, and queer icon Sylvester asked for a light at the beginning of his 1978 Top 40 hit "Dance (Disco Heat)," he could not have imagined this night, or rather, this nightmare, less than a year later.

The date was July 12, 1979. The place, Chicago's Comiskey Park.

During a double-header between the White Sox and the Detroit Tigers, a radio shock jock named Steve Dahl—an outrageous FM personality in whose footsteps Howard Stern would follow—staged a stunt to "end disco once and for all," as he put it, and boost ticket sales for a local baseball team whose popularity was at an all-time low.

The event was called "Disco Demolition Night," and it worked like this: if a Sox fan brought a disco record to the ballpark, his ticket would be discounted to 98 cents. The price was a nod to Dahl's employer, WLUP 97.9 FM.

The goal was to unload an extra five thousand stubs. It was also a way for Dahl to exact revenge. He'd been fired the year before when the station at which he'd previously been working, WDAI, switched from rock to disco, a format-flip that many stations were making at the time.

Instead of five thousand people, however, *fifty* thousand people showed up, vinyl in hand, and twenty thousand more, by some accounts, stormed the gates after the game was sold out. These fans proceeded to fling discs like Frisbees onto the field, and when Dahl detonated a dumpster full of disco records between the two games, scores of testosterone-fueled men went wild.

It was like a Monster Trucks show crossed with a MAGA rally.

"They wore Led Zeppelin and Black Sabbath T-shirts, smashed bottles on the ground, smoked God-knows-what, and chanted their almighty rallying cry: 'Disco sucks!'" remembered Steve Knopper, author of 2009's *Appetite for Self-Destruction: The Spectacular Crash of the Record Industry in the Digital Age*. At Comiskey Park that night, baseball fans destroyed not only disco records but vinyl by Black artists from other genres. This was a "Disco-*Nacht*" aiming to erase the strides that minority recording artists had made. As the house music pioneer Vince Lawrence testified in the 2020 HBO documentary, *The Bee Gees: How Can You Mend a Broken Heart*, "It was a racist, homophobic book-burning."

Fans stormed the field. Windy City hooligans—feeling as overlooked by the disco phenomenon as a Staten Island goombah standing outside the impassable velvet ropes of Studio 54—exploded, wreaking havoc, and damaging the ballfield.

The Sox were forced to forfeit the game, but that didn't really matter.

Those in attendance that night had come not for baseball at all, but for a badass show of what we now call "toxic masculinity," a display of machismo designed to fight back against a genre of music that had overtaken the country and had forgotten men like them. As the cultural observer Fran Lebowitz told *Vanity Fair*, "'Disco Sucks' was a kind of panic on the part of straight white guys. Those guys felt displaced." In many ways, they had been.

The mirror-balled cultural phenomenon of disco was being advanced not by straight white men—except for the Bee Gees and a few others, of course—but by strong women, proud people of color, and, worst of all, unapologetic queers like Sylvester, who, in the right drag, ticked all three boxes. "You could be anything in disco music, and if your song was good, you had a shot at a hit," says music historian James Arena.

"Unlike rock music, whose ideal audience is teenage, white, and male, disco brought together young and old, Black and white, gay and straight," said *Rolling Stone* critic Barry Walters. "I'm not saying disco had a black sensibility or a gay sensibility or a female sensibility, but it *didn't* have a straight-white-male sensibility and that bothered a lot of people."

"Disco was viewed as, 'This is the New York elite who hang around in Studio 54 with Andy Warhol and that group," remembers Ken Hahn, who was a classic rock DJ in Chicago at the time. "Chicagoans didn't care for New Yorkers in a general sense, and that was part of it." The popularity of disco wasn't just a threat to rock's livelihood—"We *were* losing ratings to them," he admits—but also something worse for the male ego. "A lot of young women who had been listening to rock, shifted over to disco, so there was that concern, too," he says.

For the first time ever, popular music wasn't dominated by heterosexual, Caucasian rockers, but by singing, dancing, rejoicing minorities. No wonder those young white men were so angry. The music scene for a time wasn't about them, or even rock 'n' roll, anymore. Instead, in 1979, bands like the Trammps were stoking a global "Disco Inferno" on radio, television, and in the movies. "It did become a threat to the commercial viability of rock music," says the esteemed music critic Jim Farber.

Rather than baseball, disco was now America's national pastime. In cities and towns across the country—and around the world, in fact—huge numbers of people were having a very different kind of blast than the one perpetrated that night in Chicago. Disco had become a passion for everyone *but* diehard rockers, whether you were part of the ultrachic in-crowd of Manhattan, or a thrill-seeking couple from suburban Minneapolis who signed up for Latin Hustle lessons at Arthur Murray.

From Mickey Mouse to Ethel Merman, everyone was recording disco music—even the angelic Karen Carpenter laid down a dirty disco track—and folks from "Disco Sally" Lippman, the so-called "grandmama of New York nightlife" who spent her retirement years at Studio 54 and became a local celebrity, to our own grandmothers were doing the Bump to dance records in the estimated fifteen thousand discotheques that sprang up across America.

Studio 54 matchbook.

By 1979, disco was a $15 billion-a-year industry. Even the Rolling Stones went disco with their 1978 hit "Miss You." Truly, if Mick Jagger—perhaps the most quintessential rock 'n' roll icon—could be seduced by disco's siren song, what mere mortal could resist the genre's "toot toot, hey, beep, beep" allure?

Disco had become not only the music to which the world listened and danced, but also a huge influence on what audiences watched, wore, bought, and read. The music and the lifestyle surrounding it became synonymous with the seventies. Disco defined the decade in everything from tight polyester fashion to loosened sexual mores. It became what we consumed.

Between 1977 and 1980—at the apex of the genre's popularity—there were disco movies, disco TV shows, disco Broadway musicals, disco jeans, and even disco lunch boxes, all celebrating a nonstop hedonistic ideal wrapped in loudly patterned Qiana. Only hip-hop—disco's spiritual grandchild—has ever had as pervasive a reach on as many facets of popular culture as disco did.

The "Disco sucks" backlash, which will always bear the stench of bigotry, was perhaps inevitable. No trend, particularly not one that burned as brightly as disco did or was as thorough in its effect on the world's idea of fun, could last forever. By the time the Village People movie musical *Can't Stop the Music* arrived on the big screen in 1980, disco had become yesterday's news. New Wave music—the love child of disco and punk—was becoming the soundtrack of the eighties.

But as the disco phenomenon's hold on the media waned, something unexpected happened: disco quietly dug in its platformed heels. It became, in the decades that followed, as vital a part of the American soundtrack as any other musical genre.

Disco became "house" and "techno," and ultimately laid the foundation for the two biggest musical genres of the twenty-first century—hip-hop and EDM, as electronic dance music is now called. As Leonard Greene, writing in the *New York Post* in 2007, put it, "Over time, the acrimony subsided, and disco was allowed to enjoy a place of honor in music history."

Today, classic disco songs are heard on commercials for HomeGoods, JC Penney, Target, and Taco Bell, and have been featured on the soundtracks of such buzzworthy TV shows as *RuPaul's Drag Race, What We Do in the Shadows, Pose,* and *Big Little Lies*. James Corden ended his run on *The Late, Late Show* in 2023 with a production number set to "Last Dance." Meanwhile, movies from *House of Gucci* to *Despicable Me 2* feature classic dance tracks of the seventies.

Disco's ultimate validation, however, is this:

Village People's hit "Y.M.C.A." was chosen in 2020 by the Library of Congress for preservation in the National Recording Registry. The classic anthem was deemed culturally significant. The ubergay ode to locker-room hookups—one of the most beloved dance songs of all time—is now heard in both queer spaces and at right-wing political events. The most macho of men now sing along and do the hand motions to the song in baseball stadiums. Although not at Old Comiskey. The infamous site of Disco Demolition Night was demolished in 1991.

"Got a match," indeed.

In the pages that follow, you'll learn how disco outlasted any attempts at demolition, how the genre completely overtook the popular imagination of the 1970s, and why it is being revisited today by artists from Dua Lipa to Lizzo.

Herein, you'll discover—or, if you're of a certain age, be reminded of—the greatest disco songs, movies, TV episodes, and Broadway shows of the era. From the famous ("Don't Leave Me This Way") to the infamous ("Disco Duck"), the classic ("I Will Survive") to the obscure ("Disco Trekin'"), they've all been gathered here to glimmer again in the reflected light of a mirror ball. *Disco: Music, Movies, and Mania Under the Mirror Ball* is here to say, once and for all, that disco didn't suck. In fact, it has never sounded better.

Now, as Sylvester once said, "Let's party a little bit."

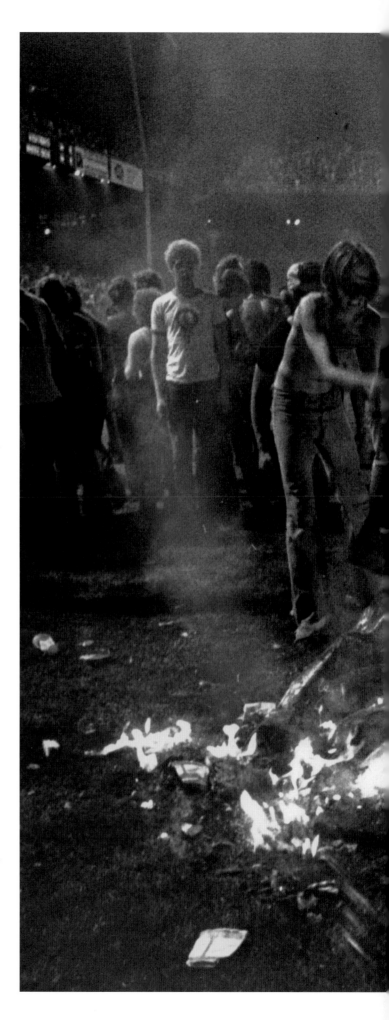

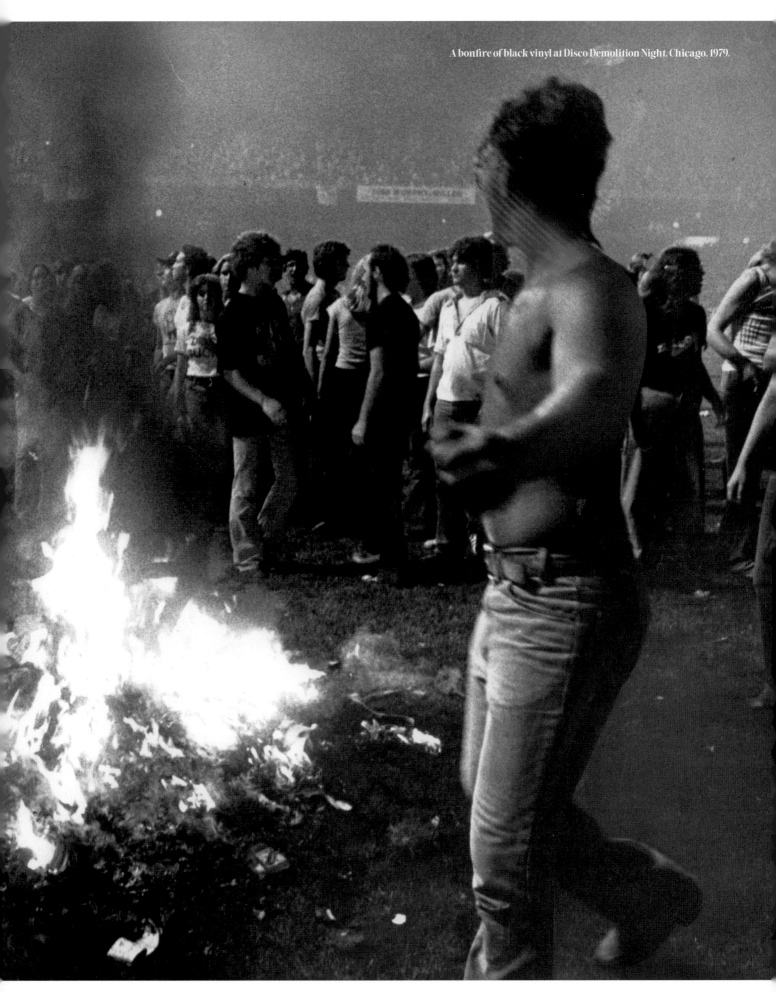

A bonfire of black vinyl at Disco Demolition Night, Chicago, 1979.

Chapter 1
A Lofty Beginning

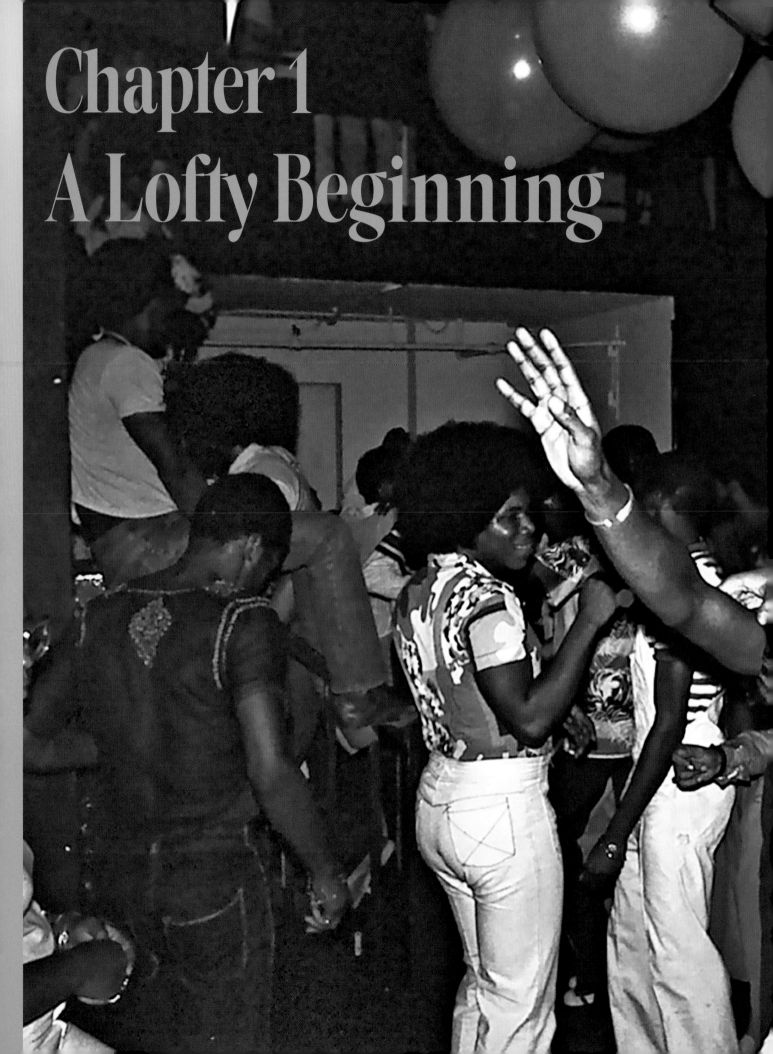

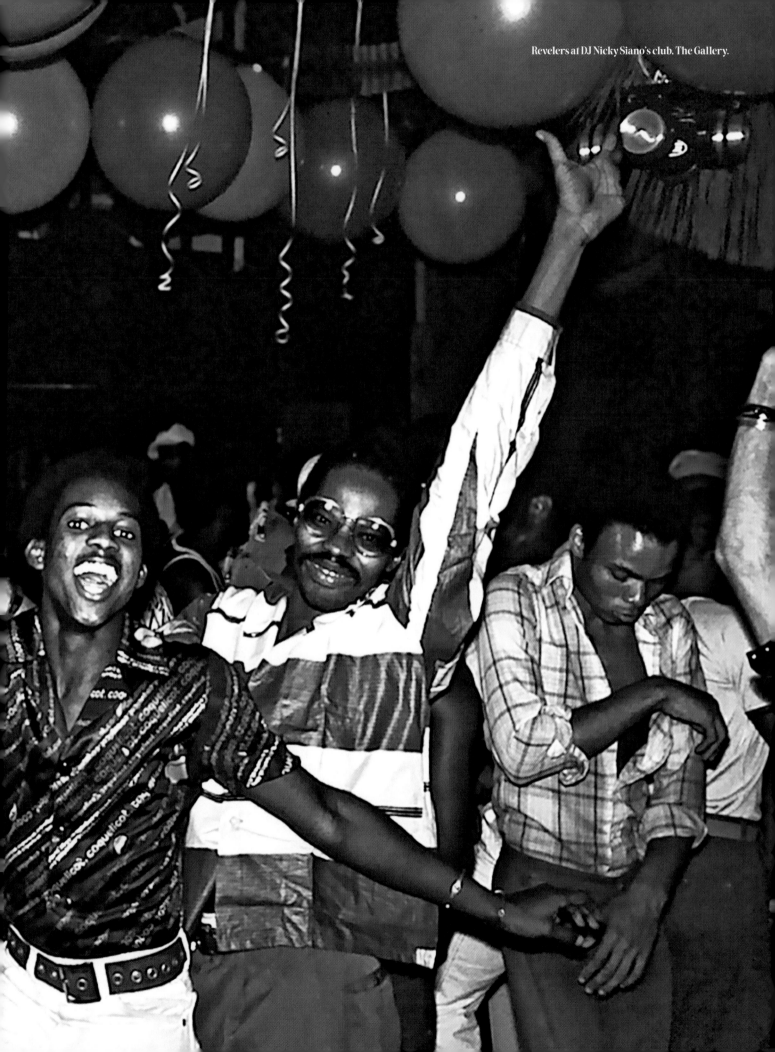

Revelers at DJ Nicky Siano's club, The Gallery.

"

WHAT WE'RE GONNA DO RIGHT HERE IS GO BACK...

—the Jimmy Castor Bunch

On Valentine's Day 1970–only eight months after the Stonewall uprising launched the modern gay rights movement–disc jockey David Mancuso threw a dance party.

The event, held in his private loft on Broadway just north of Houston Street in lower Manhattan, was called "Love Saves the Day," and it is widely considered the birthplace of seventies disco.

Mancuso's party wasn't the first time someone had played records for a paying crowd, of course. French clubs began spinning jazz discs rather than employing a live band during World War II. In the late fifties, Regine—as impresario Rachelle Zylberberg called herself—opened a nightclub in a Parisian basement and brought in a jukebox. But there was one problem—when the music stopped, so did the fun.

She had an ingenious solution. "I installed two turntables so there was no gap in the music," she once told the BBC. "It was the first-ever discotheque, and I was the first-ever club disc jockey." Some would disagree with Regine's version of disco history, but it made a good story. In the decades that followed, she came to run almost two dozen branches of Chez Regine around the world—exclusive boîtes that catered to the rich and famous.

There had been dance crazes from the Charleston to the Twist. Popular clubs where platters were played surged in the New York City of the sixties: Places like the Peppermint Lounge, Le Club, the Cheetah, Ondine, the Arthur, Aux Puces, Sanctuary, and Salvation.

Sadly, many discos now are remembered only by those old enough to have danced there. AIDS, tragically, decimated the ranks of those who frequented such legendary clubs as 12 West, Tenth Floor, and the Anvil. One notorious spot, now all but forgotten, was the Tambourine, where a seven-foot phallus stood in the middle of the dance floor.

"The spirit of Sodom and Gomorrah had come to the Big Apple," *After Dark* magazine reported in a 1976 survey of early discos. Then, of course, there were the discos of Fire Island, the narrow spit of land, a ferry ride away from Long Island, where Manhattan's tastemakers partied with abandon every weekend of every summer. "Long a gay enclave, the island boasted, in 1973, the hottest discos in the country," *Circus Weekly* reported in a disco roundup in its June 26, 1979, issue. "It was yard after yard of sweating human bodies, dancing until five in the morning." The music of choice at such Fire Island clubs as the Sandpiper and the Ice Palace, the magazine noted, was "funk, soul, R&B, Sly Stone, James Brown, Eddie Kendricks, and whatever else provided a beat that didn't stop." Disco as a bona fide genre didn't exist yet.

Still, Mancuso's loft parties stood out. They were all about the music and community. These events relied on word of mouth. Guests had to know someone to get in, or at least look like they would fit in with the crowd. A dancer's race, gender, class, or sexual orientation didn't matter. But if you weren't colorful and enthusiastic, you would not get past the door. Period. This made Mancuso's loft parties both inclusive and exclusive at the same time and set the template that velvet-roped discos would later follow.

Filled with like-minded people, these two-bucks-a-head get-togethers were such a hit they soon became weekly happenings. Mancuso's loft became the Loft. "By the end of 1970, you couldn't squeeze anyone else in, and it stayed like that for four and a half years," Mancuso once said. "I remember when we had the first blizzard and people walked over the Brooklyn Bridge to be there."

"David started throwing parties at his apartment to bring people together," remembered Daniel Waters, the curator of an exhibit called "Disco at 50" at the Morrison Hotel Gallery in New York in February 2020. "It was a spiritual experience. It became this kind of commune." Truly, the first disco was decidedly more Woodstock than Warhol. "It was very hippie in a way," the pioneering disco chronicler Vince Aletti told *Vanity Fair* in 2010.

Mancuso, who called himself a "musical host" rather than a disc jockey, skirted laws requiring a cabaret license by not selling anybody anything. Guests made voluntary donations at the door to help underwrite costs, much like the so-called "rent parties" held uptown when money got low. In return, they got free pretzels and punch. Hip people from all walks of city life came to dance from midnight to six in the morning at the Loft while Mancuso played records, mixing songs in creative ways, and creating freeform set lists from all musical genres.

"I would play everything from jazz to classical and everything in between," Mancuso said in 2003. Such eclecticism won over even jaded critics. Aletti, who wrote for such publications as *The Village Voice*, said, "It was amazing to go to a place that was playing records I'd never heard before and putting them together in a way I'd never heard before." Mancuso, he said, "heard connections between very different songs and could put them together over a period of time, creating a sense of movement through the night that was nonstop."

"A Mancuso party," wrote William Grimes in the *New York Times* in 2016, "was a sixties dream of peace, love, and diversity: multiracial, gay and straight, old and young, well-to-do and down-at-heel, singles and couples, all mingling ecstatically in an egalitarian, commerce-free space." Dancing there, he wrote, "became a near-religious rite for the city's underground."

These good-vibes-only parties were fueled by psychedelics, not cocaine and "disco biscuits," as quaaludes would come to be called. As Tim Lawrence explained in his seminal 2003 book, *Love Saves the Day: A History of American Dance Music Culture, 1970-1979*, Mancuso was "a child of the counterculture," an adventurous soul who wondered, "What if we take some acid and then instead of lying down on our backs and tripping, we actually move our bodies?" A guest once described the place as "a cross between outer space and a big playhouse."

"Once you walked into the Loft," Mancuso told Lawrence, "you were cut off from the outside world. You got into a timeless, mindless state." There were plenty of balloons, like an overgrown child's birthday party, and one clock, missing a hand. The experience was created as an antidote to the troubles of the times.

"Disco arose out of a really despairing feeling in the seventies," explains Michael Musto, who has covered New York nightlife throughout his career. "We had the war in Vietnam that dragged on pointlessly. We had Watergate. Those two things were devastating to people. The answer was to go to a glittery disco and check your mind at the door."

"Love Saves the Day"—referring to the hallucinogenic drug LSD—became an even more potent player when, in 1975, it moved to a larger space on Prince Street. It was there that legendary DJs like Larry Levan, Frankie Knuckles, Tony Humphries, David Morales, and "Jellybean" Benitez found inspiration. The party, Lawrence says, "turned into an extraordinarily joyous, compelling, creative event" that would go on to fuel such legendary discos as Paradise Garage, The Gallery, and The Saint. "DJs started to gravitate to the Loft when they were finished with their own parties for the night," he told the *New York Times* in 2016. "It was there that some of the most influential DJs of the future . . . would learn about the sonic potential of the party."

The Loft's effect cemented Mancuso's vaulted place in disco's origin story. In the 2010 book *The Record Players: D.J. Revolutionaries*, authors Bill Brewster and Frank Broughton called him, "the most influential figure in night life history."

As one of the creators of the New York Record Pool—a music distribution program for influential DJs—Mancuso fostered the notion that club DJs, not just radio programmers, could make or break a song. He popularized such songs as "Soul Makossa" by Manu Dibango, "Cherchez La Femme" by Dr. Buzzard's Original Savannah Band, and "Calypso Breakdown" by Ralph MacDonald. Long before

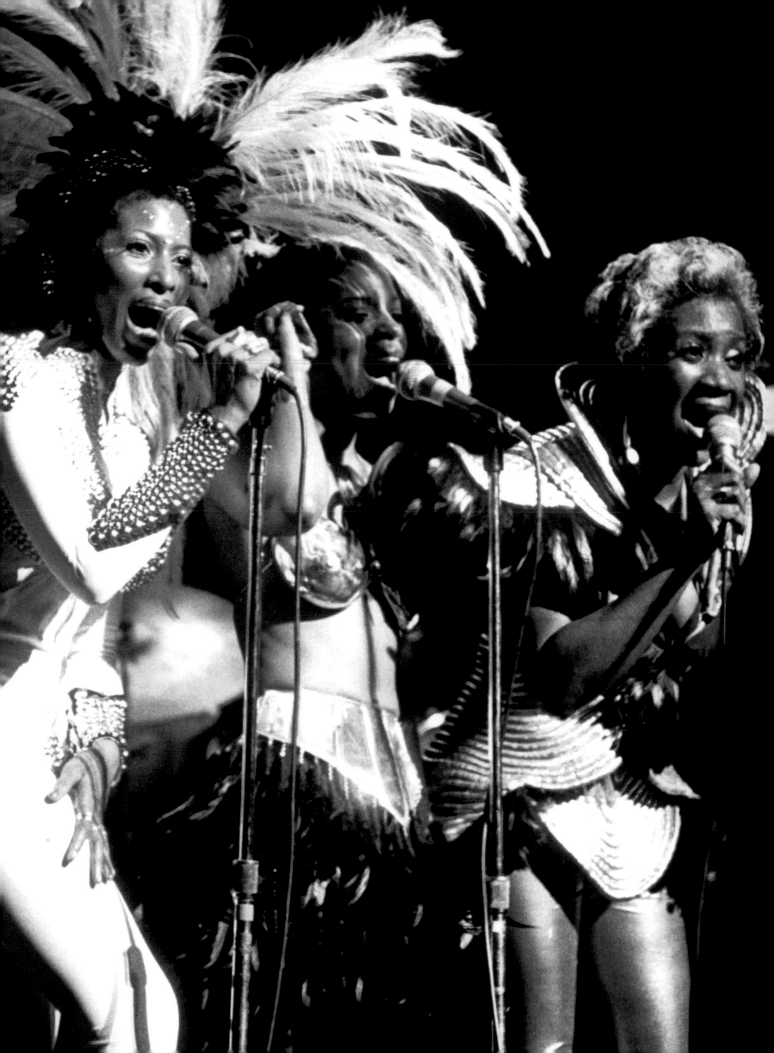

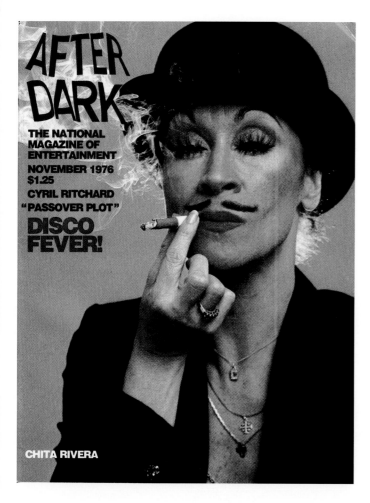

AFTER DARK

THE NATIONAL
MAGAZINE OF
ENTERTAINMENT
NOVEMBER 1976
$1.25
CYRIL RITCHARD
"PASSOVER PLOT"
DISCO FEVER!

CHITA RIVERA

Nona Hendryx, Sarah Dash, and Patti LaBelle of Labelle, the lovelies behind "Lady Marmalade," left. Above, the November 1976 issue of *After Dark* magazine featuring an early report on "Disco Fever!"

they reached the radio—or in MacDonald's case a spot on the *Saturday Night Fever* soundtrack—they were burning up the floor of the Loft.

"I'd never seen anything like it," Benitez told the *New York Post* in 2020. "I learned from watching and listening and participating in that energy." An executive producer of Sirius XM's Studio 54 Radio channel, Benitez remembers the Loft as the place where togetherness was as important as the music. "It had all these souls in the same place, dancing together and alone at the same time, living in their moment. You felt like you were part of the family."

That "family" feeling has been the key to disco's popularity since the beginning, particularly in big cities. Many disco fans had left their biological families, miles away, to find a new chosen family and a home on the dance floor.

As Nile Rodgers, a founder of Chic, told the *Los Angeles Times* in 2021, "I saw all these disparate people getting together and having the time of their lives, and nobody was putting anybody down. Everybody was dancing together, and it wasn't a black club, it wasn't a gay club, it wasn't a Latin club, it wasn't an Asian club. It was everybody. That music and that feeling," he said, "is why I made my career in dance music."

Mancuso's Loft and the discos that followed—like DJ Nicky Siano's Gallery club, for instance—became safe spaces to see and be seen for anyone of any stripe, no matter how bold. Even if the neighbors did look down their noses from time to time—one of Mancuso's fellow tenants told the *Times* in 1974 that the Loft catered to "some of the more bizarre segments of our society"—these discos were bastions of tolerance.

At the Loft, you weren't in Kansas anymore, and you were glad.

"When we started, a disco was a place where the disenfranchised could go, where they didn't need a lot of money to have a wonderful time," Siano says. "One of the most important things that discos offered, especially in the beginning, was friendship and bonding. Not so much for sex, but for friendships that were long-term. I really believe that if AIDS hadn't decimated the gay male community, we would all still be friends. I'm still friends with all the girls."

Those who survived the earliest days of disco remember them with tremendous fondness as an almost secret society. But the secret was about to get out. By 1976, *After Dark* estimated that there were nearly three hundred discos in New York City enticing two hundred thousand people a week to boogie the night away. Disco, which had been solely the bailiwick of bohemians for the first half of the seventies, was soon to bubble up from the largely gay underground and into the harsh light of mainstream media.

When two college buddies named Steve Rubell and Ian Schrager leased a former TV studio in midtown Manhattan, disco became not just a minority party-haven, but the fascination of the most beautiful, most famous people in Manhattan. Disco became daily fodder for gossip columns and magazine spreads, and anything but a secret.

Rubell and Schrager's club would become the mecca of all things disco. This dynamic duo took $400,000 and everything they'd learned from earlier clubs—particularly the fabulous-or-fuhgeddaboudit door policy of the Loft and the Gallery—and opened the disco-to-end-all-discos. While it lasted only a few short years, Studio 54 was everything everyone has ever heard, and more. As anyone who partied there will say, "legendary" doesn't begin to capture how much fun it was.

If you could get in....

He was at the epicenter of disco when it was brand new, spinning and twirling in the seventies at every New York nightclub worth its vinyl. A pioneer who could work a dance floor into a frenzy, Nicky Siano was a mainstay at such protodiscos as the Loft, his own Gallery disco, and the Enchanted Garden, where Steve Rubell and Ian Schrager cut their teeth before opening Studio 54.

Siano has always been in the right disco place at the right disco time.

When Bianca Jagger famously rode into Studio 54 on that white horse, he was up in the booth. Forty years later, when the dance mecca reopened for a one-night-only anniversary event, he was up there again, playing the kind of music he still loves best. A rare surviving DJ from the first years of disco, Siano continues to spin and has dedicated himself to sharing the history of those early days with new generations of dance music lovers.

FDC: "They say the Loft was the birthplace of disco. What was it really like?"
NS: "It was a two thousand-square-foot loft at 647 Broadway. Seventeen hundred square feet of it was the dance floor. The rest was a small area where people ate and drank. They always put out a spread. There was punch and one of our favorite things to eat was Thomas' Date Nut Bread with cream cheese. It was just so unique."

FDC: "Was it a private club?"
NS: "It was David Mancuso's *house*. It wasn't a membership. It was by invitation. It was people who lived on the Lower East Side, people who lived in the Bronx. It was very much a place where people who felt disenfranchised could go and really have a good time. It was very, very special. The vibe was very 'seventies.'"

FDC: "What was David like?"
NS: "He was mysterious. A little bit crazy. A bit rock 'n' roll. He used coke, and at the very end no one wanted to deal with him anymore. But with the Loft, he created a place where people felt safe to bond and dance together. It was great music on a great sound system."

FDC: "What kinds of music was he playing in those days?"
NS: "It was called danceable rhythm and blues. That's what everyone was spinning. But there wasn't enough of it to fill the night, so people would play gospel, they would play jazz, rock 'n' roll. Everything was on the menu as long as you could dance to it, and it had a good musical break—a drum solo or an instrumental part where the horns would go crazy."

FDC: "You got your first job DJing at only seventeen at a place called the Roundtable. How'd that happen?"
NS: "I had been hanging out there all the time. My girlfriend at the time would badger the owner and say, 'Your DJ is terrible. Nicky can do a better job than this guy.' Finally, one Friday, I'll never forget this, the owner said, 'You know what? I hate this guy, too. He just gives me attitude all the time. Let's go, Nick.' So I went to work there for about nine months. What pushed me out was a drag show. The drag master was *not* in my corner."

FDC: "In 1972, you opened the Gallery disco. How did it compare to the Loft"
NS: "The first Gallery was very similar to the Loft except we didn't have high ceilings. We had lower ceilings, but the sound was the main thing and it sounded fantastic. David closed the Loft for the summer, so everybody came to the Gallery. Unlike the Loft, the Gallery turned into this fashion industry watering hole. Every model and every designer were there—Calvin Klein, Stephen Burrows, Halston, everyone. I don't know how that happened."

FDC: "What kind of music were you spinning at the Gallery?"
NS: "Again there was a lot of jazz, rock 'n' roll. Remember the group War? They had a song called 'City, Country, City,' which was really popular back then. On a good sound system, that thing sounded like you just gave birth to your first child and your parents were there waving flags. It was a step beyond any other club."

FDC: "What made it so special?"
NS: "Like David, we invested almost everything in the sound. When we became popular, I wanted even more. I wanted four speakers instead of three. I wanted

bass horns. I put tweeters in, then I needed something to balance them out. I wanted people to walk in and say, 'Wow, this sound system is better than any other club,' because at that time, people were going out to hear the best sound and the best DJ."

FDC: "What makes someone a great DJ?"
NS: "A great DJ doesn't have barriers. You play all different kinds of music. Any music that's danceable is good. No matter what it is—it could be 'Rock Lobster' by the B-52's—it can work on the dance floor."

FDC: "What's the relationship between the DJ and the crowd?"
NS: "You have to stay out of your own way. You need to be outside of your ego, allowing God to pick the music. I know that other people do it other ways. But I also know that other people fail a lot."

FDC: "How did club DJs like you become hitmakers in the disco era?"
NS: "There was what was called 'the record pool' and the director of the pool would certify the DJs who were working. Record companies would distribute their new product to DJs free of charge. I was lucky enough to be on that list when it was just seven DJs. Then it was ten, then it was fourteen. "All the DJs played the same records, so you would go to a club and if a record was new, the DJ was playing it three or four times a night. You'd hear it a couple of times and then you'd go to the next club, and you'd hear the song there. Then people would go out and buy the record, and it would start moving up the charts. People would call in to radio stations demanding to hear a certain song that they heard in the clubs. It was the first time in history that there was an alternative to radio to make a hit."

FDC: "How did you get a job spinning at Studio 54?"
NS: "Steve used to come to the Gallery every Saturday night and stand under the DJ booth watching every little thing. When he opened a club in Queens called the Enchanted Garden in 1975, he hired me, and I worked for him there a year and a half. Finally, I said, 'You know what, this is an hour and a half from my house. Sometimes I can't get a cab at night to take me home and I've got to wait an hour. I'm tired of this. If you ever open a club in Manhattan, give me a call.' Then one day, I got a call and he said, 'I want you to come down to see this space at 254 West Fifty-fourth street'."

FDC: "What did Studio 54 look like when you got there?"
NS: "I walked in and there was sawdust on floor everywhere and half-painted walls. I said, 'When do you plan on opening?' He said, 'Two weeks.' I said, 'You'll never be ready.' He opened in two weeks, and the opening was fantastic!"

FDC: "Tell me about Bianca Jagger's birthday party..."
NS: "Steve came into the booth and said, 'Do you have anything by the Stones?' I had 'Sympathy for the Devil,' which I used to play all the time, and I put it on. Mick looked up at me and winked. The back-wall scrim went up and there were letters from floor to ceiling spelling BIANCA in little tiny twinkling lights. Then she came in on a white horse. I couldn't believe it. There had been no one in the club except us—Mick and Halston and Truman Capote, and a few others—and then out of nowhere there were like forty-seven photographers taking pictures, and the next day that picture was everywhere."

FDC: "That photo must have been great for business . . ."
NS: "It was all over the newspapers. After that, people just started hanging out outside like hungry animals to get in. There was a full centerfold in the *New York Daily News* every day showing who was at Studio 54—Cher, Liz Taylor, Diana Ross, Liza Minnelli. It was an endless parade of big, big names."

FDC: "What would you say is your place in disco history?"
NS: "I'm just another brick in the wall and there are so many bricks in the wall. But you have to start with the foundation, and I'm very proud to say that I'm part of that foundation."

FDC: "As one of the last surviving DJs of that era, do you feel like the keeper of the flame?"
NS: "A hundred and fifty percent. I always hear David in my ears, sometimes in my sleep, saying, 'You've *got* to tell them about this.'"

Must-Hear Disco Playlist:

"BAND OF GOLD" by Freda Payne, 1970

"SEX MACHINE" by James Brown, 1970

"MR. BIG STUFF" by Jean Knight, 1971

"THEME FROM SHAFT" by Isaac Hayes, 1971

"WANT ADS" by Honey Cone, 1971

"CITY, COUNTRY, CITY" by War, 1972

"FREDDIE'S DEAD" by Curtis Mayfield, 1972

"I'LL BE THERE" by The Spinners, 1972

"LOVE TRAIN" by the O'Jays, 1972

"SUPERFLY" by Curtis Mayfield, 1972

"BOOGIE DOWN" by Eddie Kendricks, 1973

"HONEY BEE" by Gloria Gaynor, 1973

"I'LL ALWAYS LOVE MY MAMA" by The Intruders, 1973

"JUNGLE BOOGIE" by Kool & The Gang, 1973

"KEEP ON TRUCKIN'" by Eddie Kendricks, 1973

"THE LOVE I LOST" by Harold Melvin & The Blue Notes, 1973

"LOVE IS THE MESSAGE" by MFSB, 1973

"SOUL MAKOSSA" by Manu Dibango, 1973

"THAT LADY (PART 1 & 2)" by the Isley Brothers, 1973

"ASK ME" by Ecstasy, Passion & Pain, 1974

"CAN'T GET ENOUGH OF YOUR LOVE, BABE" by Barry White, 1974

"DANCING MACHINE" by The Jackson 5, 1974

BARRY WHITE

DISCO TEX

1970–1974

"DO IT ('TIL YOU'RE SATISFIED)" by B.T. Express, 1974

"EVERLASTING LOVE" by Carl Carlton, 1974

"EXPRESS" by B.T. Express, 1974

"FIRE" by Ohio Players, 1974

"GET DANCIN'" by Disco Tex and the Sex-O-Lettes, 1974

"HANG ON IN THERE BABY" by Johnny Bristol, 1974

"HEY GIRL, COME AND GET IT" by the Stylistics, 1974

"I'LL BE HOLDING ON" by Al Downing, 1974

"KUNG FU FIGHTING" by Carl Douglas, 1974

"LADY MARMALADE" by Labelle, 1974

"NEVER CAN SAY GOODBYE" by Gloria Gaynor, 1974

"ONCE YOU GET STARTED" by Rufus featuring Chaka Khan, 1974

"PICK UP THE PIECES" by Average White Band, 1974

"ROCK THE BOAT" by the Hues Corporation, 1974

"ROCK YOUR BABY" by George McCrae, 1974

"ROCKIN' SOUL" by the Hues Corporation, 1974

"SUGAR PIE GUY" by The Joneses, 1974

"TELL ME SOMETHING GOOD" by Rufus, 1974

"TSOP" by MFSB, 1974

"WHEN WILL I SEE YOU AGAIN" by the Three Degrees, 1974

"YOU'RE THE FIRST, THE LAST, MY EVERYTHING" by Barry White, 1974

"YOU LITTLE TRUSTMAKER" by the Tymes, 1974

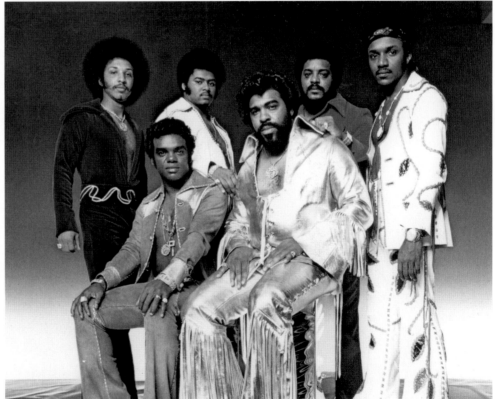

THE ISLEY BROTHERS

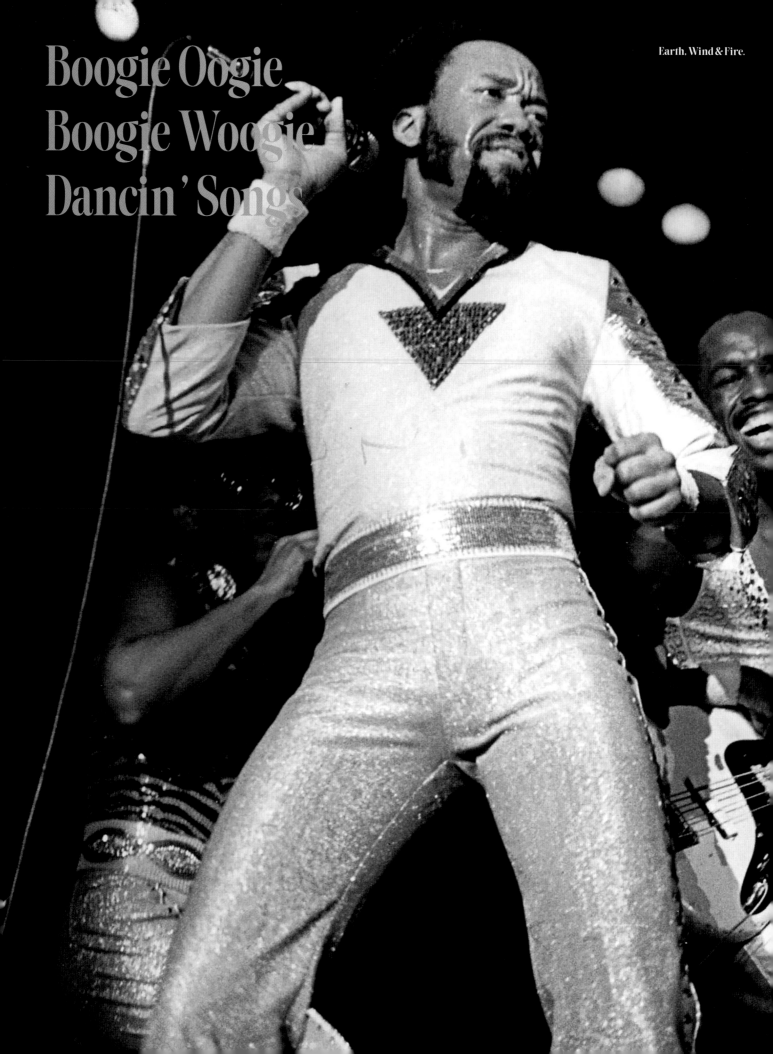

Boogie Oogie
Boogie Woogie
Dancin' Songs

Earth, Wind & Fire.

If any word came to be most associated with disco, it was "boogie." Originally referring to piano music played by southern Black musicians at the dawn of the twentieth century, "boogie" became "boogie woogie." Who in the forties—or three decades later, thanks to Bette Midler—didn't hear about the musical prowess of a certain Boogie Woogie Bugle Boy from Company B? In the words of Bohannon, he was a "boogie woogie freak."

In the disco era, "boogie" truly became part of the popular lexicon. It was used as shorthand for getting down on the dance floor or getting funky in the bedroom. "Let's boogie" meant let's go. It remains in the vernacular today. Madonna professed that she "liked to boogie woogie" in her 2000 hit "Music," and rappers before and since, from Schoolly D to Snoop Dogg, have shown they're always down to boogie.

"Shaped especially by communities on the edges of society, the boogie is nonetheless, by now, entrenched in the mainstream of national culture," wrote historian Burgin Mathews in the fall 2009 issue of *Southern Cultures*. Songs from "Doctor Boogie" by Don Downing to "Boogie with Me" by Poussez! to "Dance, Freak and Boogie" by Nightlife Unlimited to "E-Man Boogie" by the Jimmy Castor Bunch are certainly a vital part of any disco playlist. As Gregg Diamond and his group Bionic Boogie put it in 1978, it's time to "Fess Up to the Boogie."

Oogie oogie, indeed.

"Jungle Boogie" by Kool & the Gang, 1973
It was the first gold record for Jersey City, NJ's own Kool & the Gang, and one of the first official "boogie" songs of the disco era. Urging dancers to both "get up" and "get down with the boogie"—and then "shake it around," of course—"Jungle Boogie" was so sexually charged, it made Barry White sound like a choirboy. Two years later, Kool & the Gang unleashed "Spirit of the Boogie." But their biggest hits didn't start coming until 1979 and "Ladies Night" and "Too Hot." "Celebration" and "Get Down on It" followed. But "Jungle Boogie" remains their dirtiest delight. In 2022, *Billboard* named it one of the Top 30 Funk Songs of All Time.

"Boogie Down" by Eddie Kendricks, 1973
In 1971, Eddie Kendricks left the Temptations, the soul group he cofounded, for a solo career. Within two years, he had a Number 1 pop hit with "Keep on Truckin'," then followed it up later in 1973 with the very sexy "Boogie Down," which topped the R&B charts, and made it to Number 2 on the *Billboard* Top 100. "Let's get it on, girl, don't hesitate. Let my love flood your water gate," he sang, most suggestively. The track was included on the album *Boogie Down!*, released in February 1974, and called one of top songs of that year.

"The Bertha Butt Boogie" by the Jimmy Castor Bunch, 1975
New York funk outfit the Jimmy Castor Bunch had a 1972 hit with "Troglodyte (Cave Man)." Three years later, they let Bertha, the leader of the Butt Sisters, a character mentioned in the earlier song, take center stage on "The Bertha Butt Boogie." Betty, Bella, and Bathsheba Butt were A-OK, but "When Bertha Butt did her goodie, she started the Bertha Butt Boogie," they sang. The song went to Number 16 on the *Billboard* Hot 100 charts. Today, "Bertha" is considered the grandmother of such booty-worshipping hits of the late eighties and early nineties as "Da Butt," "Baby Got Back," and "Rump Shaker." Is the original "Butt Boogie" just as bootylicious as those later hits? As Castor would say, "No question."

"Boogie Fever" by the Sylvers, 1975
The Sylvers—nine brothers and sisters from Watts in South Los Angeles—infected America with "Boogie Fever" in 1975. Whether at a drive-in movie or a pizza parlor, this "new disease" resulted in the urge to dance. The only cure was to do "the bump, bump, bump" all night long and everyone did. "Boogie Fever" went to Number 1 on the Hot 100 charts. The following year, the family was hot again with "Hot Line"—which was like the song "Telephone," but years before Lady Gaga and Beyoncé were born.

"Boogie Flap" by Disco-Tex and the Sex-O-Lettes, 1975
A lesser-known entry in the Disco-Tex canon, "Boogie Flap" was cowritten by Bob Crewe, the man behind not only a string of hits for the Four Seasons, but also "Lady Marmalade." The song described the "Boogie Flap" as a "combination of the flapper and the boogie." Marrying Roaring Twenties exuberance with disco decadence, "Boogie Flap" namechecks Minnie the Moocher, Long Tall Sally and, yes, even Lady Marmalade. It's a sticky example of the nostalgic undercurrent running through seventies pop culture from a band that made its (very long) name with "Get Dancin'" and "I Wanna Dance Wit' Choo (Doo Dat Dance)."

"Boogie Nights" by Heatwave, 1976
Before it was a Mark Wahlberg movie about a man with a prodigious, uh, talent, "Boogie Nights" was an international smash for the multiculti disco group Heatwave. Opening with a teasing arpeggio, the song quickly proves that it has plenty of funks to give. "Ain't no doubt, we are here to party," Heatwave sang. The song went to Number 2 on the Hot 100—Debbie Boone's "You Light Up My Life" wouldn't let go of the top spot—and was included on the soundtrack of the disco-adjacent films *Eyes of Laura Mars*, *The Stud*, and *Summer of Sam*, but not the movie that took its name from the song. Heatwave had another hit with "The Groove Line" in 1978, but as they put it, "Boogie Nights are always the best in town."

"Get Up and Boogie" by Silver Convention, 1976
The complete lyrics to "Get Up and Boogie" are: "Get up and boogie. That's right." But the German Eurodisco trio Silver Convention never needed more than six words to fill a dance floor. Their 1975 smash, "Fly, Robin, Fly," had only five different words and it won a Grammy! "Get Up and Boogie" almost made it to the top of the American pop charts—"Silly Love Songs" by Wings kept it from Number 1—and landed at Number 24 on the biggest hits of 1976. More than thirty years later, it was remade—that's right—as "Get On Your Snuggie" to advertise wearable blankets on television.

"I'm Your Boogie Man" by KC and the Sunshine Band, 1976
He had already put on his "Boogie Shoes" in 1975. But when Harry Wayne Casey, better known simply as KC, returned the following year with the Sunshine Band's fourth album, *Part 3*, that boogie had spread to his entire body. "I'm Your Boogie Man," the Miami heartthrob sang, and from "sundown to sunup," he was ready to dance and a whole lot more. The album also included two of the band's biggest hits, "(Shake, Shake, Shake) Shake Your Booty" and "Keep It Comin' Love." "Boogie Man" went to Number 1 on the *Billboard* Hot 100 in 1977.

"Yes Sir, I Can Boogie" by Baccara, 1977
Mayte Mateos and Maria Mendiola, two Spanish dancers better known as the Eurodisco double-act Baccara, caused a sensation with their debut single, "Yes Sir, I Can Boogie." Although the *Independent* newspaper slagged the song and the whole genre as "a mind-bending Common Market melding of foreign accents, bad diction, bizarre arrangements, and lightweight production," "Yes Sir, I Can Boogie" sold upwards of 18 million copies, making it "the most successful disco song by a female duo," according to the *New York Times*. The song had a revival in 2020 after a video of Scottish footballer Andrew Considine dancing to it went viral. Forty-three years after its initial release, "Yes Sir, I Can Boogie" became an unofficial soccer anthem in the country and climbed to Number 3 on the British charts.

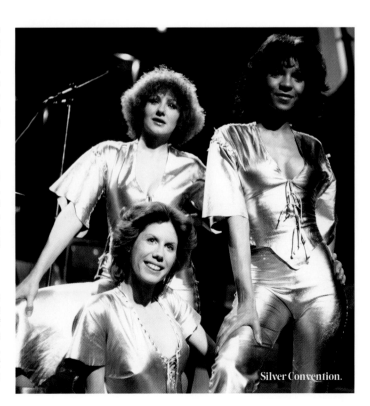

Silver Convention.

The Sylvers on *Soul Train*.

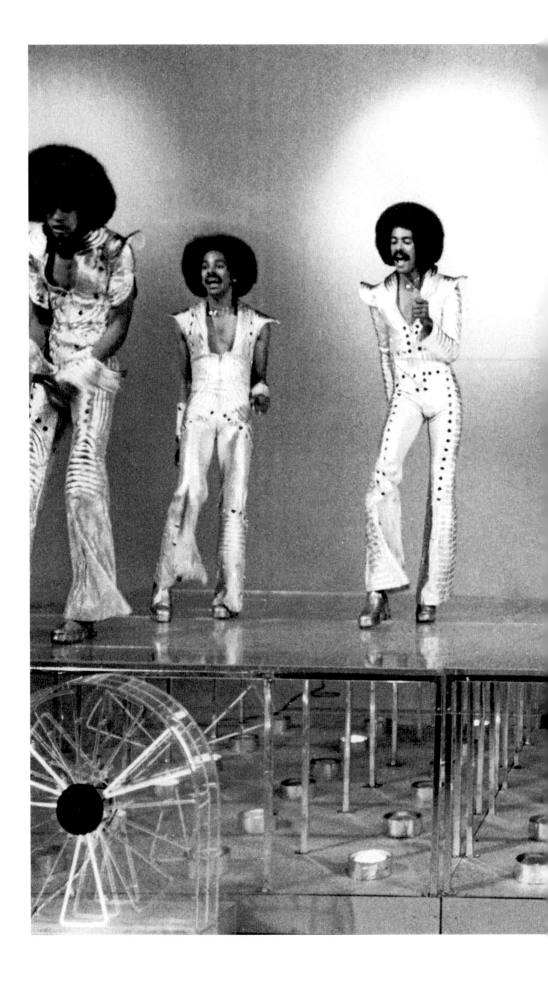

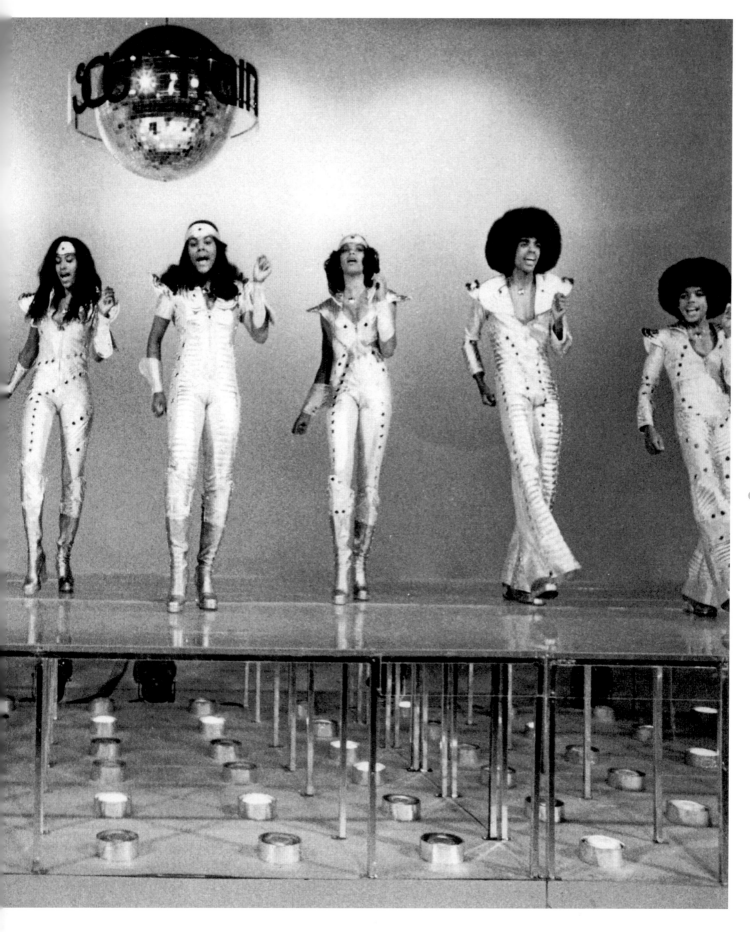

"Boogie Oogie Oogie" by A Taste of Honey, 1978

The Los Angeles—based band A Taste of Honey had been together for six years before savoring the sweet life with "Boogie Oogie Oogie," a platinum single off their eponymous debut album. The song, which invited listeners to "listen to the music and let your body flow," sold two million copies and spent three weeks at the top of the pop, soul, and disco charts. In 1979, A Taste of Honey took home a Best New Artist Grammy. A ballad called "Sukiyaki" was released the following year and became the band's only other hit. It was sayonara for A Taste of Honey until original band member Janice-Marie Johnson and Hazel Payne, a later addition, appeared together on the 2004 PBS special *Get Down Tonight: The Disco Explosion*.

"Blame It on the Boogie" by The Jacksons, 1978

It was written and recorded first by English singer-songwriter Mick Jackson—no relation—but, in the so-called "Battle of the Boogie," the 1978 version by the five much more famous Jacksons won out. Anyone with uncontrollable feet could forgive the sunshine, excuse the moonlight, and pardon the good times because, according to the song, it was all the boogie's fault. Taken from the Jacksons' 1978 *Destiny* album, "Blame It on the Boogie" brought the Indiana-born family back to the Hot 100 charts and primed audiences for their even bigger follow-up, "Shake Your Body (Down to the Ground)." British boy band Big Fun scored with a 1990 cover. A 2012 a cappella version by The Footnotes was heard in the movie *Pitch Perfect*.

"Aqua Boogie" by Parliament, 1978

Music lovers could "catch the rhythm of the stroke" without getting wet when Parliament released "Aqua Boogie (A Psychoalphadiscobetabioaquadoloop)," an indubitably strange single from the album, *Motor Booty Affair*. Written by all-time funk greats George Clinton, Bootsy Collins, and Bernie Worrell, it made a splash in 1978 and spent a month at the top of the R&B charts. "Aqua Boogie" was "a divinely inspired, drug-infested, underwater fantasy," as Rickey Vincent wrote in the 1996 survey *Funk: The Music, The People, and The Rhythm of the One*, and audiences were happy to dive in.

"Boogie Woogie Dancin' Shoes" by Claudja Barry, 1978

Jamaican-born, Canadian-raised singer-actress Claudja Barry offered timeless fashion advice for any would-be disco dancers—the right footwear is key—on this hit track from her 1978 album *I Wanna Be Loved by You*. With diamond-spangled shoes, a girl could be "queen for a night." Barry's reign lasted longer than that. After the international success of "Boogie Woogie Dancin' Shoes," she continued to record dance music. Her last chart hit, "I Will Stand," was released in 2006, her most recent album in 2015.

"Boogie Motion" by Beautiful Bend, 1978

An architect of the subgenre called Eurodisco, Russian-born composer Boris Midney was called the "one Zeus" on the "Mount Olympus of Disco." But, as producer, he preferred to hide behind such band names as Festival and USA-European Connection. With Beautiful Bend, he scored one of his most infectious hits, "Boogie Motion." Miss Piggy burned up the dance floor to the track in *The Muppets Go Hollywood*, a 1979 TV special to promote *The Muppet Movie*, leaving Raquel Welch, Cheryl Ladd, and even Christopher Reeve in the disco dust.

"Hot Buttered Boogie" by Tasha Thomas, 1979

After playing Aunt Em in the original Broadway production of *The Wiz* and providing background vocals for artists as disparate as Jim Croce and KISS, Tasha Thomas emerged as a solo artist with the 1979 album *Midnight Rendezvous*. "Shoot Me (With Your Love)" was the hit single—the *New York Times* called it "a classic of erotic dance music"—but, oh, how that "Hot Buttered Boogie" sizzles whenever you pop it on.

"I Can't Turn The Boogie Loose" by The Controllers, 1979

The Birmingham, Alabama-based soul group The Controllers scored a modest disco hit with "I Can't Turn That Boogie Loose." A single off their *Next in Line* LP, the funk song cracked the Top 50 on the dance charts. Although they opened for such superstars as Ray Charles, B.B. King, and the Temptations, appeared on *Soul Train*, and performed in such celebrated venues as Carnegie Hall and Radio City Music Hall, the band's fame was minor. Perhaps if they *had* been able to turn that boogie loose, they'd have been household names.

"Boogie Wonderland" by Earth, Wind & Fire and The Emotions, 1979

Funk, soul, disco. If you could dance to it, Earth, Wind & Fire played it. For "Boogie Wonderland," a single off their 1979 album *I Am*, the band teamed with girl group extraordinaire—and fellow Chicagoans—The Emotions. Cowritten by Allee Willis, who'd scored a hit the year before with "September," the song made it to Number 6 on the *Billboard* Hot 100. "'Boogie Wonderland' for us was this state of mind that you entered when you were around music and when you danced," Willis said. It was *the* place to chase your "vinyl dreams."

"Boogie Talk" by Madleen Kane, 1980

Best known for "Forbidden Love," a hit single from her 1979 *Cheri* album, Madleen Kane conjugated her way across the dance floor with "Boogie Talk" from her 1980 follow-up LP, *Sounds of Love*. "I can shake it. You can shake it. He can shake it. She can shake it, shake it. We can shake it. They can shake it." Was this English lesson from a Swedish model a bit simplistic? Sure. But the sultry blonde was just too beautiful to argue with. Released on colored vinyl as the B-side to "Cherchez Pas," the 12-inch single peaked at Number 9 on the U.S. dance charts.

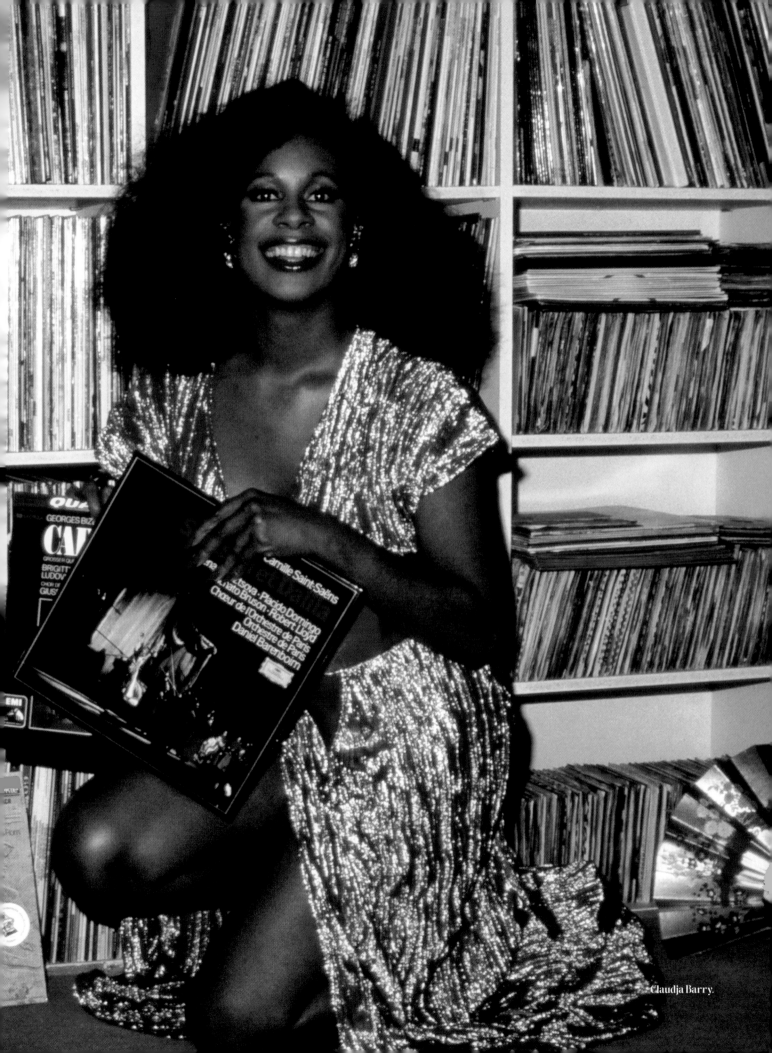

Claudja Barry.

Freda Payne

Freda Payne began singing in her native Detroit when she was a kid.

At barely twenty-one, she followed her show business dreams to New York, made a few jazz records, toured Europe, and acted on Broadway as Leslie Uggams's understudy in the 1967 Jule Styne musical *Hallelujah, Baby!* (She went on five times.) But it wasn't until Payne was lured back to Detroit by the legendary producing team of Holland-Dozier-Holland to record an album for their Invictus label that she found stardom.

The year was 1970.

"'Band of Gold' was a song they brought to me," Payne remembers. "Even though it was the title track of the album, it wasn't the first single release. The first single release was called 'Unhooked Generation,' but it didn't chart. They said, 'We've got to come out with another single quick.' We had no idea that 'Band of Gold' was going to be such a big hit."

That enduringly popular song went to Number 3 on the charts, sold a reported two million copies, and became Payne's first gold record.

"It came out just before the disco era came into focus, but you certainly can dance to it, and people love the lyrics," she says. Payne, however, did not love the lyrics, and almost didn't record the song. She's very glad she changed her mind.

FDC: "'Band of Gold' was credited to Edythe Wayne—but that was really Holland-Dozier-Holland—and their colleague Ronald Dunbar, the A&R man. I understand you weren't thrilled with the words at first."
FP: "I questioned the lyric, 'That night on our honeymoon, we stayed in separate rooms.' I didn't like that line. I said, 'Why would a girl get married, and, on the wedding night, the guy is off and gone? That's so adolescent.' I was already a grown woman, like twenty-seven or twenty-eight, and I said, 'I wouldn't do that.' Ronald said, 'Don't worry about it.' Of course, it's a good thing I went ahead and recorded it."

FDC: "What did the arrival of disco mean to your career?"
FP: "I was signed to Capitol Records in 1976 and they were intent on me doing a few disco songs on my albums. It almost like it was mandatory to do some disco tunes. I did one song that was a disco arrangement of 'Happy Days Are Here Again.' I did 'Love Magnet,' and a song called 'I'll Do Anything for You.' All the arrangements were disco-oriented."

FDC: "How did you feel about the pressure to 'go disco'?"
FP: "It was like saying, 'Oh, let me get in this lane because this is what's happening now.' Sometimes it doesn't work when you try to do something just because it's popular and selling. It doesn't mean that you can jump into that and have the same success. Sometimes you need to just drink hearty and stay with your party."

FDC: "Speaking of parties, did you go to Studio 54?"
FP: "Of course I went there! It was a big deal back then. They always let us in. But you'd have to stand in line outside, you had to be screened. I remember once going there with some old friends of mine. The doorman said 'Well, who are these

people? I said, 'These are my friends, I've known them for years.' And he said, 'Well, they can't come in, but you can.' I said, 'Forget it,' so we turned around and went someplace else."

FDC: "Why do you think people fell so hard for disco?"
FP: "It was a release. It was fun. You know, like, 'Macho, macho man'. With that music, you just felt like a whirling dervish, and you just let yourself go. There was this feeling of devil-may-care freedom because the music was so wild. Remember 'Burn, baby, burn!'?"

FDC: "Disco Inferno!"
FP: "Yes! Go and burn that mother down! Stuff like that just got you going."

FDC: "What did it feel like when you heard Sylvester's 1983 remake of 'Band of Gold'?"
FP: "To me, his version was the most inventive cover. It was *really* a disco record. I was impressed because he did his own thing. He made it his own and I loved it. It had a long introduction. You were already into it and dancing and then the vocal comes in. Sylvester was a lovely soul and he loved me. I knew him before he ever started recording. I met him in 1970, I think, or '71 at the Fairmont Hotel in San Francisco. He knocked on the door of my suite. I opened the door and standing there was this skinny guy with a *lot* of hair. He was promoting his boots. He designed boots! Next thing I know, a few short years later, it's Sylvester, *Recording Artist*."

FDC: "Why do you think America turn away from disco?"
FP: "Music is a form of art, and it moves on, and then they just rename it. In the forties and fifties, it was called 'Black music.' Then it became R&B. Then, disco. Then house and dance music, then hip-hop and rap. It's a moving force that deals with what's going on in the country, what's happening with different ethnic groups. Music evolves."

FDC: "And yet there's still 'Band of Gold,' as fresh as ever. In 2009, you sang it on *American Idol*. What was that experience like?"
FP: "Oh, that was glorious. I loved it. At that time, *American Idol* was the hottest music show on television. It was me, Thelma Houston, and KC and the Sunshine Band. I was just in seventh heaven."

FDC: "Is it still a thrill to see yourself on TV or hear yourself on the radio?"
FP: "Oh, you never get tired of that. I still get like, 'Oh my God, that's my song!' A couple of months ago, I had Sirius XM on in the car and they played 'Band of Gold.' I went into Costco and was in there about forty-five minutes and I came out and was driving back home and what comes on? 'Bring the Boys Home.' I was so excited. I said, 'Oh my god, two of my songs playing just an hour apart from one another.' I was elated!"

FDC: "Did you ever think we'd still be singing 'Band of Gold' today?"
FP: "I never had a clue. I never thought it would be celebrated or have developed into something monumental. Back then it was, 'Oh, well, it'll play out in a few years, and we'll go on to something else,' but it hasn't. I do 'Band of Gold' as my encore, and everybody in the audience is smiling, everybody's happy. I see it in their eyes, and it's amazing."

Must-Hear Disco Playlist:

"BAD LUCK" by Harold Melvin & the Blue Notes

"BOOGIE FEVER" by The Sylvers

"BRAZIL" by the Ritchie Family

"DISCO BABY" by Van McCoy

"DISCO STOMP" by Hamilton Bohannon

"DOCTOR'S ORDERS" by Carol Douglas

"DREAMING A DREAM" by Crown Heights Affair

"EASE ON DOWN THE ROAD" by Consumer Rapport

"FLY, ROBIN, FLY" by Silver Convention

"FOREVER CAME TODAY" by The Jackson 5

"FREE MAN" by South Shore Commission

"GET DOWN TONIGHT" by KC and the Sunshine Band

"HAPPY PEOPLE" by the Temptations

"HIJACK" by Herbie Mann

"HOLD BACK THE NIGHT" by the Trammps

"HOW HIGH THE MOON" by Gloria Gaynor

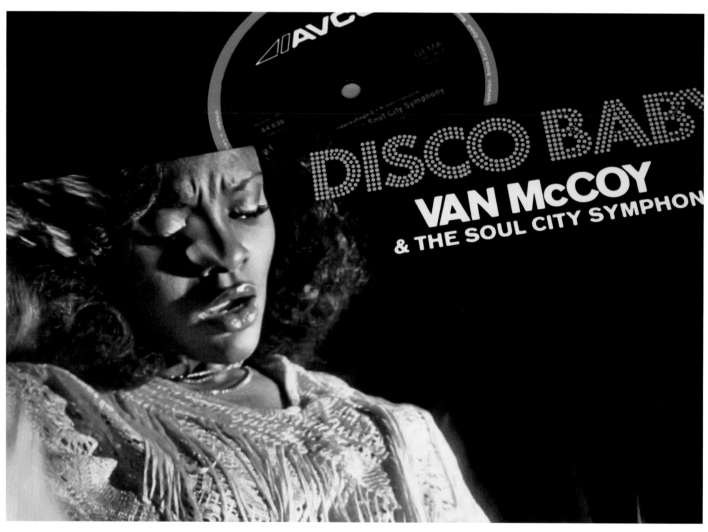

THE *DISCO BABY* ALBUM BY VAN MCCOY

1975

"THE HUSTLE" by Van McCoy

"HUSTLE LATINO" by Liz Torres

"I LOVE MUSIC" by The O'Jays

"I NEED A MAN" by Grace Jones

"IT ONLY TAKES A MINUTE" by Tavares

"IT SHOULD HAVE BEEN ME" by Yvonne Fair

"JIVE TALKIN'" by the Bee Gees

"LADY BUMP" by Penny McLean

"LOVE ROLLERCOASTER" by Ohio Players

"LOVE TO LOVE YOU BABY" by Donna Summer

"MORE, MORE, MORE" by Andrea True Connection

"SHAME, SHAME, SHAME" by Shirley & Company

"SUPERSTAR REVUE" by the Ventures

"SWEARIN' TO GOD" by Frankie Valli

"THAT'S THE WAY (I LIKE IT)" by KC and the Sunshine Band

"YOU SEXY THING" by Hot Chocolate

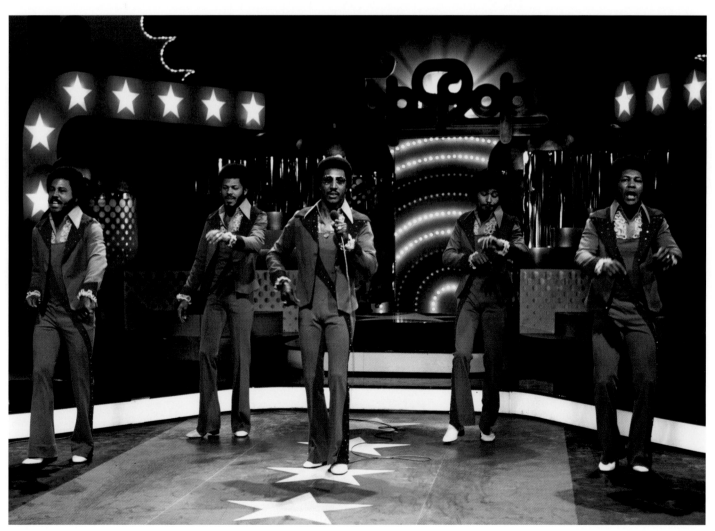

TAVARES

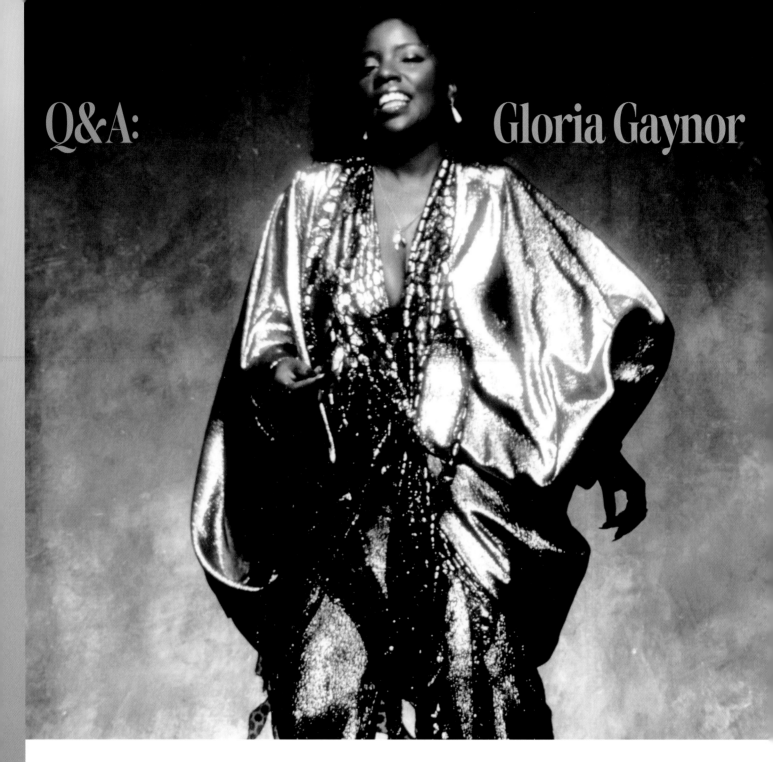

Q&A: Gloria Gaynor

Growing up in Newark, NJ, Gloria Gaynor knew early on that singing was her calling. "So much music had come out of that place that it just made me feel that it was right for me to do this," she says. After performing in such swanky nightspots as the Cadillac Club, the Key Club, the Paradise Lounge, and the Orbit Lounge—"It was *way* downtown," she says—Gaynor was signed by Clive Davis to her first major-label recording contract.

But when the legendary music mogul went off to found his own label, Gaynor was left behind. The president of MGM Records "rediscovered" her. "I remember running across town in New York City to pick up my new contract and bring it back to my manager so that they could get all the paperwork done by seven o'clock in the evening. Otherwise, the deal was off," Gaynor says. Thank heaven, she hoofed it.

Her first of three megahits followed. Gaynor's music not only defined disco for almost a decade, but also became enduring parts of the American pop soundtrack. Her 1990 cover of Frankie Valli's "Can't Take My Eyes Off You" has stood the test of time too.

Over the years, she never stopped doing what she does best. In 2022, for instance, she appeared on *The Masked Singer* competition show. When her identity was revealed, social media was awash with the news: THE MERMAID IS GLORIA GAYNOR! In 2023, the documentary film *Gloria Gaynor: I Will Survive* had its world premiere at the TriBeCa Film Festival.

In it, Gaynor proved she not only survives; she thrives.

FDC: "Your first smash was 'Never Can Say Goodbye' in 1974, which I should point out, the Encyclopedia Britannica calls "the first disco qua disco hit." How did it happen that the song became part of a longer piece—right between 'Honey Bee' and 'Reach Out, I'll Be There'—that filled one whole side of an album?"

GG: "That was the producer Tom Moulton's brainchild. He was a great mixologist, probably still is. He came up with that idea and I was all for it because I love to dance. One five-minute record on the dance floor was never long enough for me. I thought it was brilliant. I figured DJs would love it, because with that record, they could have a twenty-minute break."

FDC: "Did you realize at the time that the notion of a 'disco suite' would be such a revolutionary idea?"

GG: "I knew I wasn't the only one who loved to dance. I believed that people would pick up on that and run with it because it was an ingenious idea—DJs mixing records, one record spinning into another. We definitely had a revolutionary effect on playing records in clubs. For the DJs and the audience, it became an art form."

FDC: "How important was club play to the sales of a record in those days?"

GG: "Club Play was monumental, because that's where people would hear music and get the most out of it. If you're listening to a record on your way home in a car, your mind is really on your driving. But in a club, you are really enjoying the music."

FDC: "When 'Never Can Say Goodbye' came out, were you using the word 'disco' to describe it?"

GG: "It was around that time—'74 or '75—that disco became a thing, not just because new clubs were opening, but also because in cabaret clubs, they were removing the seating and putting in a turntable."

FDC: "What did that advent of disco mean to your career?"

GG: "Disco really set me apart and made it so that I was not in competition with the R&B artists. I was a leader instead of somebody following. Barry White and I are called the King and Queen of Disco because we were the first ones to record music specifically for dancing, specifically for clubs. So disco had a huge impact on my career."

FDC: "It's got to feel good that every man, woman, and child in America can sing your biggest hit, 'I Will Survive.'"

GG: "It's wonderful. But I don't know if people are familiar with the story of how that song came about. In my show, my two background singers and I did this tug-of-war with my microphone cord. One night, there was a mix-up and I fell backwards over the monitor. But I jumped back up and finished my show. When I woke up the next morning, I was paralyzed from the waist down. I ended up in the hospital for three-and-a-half months! During that time, the record company told me that they were not renewing my contract. So now, I don't have any gigs, I don't have a recording contract, I'd lost everything. So, I'm in the hospital and I'm praying and I'm reading the Bible. I left the hospital believing that God was going to do something. Shortly thereafter, the record company sent me a letter saying that they were not ending my contract because a new president had come over from England, where I was popular."

FDC: "What did they want to do?"

GG: "They called and told me 'We need you to go out to California and record this song called "Substitute" that the president chose.' I didn't like the song, but I had to hold on to my recording contract and my career, so I went to California. They didn't know what was going to be on the B-side. They said, 'What kind of songs do you like?' I told them I like songs that have really good lyrics, that touch people's hearts. They said, 'We think you're the one we've been waiting for to record this song that we wrote two years ago' and that song was 'I Will Survive.'"

FDC: "So 'I Will Survive' was the B-side of 'Substitute' originally?"

GG: "Yes. I was reading the lyrics and standing there in a back brace, feeling in a bad way because my mother had passed away just a few years earlier, relating to the song and I was like, 'What are you, stupid? You're going to put this on the B-side!?' I thought everybody's going to be able to relate to this song whatever they're going through. How can you put this on the B-side? They said 'Well, that's the deal.' We took it back to the record company and it wasn't even listened to. Nobody wanted to go against the president's choice."

FDC: "So how did 'I Will Survive' become a hit?"

GG: "When it was first released, they gave us a box of records. We went to Richie Kaczor, a Studio 54 DJ, and asked him to play it. The audience loved it! I was like, you know what, when a jaded New York audience immediately loves it, you know it's going to be a hit. He gave them to his DJ friends around New York. Then people began to request it on the radio, because now they wanted to hear it on the way home from work while they were held up in traffic. And, the rest, you know, is history."

FDC: "That was in 1978. Where were you the following year when you heard about Disco Demolition Night in Chicago?"

GG: "I was in New York, and I thought it was so ridiculous. It was obvious that they appealed to the mob mentality. My question to everyone, had I been there, would have been why have you got these disco records if you don't like disco? You certainly didn't go out and buy disco records to burn them. Obviously you have them already. If you don't hate disco music, why are you letting somebody corral you into this foolishness? I've always believed that the impetus behind this whole thing was that the popularity of disco music was a threat to somebody's bottom line. But do you know anybody who listens to only one kind of music? Why does music need to be separated like that? Separate the good from the bad, not one genre from another."

FDC: "Did that event embolden the so-called 'Disco Sucks' movement?"

GG: "Middle America believed that disco was associated with drunkenness and drugs and all kinds of craziness that they didn't want their children involved with. It pulled them away from disco, not that stupid thing, Disco Demolition Night. Disco music was associated with those things in the minds of those people, but really disco was about everybody coming together and having a wonderful time, period. Many people don't realize that disco music is the only music in history ever to bring together people from every race, creed, color, nationality, and age group."

FDC: "Did the success of 'I Am What I Am' in 1983 prove that the news of disco's demise was premature?"

GG: "I think so. It was recorded to be a disco record. But it succeeded because of the lyrics. With 'I Am What I Am,' people could personally relate to the lyrics and take it with them wherever they went, not only gays or Blacks, but people who are disabled, too. My song was for anyone who was being discriminated against."

FDC: Are you proud to be someone who's still associated with disco?

GG: "I started out singing jazz, then I started singing R&B, and then I started singing disco. Disco gave me my place in the music world. I own that and I'm pleased with that. But I don't want people to feel that that's all I can do. I do all kinds of music."

FDC: "Speaking of all kinds of music, forty years after winning your first Grammy for Best Disco Recording for 'I Will Survive' in 1980, you won a second Grammy, for Bests Roots Gospel Album for your album *Testimony*, in 2020. How did that feel?"

GG: "It was very, very validating because I had been wanting to do a gospel album for years. My manager was always putting it off. He said if we win another Grammy, we'll do it. As God would have it, I didn't win that Grammy until I did a gospel record. It's always wonderful to get a Grammy because it comes from your peers, people who know what it's like to do what you do."

FDC: "How did it feel when 'I Will Survive' was added to the National Recording Registry in 2015?"

GG: "Oh, that was incredible. It never even crossed my mind that something like that could happen. I was elated. And then they asked me to do a disco party at the Library of Congress, which was something that had never been done before. A lot of my friends called and said, 'When are tickets going on sale?' I told them 'Ten minutes ago.' And they called me back and said, 'Guess what, all the tickets are gone!'"

FDC: Does it please you to see disco being revived in recent years?

GG: "It feels great to see your legacy in action, to see the effect it's having on people. Not a lot of performers get to have that, you know, so it's wonderful. I'm glad that young people are liking what I've done."

FDC: Does it amaze you how widespread disco's influence remains?

GG: "Disco became very, very widespread, far more widespread than a lot of people want to admit. I'm telling you I don't go anywhere that people don't know my music. They may not know my name, but they know 'Never Can Say Goodbye,' they know 'I Will Survive,' they know 'I Am What I Am.' These songs are immortal."

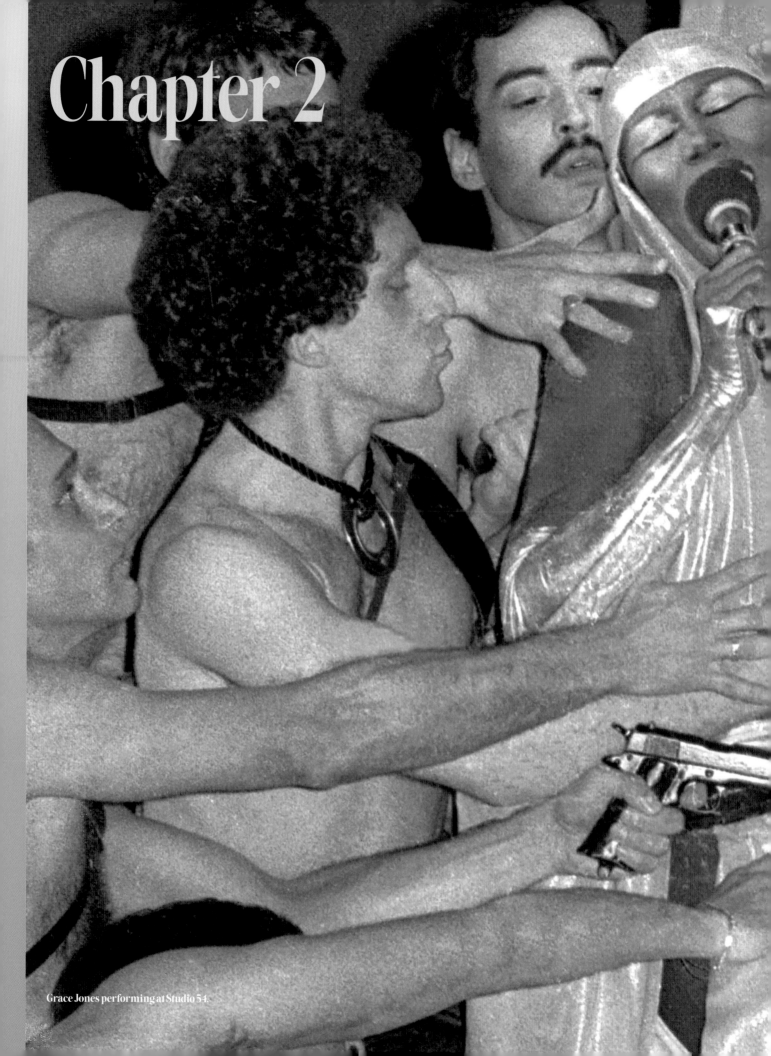

Chapter 2

Grace Jones performing at Studio 54.

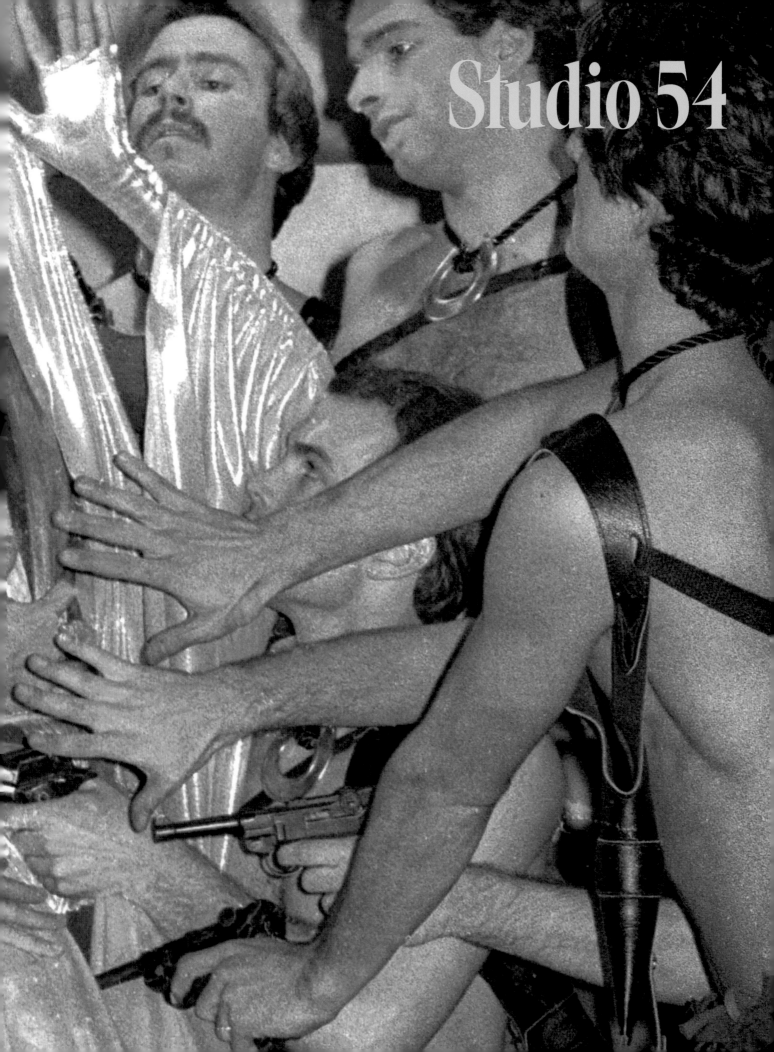

Studio 54

"

JUST COME ON DOWN TO 54, FIND A SPOT OUT ON THE FLOOR...

—Chic

In 1977, the enterprising duo of Steve Rubell and Ian Schrager—two fraternity brothers who'd both grown up in Brooklyn and met in 1964 at Syracuse University—took all they learned running the Enchanted Garden, a discotheque in a mansion on a Queens golf course, and all they'd cribbed from the Loft, the Gallery, and other protodiscos like Le Jardin, and ran with it.

With an initial investment of $400,000, they opened on April 26 a nightclub that was to become the epicenter of seventies nightlife, the stuff of legend, what Grace Jones called "the disco of all discos." It was, of course, Studio 54, or, to its fabulous habitués, simply "Studio."

An opera house in the twenties and a radio and TV studio for the likes of Jack Benny, Gary Moore, and Perry Como in the forties and fifties, Studio 54 became the exclusive watering hole of the most fantastic creatures in New York City—and a pit stop for the international jet set—from the moment it opened. "The most interesting, accomplished, and great-looking people from all over the world were there every night," uber talent manager Sandy Gallin said.

Truly, if disco music had a mecca, this was it. Nightlife chronicler Michael Musto aptly described Studio 54 as "the seventies' most head-spinning palace of disco hedonism" and Atlantic Records cofounder Ahmet Ertegun, who'd been to practically every hip-and-happening hotspot of the twentieth century, called it "the greatest club of all time."

Studio 54's opening night was literally front-page news. The morning after its premiere, a photo of Cher entering the club in a straw hat, suspenders, a sweater, and jeans was on the cover of the *New York Post*. Studio 54 wasn't even mentioned by name, but simply as a discotheque on West Fifty-Fourth Street. Legendary showbiz columnist Earl Wilson wrote, "Disco is indeed here."

While the more introverted Schrager oversaw the goings-on inside, the outgoing Rubell worked the door, picking and choosing who would be allowed inside. "The idea was I was going to build it and Steve was going to get to conquer Manhattan," Schrager said.

Rubell filled the place with beautiful people from every urban stratum—society ladies and struggling artists, starving models and fat-cat musicians—while

Tom Snyder interviewing Steve Rubell.

rejecting those whose charms weren't immediately apparent. The "Bagel Nosh polyester crowd," as he once called them, was NOT getting in for love or money.

Assisted by the strapping doorman Marc Benecke—both often wearing sleeping-bag coats designed by Schrager's girlfriend Norma Kamali—Rubell likened Studio 54's door policy to making a salad: You had to have little bit of everything for it to taste good. As literary lion Truman Capote, a frequent attendee, said, "It was boys with boys, girls with girls, girls with boys, blacks and whites, capitalists and Marxists, Chinese and everything else—all one big mix." Genuine celebrities were the croutons on top.

Stars from Elton John and Dolly Parton to world-renowned pianist Vladimir Horowitz and surreal artist Salvador Dalí rubbed elbows with the fellow famous and the merely fabulous. One-name singers mingled with no-name creatures who, by day, worked as artists, window dressers, hairstylists, and shopworkers. "The key to the success of Studio 54," Andy Warhol said, "is that it's a dictatorship at the door and a democracy on the dance floor."

"I just loved it," says Cher. "It made you feel alive and kind of heavenly." Inside, celebs could let down their hair—even lacquer-coiffed tap dancer Ann Miller. "It was Rubell's clever and ingenious way of inviting stars, after performing in New York nightclubs, theater, and fashion shows, to party in the hours after dark that made it successful," wrote photographer Ron Galella in his 2006 monograph *Disco Years*.

Gossip columnists in search of names to set in boldface type had a field day there. "At Studio, something usually happened that was worth writing about," says author Susan Mulcahy who was working at the *New York Post* in those days. "It didn't have to be a big special party. You'd always see an unusual couple— two people who wouldn't normally be seen together—having a conversation." (One magazine columnist remembered seeing Moshe Dayan talking to Gina Lollobrigida.) "It was an outrageous scene at all times," says Mulcahy.

Revelers would keep a polite distance from the most famous guests as they sat and talked, but once the stars hit the dance floor, they were fair game. Anyone who wanted to, say, boogie with a Kennedy—whether John Jr. or Little Edie Beale of Grey Gardens infamy—could sidle up and, as Chic would say, freak out. Under the watchful gaze of the club's iconic coke-snorting man-in-the-moon, mirror-ball mingling was encouraged.

"Margaux Hemingway was dancing two feet away from you," remembers Musto. "Liza Minnelli and Halston and Andy Warhol and you were all dancing together, even Michael Jackson before he was terrified of crowds. The disco music itself brought people together."

Sterling St. Jacques, a gorgeous Black male model, well over six feet tall, might be twirling publicist and party-giver Carmen D'Alessio, or hoisting her up on his shoulders, while ballet star Rudolf Nureyev freestyled with nine-year-old child actor Ricky Schroder.

"I was on that dance floor dancing with whoever would dance with me," actress Brooke Shields recounted in Schrager's 2017 book, *Studio 54*. "I would pick some dancer who was clearly on the dance floor just to dance, and I would dance, dance, dance . . ."

It was a disco free-for-all. But few guests were engaging in the kind of choreographed disco dancing of *Saturday Night Fever*. Such routines were for the movies, and dance competitions in outer-borough clubs. "If you went to the Odyssey in Brooklyn, they were doing the Hustle, all the spinning and carrying-on," remembers Cory Daye, lead singer of Dr. Buzzard's Original Savannah Band. "That was not the kind of thing to do in places like Studio 54, however."

Still, Studio 54 was the setting for much unbridled fun, and age didn't matter. "I didn't think Bob Hope would like it, but he was dancing," Rubell told Andy Warhol and Truman Capote one day over lunch in 1979. "Johnny Carson took his shirt off!"

That was the least of it. At a birthday fete for Bianca Jagger on May 2, 1977, the gorgeous wife of Mick Jagger arrived on the back of a white horse led by a stark-naked man. Photos of her on horseback, shot only a week after the club opened, cemented Studio's renown. Later that year, Grace Jones, surrounded by nearly nude male dancers with toy pistols tucked into their G-strings, performed on New Year's Eve.

It's not any wonder that on *Saturday Night Live*, Gilda Radner's big-haired newswoman character Roseanne Roseannadanna told Weekend Update anchorwoman Jane Curtin, "You know Jane, that Studio 54, it's a lot like your ear. All pink and pretty and kinda normal on the outside, but inside—oh boy, it's dark and filled with all kinda weird things!"

She wasn't wrong. At Studio 54, it was always something.

Elizabeth Taylor and the designer Valentino each turned forty-six and Karl Lagerfeld turned forty-five at parties there in 1978. For Taylor's party, Rubell filled Studio 54 with trees, painted white and festooned with lights, and hundreds of white flowers—a reported forty-six dozen white gardenias, flown in from California, and 460 white calla lilies. When it was time for the violet-eyed superstar's birthday cake, thirty Rockettes kicked their way in and presented it to her.

For Dolly Parton, he threw an haute hoedown, bringing in bales of hay and live farm animals. Capote and Warhol famously hosted an Oscars viewing party there in 1978. At other times, Studio celebrated the openings of such seminal seventies films as *Grease, New York, New York, Thank God It's Friday,* and *The Eyes of Laura Mars.* Leonard Bernstein danced the night away at the premiere party of *The Turning Point.*

There was a fete for modern dance choreographer Martha Graham with Eartha Kitt, Mikhail Baryshnikov, Yul Brynner, and Gloria Swanson in attendance, fashion shows by Bob Mackie, and more. The more lavish, the more star-studded, the more over-the-top, the better.

"I remember wading through artificial snow to get to the dance floor," says the artist Mel Odom, who was creating illustrations for *Viva* magazine at the time. "There was snow and ice and icicles and everything. It was really amazing."

The goings-on inside Studio 54 stood in sharp contrast with what was going on in the city at the time. The Son of Sam killer was terrorizing New York, urban green spaces were so filled with junkies they were called "needle parks," and Times Square was not a Disneyfied outdoor shopping mall but a porn-lover's paradise. Instead of comic book characters posing for pictures with tourists, it was crawling with hookers.

"It was a scary time," says Fern Mallis, the architect of New York Fashion Week who, in those days, was working for such companies as Mademoiselle and Gimbel's. Young couples were being found murdered in their cars. People were afraid to go out." She remembers one night at Studio in particular.

"It must have been one o'clock in the morning and, all of a sudden, the music stopped. It was like, 'Oh my God, what happened?'" she says. "Steve Rubell went up to the DJ booth and took the mic and made the announcement that Son of Sam had been caught and was in jail and drinks were on the house for the rest of the night. The place just went crazy."

Too dirty and dangerous for middle-class visitors, "Fun City" needed Studio 54 in the late seventies. For city dwellers, the club was more than just an oasis, it was a godsend. "Studio provided a radiant sunburst of energy: flashing lights, fog machines that recreated the feel of a Hollywood movie set. People dancing, drinking, and having sex—it was glamorous and decadent," Galella observed.

The disco was what model Lauren Hutton called a "recharging station in an increasingly high-strung world." Minnelli summed up the feeling most succinctly when she said, "That place made all the troubles of the day disappear."

"No matter what you did at night, you would always end up at Studio 54," designer Diane von Furstenberg remembered. Her husband, businessman Barry Diller, added, "Inside Studio you were in a magical cocoon. You felt safe inside."

"Once you were inside, you were transported to another place," says menswear designer and fashion historian Jeffrey Banks, who was at Studio 54 on opening night. "You had truly left Manhattan, and you were no longer in Kansas, Dorothy." Actress and model Morgan Brittany remembers her first time. "Francesco Scavullo, the photographer, invited a couple of us to Studio 54. It was the most insane thing I had ever seen, and I had been in the business my whole life. The stuff I saw—the people, the way they acted—I mean it was everything you think it was." Certainly, it was worth the ten-dollar weekend admission fee. It was cheaper on weekdays. The famous, of course, never paid. Rubell called them "loss leaders."

"It was the kind of environment where you could do whatever you wanted and not be chastised or arrested for it," says Mulcahy. "I wasn't there every five minutes, but whenever I would go I'd get excited." Even though she was there as a working journalist—which Mulcahy says is the only reason she was allowed in—"it was fun," she says.

In a 1996 *Vanity Fair* oral history of the place called "Anything Went," writer Bob Colacello wrote, "The whole world came together on that strobe-lit dance floor in a way that seems inconceivable in this age of plague, political correctness, moral righteousness, and social fragmentation. Uptown and downtown, LA and DC, London, Paris, Rome, and Rio, society queens and drag queens, athletes and artists, debutantes and hipsters, Mayor Beame and Roy Cohn, Diana Vreeland and Miz Lillian—they all were there."

Miz Lillian, who was President Jimmy Carter's mother, tickled Rubell when she said, "Why are all these boys dancing together? There are all these pretty girls around." Later, she told the press, "I don't know if it was heaven or hell, but it was wonderful."

Attracting diverse megawatt celebrities from Edgar Winter to Donna Summer was key to the club's notoriety. But Studio also made famous its share of colorful unknowns. As Carson, whose glamorous wife Joanna loved to boogie, once observed on *The Tonight Show*, "In discos, the people who go there are really the stars."

Everyone glittered on the dance floor.

"Studio did have its characters," remembers Patrick McDonald, a fashionista known as the Dandy of New York, who was working at the hip Italian boutique Fiorucci in the late seventies. "There would be drag queens, and a group of nurses, and these two guys in leather and harnesses who were like a hundred years old, and they'd be dancing on boxes."

Odom remembers that "women would come in wearing trench coats and be stark naked underneath. I started recognizing them by their nipples." His look of choice was not nudity but a leather spacesuit by Larry LeGaspi, who designed costumes for Labelle, KISS, and Grace Jones.

These creatures, says Mulcahy, "were just figures on the scene, but they were the reality show stars of the time, the Kardashians and the Real Housewives of the period." They were the eccentrics of Studio 54, she says, and their lives became an "ongoing saga in the tabloids." Simply put, they made for great photos and sometimes good copy.

"Disco Sally," as Sally Lippman became known, was their queen.

At age seventy-seven, she began going to Studio 54 at midnight every night and became a media darling. Wearing groovy prescription sunglasses—"I can't stand the glare," she explained—and glittered high-top sneakers, the four-foot-ten, ninety-five-pound septuagenarian cozied up to stars like Dustin Hoffman who were only too happy to Hustle with her. A widow and former lawyer, the dancing nana would always "draw an audience of adoring fans as she got down on the dance floor," New York magazine reported.

Another Studio 54 good-time girl was Rollerena, a drag fairy godmother on skates. A Kentucky native, she had been a Greenwich Village fixture since she first strapped on a set of wheels in the early 1970s and, in men's clothes, skated to her job on Wall Street.

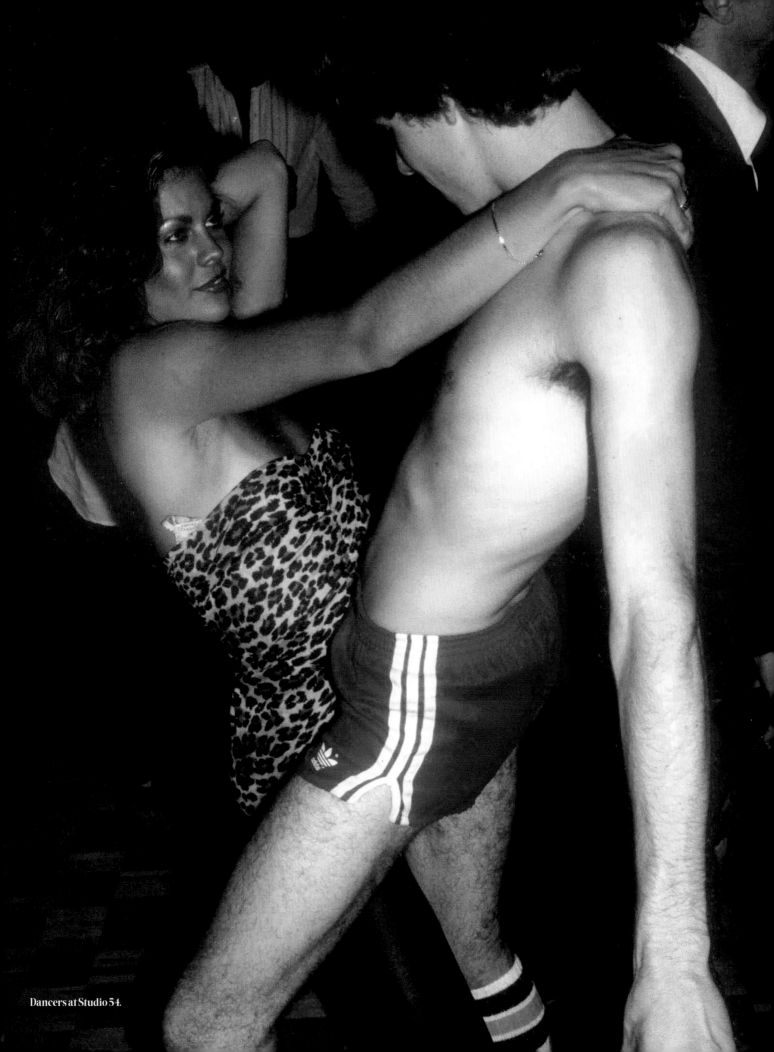

Dancers at Studio 54.

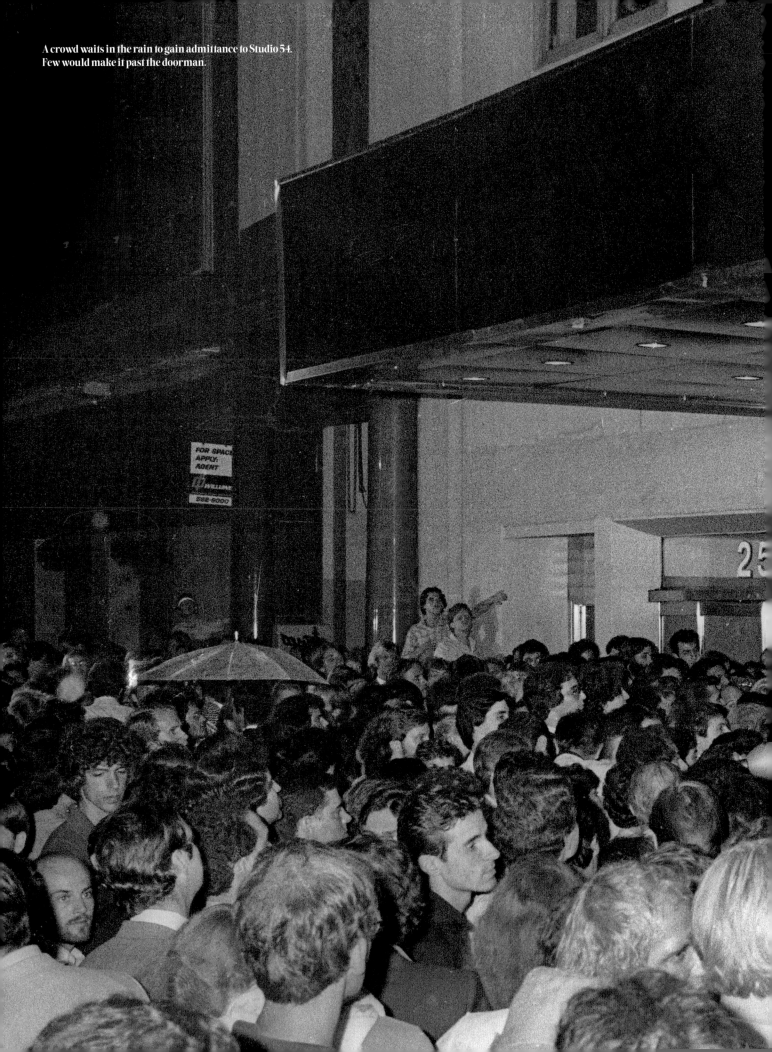

A crowd waits in the rain to gain admittance to Studio 54. Few would make it past the doorman.

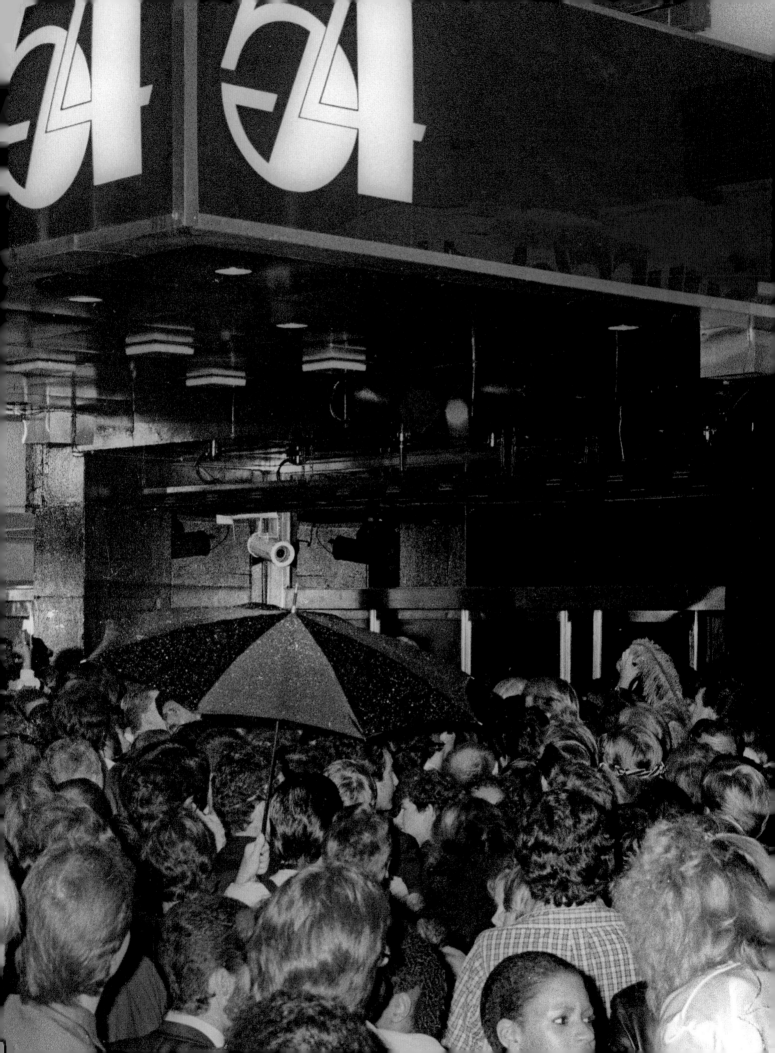

"She would roll around the dance floor, waving her magic wand over the revelers, occasionally sprinkling some glitter fairy dust over their heads," remembered photographer Bobby Miller in his 1998 monograph *Fabulous!: A Photographic Diary of Studio 54.*

Rollerena's drag was a sort of thrift-store Dame Edna look. "The costume made me more complete as a person," she said. With the help of a publicist, as Jay Blotcher wrote in *Outweek* magazine in 1989, she became a sensation. "With laser-light speed, she had become an international star of the disco age, showing up in all the glamour rags and running about with the beautiful people," he wrote.

Looking back on her Studio years, Rollerena told Blotcher, "We had great times at Studio. Steve Rubell always introduced me to people like Betty Ford and Elizabeth Taylor. But I didn't go chasing after them to be photographed. When they were ready, they would come to Rollerena. Halston had me in his home for a party. I found them all to be very loving."

"There didn't seem to be any guilt in those days," Kevin Haley, a model-turned-decorator told *Vanity Fair* in 1996. "Decadence was a positive thing. Cocaine was a positive thing. It had no side effects, or so we thought."

Studio 54 was known to employ a battalion of gorgeous bartenders. Toned and shirtless in skimpy satin gym shorts and sneakers—Rubell said the best-looking ones came straight from dance class—they poured drinks and kept customers happy. A young Alec Baldwin was an upstairs waiter for a time. "Gay men would go up to the balcony and fondle one another," he said in Schrager's book. "They would ask your boy here to go downstairs and quote-unquote fetch them a pack of cigarettes. I was a very popular 'cigarette snatcher' in the balcony."

Although many gay men went there, Studio 54 wasn't a gay bar, per se, but Rubell liked the gays because they brought energy to the place. Beautiful women, he said, brought the glamour. For anyone who made it past the door, Studio 54 was the ultimate dance hall. But for gays in the seventies, the club was also the nightly antidote to workdays spent in the closet and lives stifled by discrimination. Even for those who only heard about the goings on at 254 West Fifty-Fourth Street, it was a beacon—an Emerald City with a state-of-the-art sound system.

"When I would go home to North Carolina," says Odom, "my friends would ask me what Studio 54 was like. I would tell them it was a place where you didn't have to pretend you were straight. In fact, a lot of people pretended they were gay! Every kink on the planet was on display on the dance floor. It was a fantasy that everyone could have a piece of."

Not everyone. A Dallas Cowboy defensive end named Harvey Martin, in town to be honored as a Super Bowl MVP, for instance, couldn't get past the velvet ropes. "I asked if I could just peek in so I could tell the folks back home," he told a gossip columnist. "They wouldn't even let me do that." If he'd been queer, they might have. David Kopay, the first out gay footballer, sailed in when he went to Studio.

"A great thing about Studio was the way they not only welcomed gays, but celebrated us," says Musto. "Everyone wanted to be with the gays. We were the prize customers at places like Studio and that was really a new development."

The newfound sexual freedom of the era was part of the allure. "Up in the balcony, you literally would just sit to take a rest and you would be fending off someone grabbing your crotch," remembers Musto. "I didn't even know about all the celebrities in the basement doing coke. I wasn't interested in doing coke, but I would have liked to watch Liza do it."

"I spent a number of nights downstairs in rooms with famous people who will remain unmentioned, enjoying, uh, enjoying, I'll leave it at that," says Russell Todd, a model and actor who went to Studio several nights a week during its heyday. "It was a place where you could be yourself and be exposed to any type of person and feel just as cool, and just as special."

Such unbridled pleasure-seeking was the reason that crowds were willing to brave the humiliation of the door policy. Once you were inside, Musto says, "You didn't give a shit about the people outside. That's why you clawed your way to get away from them. I had moments of standing outside Studio, before Steve and publicists helped me get in, because Marc would just look down at me and you would just wilt. It was a horrifying feeling, because the longer you stayed there, the less chance you had of getting in."

The dictatorial door policy created not only crowds but excitement. "You'd turn that corner onto Fifty-Fourth Street and you got this excited feeling inside. It just exuded this energy," remembers McDonald. But the entranceway overcrowding had a downside.

Frank Sinatra reportedly rolled up in his limo on opening night, saw the throngs, and told his driver to just keep going. Nile Rodgers and other members of Chic were invited by Grace Jones to a New Year's Eve show, but the mercurial singer hadn't left their names at the door, figuring they were celebrities and would get right in. When they were turned away, they were furious. But Chic got even. They went home and wrote a song called "Fuck Off," which became "Freak Out," and then "Le Freak," a song which burnished their stars as disco kingpins.

Perhaps the worst experience was when Rubell reportedly told the mobbed-up owner of an outer-borough disco, "You're ugly. I don't want you here. I'm not letting you in." The guy responded with a left hook to Rubell's jaw. The five-foot-five Napoleon of Studio 54 opened his arms and said, "You want to hit me again, go ahead, but you're still not getting in." The thug punched him once more. Rubell was undeterred. The guy never made it past the velvet rope.

For those who were turned away, there were alternatives. But Musto says, none were as good as Studio 54. "You could go to Xenon, but that was a horrible alternative because it was filled with people who couldn't get into Studio or didn't even try." The only other option, Musto says, was "to go home and cry yourself to sleep."

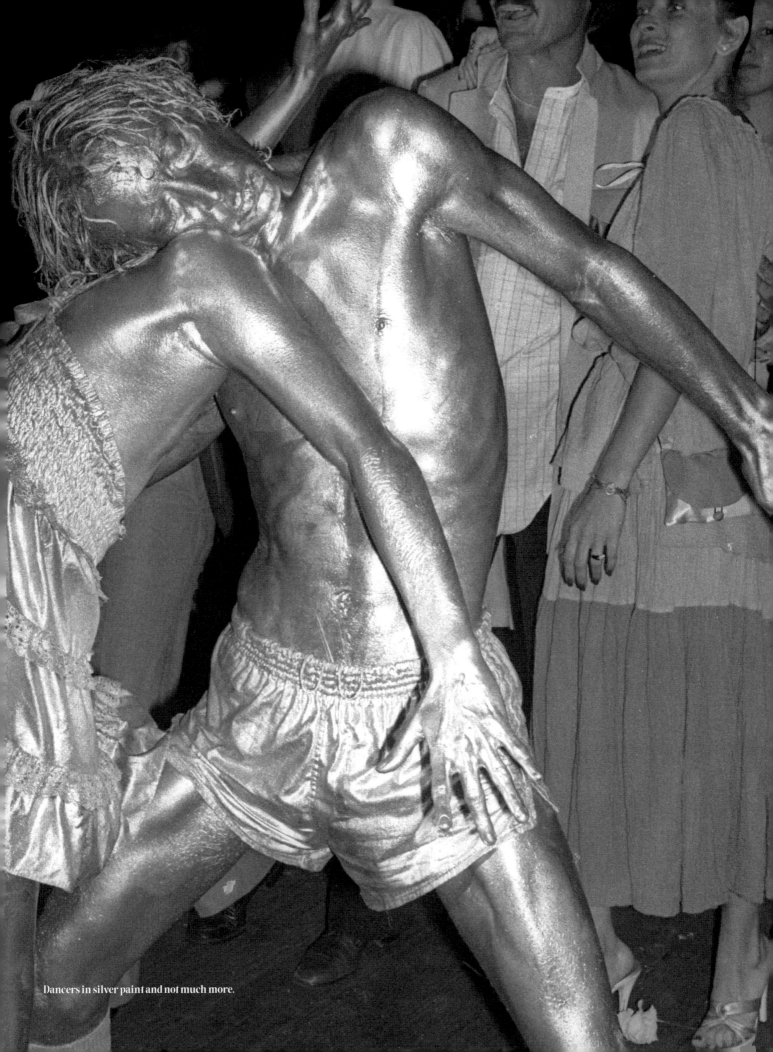

Dancers in silver paint and not much more.

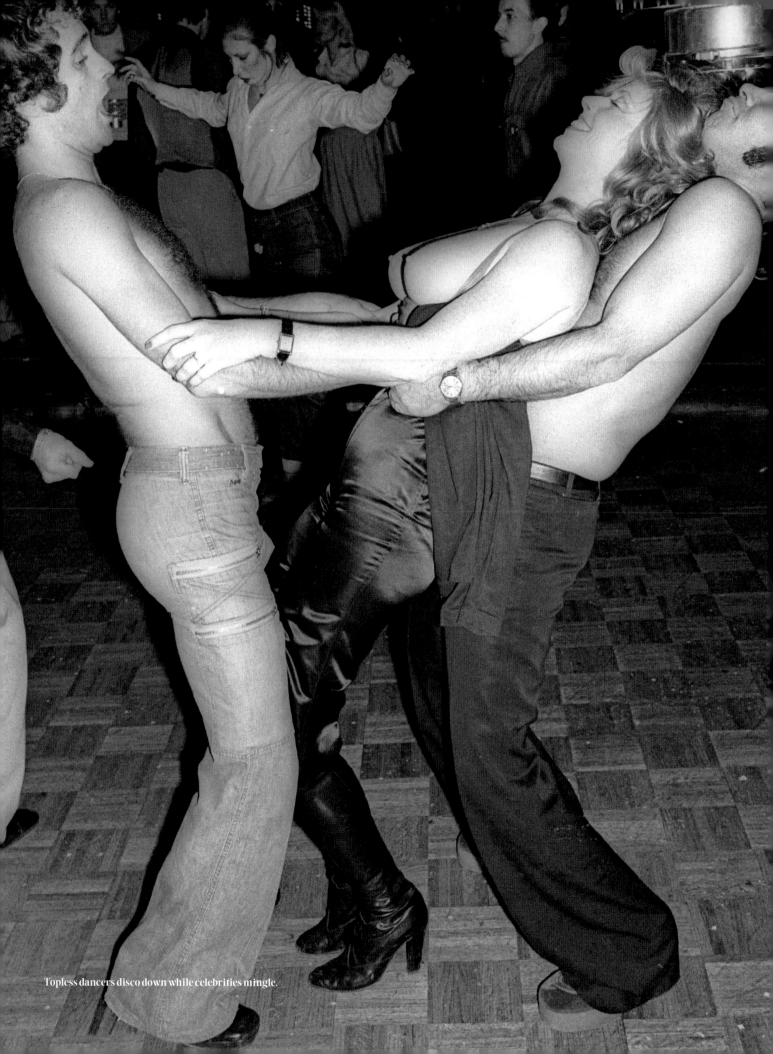

Topless dancers disco down while celebrities mingle.

Although there have been films about Studio 54—Mark Christopher's 1998 film *54* starring Mike Myers as Steve Rubell; Matt Tyrnauer's 2018 documentary *Studio 54*—those who were there say that no one has managed to capture the true excitement they remember.

"Every night at Studio was New Year's Eve and every single moment was 3-2-1 midnight," Musto wrote in the foreword to Galella's book. It was, he said, "a magical Brigadoon of depravity and delight."

But like the mythical Brigadoon, the very real Studio 54 ultimately had to disappear. "Like James Dean in the 50s and the Beatles in the 60s, Studio 54 so embodied its time that it couldn't last long," wrote Colacello in *Vanity Fair* in 1996. Its founders predicted that very early on. Schrager told the *New York Daily News* in 1978, "We know nothing goes on forever."

The heyday of Studio 54 ended when Rubell and Schrager were indicted on charges of tax evasion in 1979. Although their lawyer was Roy Cohn—a cutthroat man of high power and low morals—they were convicted.

Rubell had always said too much. "It's a cash business and you have to worry about the IRS. I don't want them to know everything," he told *New York* magazine in 1977. The powers that be made an example of the club owners, perhaps because they had always played a bit fast and loose with the law. Rubell and Schrager were first arrested only a month after Studio 54 opened for selling liquor without a license. Columnist Earl Wilson had ratted them out.

Were they sent to prison because a member of the IRS hadn't gotten into Studio 54 one night? There are stories. Before Rubell and Schrager were shipped off to the Manhattan Detention Center for six months and then a minimum-security prison in Arkansas for six more, they did what anyone in their fabulous shoes would do: On February 2, 1980, they threw a going-away party at Studio 54. Minnelli sang "New York, New York." Diana Ross sang Rubell's favorite Supremes song, "Come See About Me."

A year later, they were released from prison. Studio 54 opened under new management—all friends and associates of Rubell and Schrager. There were still crowds clamoring to get in. Banks, for instance, remembers going the night he won his second Coty Award for fashion design in 1982. "Facing a tremendous crowd, my entourage, including my mother, said, 'How do we get in?' and I said, 'Watch this!'" he recalls. "I held up my Coty trophy and the sea instantly parted, and we proceeded to go in triumphantly."

Still, the magic of Studio 54 was dimming. "Mark Fleischman tried, but it wasn't the same," remembers fashion designer Stephen Burrows. The two men who'd created Studio—dubbed "The Comeback Kids" by *New York* magazine upon their release from prison—moved on to other projects. Rubell and Schrager helped in 1985 to open the last great New York City megadisco, the Palladium on Fourteenth Street. Then they pioneered the "boutique hotel," creating destinations, like Morgans in Manhattan, that attracted celebrities the way their discos had.

After Rubell's premature death in 1989—at forty-five, an unfortunate AIDS casualty—Schrager continued to find success as a hotelier, creating buzz with such properties as the Gramercy Park Hotel in New York City, the Mondrian in West Hollywood, California, and the Delano in Miami Beach, a hotel that *Women's Wear Daily* dubbed "Studio 54 with sun." He received a full and unconditional pardon from President Barack Obama in 2017.

The heyday of Studio 54 lasted only thirty-three months. But its legend has only grown with every passing year. The club's legendary guest lists seem more absurdly star-studded than anyone today could imagine, the music more cosmically and aurally satisfying, the once-in-a-lifetime excessiveness of the place more impossible to ever recreate.

Although Studio 54 has now returned to its roots as a legitimate theater—well-regarded revivals of such musicals as *Cabaret, She Loves Me, Sunday in the Park with George, Kiss Me, Kate,* and *Assassins* have played there—its all-too-brief moment as the hottest disco in the world is never to be forgotten. To quote a 1977 *Wall Street Journal* story on the place: "This is a disco, which means that instead of air, one breathes the music. At Studio 54, it never stops."

Meanwhile, in 1977, as *Saturday Night Fever* was opening in movie theaters across America, the drumbeat of disco was only beginning for the masses.

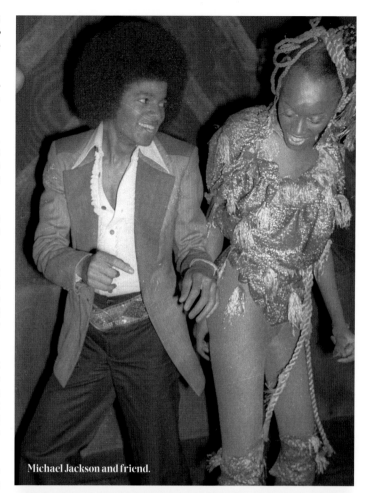

Michael Jackson and friend.

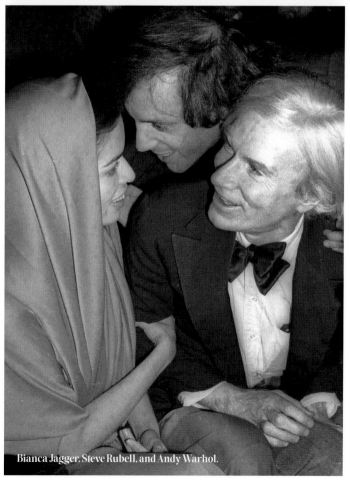

Bianca Jagger, Steve Rubell, and Andy Warhol.

A Tale of Two Studios

When Mark Christopher's movie *54* opened in theaters in 1998, it was not the Studio 54 people remembered, nor the feature-film debut the writer-director had intended to make.

Hired by Miramax on the strength of three queer shorts he'd shot in the early nineties, Christopher saw the gorgeous young cast he'd assembled, led by Ryan Phillippe and Neve Campbell, and heard a soundtrack filled with the disco music of his youth. But something vital was missing. The film—and Phillippe's character of Shane—weren't nearly as gay as they were supposed to be.

To Christopher, who grew up in Fort Dodge, Iowa, Studio 54 had always represented "a place of escape, a sparkling palace in the middle of a decaying city with the music of our subculture at its center."

That was the story he wanted to tell, but Miramax mucked it up. "By Miramax, you mean Harvey Weinstein," Christopher corrects. "Harvey was afraid it was too gay, which is bizarre because it wasn't nearly as gay as Studio 54 truly was." Weinstein's worries, he suspects, were that straight audiences would be turned off by a genuinely queer *54*.

It was a big mistake. Critics didn't warm to this straight-washed version of 54. Stephen Holden of the *New York Times* called the film "timid" and complained that it "barely hints at Shane's embrace of a self-promoting bisexuality." J. Hoberman of the *Village Voice* identified the problem, too, when he wrote, "Rumor has it that the movie has achieved its relatively svelte eighty-nine-minute running time by eliminating Shane's opportunistic homosexual trysts."

The film made only $16.6 million at the domestic box office.

That was not the end of the *54* story, thank heaven. Not by a long shot.

Ten years later, the Los Angeles Gay and Lesbian Film Festival, held a secret screening. That night in 2008, a grainy video was screened to a sold-out house. It was a re-gayed *54*.

The reaction to this new version, forty-five minutes longer, was rapturous; so positive, in fact, that a third cut—not the original theatrical release and not the 2008 video—was officially released seven years later. The bootleg version was "actually truer to my vision than the film that was released in 2015," Christopher admits, but some of the negative has gone missing and, as such, some scenes from the video aren't in the official rerelease.

Christopher is happy, nonetheless.

"I was rather embarrassed by the cut that came out in 1998," he says. "The story didn't make any sense to me, and I was blamed for it. I owed it to the gay community and the Studio 54 community to make the film as true to the place as I could."

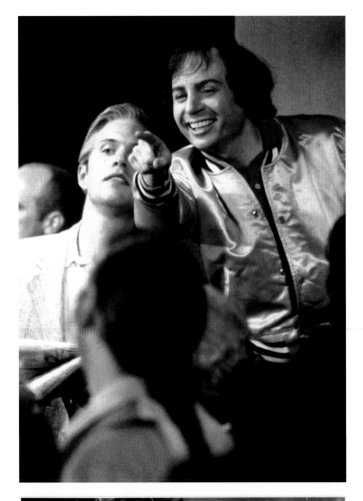

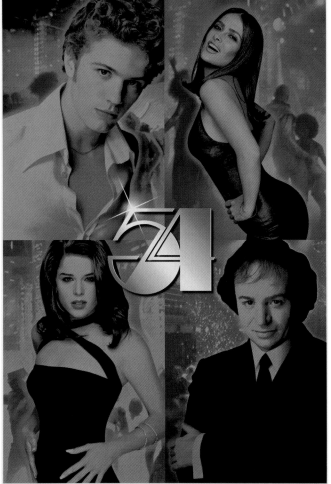

Mike Myers as Steve Rubell in *54*. The film's poster features Ryan Phillippe, Salma Hayek, Neve Campbell, and Mike Myers.

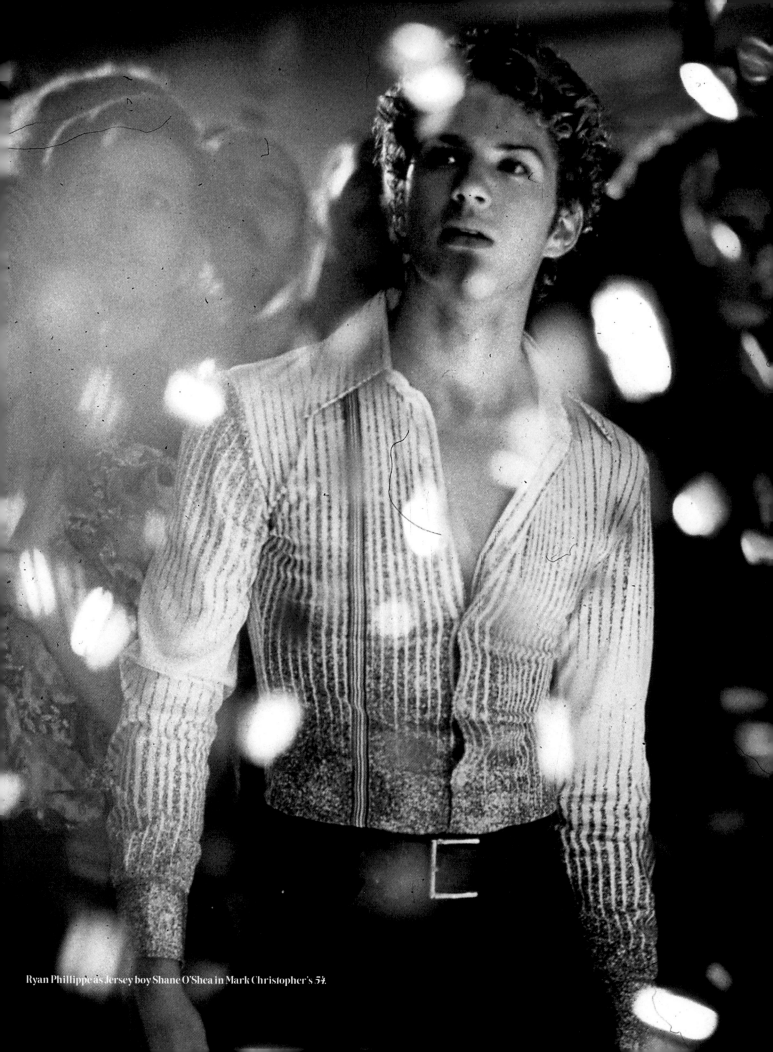

Ryan Phillippe as Jersey boy Shane O'Shea in Mark Christopher's *54*.

She may or may not have been the inspiration for Odyssey's "Native New Yorker," but Cory Daye certainly fits the bill. No tramp, but no lady either—to paraphrase that 1977 disco hit —she was born in the Bronx. But, as lead singer of Dr. Buzzard's Original Savannah Band from 1976 to 1979, her unique way with a song was as sophisticated as any Manhattanite's. Few disco songs have stood the test of time as beautifully as "Cherchez La Femme/Se Si Bon."

After she flew Dr. Buzzard's coop, Daye had dance-floor hits as a solo artist with "Green Light" and "Pow Wow," two tracks from her 1979 album, *Cory and Me*. Years later, she reteamed with her Savannah bandmates August Darnell and Andy "Coati Mundi" Hernandez and their group, Kid Creole and the Coconuts. These days, when Daye is told that she's as fabulous as ever, she has a stock answer: "Whenever people tell me I look good for my age, I like to say I was preserved in alcohol."

Said like a real native New Yorker.

FDC: "Is it true that in 1976 you were not the original choice to be the lead singer of Dr. Buzzard's Original Savannah Band?"

CD: "I was not! I was a background vocalist. They wanted a crooner, a male vocalist. We fashioned ourselves on swing, jazz, and Latin music, and from the days of Rudy Vallee to Bing Crosby to Frank Sinatra to Elvis to the Beatles, it was all male vocalists. So that was the idea. But we had already been in the studio for five months and they just couldn't find anybody. RCA was throwing their hands in the air. They weren't happy about it. The cost was astronomical. So they said, you go ahead—we're stuck with you!—which coincidentally was great because female vocalists were starting to dominate the songs of the disco era."

FDC: "Your bandmate August Darnell credits you with lifting up the band."

CD: "I would respond by saying that, yes, I completed them. They may have built the car, but I drove it. I don't think anybody else would have done the same vocals. Maybe they would have pulled it off, but not the way I did."

FDC: "How did the band's signature multicultural sound come about?"

CD: "We did a lot of research. Because there was no internet, we just bought a lot of albums. We started with ragtime—Mae Barnes, Bessie Smith—and then went on to Billie Holiday and into the swing of Glenn Miller and the Dorsey Brothers, the harmonies of the Andrews Sisters. For phrasing, we listened to Ray Charles.
"Because of the different backgrounds and cultures and colors of the band members, the music that came together, we always just called it 'mulatto music.' The word 'fusion' was not being used yet. We loved the clothing of the forties, old musicals, and gangster movies. I grew up in the South Bronx watching Fred Astaire and Ginger Rogers while listening to Perez Prado. Everything was blended because *we* were all blended."

FDC: "Did you suspect that the band's self-titled debut album would be successful?"

CD: "We knew that it was going to be a hit because we thought the audience was ready for something different. It was the end of the British Invasion, and disco and R&B were becoming prominent. We thought, yeah, it's our time."

FDC: "Was the record company as convinced?"

CD: "They didn't believe in us. Executives only listen to something wondering if it's going to make money. They don't listen to it for entertainment or for the creativity involved. They were going to can the album and use it as a tax write-off. But Tommy Mottola was our manager at the time, and he had the foresight to hire a promotion company. They took the album to Fire Island, it was a hit at Tea dance, and it blew up."

FDC: "Did the band go to Fire Island too?"

CD: "When we were there that summer, every house we passed was playing a different cut off that album. It was amazing. When the Fire Island season closed, they brought the record back with them and that's when it started getting airplay. That's when RCA started promoting it. Then we had the posters in the subways, we had press kits. That's when we started doing promotion, but only because of the gay community. A lot of artists realized at the time that it was the gay community that would make or break a song. The gay community was always more accepting of change and more inclusive."

FDC: Speaking of Tommy Mottola, how did he feel about being mentioned in the first line of 'Cherchez La Femme/Se Si Bon'?"

CD: "Tommy was an entertainer, so it didn't faze him. I think that may have helped promote him because he opened a lot of doors in the industry and just walked right through. He loved the fact that we immortalized him. It was our way of thanking him. It really was. It was all done with good intentions. I think he probably cringes now because he became CEO of Sony."

FDC: "Did he ever really 'live on the road and lose his lady three months ago'?"

CD: "No! We don't even remember the original name that we first used in the song."

FDC: "What did it feel like when 'Cherchez La Femme' pushed the Bee Gees out of the top spot on the disco chart?"

CD: "It was amazing. I still have the clippings from *Billboard* magazine. I put them in a scrapbook. Then while we were doing the second album, we got the news that we were nominated for a Grammy as best new artist. That was like, 'Pinch me, tell me I'm awake.'"

FDC: "I hate to say this out loud, but Starland Vocal Band won that year."

CD: "The other nominees were Boston, the Brothers Johnson, and Wild Cherry. 'Play That Funky Music'. I thought they would win. But we were all like, 'Afternoon Delight'? I mean, come on. Could you get any more bubblegum? When they said, 'Afternoon Delight,' it's a good thing they didn't pan to our faces because the look of confusion on them. It was like, 'Are you serious?' I still switch the station every time I hear that song."

FDC: "What did it feel like when disco broke wide open and became the thing on everyone's lips?"

CD: "I was doing the clubs before that, so I really didn't notice the difference until I saw all the different cultures coming together at Studio 54. We were in Los Angeles recording the second album and saw stories on the news. We couldn't wait to get back to the city to experience it. And everything they said about Studio was so true. That to me was when disco became mainstream, like full-out mainstream, because there were all different walks of life coming together to party. It was one big lovefest."

FDC: "Was it really a great place to go? What about other discos?"

CD: "My stock answer is that Studio 54 was like New Year's Eve every night. It was just amazing. At that time, discos used to have theme parties. They would hire someone to decorate. When Bond, the clothing store in Times Square, became a disco, I was the second performer to perform there. The party was called 'Jungle Madness,' so I had all these musclemen carry me out on a litter. I was in a sarong, and I was like, 'OK, here we go, Dorothy Lamour!'"

FDC: "Is being carried out on a sedan chair by a bunch of hunks as exciting as one would imagine?"

CD: "Yes! They had to raise me up to go from the dressing room to the stage. I was going through the audience. If I had really thought about it, I would have had them throw rose petals as well. I mean, come on!"

FDC: "I hear that you and your friends had a nickname for Studio 54's rival club, Xenon . . ."

CD: "We used to call it 'Xerox.' It was a horrible thing to say because it sounds so snooty. But people would stand outside in the dead of winter trying to get into Studio 54 until they got frostbite, and then they would go to Xenon. Xenon was actually a lot of fun."

FDC: "Did you go to any of New York's infamous after-hours clubs back in the day?"

CD: "After the clubs closed, we would go to Crisco Disco. It was very popular. The DJ booth was a can of Crisco. I remember we sat in the basement on top of wine crates, and I thought, '*This* is the VIP area?' I'm not going to get into what we were doing down there, but I looked like I was eating jelly doughnuts. There were hardcore boy bars, too, in particular, the Anvil. They loved me there, but once I tried to sneak downstairs and somebody at the foot of the stairs was like, 'No, no, no!' The boys were being boys. There were some bars that had drag shows too. I got see myself impersonated by a drag queen once. That's when I knew I'd arrived."

Must-Hear Disco Playlist: 1976

Disco heartthrob Harry Wayne Casey of KC and the Sunshine Band.

"THE BEST DISCO IN TOWN" by The Ritchie Family

"BOOGIE NIGHTS" by Heatwave

"CAR WASH" by Rose Royce

"CHERCHEZ LA FEMME / SE SI BON" by Dr. Buzzard's Original Savannah Band

"CALYPSO BREAKDOWN" by Ralph MacDonald

"DADDY COOL" by Boney M.

"DANCING QUEEN" by ABBA

"DISCO INFERNO" by the Trammps

"DISCO LADY" by Johnnie Taylor

"DISCO PARTY" by the Trammps

"DON'T LEAVE ME THIS WAY" by Thelma Houston

"DON'T TAKE AWAY THE MUSIC" by Tavares

"DOWN TO LOVE TOWN" by The Originals

"A FIFTH OF BEETHOVEN" by Walter Murphy and the Big Apple Band

"GET UP AND BOOGIE" by Silver Convention

"GIVE UP THE FUNK (TEAR THE ROOF OFF THE SUCKER)" by Parliament

"HEAVEN MUST BE MISSING AN ANGEL" by Tavares

"HOT LINE" by The Sylvers

"I'LL BE GOOD TO YOU" by The Brothers Johnson

"LOVE HANGOVER" by Diana Ross

"LOVE IN C MINOR" by Cerrone

"MIDNIGHT LOVE AFFAIR" by Carol Douglas

"MIGHTY HIGH" by Mighty Clouds of Joy

"MOVIN'" by Brass Construction

"MY SWEET SUMMER SUITE" by the Love Unlimited Orchestra

"NICE & SLOW" by Jesse Green

"RIGHT BACK WHERE WE STARTED FROM" by Maxine Nightingale

"THE RUBBERBAND MAN" by The Spinners

"(SHAKE, SHAKE, SHAKE) SHAKE YOUR BOOTY" by kc and the Sunshine Band

"THE SHUFFLE" by Van McCoy

"THAT'S WHERE THE HAPPY PEOPLE GO" by the Trammps

"THEME FROM S.W.A.T." by Rhythm Heritage

"THIS IS IT" by Melba Moore

"TRY ME, I KNOW WE CAN MAKE IT" by Donna Summer

"TURN THE BEAT AROUND" by Vicki Sue Robinson

"YOU SHOULD BE DANCING" by the Bee Gees

"YOU MAKE ME FEEL LIKE DANCING" by Leo Sayer

"YOU'LL NEVER FIND ANOTHER LOVE LIKE MINE" by Lou Rawls

"YOUNG HEARTS RUN FREE" by Candi Staton

DR. BUZZARD'S SELF-TITLED 1976 ALBUM

CANDI STATON PORTRAIT BY SINA SHAMSAVARI

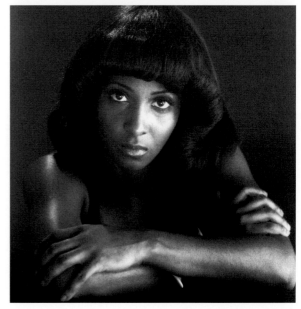

CAROL DOUGLAS

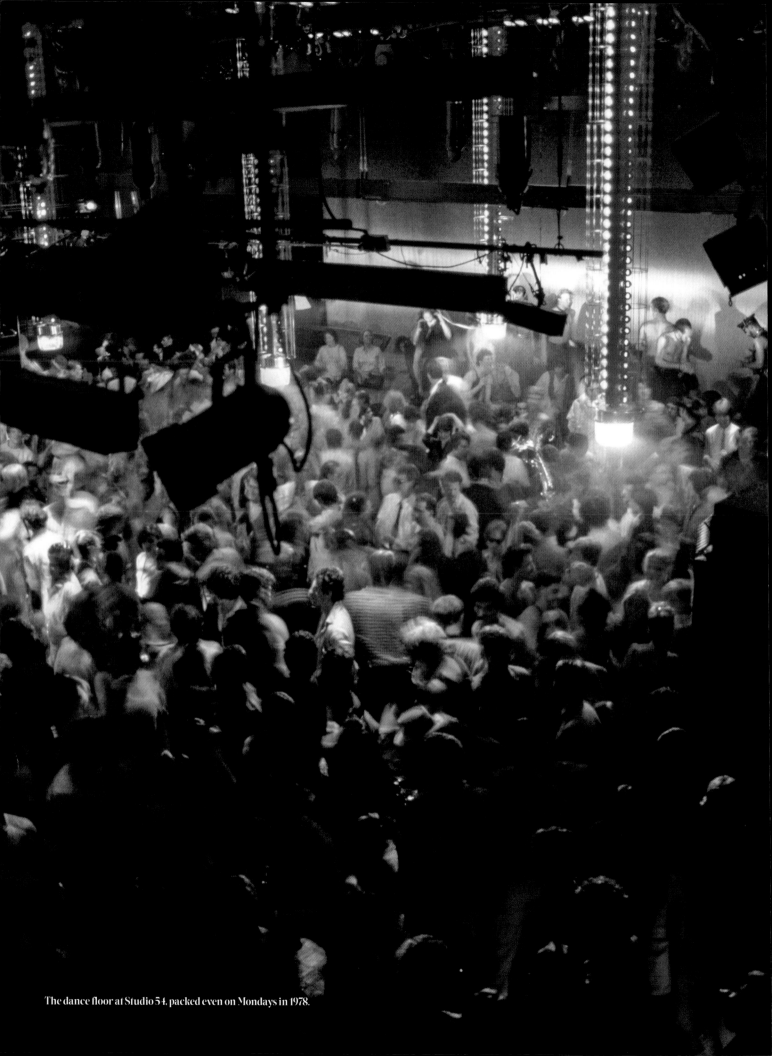

The dance floor at Studio 54, packed even on Mondays in 1978.

Legendary Djs

"Disco deejays, once relegated to the anonymity of a booth in the rear of a dark club, have come into their own as personalities and creative artists," *Circus Weekly* reported in June 1979. Decades later, these men, along with Mancuso and Siano, remain among the most legendary turntablists of the seventies disco era.

TERRY NOEL

Considered the first superstar DJ, Noel earned his reputation at Arthur, a star-studded proto-disco run by Richard Burton's ex-wife, Sybil. "In New York City in the 1960s, you'd be hard-pressed to find a more in-demand DJ," wrote Bill Brewster of djhistory.com in 2016. Noel's power was such that he refused to play requests—even one that came from John Wayne. The DJ later moved to Ondine, then Salvation, sometimes working three turntables at once. "I got to the point where I would play two records at the same time," Noel said in a 1998 interview. "You'd be hearing 'Foxy Lady' by Hendrix, and you'd hear the lyrics from the Beatles."

FRANCIS GRASSO

As the story goes, Grasso got his first shot when Noel showed up late for a gig. He quickly became a spinning sensation. "One of the greatest draws at Sanctuary was the only straight guy in the place," wrote Albert Goldman in his 1978 survey, *Disco*. Grasso is seen DJing there in the 1971 film *Klute* starring Jane Fonda. Credited with inventing "slip-cuing" and perfecting the seamless mix, Grasso was deemed, as Goldman put it, "the most influential spinner in the short history of the craft." His ability to "beat match" songs set the standard for all DJs to follow. "Nobody mixed like me," Grasso once said. "To me, it was second nature. I did it like I walk my dog." He passed in 2001 at fifty-one.

WALTER GIBBONS

At the Manhattan nightclub Galaxy 21 in the mid-seventies, Gibbons became known as a "DJ's DJ," doing things with turntables that other DJs could only hope to emulate, and they tried. When the discs themselves weren't enough to get dancers on their feet, he added a live drummer to his sets. Salsoul Records tasked him in 1976 with remixing "Ten Percent" by the Philly-based band Double Exposure. It became the first commercially available 12-inch disco single. He died, like so many of his generation, of AIDS-related causes in 1994, at age forty.

RICHIE KACZOR

One of the two original Studio 54 DJs along with Nicky Siano, Kaczor made his name at Hollywood, a disco in the former Peppermint Lounge. "He plots the hour-by-hour condition of his tweeter and bass amps like a NASA mission controller," the *Daily News* raved in 1975. Kaczor was renowned for his ability to recognize a hit. He famously heard the Gloria Gaynor single "Substitute" and realized its B-side—"I Will Survive"—was the standout. After Studio 54, Kaczor opened a disco in Bermuda. He survived until 1993, dying at age forty.

TOM SAVARESE

Having spun at such important New York discos as Le Club, 12 West, and, on Fire Island, the Sandpiper, Savarese was named Billboard's DJ of the Year in 1976. He was perhaps the first DJ to urge his colleagues to consider themselves artists vital to the success of a club and central to the popularity of dance music. His eight-minute-and-twenty-one-second mix of "Dance, Dance, Dance (Yowsah, Yowsah, Yowsah)" in 1977 helped make the song a hit for Chic. He later was one of the first DJs to spin music for a live fashion runway presentation. "You must love all music, not only what is heard, but everything . . ." he once said.

JIM BURGESS

Burgess spun records in his native Florida, then Atlanta, before making his way to the DJ booths of such legendary New York clubs as 12 West, the Saint, Studio 54, and the Ice Palace on Fire Island. One of his signatures was incorporating film dialogue into his sets. As a remixer, Burgess famously took disco songs like "I Love the Nightlife" by Alicia Bridges, "Da Ya Think I'm Sexy" by Rod Stewart, and "I Was Made for Loving You" by KISS and made them even more dance-floor friendly. He died at thirty-nine in 1993.

TOM MOULTON

A groundbreaking record producer and turntablist, Moulton is credited with creating the first official disco record, taking Gloria Gaynor's hit "Never Can Say Goodbye" and turning it into a nonstop album-side of continuous music. "I learned to create suites," he told the *New York Times* in 1979. "A good mix should be like a story that builds and goes to different levels with changes in the music." Moulton famously produced Grace Jones's 1977—1979 trilogy, *Portfolio, Fame*, and *Muse*, establishing her as a true disco superstar. "I wanted to make records that sounded big, like New York, with all the razzle-dazzle and the bright lights and the glitter, the cabs going by, everything moving fast, the excitement," he said in 2015. "But I don't think of it as disco music. I think of it as emotional songs you can dance to."

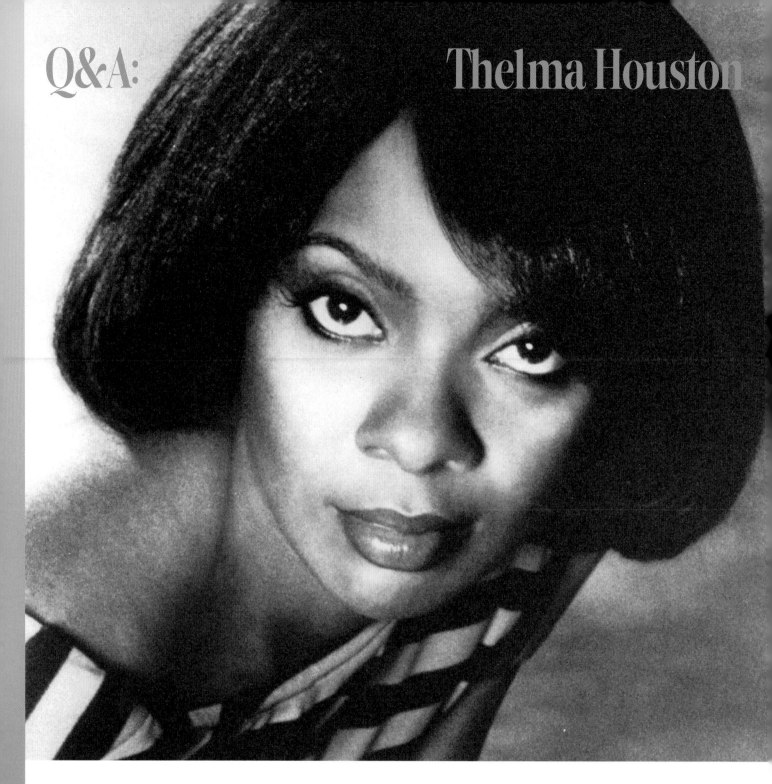

Q&A: Thelma Houston

Mississippi-born Thelma Houston has only ever wanted one thing: "Even when I was singing in choirs, I wanted to be an entertainer." Her junior high school principal—she had moved to California by then—encouraged her pursuits.

"He said, 'You really have the talent. If you keep your nose clean, you could make your living doing this.' He kept pushing me and it came true," Houston remembers. Did it ever! After working in such venerated nightspots as Chicago's Playboy Club and gaining some exposure on television, Houston recorded her third album, *Any Way You Like It*, in 1976.

The first single from that album? A little song called "Don't Leave Me This Way."

It was a cover of a Harold Melvin & the Blue Notes song, but Houston made it wholly and forever her own. She took the song to Number 1 on the *Billboard* Hot 100 in 1977 and garnered a Grammy as Best R&B Vocal Performance Female.

Her next hit was "Love Masterpiece"—an up-tempo track incorporating parts of a famous Rachmaninoff composition—from the soundtrack of the 1978 disco film *Thank God It's Friday*.

While continuing to record over the years, Houston has toured the world, not only in concert but in musicals, acting in the stage version of *Fame*, for instance. Her TV gigs have run the gamut from *Simon & Simon* and *Cagney & Lacey* in the eighties to *American Idol* and *America's Got Talent* in the aughts.

No less importantly, Houston—no relation to Whitney—became an inspiration to other performers, most notably the Glasgow-born singer Jimmy Somerville, the pioneering queer leader of Bronski Beat and The Communards. "I'm small, I'm male, and I've got red hair. But I would sing in front of the mirror smiling and I would think I was black," Somerville once said.

He did Houston justice with his own version of "Don't Leave Me This Way" in 1986.

FDC: "How did 'Don't Leave Me This Way' first cross your path?"
TH: "The song came to me through Suzanne de Passe at Motown. She thought that 'Don't Leave Me This Way' would be interesting from a woman's perspective. She asked me to listen to it and see if I liked the song, and I did. Hal Davis, the producer, came up with what I call the true disco formula. He knew the exact number of beats—first the slow part, the build-up to get people onto the dance floor, then the workup, then the explosion and, you know, the whole thing. That's how we did it and I'm glad we did, let me say that!"

FDC: "Did you suspect your version would be such a massive hit?"
TH: "Disco music was really happening. It had been underground for quite some time, but it was starting to come to the forefront and people were ready, you know. I would go out dancing with my friends on Thursday nights in LA. There was Studio One, Catch One over on Pico, and some other little underground places. When I heard our version of 'Don't Leave Me This Way,' I knew people were going to love dancing to it."

FDC: "You and millions of others! So did you ever go to Studio 54?"
TH: "I never went to Studio 54 to party. I went there to work several times. I would go in the early evening to have a sound check. The space would be empty. You would get up on this catwalk kind of thing on wheels and they would roll you out into the audience. I remember thinking to myself, 'Lord Jesus, please don't let me lose my balance up here.'

"Sometimes, if you lived on the West Coast, when you came to New York, you would perform in three different clubs in one night. I would hit the Red Parrot, boom, go to Studio 54, boom, and then end up at the Paradise Garage. That's where I'd stay. After the show, I'd change into my jeans and dance until the next morning."

FDC: "What was it like winning the Grammy Award for "Don't Leave Me This Way"?
TH: "Obviously, it meant a lot. But I had been nominated a couple of years before. I was up against Aretha Franklin and, of course, Aretha won. But I was all excited this time. I thought, well, maybe, you know, maybe I have a shot. I had a beautiful dress to wear and the whole bit. But I talked myself out of going. Then when I got the call from Suzanne de Passe that I had won, I felt like an idiot. There I was in my apartment. I had just finished cleaning my kitchen. She accepted the award for me. The lesson I learned from that was, whenever you're fortunate enough to be nominated for something, by all means go. You never know, you might win."

FDC: "Did disco present a lot of new opportunities for singers in the seventies?"
TH: "For a lot of people, disco was a chance to go out and perform live in dance clubs. That's when people started singing to recorded tracks. That was unheard of before the disco era. You would always sing with live musicians. You had more opportunities to work because you didn't have to have live musicians. That was the advantage of it."

FDC: "How would you describe the disco era for those who didn't live through it?"
TH: "When I look back at it, I think about fun; I think about dancing; I think about friendships. It was a good time, probably some of the best times of my life. Of course, it was a lot of excess. And, unfortunately, then AIDS started. That's when everything changed."

FDC: "You stepped up during the AIDS crisis and did benefit concerts."
TH: "It wasn't some noble thing. That was out of necessity. These were the people that I had grown up with, my friends, the people whom I was going out dancing with, and the people who were supporting me. When they were dying off and nobody knew what was going on, it was like, 'We've got to do something about this.' It started out of desperation."

FDC: "Why do you think there was such a backlash to disco's popularity?"
TH: "There are two reasons in my opinion. The business came up with a formula for disco and people just started doing everything that way and it really ruined the music. There was so much crap that started coming out. I also think there was a backlash because disco was getting so much attention. They felt they were being displaced. Then people started writing stupid stuff about disco, and it became the hated child. The feeling was 'We have to beat it down because it's ruining music, this disco thing.' That's when they started burning 45s."

FDC: "You mean, Disco Demolition Night."
TH: "There was some terrific music that came out of that era. You know it was good because people are still sampling it and using it now. That Beyoncé with Robin S thing—'Break My Soul'—that's really good."

FDC: "How did you feel when the Communards covered 'Don't Leave Me This Way'?"
TH: "Oh, I thought it was great. There was one time I was in Europe for a gig. I can't remember the country that we were in. But Jimmy Somerville was performing the next day. So, I went to his performance and let his manager know that I was there in the audience. He gave me a microphone. When Jimmy started to sing 'Don't Leave Me This Way,' I came up from the audience and was singing along with him. He was like, 'Oh my God,' and he was so shocked. That was so much fun."

FDC: "How does it feel to be considered one of the true superstars of disco?"
TH: "I tell you I never think about that. This is what I love doing. So, in my mind, even before I got a Grammy, I thought I was successful. This is all I've ever done. This is all I've ever wanted to do. And I'm still doing it at my age, and I feel really good about that."

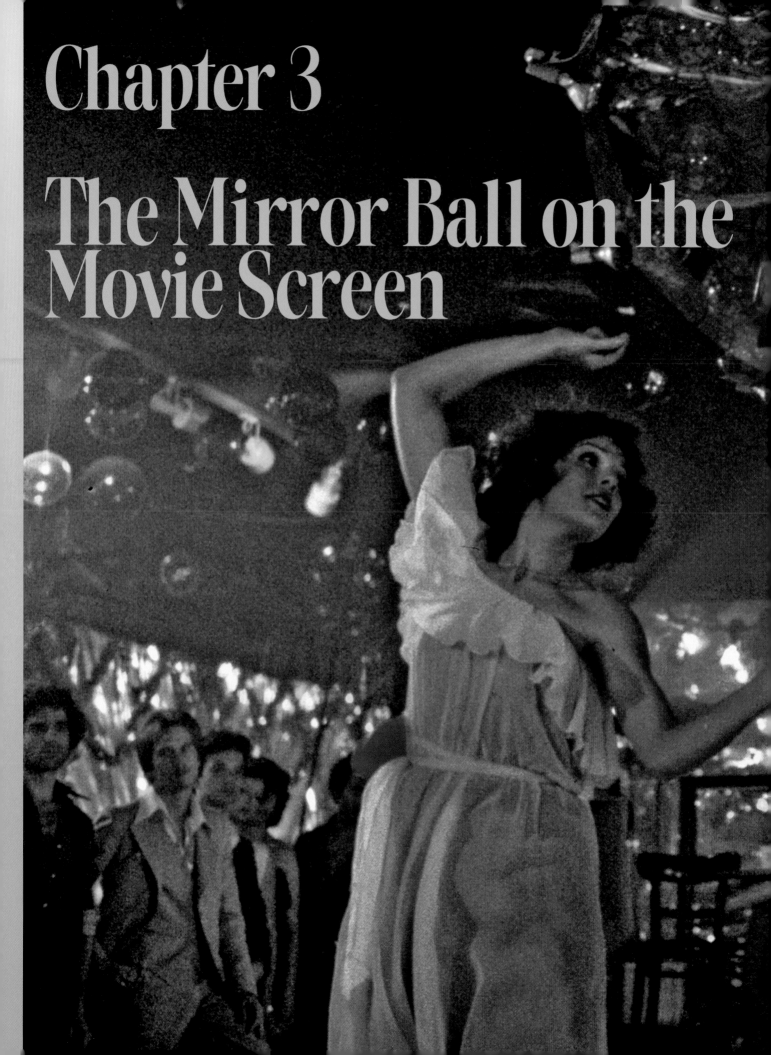

Chapter 3

The Mirror Ball on the Movie Screen

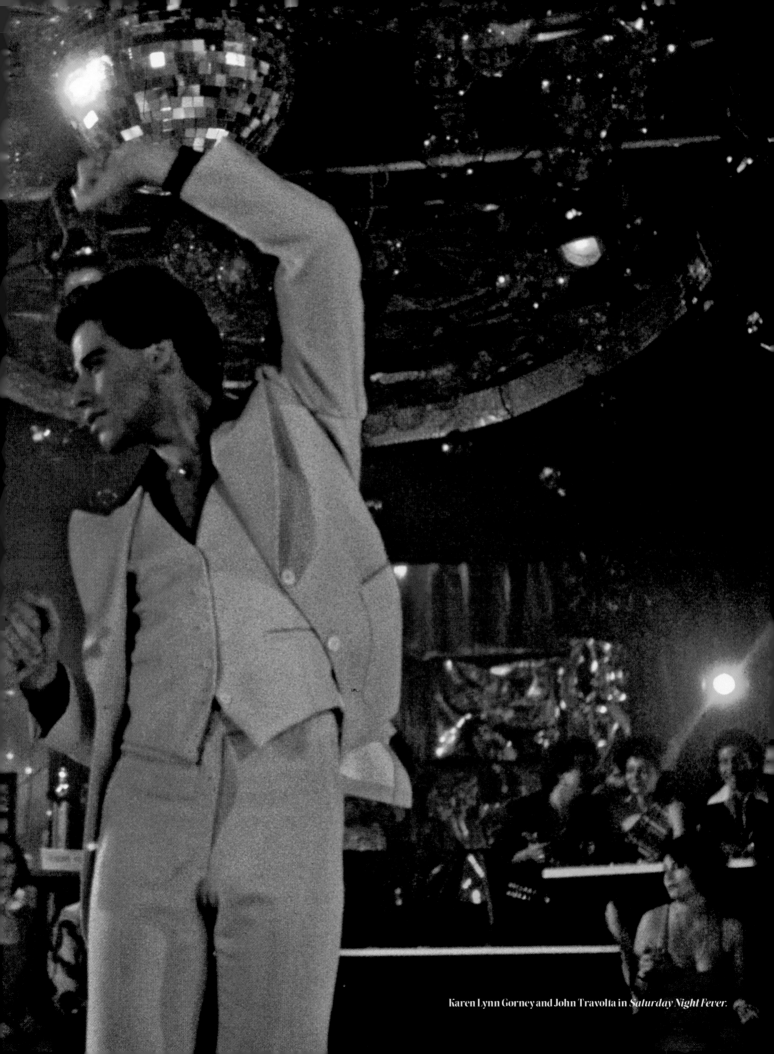

Karen Lynn Gorney and John Travolta in *Saturday Night Fever*.

"

IF YOU WANT TO KNOW HOW I REALLY FEEL, GET THE CAMERAS ROLLING....

—Andrea True Connection

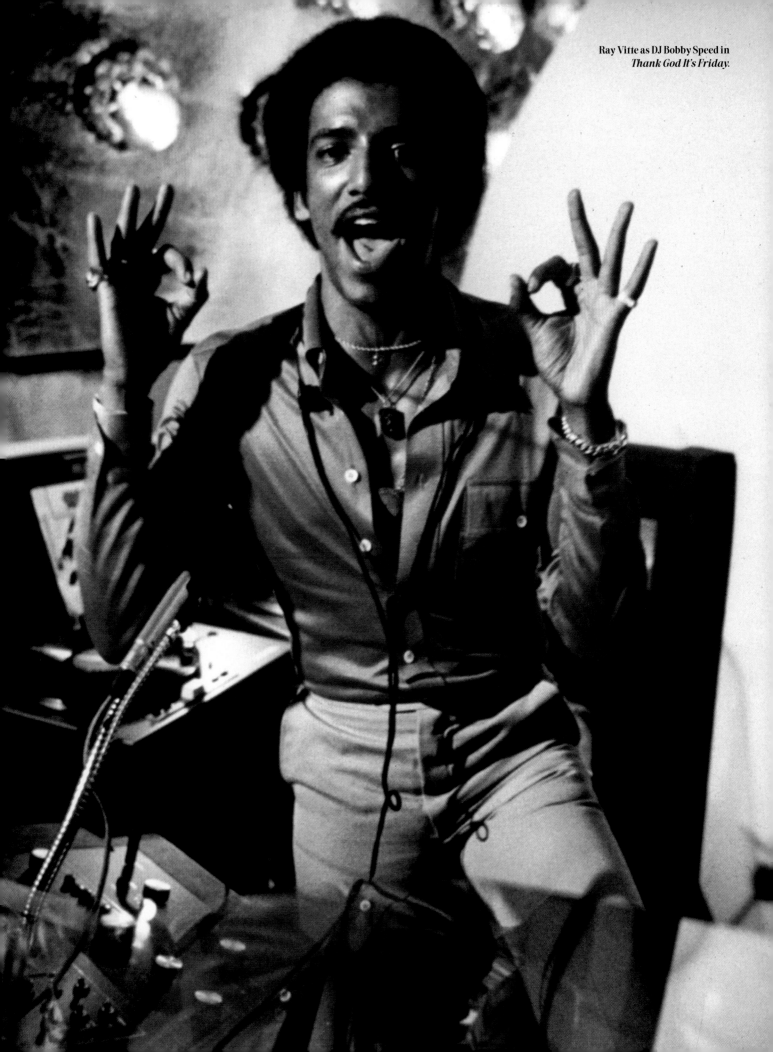

Ray Vitte as DJ Bobby Speed in *Thank God It's Friday.*

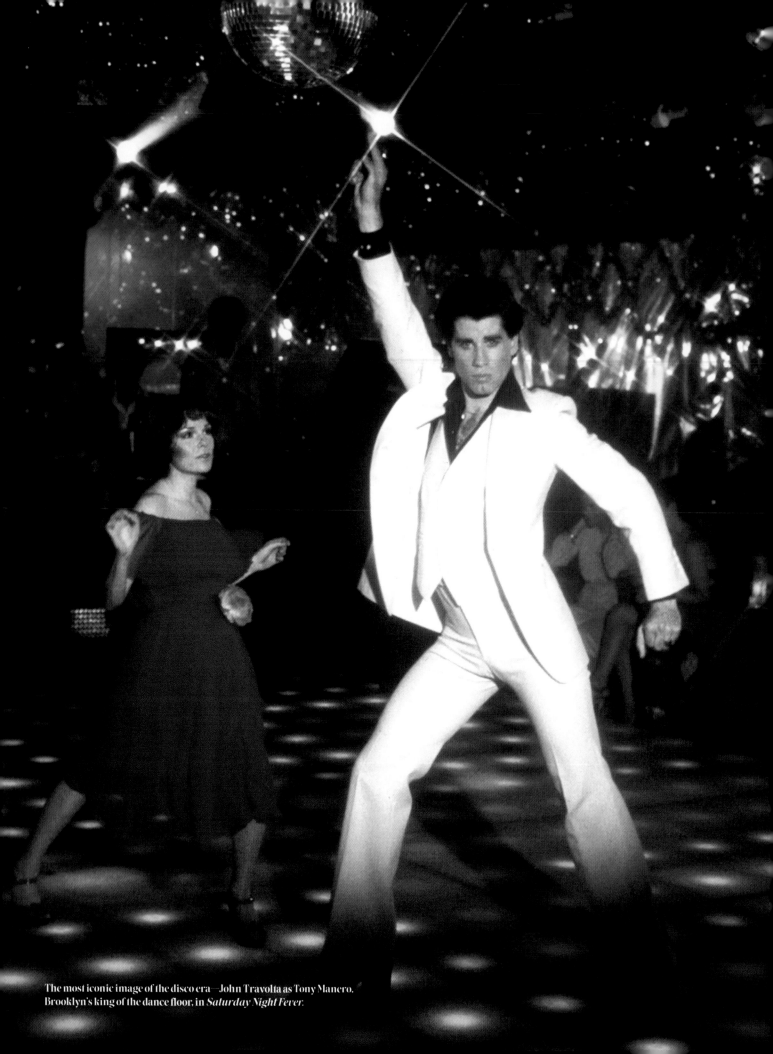

The most iconic image of the disco era—John Travolta as Tony Manero, Brooklyn's king of the dance floor, in *Saturday Night Fever*.

There were disco movies before *Saturday Night Fever* and disco movies after *Saturday Night Fever*, but none had anything even close to cultural impact of the 1977 urban drama.

Without that film—and John Travolta's star turn as Tony Manero, lowly paint-store clerk by day, sizzling dancefloor king by night—disco would never have become the mainstream American pastime that it did. Warehouses would have been filled with unworn white polyester suits, and the Bee Gees could just as well have remained a folk act.

What happened inside Studio 54 would have stayed inside Studio 54.

But much to everyone's surprise, America caught a raging case of Saturday Night Fever in the year that followed the film's opening. Producers at Paramount had no idea it would become such a landmark. No one did. Nor did anyone imagine that the soundtrack, featuring such songs by the Brothers Gibb as "Night Fever," "You Should Be Dancing," "Stayin' Alive," and "Jive Talkin'," would go on to sell forty million copies and, for the next fifteen years, be the top-selling soundtrack recording of all time. The double album still sits at Number 2, behind 1992's *The Bodyguard*.

Saturday Night Fever was the right movie at the right time.

"I can remember promoting it around the country in December of '77," Travolta said in 2017. "There was a vibe happening about the movie. It started to become a social phenomenon. It became the surprise movie that everybody must see."

Enthusiastic press set the *Fever* in motion, but as Travolta noted, "The public agreed with it and took it home literally, meaning you could dance with it, you could drive with it, you could be in your living room with it, you could be everywhere with it."

That's not hyperbole. By early 1978, everyone wanted to either be Tony Manero or be with him, or both. In a matter of months, the character had become an icon. Understandably, those who had created the underground disco scene beginning in 1970 felt sold out, their private world exposed by the success of the film. As the writer Vince Aletti put it, "The disco community, whatever that was, felt very ambivalent about *Saturday Night Fever*. It brought a lot of attention to disco, it exploded and once something becomes so big, it has to be over."

For them, maybe. But not the masses. The film washed over America like a tsunami.

Grittier than expected, *Saturday Night Fever* was helmed by John Badham, a British director who was coming off the success of the sports comedy *The Bingo Long Traveling All-Stars & Motor Kings*, with Billy Dee Williams, James Earl Jones, and Richard Pryor. Badham took over *Saturday Night Fever* after *Rocky* director John G. Avildsen was let go shortly before shooting began. He brought in soap actress Karen Lynn Gorney to be the female romantic lead.

Norman Wexler, who'd cowritten the 1973 cop drama *Serpico*, based the script on "Tribal Rites of the New Saturday Night," a June 1976 *New York* magazine story by Nik Cohn. The journalist, it was later revealed, took tremendous poetic license with the story. But it didn't matter whether it was fact-based fiction or true reportage because it made for a great movie.

"When you saw *Saturday Night Fever* for the first time, you thought to yourself, this is really good, like a *Rebel Without a Cause* for that era," says longtime *Paper* magazine film critic Dennis Dermody. "And John Travolta was sensational in it."

Truly, it is Travolta's performance which elevates the film to classic status. As the young, tough-but-sensitive, Italian-American heartthrob, he's sexy, funny, and moving, and his dancing is nothing short of breathtaking. "Travolta on the dance floor is like a peacock on amphetamines," wrote Gene Siskel in 1977. The film became the critic's favorite of all time.

Although Travolta had done Broadway musicals before becoming a TV heartthrob on the 1975—1979 sitcom *Welcome Back, Kotter*, he had to train hard for the role of Tony Manero. "It was seven months of dancing almost every day," he recalled. "I was doing a mix of learning it in the studio with Deney Terrio, and then, about once a week, I would go to a club to try it out."

All the work paid off. As film critic and author Alonso Duralde puts it, "John Travolta, as that character, doing those dances, has all the things that you want a movie star to do and be and look like. It's a once-in-a-lifetime thing, and one that people can spend a career trying to recreate." Conjuring such magic a second time is nearly impossible, although many agree that Travolta did it again in the 1978 musical *Grease*. But, as Duralde says, "It's not like you feel the same way when you watch him in *Staying Alive*."

In that film, a 1983 sequel directed by Sylvester Stallone, Tony Manero gets out of Brooklyn, waxes his chest, dons a loincloth, and embarks on a Broadway dancing career. *Staying Alive* died at the box office, and it wasn't even the worst of the disco movies that arose after the success of the Badham original.

"*Saturday Night Fever* started a whole series of rip-offs that just drove you nuts," says Dermody. Such copycat tactics were typical of the film business, particularly in those days. "If there was a movie in the seventies and it was a hit, they made like two thousand of them. With *Jaws*, it was a shark, then it was piranhas, then a killer whale," he remembers. The disco movies that followed in the wake of *Saturday Night Fever* were, at best, more fun than good.

At the time, Dermody was managing a Provincetown, Massachusetts, movie theater and remembers the glut of cinematic disco also-rans. "Some of these movies would come through and you would just roll your eyes and think oh my god, they're trying too hard with this." *Thank God It's Friday*, released in 1978, was the most high-profile of them.

The second-best-known disco film, *TGIF* was a day-in-the-nightlife comedy that took the structure of 1976's *Car Wash*, an early disco movie, and set in a nightclub. Shot in and around Osko's, a popular Los Angeles disco, the film was envisioned by Casablanca Records honcho Neil Bogart as a showcase for artists on his label like Paul Jabara, Pattie Brooks, and Donna Summer.

"If that sounds like an expensive and lengthy commercial for Casablanca, that's exactly what it was," wrote the label's co-founder Larry Harris in his 2009 memoir, *And Party Every Day: The Inside Story of Casablanca Records*.

That was the problem. Although *TGIF* featured a cast of future megastars including Jeff Goldblum, Debra Winger, and Terri Nunn—not to mention the Commodores—the film was little more than a ninety-minute aperitif for audiences on their way to a real-life disco. *Friday* was all glitter and no gravitas and didn't hold a candle to *Saturday Night Fever*.

The movie starts strong: the animated Columbia Pictures "Torch Lady" gets down to a thump thump beat before the film even begins. But the fun ends as soon as the audience meets the group of messy clubgoers at the center of the story, all of whom are having a lousy night at the Zoo, a disco that one particularly crass character calls "Disneyland with tits."

Summer plays Nicole Sims, a shy but ambitious singer who'll do anything to get the DJ (Ray Vitte) to play her record. Goldblum is the Zoo's slithery owner, a Porsche-driving pussy hound out to bag a married babe on a bet. Winger, in one of her earliest roles, is an innocent abandoned by her friend. Meanwhile, Nunn, who'd find stardom in the eighties as the lead singer of the new wave band Berlin, is an underage high school student who wants to win the disco dance contest just to nab the prize—KISS tickets. Jabara, who played a frightening drag queen in 1975's *Day of the Locust*, wants to meet a girl but instead gets trapped in a stairwell. Even the Commodores lose their instruments!

Only the movie's extras have any real fun on the dance floor.

"*Thank God It's Friday* is a terrible movie," says pop culture critic Michael Musto. "Donna Summer basically plays herself and her entire part is going into the DJ booth and singing 'Last Dance.' It's so bizarre. And it's an Oscar winner because it won for Best Song." (Famed movie critic Leonard Maltin maintains that *Thank God It's Friday* is "the worst film to ever win any kind of Academy Award.")

But then there is Chick Vennera, an actor whom *Golden Girls* fans know as both Pepe the prizefighter and consumer reporter Enrique Mas. In *Friday*, he plays Marv Gomez, who ecstatically dances atop cars in the disco's parking lot. Vincent Canby of the *New York Times* called it, "the film's only good number." As Marv says, "Dancing! Everything else is bullshit!," which is true of this movie.

In the end, of course, there is Summer, looking gorgeous with a Cotton Club-era wig on her head and a giant flower behind her ear, singing "Last Dance" and it is a truly glorious moment. The song won the film's only Oscar for Jabara—always a more successful songwriter than actor—and earned him a Grammy and a Golden Globe."Last Dance" *was* the saving grace of *TGIF*.

Reviews were dreadful. Canby said the film was not so much a disco movie as "a record album with live-action liner notes." And, as for the Queen of Disco's movie debut, he sniffed, "Miss Summer, whose wigs are as elaborate as Diana Ross's, is competition for the superb Miss Ross in no department other than hair." Ouch. Still, *TGIF* was a boon for the careers of those involved—exposing disco music and disco performers to wider audiences via promotional appearances, like a two-night salute to seventies nightlife on *The Merv Griffin Show* and a disco installment of *The Midnight Special*.

The film's soundtrack, which featured songs by Love & Kisses, Thelma Houston, and Diana Ross, went on to sell nearly a million copies. But the film was destined to be second best. As Harris noted in his book, "There was room for only one picture centered on dancing, and RSO's Robert Stigwood had the better one . . . *Saturday Night Fever* left us in the dust."

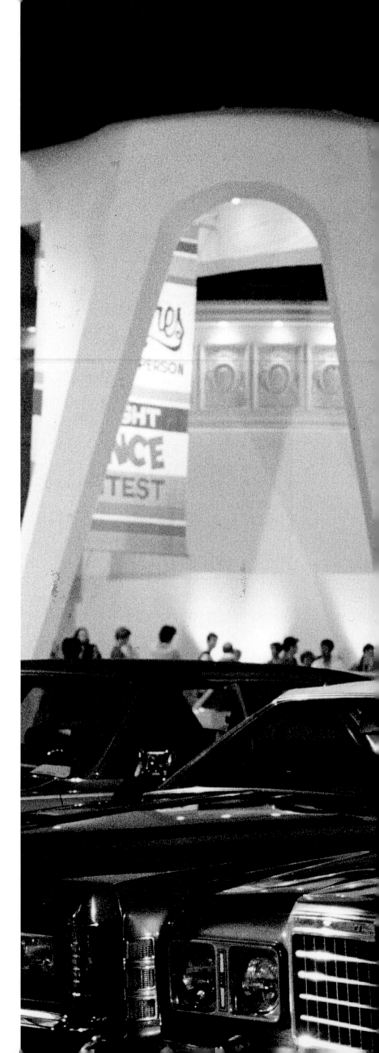

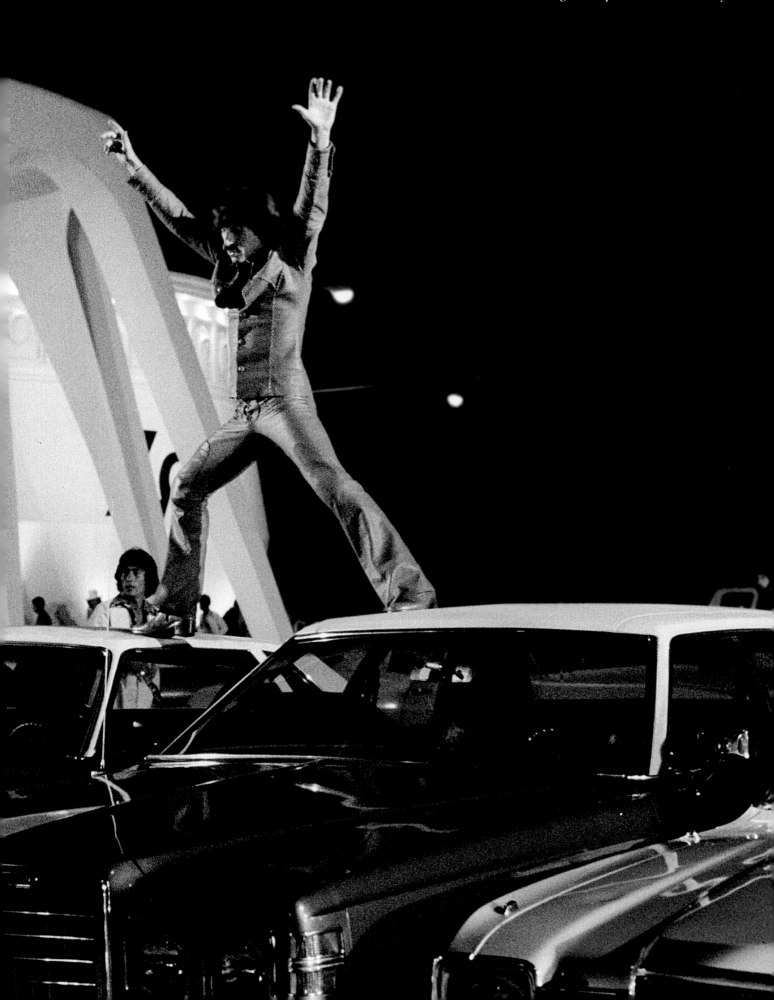

Chick Vennera as leather man Marv Gomez dancing on car tops in *Thank God It's Friday*.

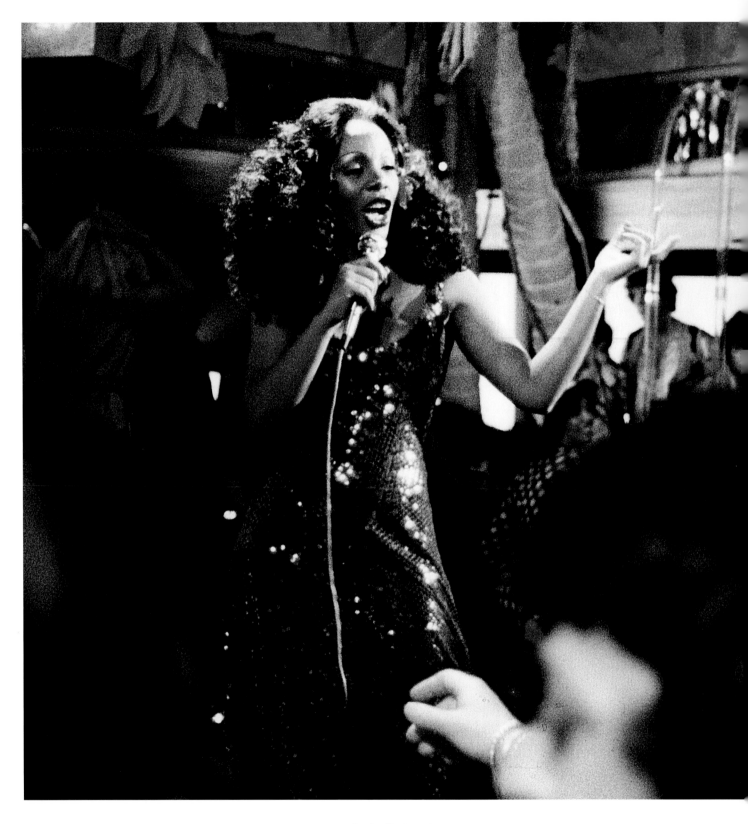

Donna Summer makes her film debut as a wannabe disco singer in *Thank God It's Friday*, left.

As the poster shows, right, the movie features future stars Jeff Goldblum, Debra Winger, and Terri Nunn, not to mention the Commodores.

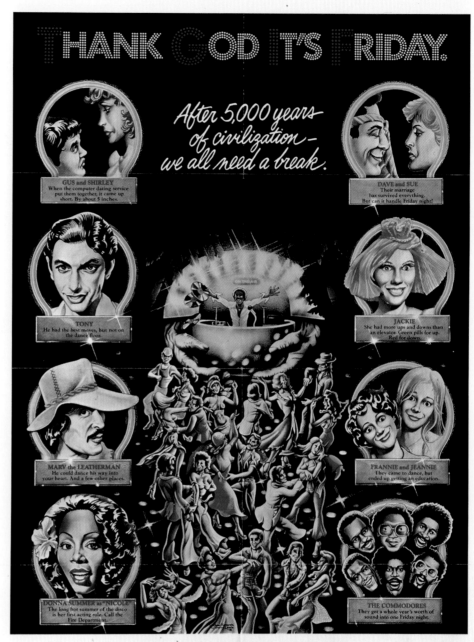

Flash forward two years to the third important disco movie—1980's *Can't Stop the Music*. A fictionalized, sanitized Village People origin story, the film featured the hottest disco band in the land in lavish production numbers, Steve Guttenberg on roller skates, Valerie Perrine in a giant martini glass, and Caitlyn Jenner, then known as Olympian Bruce Jenner, in denim hot pants and a crop top prancing through Greenwich Village.

The movie had everything. Except an audience.

Produced by Allan Carr, the impresario best remembered for inviting Rob Lowe and Snow White to sing together on the 1989 Academy Awards, the film tanked at the box office. Despite tremendous promotion—including a Baskin Robbins tie-in flavor called "Can't Stop the Nuts"—*Can't Stop the Music* brought in only $2 million.

Reviews were savage.

Janet Maslin began her *New York Times* critique with the words, "*Can't Stop the Music* is a movie with its own ice cream flavor...beyond that, what is there to say?" Gene Siskel and Roger Ebert included *Can't Stop the Music* on their list of "dogs of the year." And, perhaps worst of all, the film inspired the creation of the Golden Raspberry Awards, winning the inaugural Razzies for Worst Movie and Worst Screenplay.

Was *Can't Stop the Music* a failure because director Nancy Walker—the actress who played Valerie Harper's mother on *Rhoda* and sold Bounty paper towels as the "quicker picker upper" waitress—wasn't up to the task of helming a big-budget film? Those who were on set say the cinematographer did most of the work. Or was it because, by 1980, the bloom was off the disco rose? The answer, most likely, is both.

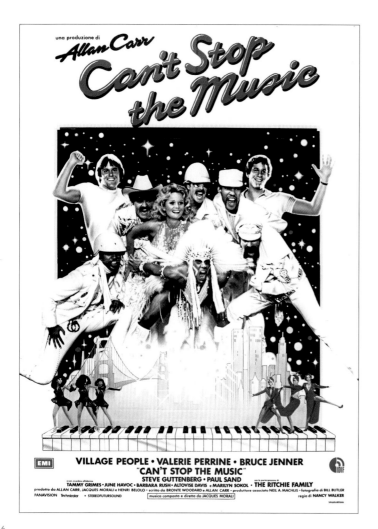

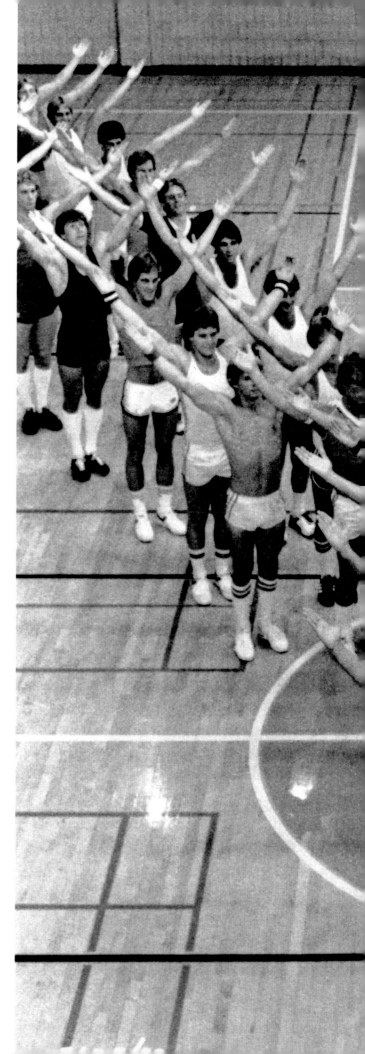

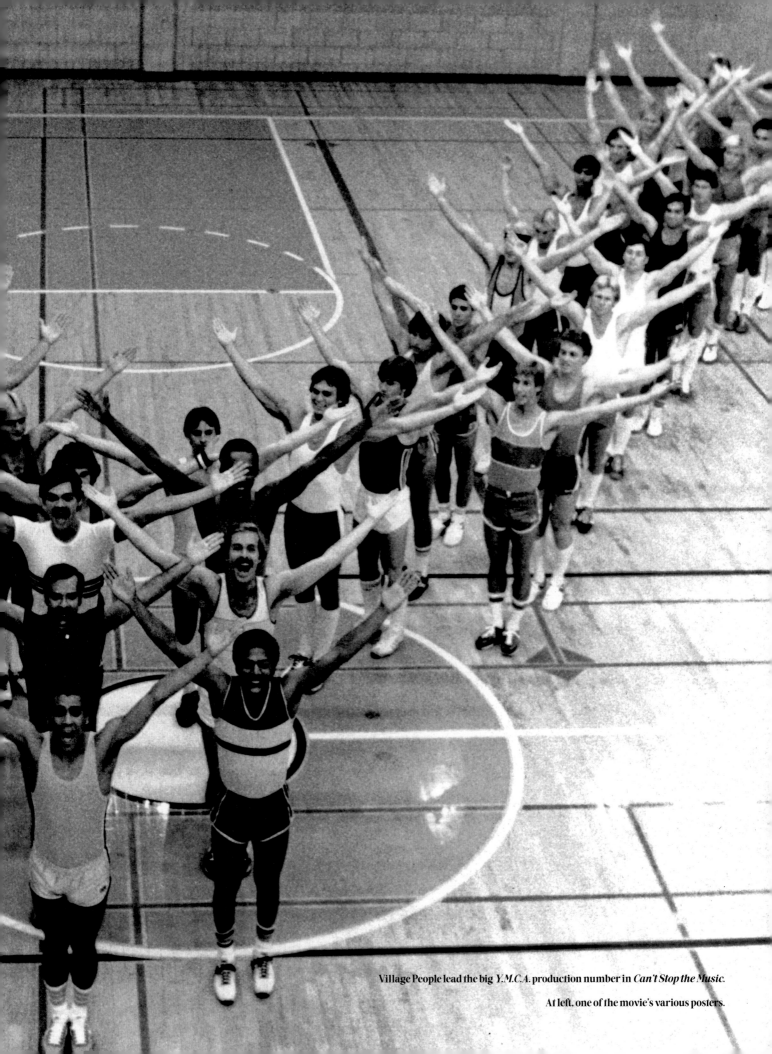

Village People lead the big *Y.M.C.A.* **production number in** *Can't Stop the Music.*

At left, one of the movie's various posters.

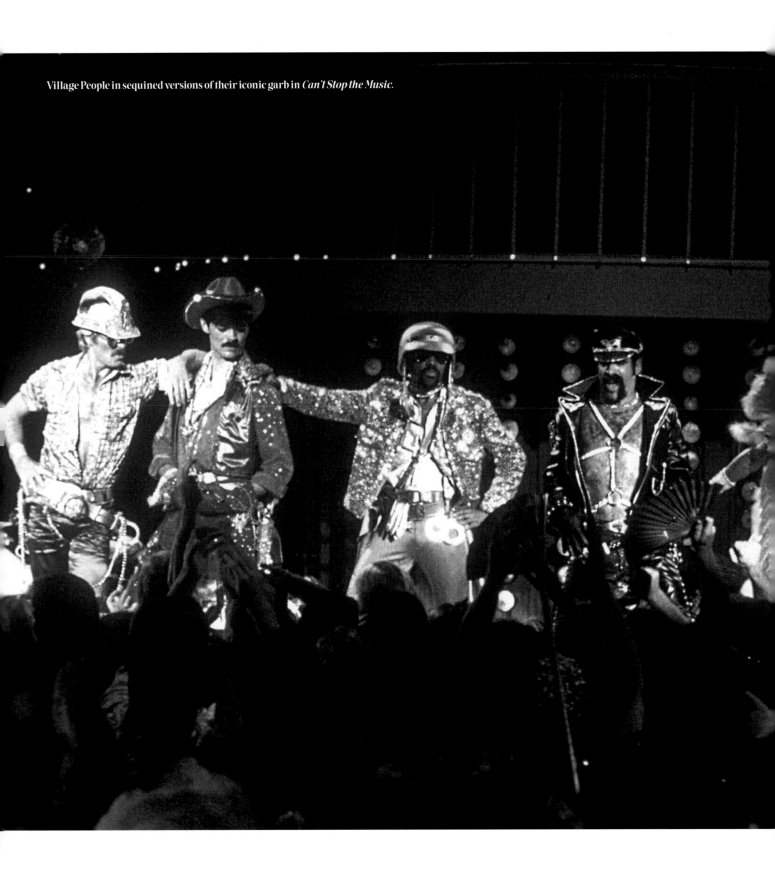

Village People in sequined versions of their iconic garb in *Can't Stop the Music*.

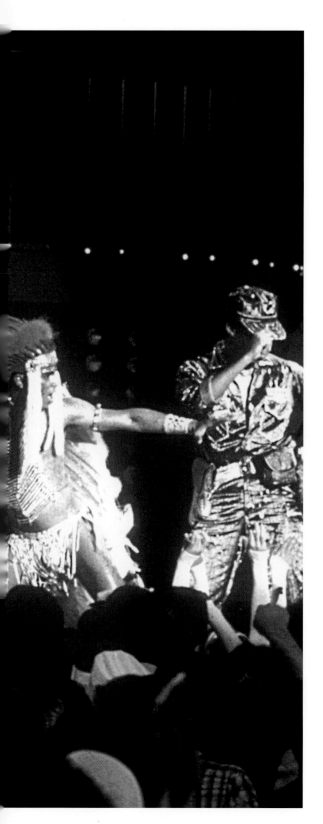

"It was released as disco was waning," says Bruce Vilanch, who wrote the first draft of *Can't Stop the Music*, a script then titled *Discoland . . . Where the Music Never Ends.* Extensively rewritten, the film did do well in parts of the world where there was no disco backlash. "If the movie made any money at all, it made it in Australia," Vilanch says. But in America, *Can't Stop the Music* was considered the movie that nearly ended big-screen musicals.

Today, however, it is regarded as a classic, at least in some corners.

If, in the triumvirate of important disco movies, *Saturday Night Fever* was brilliant and *Thank God It's Friday* was bad, *Can't Stop the Music* was brilliantly bad. But in 1980, the notion of so-bad-it's-fabulous was barely understood outside the urban gay demimonde.

At that time in the media, only the flamboyant critic Rex Reed understood the point of *Can't Stop the Music*. He wrote in his *New York Daily News* review, "If you can suspend disbelief long enough to treat this movie as a total camp, you'll have a fine time."

Audiences, he predicted, would love the musical numbers—including one in which little kids dress up as the Village People and drink milkshakes—even if the film's jokes about leathermen having feelings, too, went over their heads and straight audience members had no idea how gay the movie really was.

In fact, Reed called *Can't Stop the Music* "a revolutionary kind of musical that explodes on the screen like Roman candles." As for the big "Y.M.C.A." production number, which plays like a Roman *orgy*, Reed said, "On the day it was filmed, every gay bar on Santa Monica Boulevard must have been empty."

Years later, cultural commentator Michael Musto said, "It's one of those movies that's not really as bad as people say. The 'Milkshake' number is kind of classic." So what if straight audiences in 1980—"people who still thought Liberace was a bachelor," Musto calls them—didn't get it? Urban gays were always good at hearing what wasn't being explicitly said. "Allan Carr was the gayest queen who ever lived in Hollywood, so the film has a gay imprint, even if they never had the nerve to actually go there," Musto says.

In retrospect, there is a certain poignancy to the film beyond the camp. Critics have pointed out that *Can't Stop the Music* stood on the threshold of a new decade and all the heartbreak that the eighties would bring, particularly for gay men. "As queer films go, it serves as a cultural milestone: Demarcating where the civil rights era that began with Stonewall ended, and where the era of AIDS began," wrote Tony Correia in *Xtra* magazine in 2020.

Can't Stop the Music, he notes, has a "wide-eyed optimism for the '80s. From the film's idealist perspective, the '80s were meant to be 'new and different,' and you were 'going to do a lot of things you've never done before!' The film was right, just not in the light-hearted, campy way it had envisioned."

Like disco itself, the film holds cultural import for marginalized audiences. Looking back on these and other films of the disco era, one sees that there was more to the outré fashions, the music-as-liberation ethos, and the onscreen exuberance of a macho man on one knee singing "Danny Boy," as Glenn Hughes does in *Can't Stop the Music*, than critics ever imagined.

Most importantly, in the seventies, movies helped bring the glamour of disco to the masses, whetting an appetite for a new and different kind of nightlife. "The discotheque phenomenon that took root in the black and the gay subcultures of New York has established itself in nearly every major urban center in the country," *After Dark* reported in 1976.

"Only time will tell whether the crowds will be faithful or fickle to the discotheques," Craig Scott Druckman wrote in that popular nightlife magazine. From Pier Nine in Washington DC to the 1270 Club and 15 Landsdowne in Boston, to the Bistro in Chicago, to Studio One in West Hollywood and the City in San Francisco, people were dancing across the USA—living out the disco fantasies most folks had heretofore only seen in movies.

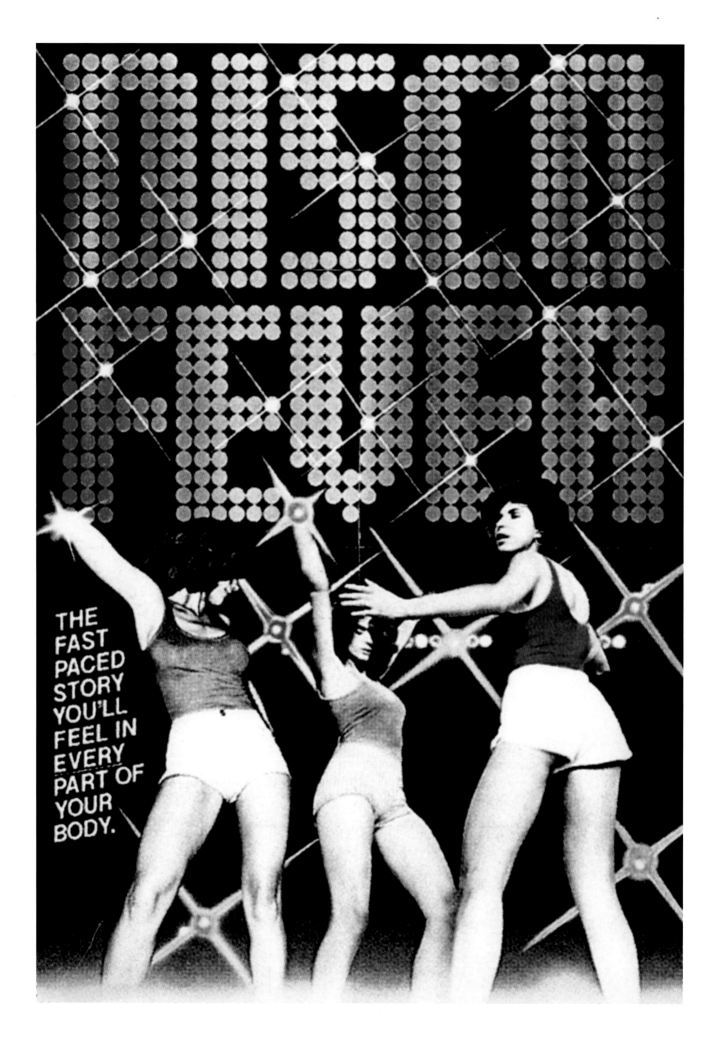

More, more, more...

Beyond the big three titles in the disco movie canon—*Saturday Night Fever*, *Thank God It's Friday*, and *Can't Stop the Music*—there's plenty of entertainment to be found.

So what if most critics were, how shall we say, *underwhelmed* by these motion pictures.

A typical review of one notorious title read, "If someone had set out deliberately to make a bad film, they couldn't have made a worse one than *Nocturna*."

But from the dance-floor exorcism of the 1974 Blaxploitation horror flick *Abby* to the insane excesses of the 1980 disco disaster *The Apple*, these movies offer a fascinating window into the seventies, showcasing the music, fashion, and sexual freedom of the disco era.

Here are eighteen more titles worth a look-see by any disco fan.

ABBY (1974)

Originally titled *The Black Exorcist*—until Warner Brothers raised holy hell—*Abby* stars Blaxploitation queen Carol Speed as a young woman possessed by Eshu, a Nigerian trickster god. "She's a good Christian girl and she's not mentally ill," her mother (Juanita Moore) maintains in director William Girdler's 1974 thriller.

But with the devil inside her, Abby talks dirty, sexually assaults her reverend husband (Terry Carter), and beats the crap out of a church organist. "Whatever possessed you to do a thing like that?" her hubby says at one point. After a visit to a mental hospital, Abby escapes and heads to the most sinful place of all—a disco. "There was the sound of dance music!" her husband says in horror when he gets a call from a pay phone there.

Now a demon dancer, Abby boogies up a storm and puts the moves on every man in sight, until Bishop Garnet Williams (William Marshall) shows up to exorcise the evil spirit out of her, right on the dance floor. During the spiritual cleansing, Abby levitates, a jukebox explodes, and, most spectacularly, the disco's mirror ball whirls out of control and bursts into flames.

Eshu is eschewed, but he seems happy to go.

"I'm tired of this stupid bitch anyway," the devil says.

THAT'S THE WAY OF THE WORLD (1975)

Fresh off attention-getting roles in *Mean Streets* and *Alice Doesn't Live Here Anymore*, a Qiana-clad, roller-skating Harvey Keitel starred as Coleman Buckmaster, an A-list producer at A-Chord Records in Los Angeles.

He's working passionately with a talented act called The Group—played by members of Earth, Wind & Fire—when his Mob-tied boss (Ed Nelson) saddles him instead with The Pages, a family of white-bread vocalists of dubious talent.

Franklyn, Velour, and Gary Page—played by Miss America Pageant host Bert Parks, former Miss Kentucky Cynthia Bostick, and Jimmy Boyd, a singer best known for "I Saw Mommy Kissing Santa Claus"—may seem decent, but they're morally bankrupt.

Velour even *bites* legendary DJ Murray the K.

Torn, Buckmaster laments, "If I can't make my kind of music, I might as well be selling shingles." But he's told, time and again, "That's the way of the world."

Long-play story short, Buckmaster trades his lucrative contract with The Pages for the right to work with The Group, a band that real-life DJ Frankie Crocker, playing himself, says "will make your knees freeze and your liver quiver!" The Group does just that with a rousing rendition of "Shining Star."

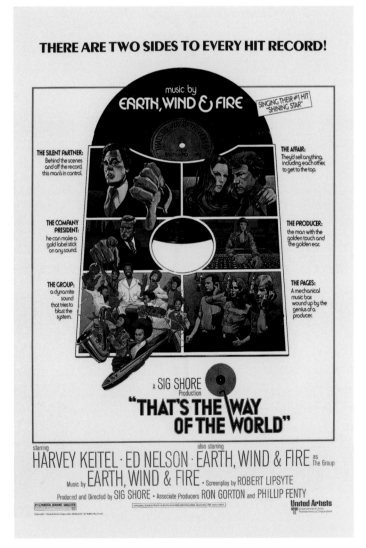

The one-sheet for *Disco Fever*, left.

The poster for one of Harvey Keitel's early films, *That's the Way of the World*, featuring Earth, Wind & Fire, above.

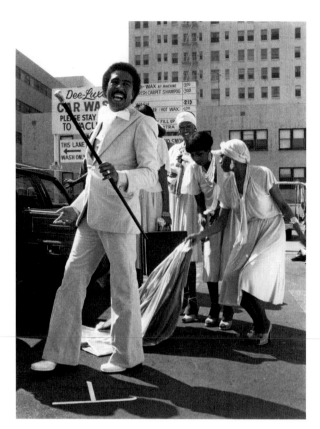

Richard Pryor and the Pointer Sisters in *Car Wash*.

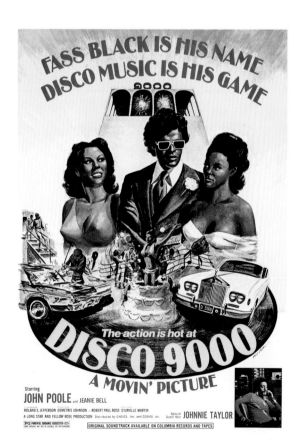

The poster for *Disco 9000*, above.

A triple-X entry in the disco movie canon, *The Night Bird*, right.

CAR WASH (1976)

More widely seen than *Abby* and *That's the Way of the World*, *Car Wash* is remembered as perhaps the first real disco movie—even though it's not set in one—thanks to its Grammy-winning disco soundtrack composed by Norman Whitfield and performed by Rose Royce.

Featuring appearances by stand-up legends Richard Pryor and George Carlin—not to mention the Pointer Sisters—the comedy captures a day in the life at the Dee-Luxe Car Wash, where the staff includes a Black activist (Bill Duke), a flamboyant fashion queen (Antonio Fargas), and a lovelorn guy (Franklin Ajaye) who just wants to win a radio call-in contest so he can take his waitress girlfriend (Tracy Reed) to a disco concert.

The motley crew must contend with all sorts of difficult customers, including a Beverly Hills mom whose carsick son is hellbent to ruin her expensive car upholstery, a terrorist known as the "pop bottle bomber" (Professor Irwin Corey), a hooker hiding in the ladies' room from the taxi driver (Carlin) that she stiffed, and an evangelist (Pryor) whose gospel is pure greed.

Although the film boasts a clever script by Joel Schumacher, who later adapted *The Wiz* for the screen, its greatest feature is its score. The title track was a Number 1 pop hit, and two other songs—"I Wanna Get Next to You" and "I'm Going Down"—made the R&B Top 10.

DISCO 9000 (1977)

Fass Black (John Poole) owns Disco 9000, the swankiest nightclub on the Sunset Strip, and he has it all—looks, women, and a sidekick named Midget played by the brilliant dancer Harold Nicholas of the famed Nicholas Brothers.

As the movie poster explains, "Disco music is his game." But when Fass passes on a gangster's demand that he spin the mob's music at his club, he gets shaken down. His ex-girlfriend is hit and killed by a van. Henchmen smash cars in his parking lot, destroy Black's recording studio and steal his master tapes, then finally demolish the disco itself.

"If *Soul Train* had a soap opera in it" was how Poole described the plot.

But good wins out in this film, shot in 24 days on a budget of $750,000 by actor-turned-director D'Urville Martin. Fass thwarts the villainous kingpin Bellamy (Nicholas Lewis) on his yacht—using legal paperwork rather than violence—then gathers his compatriots. "C'mon y'all, let's get out of here," he says, "Let's go boogie. Let's go disco." Fass goes back to spinning his own music and reassumes his mantle as "the King of Boogie-Land."

When *Disco 9000* was released, eleven months before *Saturday Night Fever* exploded, executive producer Robert Ross predicted, "In the next year, the disco film idea will really catch on." And it did. But the fate of *Disco 9000* was obscurity. Still, Johnnie Taylor's score and the catchy single "Disco Lady" redeem it.

THE NIGHT BIRD (1977)

High Society pronounced, "*The Night Bird* is to porno what Studio 54 is to disco," and if, by that, the magazine meant "hard to get into, but fun once you do," they were right. This triple-X feature "for ladies & gentlemen over 21," written and directed by Felix Daniels, has line dancing, urban grit, explicit sex, gang warfare, and a bomb because, well, why not?

Sharply dressed and slippery with swagger, Southside (Marcus Valantino) brags "I stabbed my first spic when I was fifteen!" But secretly he longs for a life better than bar fights and selling black-market jewelry out of the back of his car. All he really wants is to boogie!

But the patrons of the Night Bird disco do so much more. The crowd line dances while the DJ (David Davidson) gets a hummer. There's vibrator play, then dancing, group sex, then more dancing, then a little girl-on-girl action after some jadrool yells, "You said you was lesbians! We want to see you prove it!" Then it's back to the disco for more. "I want you to dance your asses off tonight! Come on now!" the DJ commands and they do. In close-up.

"This place is unbelievable," Southside says to the proprietor Maggie (Misty Winter), and it is, if you like tinfoil and Christmas lights. After ninety sleazy minutes, the movie's theme song—"Come on, dance with me. Make a real-life disco fantasy"—swells like a big you-know-what in a pair of polyester pants on prom night.

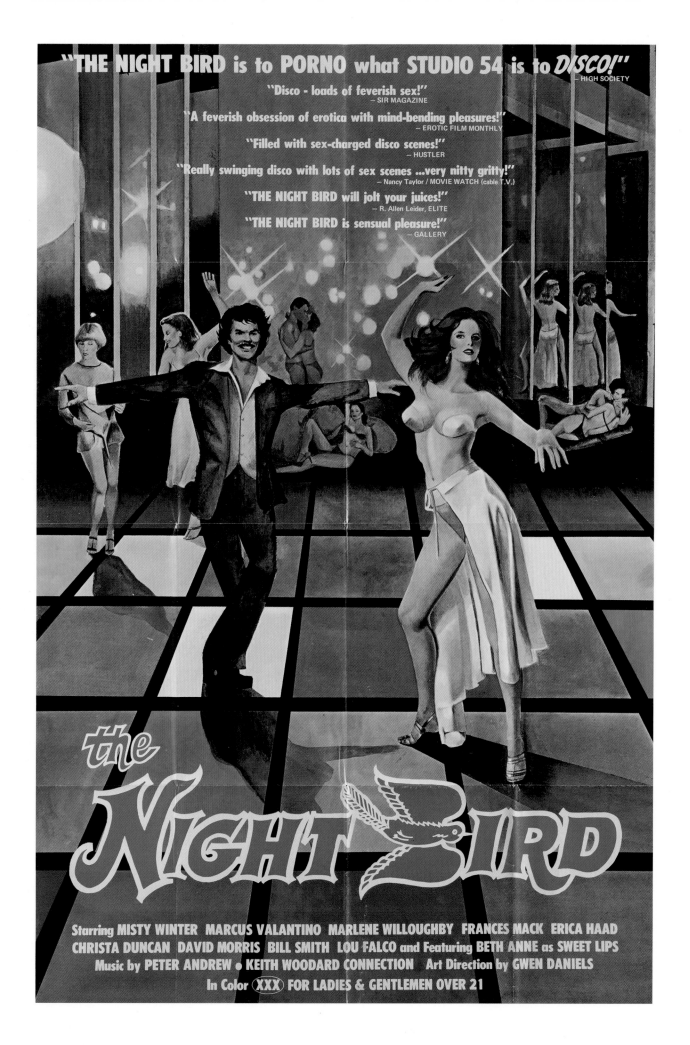

JENNIFER (1978)

A low-budget horror film, *Jennifer* tells the story of a naïve scholarship student (Lisa Pelikan) working her way through a posh academy for girls. "The rich are always right," the manipulative headmistress (Nina Foch) says, as she wheedles checks out of handsome Senator Tremayne (John Gavin), whose pretty-but-evil daughter Sandra (Amy Johnston) is nothing but trouble. She cheats on tests, smokes, pops pills, and, most telling of all, sneaks off to the hottest disco in Los Angeles, where she brags about dating celebrities.

"Imagine turning down John Travolta!" her gullible gal pal sighs.

Snooty Sandra *really* doesn't like poor Jennifer. She strangles the girl's beloved kitten, tries to drown her in the school swimming pool, steals her clothes from the locker room, posts naked pictures of her on a hallway bulletin board, and then kidnaps her in the middle of the night and throws her in a car trunk. She shouldn't have done that.

Jennifer may be a hayseed whose only real friend may be Bert Convy, who plays her favorite teacher, but she has a secret: She can unleash the "vengeance of the viper." When Sandra and her friends try to run Jennifer over in a car park, the supernatural student summons snakes, big and small, to destroy her enemies.

New York Times film critic Janet Maslin called this American International release "a hand-me-down version of *Carrie*," but added, "All things considered, *Jennifer* could be a whole lot worse." For one thing, Sandra could have *not* gone to that fabulous disco, actually Osko's, the same location where *Thank God It's Friday* was shot. The girl is mean but, dressed like a disco Daisy Buchanan in a sequin skullcap, she looks amazing.

THE WIZ (1978)

If a thirty-three-year-old Diana Ross could play Dorothy Gale—a socially awkward teacher who has never been south of 125th street—a gritty, grimy New York City could stand in for Oz in Sidney Lumet's funky urban retelling of *The Wizard of Oz*.

Based on the 1975 Broadway smash, which had made Stephanie Mills a household name, the big-screen *Wiz* traded a snow squall for a tornado and sent Ross down the Yellow Brick Road with Michael Jackson as the Scarecrow, Nipsey Russell as the Tin Man, and Ted Ross as the Lion, recreating the role for which he won a Tony.

In their travels from the outer boroughs to Coney Island, the four encounter smack-talking crows, Munchkins who are walking graffiti zombies, Forty-Second Street hookers outside the Poppy Love perfume company, not to mention Mabel King, Lena Horne, and Richard Pryor.

But is *The Wiz* really a disco movie?

When Dorothy and company ease on down the yellow Congoleum road to Emerald City, it becomes one. Dorothy's fabulous shoes gain the four access to a giant, color-changing dance party staged at the base of the Twin Towers of the World Trade Center, just as a fashion show begins. "You've got to be seen in green!" they're advised.

That is, until red becomes the new must-have color. Then, suddenly, it's all about gold. Men in metallic suits dance up a storm with sequined women in billowing disco dresses. It's all fabulous—with clothes credited to such disco-era hotshots as Halston, Zoran, Stephen Burrows, and Norma Kamali—but the Emerald City is just not Dorothy's scene. "I could never be happy here," she says. The woman prefers bad weather and ugly shoes. Go figure.

DISCO FEVER (1978)

Fifties teen idol, early seventies *Playgirl* model, late-seventies *Laverne & Shirley* guest star . . . is how Fabian is best remembered and not from his starring role in *Disco Fever*. Playing Richie Desmond, a past-his-prime rock musician, the one-named wonder wanders as if lost through the movie and the chic disco in which it's set.

Richie just wants to make music, ride his dirt bike, and meet a hot chick. But the scheming owner of Cybils—no apostrophe—Cybil Michaels (Phoebe Dorin) has plans for him beyond her disco empire. When Richie won't sleep with her, however, she decides to use his nostalgic appeal to promote Tommy Aspen (Michael Blodgett), a boy toy who will.

Also known as *Jukebox*, the film credits the story to custom carmaker George Barris, who also appears. Real-life disc jockey Casey Kasem plays a manager trying desperately to score with any woman who'll have him. "You just hung up on Marta?!? Marta, the Brazilian disco queen?!?!" he whines, having missed out on yet another chance to hook up.

The best reason to watch this forgotten drama is the climactic scene aboard Cybils Disco Jet. Adolfo "Shabba-Doo" Quinones, the hip-hop dance pioneer who'd go on to star in *Breakin'* and *Breakin' 2: Electric Boogaloo*, practically sets the private plane on fire with his moves.

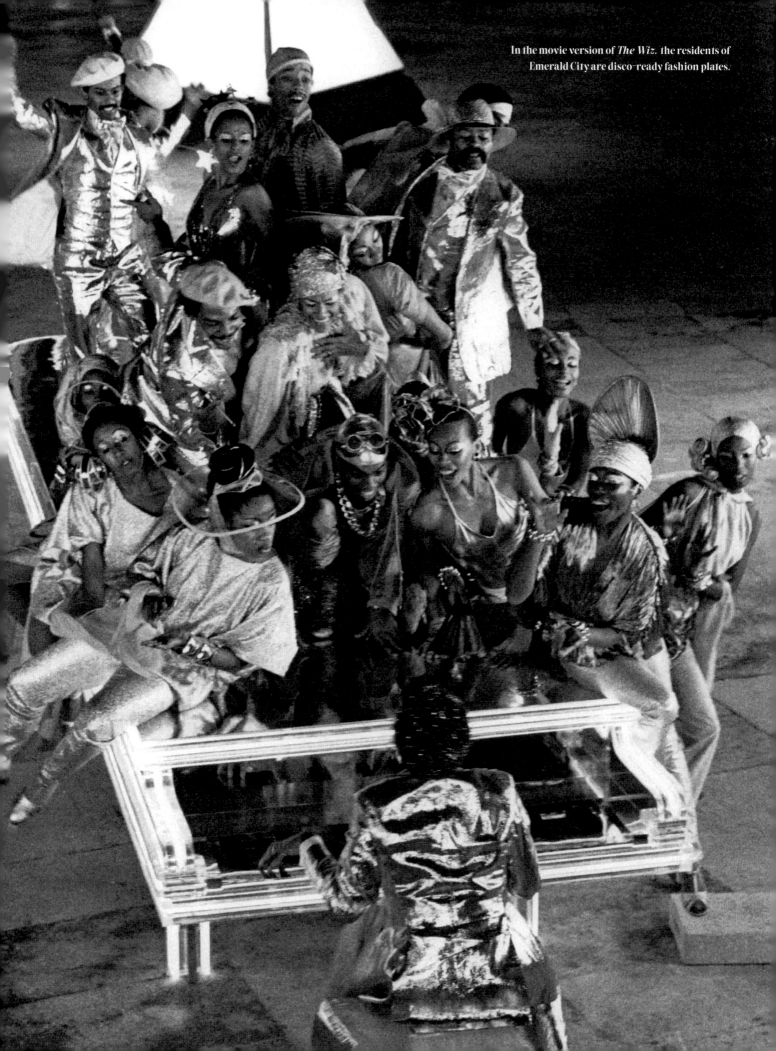

In the movie version of *The Wiz*, the residents of Emerald City are disco-ready fashion plates.

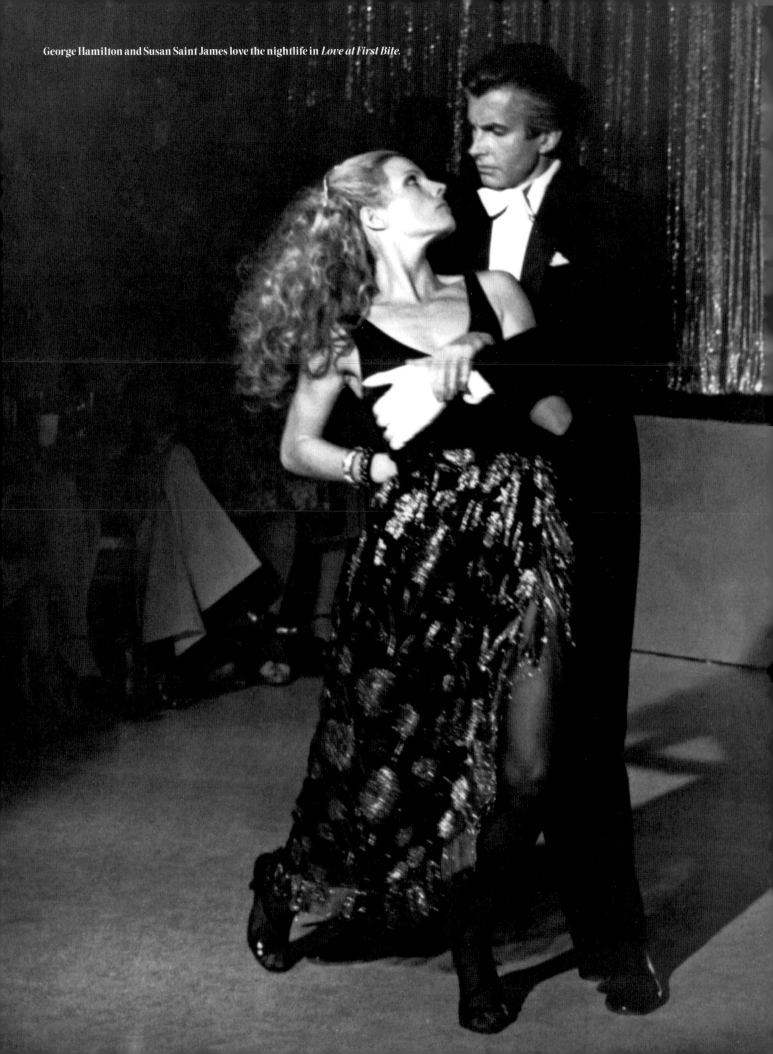

George Hamilton and Susan Saint James love the nightlife in *Love at First Bite*.

LOVE AT FIRST BITE (1979)

The tannest man in Hollywood, George Hamilton, plays the palest vampire in Transylvania, Vladimir Dracula, in this 1979 horror spoof costarring Susan Saint James and featuring Arte Johnson as the bug-eating manservant Renfield.

After being ousted from his Romanian castle for nonpayment of property taxes, the fang-tastic refugee relocates to Studio 54–era New York City. In less time than it takes to quote the film's most famous line—"Children of the Night, shut up!"—the nightclub Nosferatu falls for Cindy Sondheim (Saint James), a glamorous fashion model whose boyfriend (Richard Benjamin), is a descendant of the vampire hunter Van Helsing.

Radio spots dubbed Hamilton, "A Dracula with a difference—he loves to boogie!" and the film becomes a true disco classic when he and Saint James Hustle to the Alicia Bridges hit, "I Love the Nightlife (Disco 'Round)." "Susan was a natural dancer," Hamilton says. "I thought I was OK with it. He was Dracula. So, I had to have a certain kind of detached arrogance about it."

When the film was released on DVD without "I Love the Nightlife"—the song replaced by generic disco, likely to cut licensing costs—fans were out for blood. But when *Love at First Bite* came to Blu-ray in 2015, the disc's distributor, Shout Factory, made much noise about the disco song's restoration. As one critic wrote, "If you watch this scene and don't feel joy, you might not have a heartbeat. (Although if you're a vampire, or otherwise undead, disregard.)"

NOCTURNA (1979)

If *Jennifer* is the cut-rate *Carrie*, *Nocturna* is the low-rent *Love at First Bite*.

A horror comedy, *Nocturna* introduces audiences to Dracula's disco-loving granddaughter, played by Nai Bonet, a belly dancer who put up $50,000 of her own money to make the film. Nocturna, she says in an accent more Bronx than Baltic, "is an old Transylvanian name. It means, 'of the night.'"

The only thing the voluptuous vampire craves more than plasma is the company of the red-blooded Jimmy (Antony Hamilton), a blond stud in tight jeans who plays guitar in a disco band. After she whirls like a dance-floor dervish, Nocturna and Jimmy have a softcore moment. After one tumble and a booby-baring bubble bath, she's in love.

Nocturna follows Jimmy to New York City and goes to live under the Brooklyn Bridge with Jugulia Vein (Yvonne de Carlo), a member of the Blood Suckers of America. Vein has her eye set on Nocturna's grandfather (John Carradine), who's so old his fangs are dentures.

After finding Jimmy at the Starship Discovery nightclub in New York City, Nocturna realizes that her love for the disco axe-man is so strong that she's able to live with him in the daylight. And even though Dracula calls Jugulia a "sentimental suction pump," the batty duo fly back to the old country together in a coffin built for two. Love is love, after all.

Columnist Earl Wilson called *Nocturna* "Dracula in Discoland," but critics savaged the movie. They loved the soundtrack, however, which featured "Love is Just a Heartbeat Away" by Gloria Gaynor, and "Nighttime Fantasy" by Vicki Sue Robinson. "It's really a danceable bonanza and disco fans will love it," the *New York Daily News* gushed.

Dolemite himself, Rudy Ray Moore, is the *Disco Godfather*.

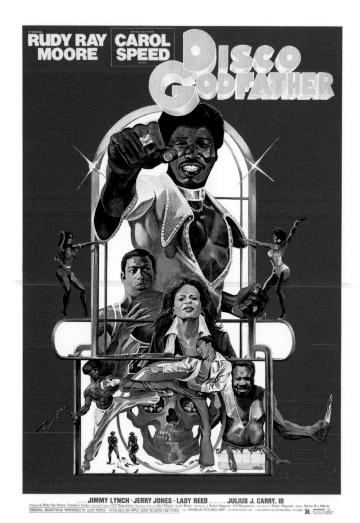

RUDY RAY MOORE · CAROL SPEED · DISCO GODFATHER

JIMMY LYNCH · JERRY JONES · LADY REED · JULIUS J. CARRY, III

"This was the late seventies—a lot of actresses were letting it all hang out," Collins told *Los Angeles* magazine in 2020. As for *The Stud*'s famous orgy scene in which she swings above a pool wearing nothing but a smile, Collins said, "We got absolutely drunk out of our skulls. That was the only way we could do it." Audiences are glad they did.

DISCO GODFATHER (1979)

Rudy Ray Moore followed up his infamous *Dolemite* films—underground actioners filled with sharp-dressed pimps, foxy women, and kung-fu fighters—with *Disco Godfather*, an antidrug dramedy set in a club in the Crenshaw neighborhood of Los Angeles.

Tucker Williams (Moore) has given up his policeman's uniform for the Funkadelic finery he wears as the impresario of the hopping Blueberry Hill disco. "This is the place to party and I'm coming on strong. If you don't want to boogie, take your ass on home!" he raps.

But when promising young basketballer Bucky (Julius J. Carry III) gets hooked on angel dust, the ex-cop vows to bring down drug uber dealer Stinger Ray (James H. Hawthorne). In the process of cleaning up the neighborhood, there's roller-skating in short-shorts, terrific disco dancing, a pile of cocaine blown off a copy of the *Saturday Night Fever* soundtrack, plenty of kung-fu action, and ghastly visions of the Angel of Death, a zombie straight out of *Blacula*.

Although Keenan Ivory Wayans, discussing stereotypes, once said, "It's movies like this that gave the NAACP something to do!" *Disco Godfather* and Moore's other work had a huge impact on filmmaker Quentin Tarantino, and such rap artists as Snoop Dogg, 2 Live Crew, and the Beastie Boys. Moore was pleased with the rediscovery of his pioneering oeuvre. As he rhymed in a 1991 interview, "I was through with it before they learned what to do with it."

SKATETOWN U.S.A. (1979)

It was touted as "The Rock and Roller-disco Movie of the Year," and it was, if you didn't count Roller Boogie. Still, as a time capsule of the roller-disco fad, *Skatetown U.S.A.* has a lot going for it—a pumping soundtrack of disco favorites, GQ performing "Disco Nights" live, many pairs of short-shorts, and some of the era's best practitioners of the "ball-bearing boogie": the Hot Wheelers, the New Horizons, and the Jerry Nista Disco Rollers.

Set in a Los Angeles roller-disco—actually the Hollywood Palladium dressed to resemble the real-life hotspot Flipper's Boogie Palace—*Skatetown U.S.A.* features a veritable who's-that of seventies show business, including Scott Baio, Maureen McCormick, Ron Palillo, Judy Landers, Flip Wilson, Billy Barty, Ruth Buzzi, and the decrepit comedian Leonard Barr, who does his ancient stand-up routine for anyone who'll listen.

Greg Bradford, a toothy blond skater who'd go on to model for Chippendales calendars, plays Stan, a goody-goody from the San Fernando Valley who hopes to defeat bad boy Ace Johnson, leader of the Westside Wheelers, to snag the $1,000 top prize in the skating competition. This is where *Skatetown U.S.A.* gets very interesting.

Ace is played by Patrick Swayze in his first film role. Fresh from the Broadway company of *Grease*, Swayze looks great in Lycra and skates up a storm. In the end, Ace and Stan face off on souped-up motorized skates on the Santa Monica Pier, almost drown in the Pacific, and bond in a homoerotic surf scene that is one drop of axle grease short of soft-core.

As a critic for the *Palm Beach Post* wrote in one of the film's only known positive reviews, "The plot is a throwaway, the acting, marginal. And the dialogue is verbal Muzak. But, my oh my, everything else is pure unbridled joyous roller-disco energy."

Skatetown U.S.A. is a mess. You'll love it.

THE STUD/THE BITCH (1978/1979)

Oliver Tobias is *The Stud*, Joan Collins is *The Bitch*, and together this pair of soft-core late-seventies melodramas offers a glimpse inside European-style discotheques—not to mention a certain Dame of the British Empire's naked assets, top and bottom.

Based on her sister Jackie Collins's steamy novels of the same names, both films feature Joan as Fontaine Khaled, the wife of a rich Arab businessman and the proprietress of a chic London disco called The Hobo. Each night, the dance floor is a sea of chaps in satin shirts and chippies in sequined tube tops shaking their groove things to tracks by Baccara, Heatwave, the Michael Zager Band, and Hot Chocolate. "Every 1's a Winner," indeed!

Swiss-born, London-trained actor Tobias is Tony Blake, Fontaine's studly plaything in the first film. "You reek of sex. It's your main attribute!" she tells him. Italian actor Michael Coby is her love interest, a conman and gambler named Nico, in the second.

There's lots of flash and plenty of flesh in both.

The *New York Times* called *The Stud* "illiterate and anti-erotic" and complained about the film's "pointless obscenity." A London newspaper claimed that *The Bitch* was "enough to give female dogs a bad name." But both films were popular enough to revive Joan's acting career. She joined the cast of TV's *Dynasty* in 1981 and became an international superstar as Alexis Carrington Colby, another glamorous bitch with plenty of studs vying for her affections.

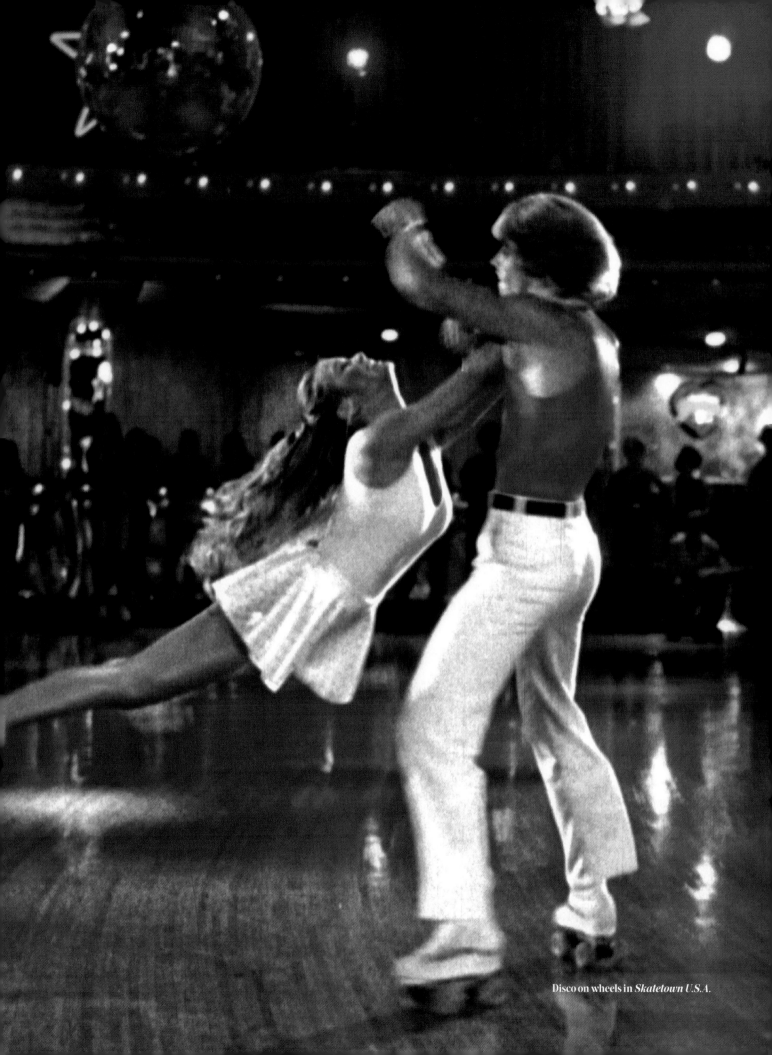

Disco on wheels in *Skatetown U.S.A.*

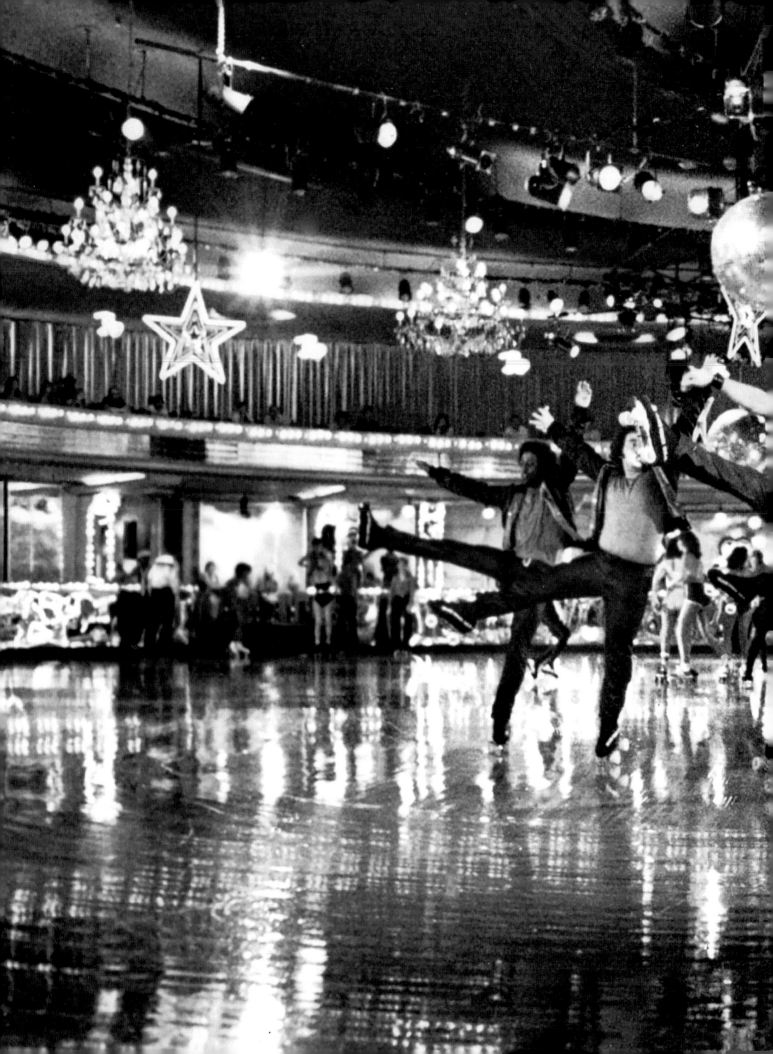

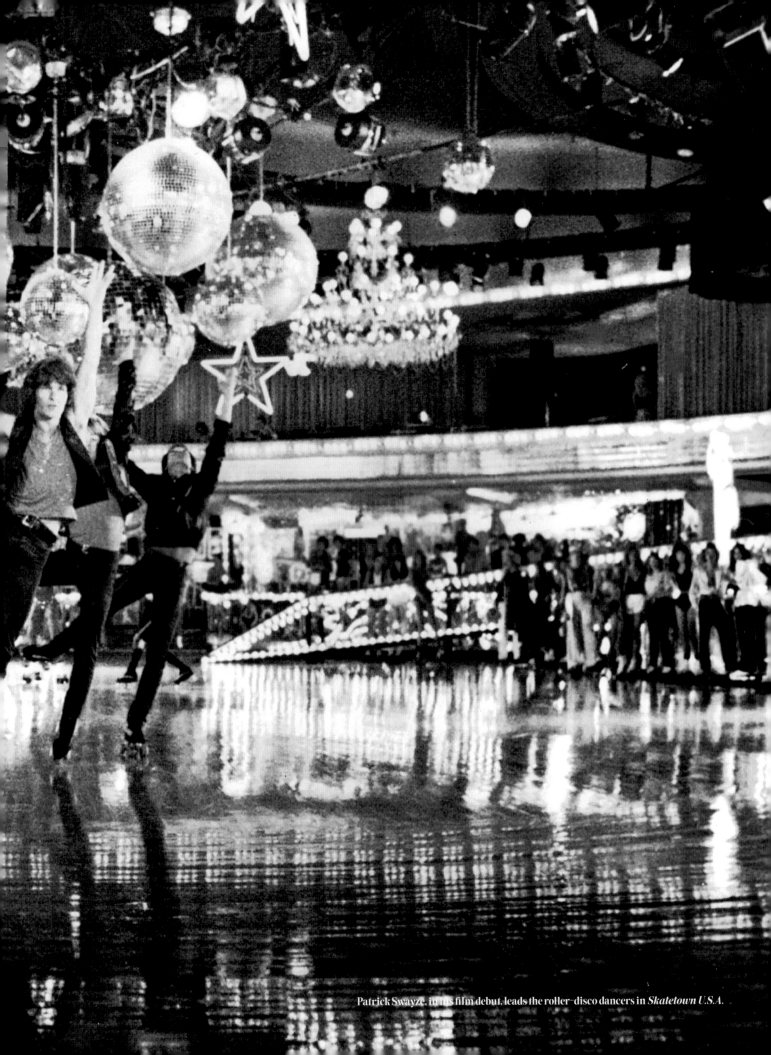

Patrick Swayze, in his film debut, leads the roller-disco dancers in *Skatetown U.S.A.*

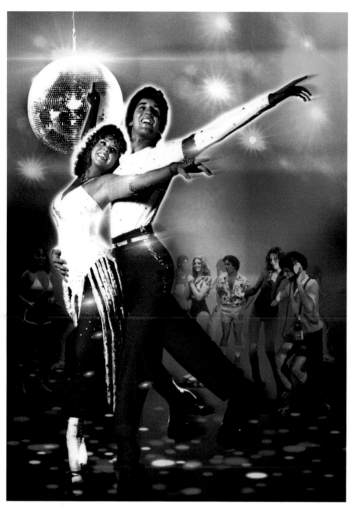

Linda Blair and Jim Bray in *Roller Boogie*.

ROLLER BOOGIE (1979)

SoCal rich girl Terry Barkley (Linda Blair) is a Juilliard-bound flute prodigy until she ventures beyond Beverly Hills and meets sweetheart-on-wheels Bobby James (real-life skating champ Jim Bray) on the boardwalk in Venice.

She's in love—and not just with Bobby, but skating, too—and ready to chuck it all. "So what? I'm a musical genius. What a drag! What a bummer!" Terry tells her mother (Beverly Garland). "I want to win a roller boogie contest down at the beach!"

Bobby coaches Linda to dance on wheels, while she tutors him in the ways of love.

There's trouble at their beloved Jammer's Roller Rink, however. The owner, Jammer Delany (Sean McClory), a former roller-derby skater, is being shaken down by the mob and forced to sell the place so it can be torn down by developers.

But wait! Phones (Stoney Jackson) accidentally recorded their threats on his boom box! Will the cassette be enough to convince Terry's lawyer dad (Roger Perry) that the developers are evil, and that he hasn't lost his daughter to "that insane disco music thing?"

Guess.

When *Roller Boogie* opened only two months after *Skatetown U.S.A.*, critics couldn't help but compare the two. Eleanor Ringel of the *Atlanta Constitution* said such an assessment was like "choosing between lung cancer and leukemia." Ouch.

"*Skatetown* was leeringly offensive while *Boogie* is embarrassingly moronic," she wrote. Ultimately, Ringel enjoyed *Roller Boogie* more, but liked Blair better in *The Exorcist*. "Bray acts passably well for someone who's spent his life going in circles around a roller rink," she wrote. "However, I preferred Linda when she was spewing pea soup."

PROM NIGHT (1980)

When the party's theme is "Disco Madness" and there's an axe-wielding killer on the loose, a high school formal is sure to be a bloody memorable evening, especially when the prom queen is scream queen Jamie Lee Curtis.

After starring in *Halloween* and *The Fog*, the future Oscar-winning Activia spokesmodel put on her sexiest dancing shoes to play Kimberly Hammond, a high school student whose little sister accidentally died, six years prior, during a particularly sadistic version of hide-and-seek.

Now, on the anniversary of her passing, someone is stalking those who left her for dead.

There are threatening phone calls—one film critic said sounded they like a "cross between Ethel Merman and Godzilla"—a shot-up bathroom mirror, a creepily torn yearbook, an exploding van, a couple of slit throats, and one neatly severed head before the murderer's identity is finally revealed in Paul Lynch's 1980 Canadian thriller.

What's *really* killer about *Prom Night*, though, is the big disco dance scene.

After a brief low-impact boogie with her father (Leslie Nielsen), whom Curtis describes as a "principal by day, disco king by night," Kim joins prom king Nick McBride (Casey Stevens) on the light-up dance floor in the gymnasium. Their mélange of the Bump and the Hustle, punctuated by a few flips, is, quite simply, to die for.

At the time, critics weren't impressed with the "original disco music" by Canadian composer Paul Zaza. "With disco on the way out, it gives *Prom Night* a rather dated appearance," wrote one newspaper critic. But fans clamored so long for an official soundtrack album that one with thirty-four tracks, most not used in the film, was finally released in 2019.

XANADU (1980)

It was supposed to be a roller-disco movie, but when two other such projects were announced early in its production, the creators of *Xanadu* switched directions and made something entirely different—a roller-disco movie with big-band numbers, trippy underwater animation, and Olivia Newton-John glowing like a neon sign.

This mishmash of a musical—It's eighties! It's forties! It's dancers in Lycra! It's women in snoods!—is weird and it's wonderful, and it's got classic song-and-dance man Gene Kelly, nearly seventy at the time, in a tuxedo on roller skates. You can't ask for more eclectic fun than that in just over ninety minutes of camp-tastic excess.

Well, now. When it was released, *Xanadu* was considered a dismal failure. The film cost an estimated $20 million and brought home only $23 million at the box office. The nicest thing Roger Ebert said about *Xanadu* was "It's not as bad as *Can't Stop the Music*." Adding insult to injury, the movie was nominated in 1981 for six Razzies, including Worst Picture.

Today, of course, *Xanadu* is a cult classic and it's easy to see why: Newton-John is gorgeous in ethereal prairie dresses and sings like an angel. Her love interest, a painter named Sonny Malone (Michael Beck), is a floppy-haired hunk in short-shorts, and did I mention Gene Kelly is in a tuxedo on roller skates? As clarinetist Danny McGuire, Kelly and his leading lady tap dance too. (Kira was Danny's muse before she inspired Sonny to open a huge disco in the ruins of Los Angeles' Pan-Pacific Auditorium. Are you getting all this?)

The real strength of *Xanadu* is the music by Electric Light Orchestra, especially the Olympian title track. Trailers for the film touted it as "the most exciting original score since *Saturday Night Fever*." John Farrar, the songwriter who added the catchiest tunes to the *Grease* movie, gave Newton-John plenty to sing too, including the number one hit, "Magic." Six songs from the soundtrack were released as singles.

Amid the chorus of naysayers in 1980, one voice stood out. Critic Tom Shales understood the film's charms early on, writing in the *Washington Post*, "*Xanadu* cannot possibly be described as a good movie, but it can be recommended to those who can tolerate large amounts of intravenous marzipan." It sounds delicious, especially now.

THE APPLE (1980)

Allan Carr hoped his 1980 Village People movie *Can't Stop the Music* would be a discofied *Singin' in the Rain*. Compared to *The Apple*, a musical released five months later, it was all that and a gallon of Can't Stop the Nuts Baskin-Robbins ice cream to boot.

Written and directed by Menahem Golan—half of the notoriously shlocky Israeli production team Golan-Globus—*The Apple* is a futuristic, Faustian musical set in a fascistic, shoulder-padded 1994. Shot in West Berlin with a budget of $6 million, it's crammed with spandex-clad seductresses, fever-dream drag queens, and hottie Euro-dancers in thongs.

Mr. Boogalow (Vladek Sheybal), the devilish head of BIM (Boogalow International Music), tempts an innocent young couple from Moose Jaw, Canada, Alfie (George Gilmour) and Bibi (Catherine Mary Stewart), with promises of fame if they sign with him.

Bibi bites the apple, crimps her hair, and becomes a sensation. But Alfie refuses and goes back to writing songs no one wants to hear, under the watchful eye of his chicken-soup–pushing landlady (Miriam Margolyes).

Even she gets it better than he does, asking Alfie, "Why don't you write the kind of shit that they like?" Instead, Alfie becomes a hippie, rescues Bibi, and, in the end, goes off to a heavenly planet with the godlike Mr. Topps (Joss Ackland), who drives a Rolls-Royce to the Rapture. Honestly, this movie should be rated WTF.

At its initial screening, *The Apple* was so poorly received that, as the story goes, fans threw souvenir soundtrack records at the screen and Golan considered suicide. It's bad, but it's not *that* bad. Sean Burns of *Philadelphia Weekly* wrote that the film "isn't just the worst disco musical ever made; it could very well be the worst movie ever made, period." But *The Apple* has its fans. They forgive the film its sins, even if they know Alfie and Bibi should have sold their souls to Boogalow and stayed at the disco, if only for the drugs, sex, and shoes.

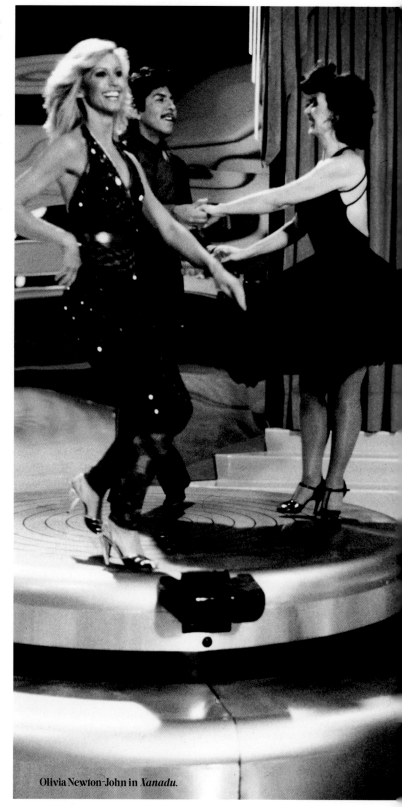

Olivia Newton-John in *Xanadu*.

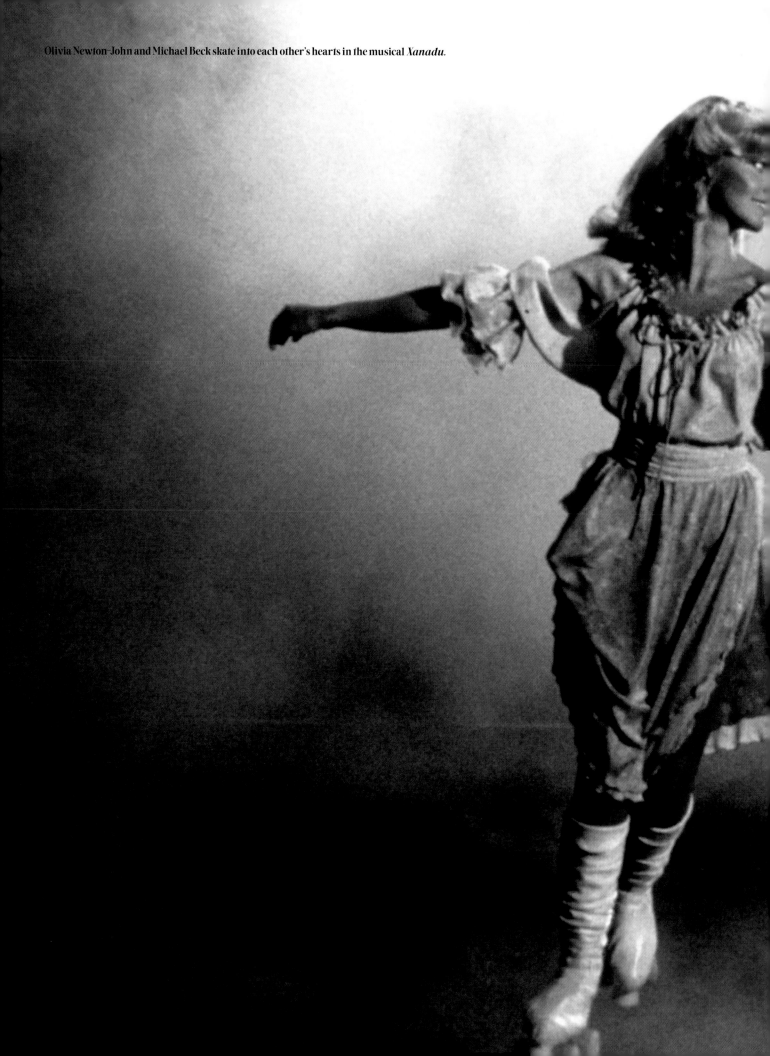

Olivia Newton-John and Michael Beck skate into each other's hearts in the musical *Xanadu*.

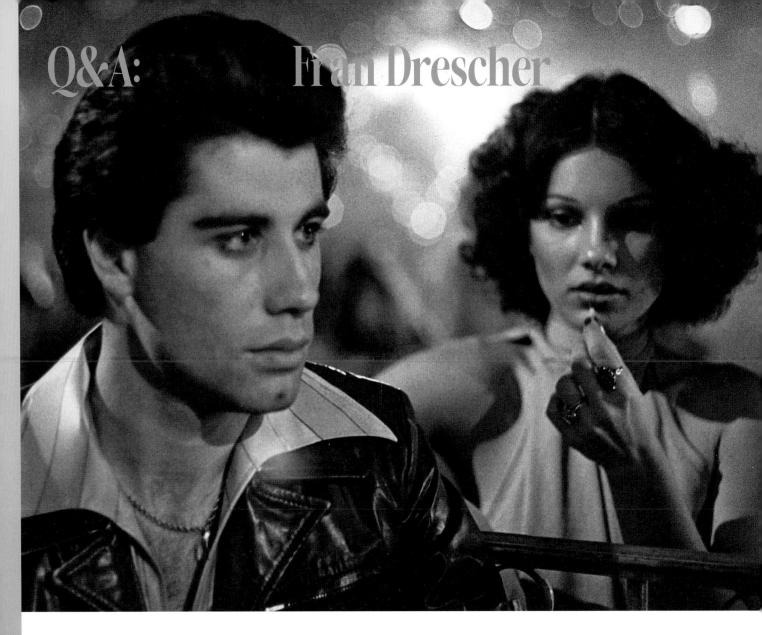

Q&A: Fran Drescher

Before they became household names as the stars of their own sitcoms *The Nanny* and *Angie*, Fran Drescher and Donna Pescow danced with John Travolta in *Saturday Night Fever*. Karen Lynn Gorney, who played Stephanie Mangano, may have won Tony Manero's heart in the movie, but, after appearing as the smart-mouthed Connie and the vulnerable Annette in the classic film, these two actresses won something more lasting—America's heart. Each reminisced in 2022 about their time in the arms of the disco king and *Fever*'s place in pop culture history.

Those two interviews are presented together here.

Two of Tony Manero's dance partners in *Saturday Night Fever* went on to major TV stardom, Fran Drescher, at left, and Donna Pescow, at right, both with John Travolta.

FDC: "How did you land your role in Saturday Night Fever?"

FD: "I auditioned for the original director John Avildsen for one of the female leads. He had directed *Rocky* and was supposed to direct *Saturday Night Fever*. When he left the film and John Badham came in, I thought to myself, I'm going to be out. He ended up hiring Karen Lynn Gorney. But he gave me a smaller part, Connie. She dances with Tony and then he goes into his famous dance solo."

DP: "There was this wonderful, very old-school casting director named Shirley Rich. When I went in to meet with her, she said, 'You don't sound like you come from Brooklyn.' My accent had been so drummed out of me at the American Academy of Dramatic Arts. She said, 'Go home, listen to your parents, and come back with a Brooklyn accent.' I had three auditions with John Avildsen. Then when John Badham was brought in, I had two or three more. There was maybe a three-day window between getting the role and starting the movie. It was crazy."

FDC: "Did you have to take dance lessons?"

FD: "I did not consider myself a dancer, and Connie wasn't supposed to be a good dancer. Tony kind of spins her off and says, 'forget this.' But John is such a good dancer that it's hard to be bad with him. When you dance with him, and particularly doing that style of dancing, you're working with the male leader. Hopefully I pulled it off."

DP: "I was a good enough dancer to get a gig, but I was never a phenomenal dancer and I had never done any kind of disco dancing. I'd never even been to a disco. John Badham knew he had hired a bunch of people who had no clue about what that world was like. We had two weeks of rehearsal and, as part of that, we went to the club in the movie to really see what it was about. Travolta didn't go because he was too recognizable. But the rest of us went. We walked in and they instantly knew we didn't belong there. These people took it really seriously and it was very territorial. It was a little bit threatening, but that gave

and Donna Pescow

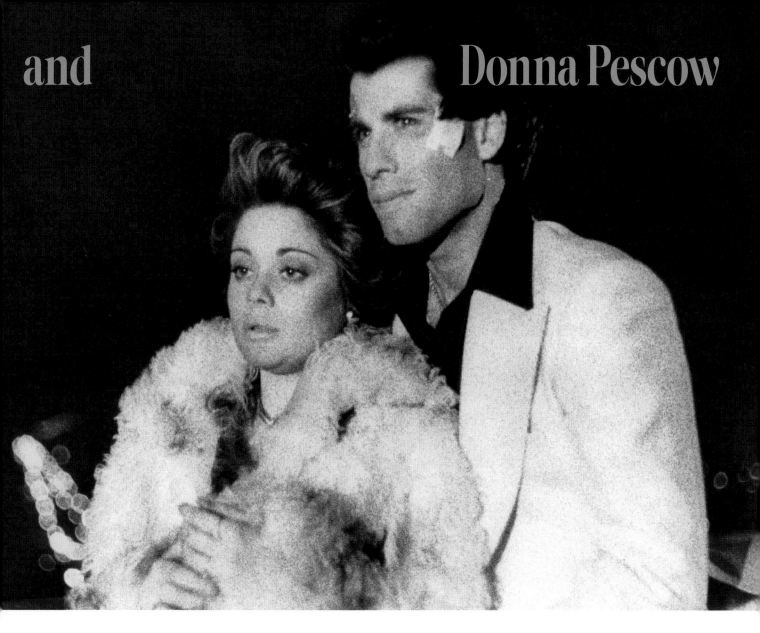

us tremendous insight to really what this meant to that neighborhood and the people who went to this club every weekend. It was *their* place."

FDC: "You shot the dance scenes at the Odyssey, yes?"

DP: "That was the actual club. But the production put in the light-up dance floor. Initially, it was just a wooden dance floor. The budget on this film was small. So, there was aluminum foil on the walls to make it shinier. They did as much as they could to make it glitzy but keep that neighborhood groove to it. There was that bar with the girl who did the strip. She really worked there. A lot of the people who were extras in the film were the neighborhood kids who went to the club."

FDC: "What was it like dancing on that light-up floor?"

DP: "The floor was plastic and they wanted to have this sort of smoke effect most of the time, so they would spray this stuff. I don't know what it was, but the floor would be soaking wet after a while. When we'd start dancing, it was like the Ice Capades. We'd fly around the floor because it was so slippery. We were doing the Hustle and then we had to wait for them to mop up around us before we could leave, or we'd fall on our asses. It's funny now, but I would scream at my agent at the time."

FDC: "Was John Travolta an amazing dance partner?"

DP: "He knew that we were all neophytes with no idea what we were doing in front of the camera. He wanted everybody to feel that their role was as important as his role was, and to feel comfortable. There was tremendous camaraderie on the set. He really cared about every aspect of the film, and I have to say he really did set the tone. He's one of those people who is grateful for where his life is. A lot of people at that level of fame will just care about what they're doing and stay very isolated from everybody else. John is just the opposite."

FDC: "How important was the connection between fashion and you finding your character?"

DP: "The clothes were *very* important. If you wanted to be in that club, you had to look a certain way. The shoes were platforms. High heels were a must. I remember rehearsing in those because I said, I will kill myself if I don't work in these from the start. It was like that for some of the guys, too, because they had them in really high platforms. Barry Miller has one scene that kills me every time. When he walks away, you see the shoes. He's hysterical."

FDC: "After Tony Manero's white suit, Annette's rabbit coat is the most iconic!"

DP: "That little terrible fur jacket that I wore was just such a strange piece of clothing. But they were so popular at the time. That jacket actually got stolen from one of the wardrobe trucks. They had to go out and find another one to match everything that we had already shot. They started to refer to it as 'that fucking jacket.' It was like that jacket became another character. Somewhere in Brooklyn, to this day, there's a woman wearing it saying, 'I swiped this jacket from *Saturday Night Fever.*'"

FDC: "Fran, you had a funny thing happen on one of your *Saturday Night Fever* shoot days."

FD: "My dad was working in Brooklyn, and he came to visit me on his lunch hour. I was a teenager living with my parents so for me to be off making a movie by myself, he wanted to check up on me. The security people said that it's a closed set, and he said, 'But I'm the star's father,' and they said, 'Oh, right this way, Mr. Travolta,' and he walked right in."

FDC: "When did you know the movie was going to be so big?"

DP: "There used to be a movie theater on Broadway where they'd show previews outside. I was walking and I saw all these people huddled around this little TV screen. It was the trailer for *Saturday Night Fever*, which I had not seen yet. I was wide-eyed and amazed. And then people started to realize that I was in the trailer. They said, 'Oh my God, you're her!' I was so freaked out. I didn't know how to respond and I just kind of scurried away.

"When the film opened, it was crazy town. It became so big, so fast. Suddenly I was getting phone calls from agents. I did not know what was going on, but it was just massive. Paramount said we're going to put you on a little promotional tour to a couple of cities. It was huge. People were dressing like our characters. Suddenly, it was like the movie came to life. It was thrilling, but it was also intimidating. I don't think you can ever be prepared for something so big."

FDC: "Why do you think *Saturday Night Fever* was such a hit?"

DP: "This film came out at the right time with the right vibe, and people were ready to see it. Paramount never in their wildest dreams thought this would happen. It was some little art film that, against all odds, became what it did."

FDC: "Why do you think the film holds up so well?"

FD: "It has depth of feeling. It really explores the struggles of people living in a small-town environment with big dreams, looking across that bridge. We explored that on *The Nanny* too. Fran crosses that bridge in the opening titles—she passes a sign that says, Queens this Way, Manhattan that Way. When you come from one of the outer boroughs, Manhattan is where you make your dreams come true. You saw that with Travolta's character, particularly in the sequel, *Staying Alive*. It's amazing how, just across the bridge, life can be so much more hospitable for kids with dreams."

DP: "It's a universal kind of thing where people are trying to find themselves and their places in the world. In that club, Tony's got all the perks, unlike in his real life. That disco was the place where he felt like he belonged. That need to belong doesn't change. Everyone needs to feel a part of something and feel valued, to be respected somewhere. When we met these kids—our real-life counterparts—disco was such an important part of their lives. The disco was where glamour was, where freedom was. Today, fans of the film tell me personal stories—'This was my life,' 'I was in high school,' 'I never would have met my wife if I hadn't gone to that club.' Their connection to the film is still so deep."

FDC: "Donna, you won the New York Film Critics Circle Award for best supporting actress for *Saturday Night Fever*. Did that performance lead to your sitcom *Angie*?"

DP: "I came to LA maybe six months after the movie opened and had all these meetings with all these major Hollywood people. I never intended to stay. I was going to go back to New York. But then Garry Marshall called my agent and said, 'I'd love to meet with her and talk to her about a series.' So, I took this wonderful meeting with this incredible guy and laughed my butt off as he pitched *Angie* to me. Garry Marshall pitching a show is a show in itself."

FDC: "There were some call backs to *Saturday Night Fever* in *Angie*. Doris Roberts, who played your mother, danced with Tim Thomerson in a disco dance contest, for instance."

DP: "It was always fun. But I would try and keep the references to a minimum, because sometimes it was just a joke for the joke's sake. It kind of tips the reality of what you're trying to create. There was also an episode of *Angie* where her old boyfriend comes back. Paul Pape, who played Double J in *Saturday Night Fever*, played the role. So that was a lot of fun."

FDC: "Fran, you had a few disco moments on *The Nanny* too."

FD: "As a girl from Queens, the disco era was very big when I was in high school. Because I was playing a girl from Queens, we had an episode with Richard Kind. It seemed like it would be perfect nostalgia to bring that up."

FDC: "Did either of you ever go to Studio 54?"

FD: "No, I was such a good girl. I liked being home with my parents."

DP: "The few times I went, it was like disco Disneyland. It was like a planet unto its own. I didn't frequent clubs on a regular basis, but when I would go to a disco, the general vibe was always kind of wonderful. It was very much a time when people would get together and feel better about themselves and feel good about what was going on around them."

FDC: "What did the disco sucks backlash mean for people who were associated with disco?

DP: "To be honest, I paid very little attention to it. I know more about it now because I see it in documentaries. I had no idea it was that intense. But people get on bandwagons for the dumbest reasons. It was a radio promotion that blew up into something real, which I don't think it was ever intended to be really. People burning albums and all that, that was moronic. I think of it as a really embarrassing, stupid time in our culture. Disco was just the strangest scapegoat."

FDC: "How does it feel to have been part of such a landmark movie?"

DP: "It really is unbelievable. I'm so grateful and touched by how people feel about the film and my participation in it. Every actor would love this to happen but never thinks that it would be possible to make that kind of impact or be memorable enough for people to care all these years later. The movie really does hold up, though. Everybody remembers the music and the dancing, but we forget that it's really an amazing film."

FD: "It's almost like a time capsule of that time. And, for that reason, it's a classic movie."

FDC: "Did you both keep in touch with John Travolta?"

FD: "I was always a big fan of his. I used to watch him on *Welcome Back, Kotter*. Years after we worked together, I saw John on a red carpet. I went up to him and I said, 'Are you as good in bed as you are on the dance floor?' and his wife's jaw dropped, may she rest in peace. She didn't realize that I was saying my line from the movie. But he knew, and he said, 'Oh, my God, Fran, it's so good to see you!' I'm still a big fan of his."

DP: "He's the definition of a sweetheart."

Meco and Moroder at the Movies

One man brought Hollywood to disco, the other brought disco to Hollywood. In the late seventies, their music was everywhere, and their immeasurable contributions to the pop charts and film soundtracks made some of the biggest movies of the day infinitely more danceable.

Growing up in smalltown Pennsylvania, Domenico Monardo planned to be a classical trombonist. He studied at Rochester's prestigious Eastman School, played in the West Point Band, then moved to Manhattan to find a gig in the music business.

That gig turned out to be big. In 1974, with his studio partner Tony Bongiovi, Monardo formed the Disco Corporation of America and produced two of the genre's founding hits—Gloria Gaynor's "Never Can Say Goodbye," which was the first Number 1 record on the newly created *Billboard* Disco Chart, and Carol Douglas's infectious "Doctor's Orders," which went to Number 2.

And all that was before Monardo went to outer space.

Morphing his named into Meco, he taught Darth Vader to dance with the 1977 hit single, "*Star Wars* Theme/Cantina Band." A disco medley of John Williams's soundtrack, punctuated by R2D2 beeping and Luke Skywalker's X-wing fighter pew-pew-pewing, the song rocketed to Number 1 in America. The album on which it appeared, *Star Wars and Other Galactic Funk,* climbed to Number 13 on the pop charts.

The movie medley was so well-regarded—even Williams called it "marvelous" — that it was nominated alongside the original for a Best Instrumental Performance Grammy. Williams won, not surprisingly. At that point, Meco had never even made a TV appearance as an artist. His one broadcast spot was on Dick Clark's *Live Wednesday* in 1978. Academy members, as Meco said in a rare 2005 interview, "didn't know what the hell I was."

Today, they know.

Having created dance versions of the soundtracks to *Close Encounters of the Third Kind, The Empire Strikes Back, Star Trek, The Black Hole,* and *Superman*—not to mention *The Wizard of Oz, An American Werewolf in London,* and an infamous Christmas album—*Meco* is considered the Supreme Commander of Space Disco. "My mission is complete! The entire galaxy is boogying!" he once said. His rallying cry remains "dance your asteroids off!"

While Meco was turning movie soundtracks into disco hits, Italian record producer and composer Giorgio Moroder was creating disco soundtracks for some of the most exciting movies of the period. He cowrote and produced songs for 1980's *American Gigolo,* including the Blondie smash "Call Me," *Cat People,* which featured David Bowie "putting out fires" on the title track, *Scarface, The Neverending Story,* and the score for the 1984 restoration of Fritz Lang's 1927 dystopian classic *Metropolis,* among others.

Moroder's success at the movies was enormous from the beginning. His compositions for *Midnight Express,* the 1978 prison escape movie, won him both the Academy Award and a Golden Globe for Best Original Score. The soundtrack album launched the international hit single "Chase." He later won Best Original Song Oscars for "Flashdance . . . What a Feeling" by Irene Cara from 1983's *Flashdance,* and "Take My Breath Away" by Berlin from 1986's *Top Gun.*

An Italian native, Moroder found his calling as a professional musician while still in his teens. After moving to Munich in 1968, where he founded Musicland Studios, Moroder had hits as a performer—including the albums *From Here to Eternity* in 1977 and *E=MC² in 1979.

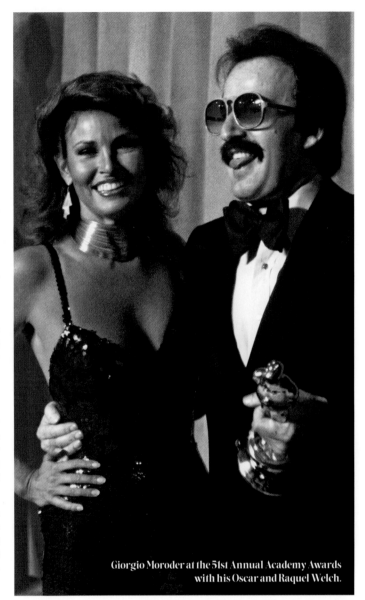

Giorgio Moroder at the 51st Annual Academy Awards with his Oscar and Raquel Welch.

But he was best known for his behind-the-scenes work with Donna Summer. Moroder cowrote and/or produced a string of landmark hits for the Queen of Disco, including "Love to Love You Baby," "I Feel Love," "MacArthur Park," "Last Dance," "Hot Stuff," and "On the Radio."

Considered the "Godfather of Disco"—a term he says he does not like—Moroder had a major resurgence after the award-winning Daft Punk album, *Random Access Memories,* was released in 2013. The Parisian electronic duo's international hit record included the track, "Giorgio by Moroder." Suddenly, his career was on fire again.

Since then, Moroder has reached a new generation with such projects as the 2014 single "Giorgio's Theme," a remix of "I Can't Give You Anything but Love" by Tony Bennett and Lady Gaga, and a 2015 studio album called *Déjà Vu,* which featured collaborations with such modern-day artists as Sia, Britney Spears, and Charli XCX. In his seventies, he became a superstar club DJ, too. "I don't even like dancing," he admitted sheepishly at the time.

Moroder also worked with Kylie Minogue on a 2015 single called "Right Here, Right Now" that rocketed to Number 1 on the American dance charts—his first time there in a decade and a half.

In 2021, he cowrote and produced a song on the Duran Duran album *Future Past.* "This is music for a world that's coming back together," front man Simon Le Bon said of their collaboration. The album was an international success. "I still love dance songs and EDM," Moroder said at age seventy-eight. "Not everybody likes it, but I do."

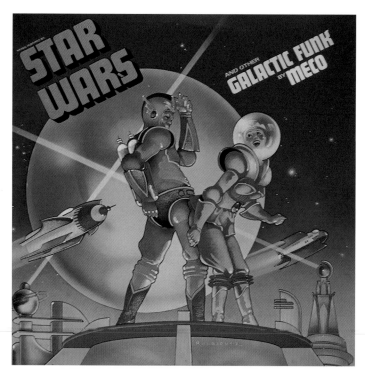

Meco's album *Star Wars and Other Galactic Funk*.

Shadow Dancing: Movie Themes Gone Disco

Meco Monardo may have been the king of turning movie themes into dance-floor hits—nobody did it better—but he wasn't alone in the endeavor. His achievements inspired many others to do the same with varying degrees of chart success.

As the British musician Kenny Denton, who discofied the theme to *Alien* in 1979, put it, "After Meco's brilliant and bestselling adaptation of 'Star Wars,' it was a free-for-all."

Neil Norman and His Cosmic Orchestra, for instance, pressed a four-sider of sci-fi disco themes from "Moonraker" to "March of the Lizard-Men" in 1980. Guy de Lo and His Orchestra turned a classic Henry Mancini spy theme into "The Pink Panther (Discostar)" in 1978.

These boom-boom box-office tracks, though, are the best. Meco not included.

"JAWS" BY LALO SCHIFRIN (1976)
Lalo Schifrin was best known as the composer of the title song to the 1966 TV show *Mission: Impossible* when he entered the cool, dark waters of disco in 1976. He did so with a remake of John Williams's terrifying theme to Steven Spielberg's thriller *Jaws*.

Schifrin's reimagining nodded to the original then swam off on its own, which critics appreciated. Canadian scribe Bob Beech called *Black Widow*, the album from which the single was drawn, "a tasteful exercise altogether."

These "Jaws" did best in England, spending nine weeks on the charts, peaking at Number 14. For an October 1976 installment of *Top of the Pops*, a shiver of shark-braving dancers in short rubber wetsuits danced to this disco "Jaws," prompting the host to say, "Fins ain't what they used to be." They are still on YouTube.

"THEME FROM *KING KONG*" BY LOVE UNLIMITED ORCHESTRA, 1976
Put together by Barry White, Love Unlimited Orchestra had a Number 1 hit in 1973 with "Love's Theme," a sexy, gorgeous, and timeless composition written by the R&B giant in the mid-sixties. Three years after the group's chart triumph with that song, they tried to work the same magic on another romance—this one between Jessica Lange and a giant ape—with a disco take on the theme to the Dino De Laurentiis remake of *King Kong*.

It worked well enough. Taken from *Super Movie Themes: Just a Little Bit Different*, an album which also included reworkings of the themes to *Superman, A Summer Place, Shaft*, and *Grease*, "Kong" went to Number 7 on the American dance charts.

Two other versions of the *King Kong* theme—an instrumental by Roger "Mr. Piano" Williams, which featured a chant of "Kong! Kong!" and a disco vocal rendition called "Are You in There?" by Andy Williams—were also released. But it was Love Unlimited Orchestra's track that made audiences really go bananas.

"THEME FROM THE DEEP (DOWN, DEEP INSIDE)" BY DONNA SUMMER, 1977

A year before her "Last Dance" triumph in *Thank God It's Friday*, Donna Summer took the plunge into soundtrack recordings with "Theme from *The Deep* (Down, Deep Inside)." The Peter Yates underwater mystery, based on the book by *Jaws* author Peter Benchley, stars Nick Nolte, Robert Shaw, Louis Gossett Jr., and, quite memorably, Jacqueline Bisset in a wet T-shirt.

Summer cowrote a disco version of the theme with the lauded British composer John Barry who, over his long career, scored eleven James Bond films and won five Academy Awards. Although the Oscars took no notice of Barry's instrumental original, Summer's sped-up disco version of "Down, Deep Inside" was a hit on the dance charts.

A 2014 reissue of the soundtrack to *The Deep* prompted Joe Marchese of the blog *The Second Disc* to praise the track anew. "In Summer's disco version of the haunting, slightly ominous theme, her ethereal, sensual, and coolly detached vocal floats above Barry's evocative orchestration and the pulsating club beat." The soundtrack, which also includes a song called "Disco Calypso," Marchese wrote, is "a work of style, beauty, and high adventure."

"SINGIN' IN THE RAIN" BY SHEILA AND B. DEVOTION, 1977

Gene Kelly sang and splashed through puddles to it in *Singin' in the Rain*, Cary Grant whistled the tune in the shower in *North by Northwest*, Malcolm McDowell sneered it during a horrifying rape in *A Clockwork Orange*. And, over the years, everyone from Sammy Davis Jr. to Leif Garrett to Taco put his own stamp on the world's most famous meteorological melody.

But it took French pop singer Sheila—née Annie Chancel—to turn "Singin' in the Rain," the 1929 Arthur Freed/Nacio Herb Brown standard, into a European dance club hit in 1977. Her version was popular on the continent and marked a new chapter for Sheila, who had first gained fame in sixties France as a so-called "Yé-yé" singer.

Backed by an American trio—sometimes known as Black Devotion—she recorded two disco albums with English lyrics in London. The group lasted three years before folding its umbrella. But Sheila continued to perform, selling millions of records over her long career. In 2019, she sang dressed as a rabbit in a space suit on the French version of *The Masked Singer*.

"GONNA FLY NOW (THEME FROM *ROCKY*)" BY RHYTHM HERITAGE AND CURRENT, 1977

New York Times critic John Rockwell may have described "Gonna Fly Now" as a "classic bit of movie-music pomposity" with "cheesy inspirational appeal," but the theme to *Rocky*, Sylvester Stallone's 1976 paean to pugilism, was popular enough to spawn several hit versions.

Composer Bill Conti went to Number 1 with his original in the months that followed the film's opening. Jazz trumpeter Maynard Ferguson saw his recording climb to Number 30. And, at the same time, not one but two disco groups—Rhythm Heritage and Current—found success with their own dance floor–ready renditions.

Rhythm Heritage previously had charted with their version of the "Theme from S.W.A.T." in 1976, while Current, a session band put together by producer Joe Saraceno, had recorded "Classica's Love Song," a Rachmaninoff melody tarted up with shouts of "Do you wanna?" and "Dance with me!" Both disco versions of "Gonna Fly Now" are bouncy enough to get any would-be Balboa up the many stairs outside the Philadelphia Museum of Art.

"LOVE STORY (WHERE DO I BEGIN)" BY ANDY WILLIAMS, 1979

Best known for singing "Moon River" from *Breakfast at Tiffany's*, Andy Williams first song played at studio 54 tried his hand at movie-theme disco with a 12-inch version of the theme from *Love Story*, the 1970 Ryan O'Neal/Ali MacGraw tearjerker. Williams had released a dramatic rendition of the song in 1971, but his 1979 up-tempo version, produced by Bob Esty, is really something else—all the Sturm und Drang of the original, but you can dance to it!

Unfortunately, by the time of the song's release, critics were gunning for middle-of-the-road artists jumping on the disco bandwagon. "Andy Williams just redid 'Love Story' *a la* disco, and, thankfully, it's not going anywhere," sniped *Seattle Gay News* critic Tom O'Brien. He was right. The almost ten-minute version has been banished to YouTube, where it lives on—unlike poor Jenny Cavilleri in the movie.

"THEME TO 2001 (ALSO SPRACH ZARATHUSTRA)" BY THE DOCTOR EXX BAND, 1979

When it comes to discofied movie themes, Doctor Exx was no Meco Monardo. But his band's funky takes on songs from some of the biggest films of the era made their 1979 album, *Superman and Other Disco Hits*, a dance-floor oddity for the ages.

Liner notes suggested that the group's more than thirty members—not to mention a studio full of synthesizers—made for "get-on-down disco dynamite." The album, they promised, would take listeners on "a non-stop trip from *Superman* groovin' out of sight to spaced-out goodies like *Star Wars* and *2001* themes."

Spaced-out was right. The album also contained a cover of the theme to *Close Encounters of the Third Kind*, and original tracks like "Lois Gets on Down" and "Panic on Planet 'K'," which likely meant Krypton, not Ketamine. The doctor's final orders? "Let's get it on!"

HAIR: DISCO SPECTACULAR BY VARIOUS ARTISTS, 1979

When Milos Forman's big-screen adaptation of the 1968 Galt MacDermot/Gerome Ragni/James Rado rock musical *Hair* hit cinemas in March 1979, reviewers said the film improved on the original stage production.

Critics weren't quite as kind to *Hair: Disco Spectacular*, an album that remade five of film's best songs into dance tracks with vocals by such superstars as Evelyn "Champagne" King, who sang "Aquarius/Let the Sunshine In," and Vicki Sue Robinson, who sang, "Easy to Be Hard." A group called The Brothers sang, "Where Do I Go?"

The album unfortunately didn't go anywhere. But not for lack of promotion.

On May 9, 1979, King presided over a coiffure competition for the most outrageous disco hairstyle at Uncle Sam's, a Long Island, NY, club. A newspaper in Jackson, Mississippi—hey, this contest was *national* news!—called her a "singing, swinging disco judge." Music Warehouse, a chain of record stores, sponsored the event with a grand prize of $500. At that week's sale price of $3.99 a disc, that was a lot of *Hair*.

"ALIEN" BY NOSTROMO, 1979

British musician and producer Kenny Denton put together a studio band to create a dance version of the theme from *Alien* and called the group Nostromo, after the spaceship in the Ridley Scott sci-fi thriller. Their highly synthesized rendition got some radio play and a few decent reviews, but the record didn't sell.

That didn't stop Denton. He later launched space-disco versions of the theme from *The Black Hole* and the "The Imperial March (Darth Vader's Theme)" from *The Empire Strikes Back*, which honestly sounds like it's played on a video slot machine.

While Nostromo was soon recording no mo', Denton continued to work in the music business. On his website in 2022, he shared his experiences discofying *Alien*. "Although the single never made the charts, over the years it has become somewhat of a cult record," he wrote in an entry headlined, "In Space, No One Can Make You Dance." A compilation called "The Complete Nostromo Collection," including two versions of the *Alien* theme, is available for download on iTunes.

"THE (DISCO) SOUND OF MUSIC" BY SHOW-STOPPERS '81, 1981

An English release, this disco medley of songs from the movie version of Rodgers and Hammerstein's Broadway classic *The Sound of Music* mixes the title tune with "My Favorite Things," "Sixteen Going on Seventeen," and after a long sax-filled dance break, "Edelweiss," "Do-Re-Mi," "Something Good," and "Climb Ev'ry Mountain."

One British newspaper noted, "The female singer on this could pass very well as Julie Andrews—she sounds remarkably like her." But many believe that singer is Sarah Brightman, who'd recorded several disco records before finding fame as the star of *Phantom of the Opera*, and, for six years, as Mrs. Andrew Lloyd Webber.

Felipe Rose and David Hodo

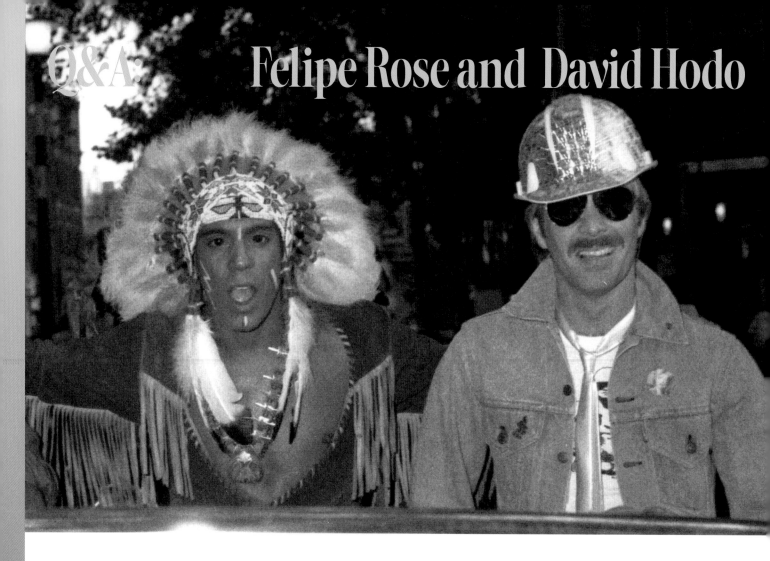

One was the Native American. The other, the Construction Worker. And, with all due respect to that cowboy fellow, the late great leather dude, the military man, and both cops, they were always the most eye-catching and popular members of Village People.

They are Felipe Rose and David Hodo, and beginning in 1977, they helped transform archetypes of gay masculinity into a singing sensation with whom the whole world fell in love.

From their casting-call origins to the band's camp-tastic 1980 big-screen musical, *Can't Stop the Music*, Village People were a multimedia international phenomenon. With producer-songwriter Jacques Morali as their Svengali, they sold more than a hundred million records.

Today, Village People have such enduring, multigenerational appeal that even the Minions have impersonated them. Here, original bandmembers Rose and Hodo reminisce about their days together, and how it feels, all these years later, to have one of their biggest hits officially deemed "culturally, historically, or aesthetically significant" by the Library of Congress.

FDC: "What are your earliest memories of the band coming together?"

FR: "Jacques was doing all the casting. Except for Victor Willis and me, the first album was basically done with models. Once that album was released, we immediately got a show, and honestly it was a trainwreck. Jacques said, 'We have got to get rid of all the others.'

"Victor met Alex Briley at a recording session and invited him to come in. Then, we started to audition professional singers in San Francisco, Los Angeles, and New York. When Randy Jones walked in, he took his cowboy hat off, threw his hair back, said 'Howdy, y'all,' and it was like, 'OK, he's the cowboy.' Then Glenn Hughes walked in with that mustache, and we knew he had to be the biker. He was a Brooklyn Battery Tunnel toll collector and he drove his motorcycle to the audition, and he came in and sang 'Danny Boy.'"

FDC: "David, how did you find your way into the band?"

DH: "I was working on what was supposed to be my third Broadway musical. It was a rollicking, tapdancing tearjerker of a show about the Grand Ole Opry called *The Red Blue-Grass Western Flyer Show*. But it closed out of town.

"I had filed for unemployment, but I wasn't getting any checks because I needed one more week of work to qualify. I grabbed a copy of *Show Business* and saw this ad that said, 'Men wanted for disco group.' They were casting for a construction worker, and I figured, perfect.

"I felt like I was stooping so low to be calling about this job. I told my three roommates, 'I just had this really tacky audition.' That night, Jacques called and said, 'Allo, David, you got ze job. You are part of the family.' I hung up and told my roommates, 'Remember that awful thing I auditioned for today? I got it.' The first thing we did was record 'Macho Man.' I went home to my roommates again and said, 'I've just recorded the most stupid song you've ever heard.'

FDC: "How long did it take for Village People to become popular?"

FR: "The first album was released during the backlash against the Anita Bryant Save Our Children campaign. That June, it became the musical backdrop to everyone coming out of the closet. So we quickly went back into the recording studio to do the *Macho Man* album."

DH:: "It just became this five-ring circus onstage, and we were an immediate hit with audiences. We were never anything less than a triumph."

FDC: "What kind of places were you playing at first?"

DH: "They put us on this bus and traveled us all over the East Coast. We had some of the strangest experiences. Retirement-age strippers with cellulite and bruises on their backs were walking around on the bar while we were performing. The first real disco we played at was Hurrah's. That's where we had our first big coming out performance. The audience stood there dumbfounded. We also did a performance at 2001 Odyssey in Brooklyn. They all looked like John Travolta and Farrah Fawcett, with the gold chains and the winged hair. At first, it was like wind blowing wheat, like, 'What the fuck?' But they ended up loving us. Then we literally performed our way across the United States."

FDC: "Village People quickly became very popular guests on television."

DH: "When we got to LA, they were shooting a special to hype the movie *Thank God It's Friday.* We just sort of walked in off the bus and they filmed us doing 'San Francisco' and 'In Hollywood.' No one had ever seen a group like this in their lives. Right after that, we did Merv Griffin. He was very good to us. Once people saw us on television, it was like, 'Oh, we get it now.' But our producers never knew when to stop. It was always more, more, more, until you could see us on television twice a week."

FR: "We did a lot of shows, so many I can't even recall. The best was *The Love Boat* because it was with Betty White. We would meet her in the commissary. Our lunch hours got longer and longer because Betty was such a stitch. You didn't know what the hell she was going to say."

FDC: "Was there a downside to Village People's meteoric rise?"

DH: "It looked glamorous to everybody, but it was anything but glamorous. We were being worked to death. They just got the most out of us that they could. I never worked as hard as I did then, constantly changing time zones and filling yourself up with espresso to wake up. I thought, 'Is this what it means to be a superstar?' But we had to strike while the iron was hot. We had wonderful highs and some lows. It was definitely a life of extremes."

FDC: "What was the highest moment?"

FR: "I would say playing Madison Square Garden. We played three sold-out nights. It was amazing. We could see replicas of ourselves in the crowd. You'd have all the leather guys in the first five rows rooting for Glenn. There were even kids in the audience dressed like us with their mothers and fathers. I remember thinking, 'Do these parents know that all the men in their row are homosexuals?' But it didn't matter to them."

DH: "Nobody seemed to care. We were giving a different view of what gay people were and, at the time, we were a little scandalous. We'd pull our shirts open, but we never had a negative reaction from the audience."

FDC: "How did the Village People movie *Can't Stop the Music* come about?"

FR: "Allan Carr sauntered in that summer while we were doing the big national tour, and suddenly we were doing a motion picture. They brought the script backstage to the dressing rooms. It was originally called *Discoland: Where the Music Never Ends.*"

DH: "The morning after Madison Square Garden, I got a mug of coffee and sat down with the script. I thought it was dreadful. About sixteen pages into it, I threw it across the room."

FR: "I had to duck!"

DH: "Nancy Walker was supposed to be the director, but she didn't know what she was doing. She made a good show of walking around with a clipboard. But the cameraman, Bill Butler, and the choreographer, Arlene Phillips, were *really* the directors. Tammy Grimes and June Havoc and Barbara Rush were all a joy to work with, though. And, when they gave us those white costumes for the 'Milkshake' number, well, Theoni V. Aldredge was designing that shit. She did *A Chorus Line,* and she was top of the line. We put those things on, and they felt like Ken doll clothes."

FDC: "The reviews for the film were—how do I put it delicately?—not very good."

DH: "Critics went after our movie like they were reviewing Tennessee Williams. Rona Barrett came to the opening at the Ziegfeld. She was telling the producers, 'Oh, I just love it!' and then on her show, she just did a complete 180 on us. Rex Reed said the movie was so bad you had to see it twice. I always thought he hit the nail on the head with that one. Of course, the next day there was a double-page ad that just said, 'You have to see it twice!'"

FDC: "Although the band was built on gay archetypes, you didn't explicitly acknowledge the queer nature of the act. Did gay fans give you flack for that?"

FR: "The gay community fell in and out of love with the group from album to album. And activists let me have it. But what was I supposed to do on the Merv Griffin show? We were selling music. I wasn't selling my private life. Back then, we didn't discuss our private lives *with each other*. We were all just very professional with each other. But we did have a blast. We laughed at everything."

FDC: "Who was most colorful personality you ever hung out with?"

FR: "Oh, Grace Jones, by far. She was such a hoot to be with. We worked with her at Le Jardin, Studio 54, Xenon. We flew back from Paris with her one time, and she got bored. She walked down the aisle to the back of the plane. She said, 'Come with me. Let's do something naughty, darling.' She was flipping people's newspapers and spilling drinks, pretending she was bumping into people. Grace was so much fun."

DH: "We had a ball with Joan Collins once, and Cher was quite a lot of fun. She's a good old gal. When we were touring with her, she was just wonderful."

FDC: "How did you feel about the makeover the band got for the 1981 album *Renaissance*?"

DH: "I still say that *Renaissance* had some of the best music we ever did and some of the worst. I was embarrassed by 'Food Fight.' There was a song about Big Macs, a song called 'Diet.' But there was also 'Five O'clock in the Morning.' We never could get a damn hit in Italy to save our lives. Then, we released this flop album and, don't you know, 'Five O'clock in the Morning' becomes a huge hit there. Every time we went, we'd have to perform it."

FDC: "Looking back, what is your take on the whole disco backlash?"

DH: "We always had to deal with people who'd give us the cold shoulder because we were a disco act. Somehow our success was a threat to them. We just had to learn to deal with it."

FR: "Disco was our bread-and-butter, but then it became no good in the United States. That was a hard drink to swallow. Thank God we had an international following so we were able to stay in Europe for a few years and travel the world while they said disco was dead. I said no to that funeral because disco was alive in every other part of the world."

FDC: "Thankfully, disco has ended up having the last laugh. What was it like to see 'Y.M.C.A' inducted into the National Recording Registry at the Library of Congress in 2020?"

FR: "It was really very sweet. I got the official letter. I thought, oh, wow, this is amazing."

DH: "We really made an impression with 'Y.M.C.A.' There isn't a sports event now where they don't play that. People do the arm movements. We didn't even come up with that, it was the kids on *American Bandstand.* Seeing two hundred thousand arms go up in the air is just a triumph for us."

FR: "These days, I like to say that disco is having its rock 'n' roll moment. Everybody twenty or thirty years younger than us is discovering disco and finding that it was just happy music. I still love the joy I give people."

DH: "I'm very proud to have been one of the Village People."

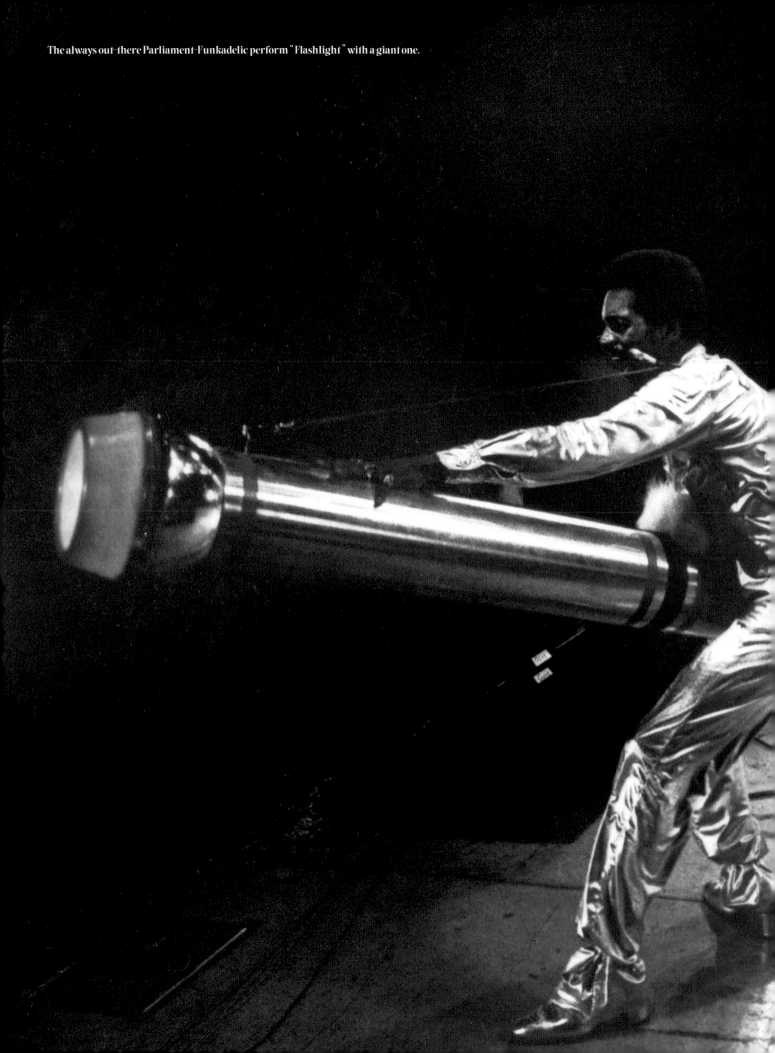

The always out-there Parliament-Funkadelic perform "Flashlight" with a giant one.

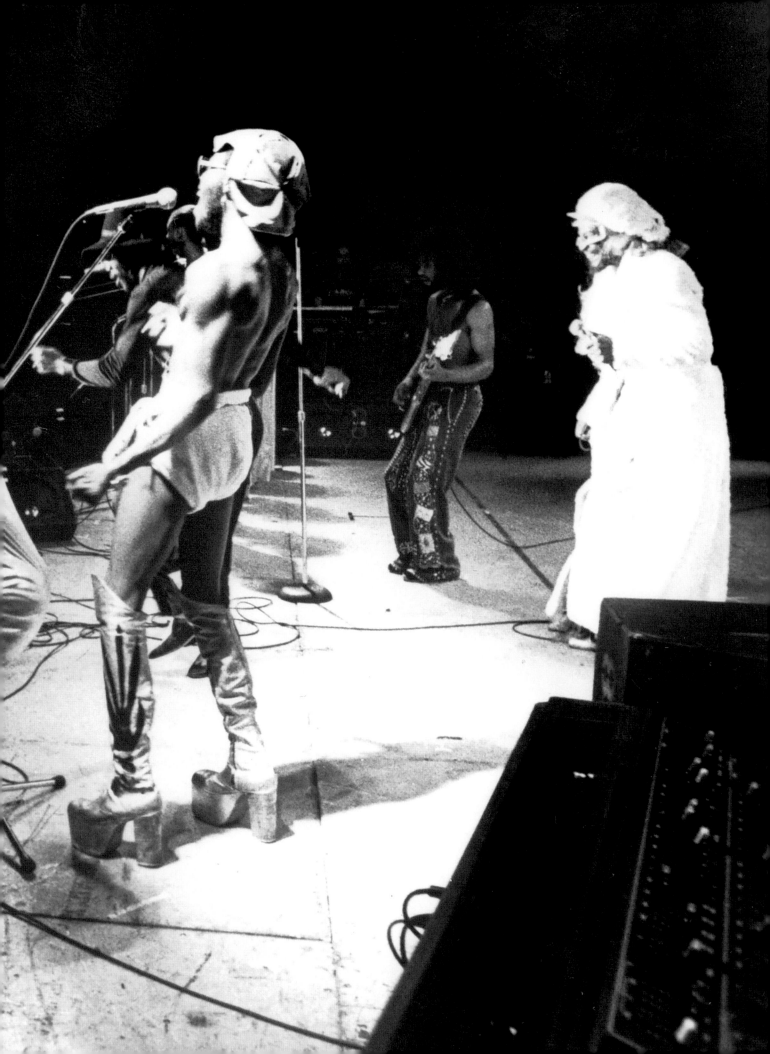

Must-Hear Disco Playlist:

"AIN'T GONNA BUMP NO MORE (WITH NO BIG FAT WOMAN)" by Joe Tex

"BABY, DON'T CHANGE YOUR MIND" by Gladys Knight and the Pips

"BEST OF MY LOVE" by The Emotions, 1977

"BRICK HOUSE" by Commodores, 1977

"DANCE, DANCE, DANCE (YOWSAH, YOWSAH, YOWSAH)" by Chic

"DEVIL'S GUN" by C.J. & Co.

"DISCO LUCY" by Wilton Place Street Band

"DISCO WEEKEND" by Miam

"DO WHAT YOU WANNA DO" by T-Connection

"DOCTOR LOVE" by First Choice

"DON'T MAKE ME WAIT" by Pattie Brooks

"EVERYBODY DANCE" by Chic

"FLASH LIGHT" by Parliament

"FROM EAST TO WEST" by Voyage

"FROM NEW YORK TO L.A." by Patsy Gallant

"GOT TO GIVE IT UP" by Marvin Gaye

"HAVEN'T STOPPED DANCING YET" by Gonzalez

"I FEEL LOVE" by Donna Summer

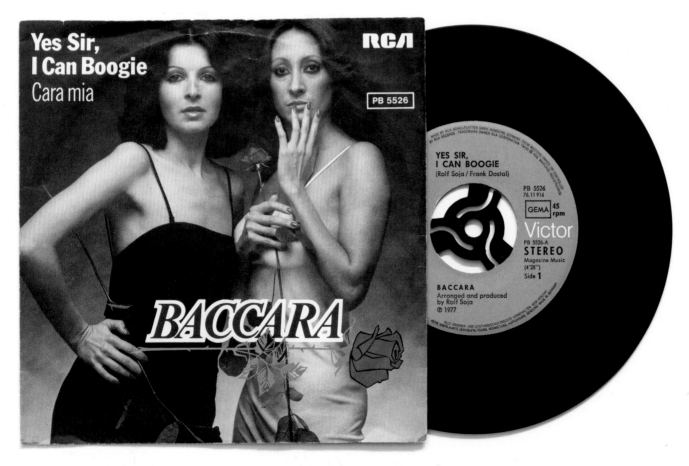

BACCARA'S BIGGEST HIT SINGLE, "YES SIR, I CAN BOOGIE."

1977

"I FOUND LOVE (NOW THAT I'VE FOUND YOU)" by Love & Kisses

"I WAS BORN THIS WAY" by Carl Bean

"IF I CAN'T HAVE YOU" by Yvonne Elliman

"LA VIE EN ROSE" by Grace Jones

"LET NO MAN PUT ASUNDER" by First Choice

"LOVE IS IN THE AIR" by John Paul Young

"LOVIN' IS REALLY MY GAME" by Brainstorm

"MANHATTAN SKYLINE" by David Shire

"NATIVE NEW YORKER" by Odyssey

"NIGHT FEVER" by the Bee Gees

"QUIET VILLAGE" by the Ritchie Family

"SAN FRANCISCO (YOU'VE GOT ME)" by Village People

"SHAME" by Evelyn "Champagne" King

"STAYIN' ALIVE" by the Bee Gees

"STRAWBERRY LETTER 23" by the Brothers Johnson

"SUPERNATURE" by Cerrone

"TEN PERCENT" by Double Exposure

"YES SIR, I CAN BOOGIE" by Baccara

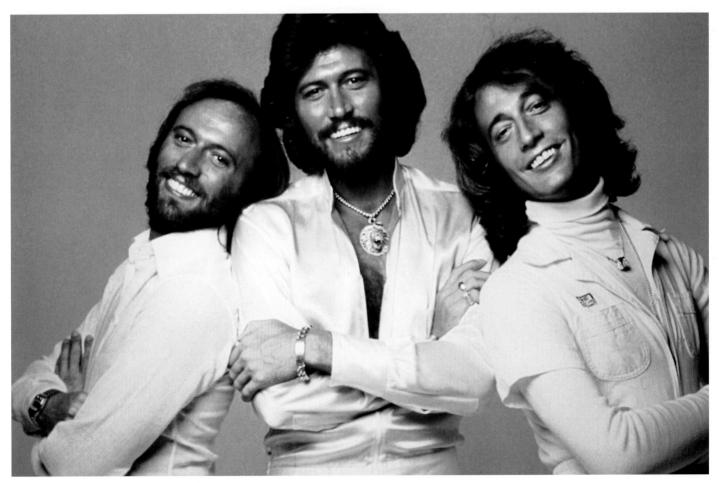

THE BEE GEES AT THE HEIGHT OF THEIR DISCO-ERA FAME.

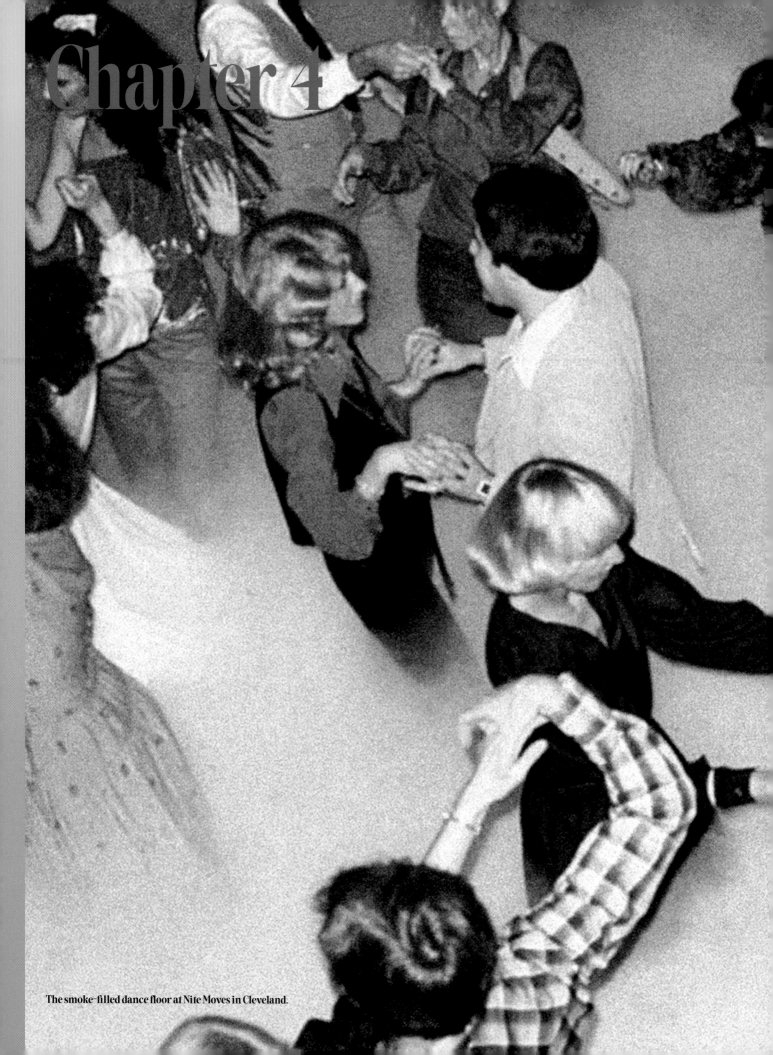

Chapter 4

The smoke-filled dance floor at Nite Moves in Cleveland.

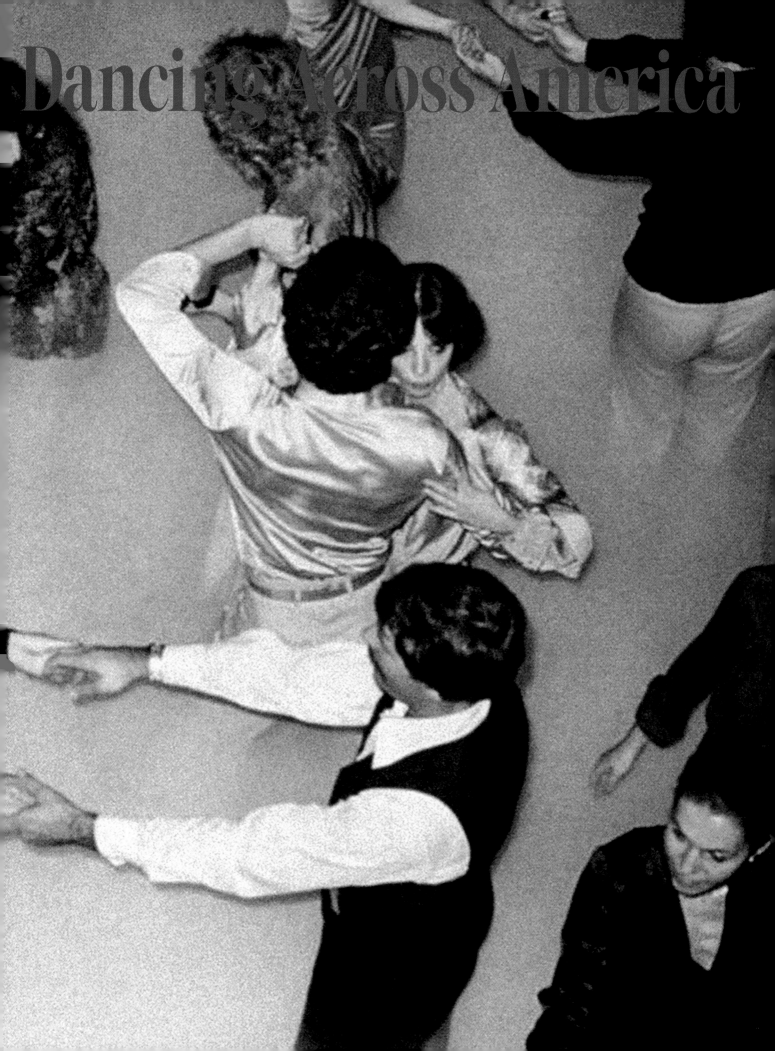

IT'S THE BEST DISCO IN TOWN, BUMP AND BOOGIE ALL AROUND...

—the Ritchie Family

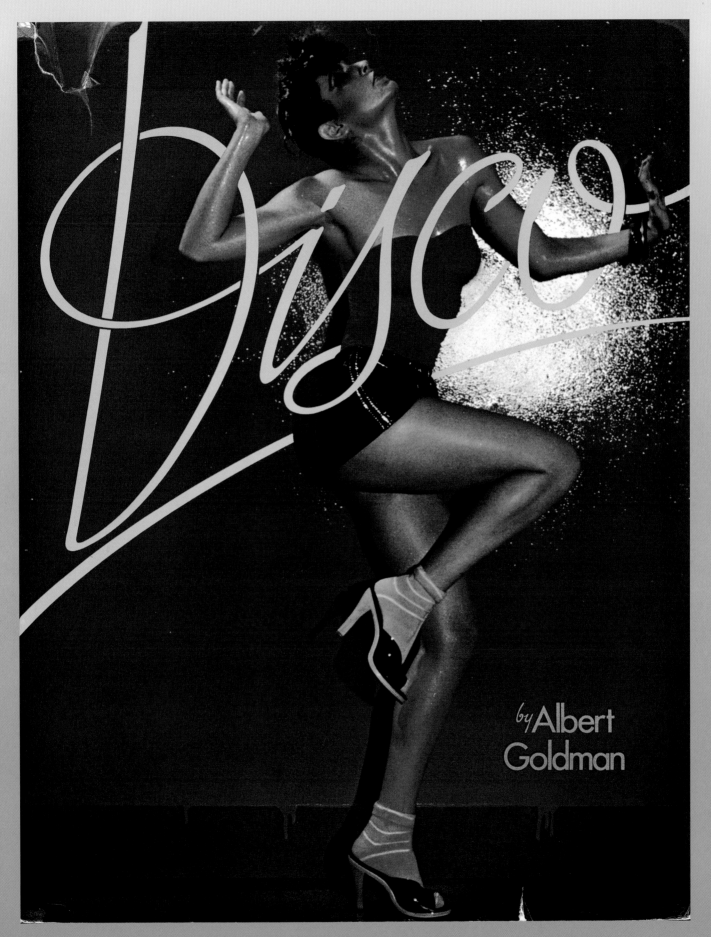

Albert Goldman's landmark book *Disco*, a real-time chronicle of the phenomenon.

By the late seventies, Americans of every gender, race, and orientation, were yearning to Hustle, realizing that if they didn't step up and step out, they'd be left behind by a culture that had gone full-tilt boogie for disco.

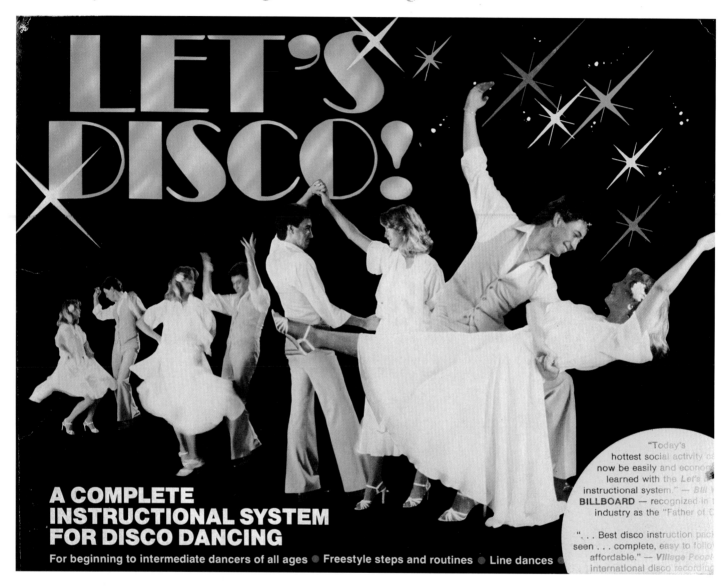

LET'S DISCO!

A COMPLETE INSTRUCTIONAL SYSTEM FOR DISCO DANCING

For beginning to intermediate dancers of all ages ● Freestyle steps and routines ● Line dances ●

"Today's hottest social activity can now be easily and economi... learned with the Let's ... instructional system." — Bill ... BILLBOARD — recognized in ... industry as the "Father of D...

". . . Best disco instruction pac... seen . . . complete, easy to follo... affordable." — Village Peopl... international disco recording...

"Like a tidal wave, disco has swept the country, carrying with it people of all ages who are eager to take part in the mystique, the fun, and the excitement of disco dancing" as Bruce Pollack wrote in the introduction to his 1978 guidebook *Let's Disco!*.

Billboard called dancing "today's hottest social activity" and it was true. In the wake of *Saturday Night Fever*'s smashing success—and the record-setting sales of the Bee Gees soundtrack that went with it—everyone either wanted to be Tony Manero, or at least dance like him. As Sam Kashner wrote in *Vanity Fair*, "What Brando and James Dean had been to the 1950s, Travolta was to the 1970s." The film brought disco to the masses.

"Last year, no less than thirty-seven million Americans got out on the disco floor at least once," pop culture chronicler Albert Goldman reported in the November 1978 issue of *Life* magazine. Meanwhile, a *Newsweek* story headlined "Disco Takes Over" and featuring Donna Summer on the cover noted that an estimated twenty thousand discos had opened by the spring of 1979.

"There are disco proms, disco cruises, and disco roller-skating rinks," *Newsweek*

wrote. There were disco wedding services "complete with smoke machine and light effects" and pop-up discos in shopping malls and motel ballrooms. Dubbing the trend "Thumpus Uninteruptus," the magazine also reported that nearly two hundred radio stations across the country had switched to an all-disco format, bringing dance music into American cars and homes.

"Denver all of a sudden has two disco stations," Issy Sanchez, the head of disco promotion at Atlantic Records, told *Circus Weekly*—a self-described "Rock & Roll Magazine"—in June 1979. "Wichita, Kansas—how's that one? Minnesota's comin' very, very strong . . . Seattle . . . Wisconsin . . . Arkansas . . ." he enthused.

One radio outfit in particular, New York City's WKTU, switched from mellow rock to dance music and, in four months, became the most-listened-to station in the nation. Disco 92, as it was called, made stars of such sultry-voiced DJs as Paco Navarro and William "Rosko" Mercer. Both of those men were so beloved by New Yorkers that when they passed, decades later, they were eulogized in the *New York Times*.

"I loved the music. It was great," Dan Ingram, a WABC DJ in the seventies, told the *New York Post* in 2007. "It was nine minutes of something, and you could go to the

bathroom before you had to play the next record." Fellow DJ Al Bandiero, who became famous on WKTU, added, "A lot of people felt there was no substance to the music, but it was never meant to have substance. Disco music was all about having a good time. It wasn't about changing the world." (Even if it did end up doing just that.)

By the late seventies, disco had become a multibillion-dollar industry with its glittering tentacles extending to every corner of the entertainment business. "Just like sock hops in malt shops in the fifties, folk music in the protest marches of the sixties, superstar rock in the concert halls of the (early) seventies, disco has become more than just music," wrote Pollack. "For all those whose hearts pound to a disco beat, it is an identity, an image, a crowd, and a scene in one package—the ultimate fantasy fun experience."

Of course, most folks would never get to experience the ultimate fun of Studio 54. Even if they flew to New York, they'd likely not get past the door. But that didn't mean they didn't seek out the total exhilaration of disco in their hometowns. "Clubs that had been dives were installing light-up dance floors," remembers pop culture critic Roger Catlin. "They had dance contests and brought in dance instructors. Disco was well accepted, even in the Midwest."

As the New York nightlife chronicler Michael Musto put it, "In a cultural landscape that also included ditzy sitcoms and escapist disaster films, disco gave the masses a chance to mindlessly indulge in flash, showing-off, and carrying-on, with not a second's thought wasted on dumb old yesterday, or silly old tomorrow."

Nite Moves, the so-called "Studio 54 of Cleveland," for instance, opened in the summer of 1978 in the former Alpine Village, a nightclub dating to the early thirties. The original proprietor had been known to wear Bavarian leather shorts and a Tyrolean hat when greeting customers. But at Nite Moves, the mountains of "snow" were of a different variety than those at Alpine Village. People would snort coke off a glass-topped backgammon table in a sunken area called "The Pit," the club's owner Robert Hammer remembered in 2018 on Cleveland.com. Above them was $90,000 worth of brand-new neon lighting.

"The club had everything: four disco balls, fog machines, fish tanks, a three-level dance floor, a raised see-through stage, and sleek futuristic art deco design," according to a fortieth anniversary tribute to Nite Moves in 2018. The atmosphere was modern and so was the attitude of the place. If you were going to dance at Nite Moves, you had to be open-minded.

Printed invitations to the disco's first Halloween party told prospective attendees to expect anything and everything and to be cool with that. "Kindly appreciate," the fliers read, "you will be rubbing shoulders with a cross section of dancers, designers, would-be rock stars and rock stars, motion picture producers, publishing magnates, all kinds of ladies and gentlemen, angry husbands, bold, anxious, and itchy long-legged women, pompous snobs, faggotry, tricksters, fat people and unique trash—and an array of every sort of variation of love, anxiety, perversion, diversions, deviations, and fantasy of your thoughts that you could ever have imagined existed at one time in one place ever before!"

For some, that wasn't just Halloween hyperbole, it was hope.

Discos like Nite Moves "provided a kind of glamour that many towns didn't otherwise have," says Owen Keehnen, author of *Dugan's Bistro and the Legend of the Bearded Lady*. "They were flashy and fun and offered a sense of escapism, especially for gay people. For someone in the Midwest, going out to a disco and having a good time provided a real sense of relief. Disco was the antidote to a lot of shit you had to take."

Dugan's Bistro was most definitely a gay bar, and while not nearly as flashy as Nite Moves or Studio One in Los Angeles, it became Chicago's answer to Studio 54. There were far more fabulous spaces, architecturally speaking, but that didn't matter. "The Bistro didn't have the high ceilings of Studio 54. It didn't have the every-night celebrities. It didn't have the press there constantly," Keehnen admits.

What it did have, though, was a fabulous clientele—the Bearded Lady of his book title was not alone in her antics—and an electric feeling of unpredictability in the air. Although not often, national celebrities like Bette Midler, Diana Ross, John Waters, and, yes, Andy Warhol, did check out the scene there while visiting the Windy City. Nite Moves could boast only Mike Connors of *Mannix* fame.

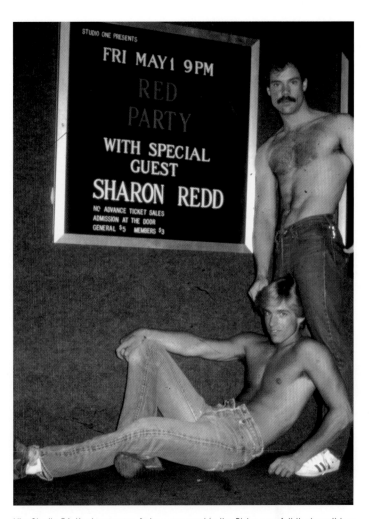

Let's Disco! teaches readers how to Hustle and more, left.

Michael Koth and friend outside Studio One in West Hollywood, California, below.

Like Studio 54, Keehnen says, "when you went to the Bistro, you felt that anything might happen any night of the week. That was the huge pull. You didn't want to *not* be at the Bistro the night something happened. It was a way to embrace outrageousness and shake up the humdrum, and it was a place to be yourself."

The best discos allowed for free expression. They were places to see and be seen, to have a few drinks, maybe indulge in recreational drugs, meet new people of every stripe, possibly hook up, and, most definitely, dance the night away. Not everyone there was living a fast life, of course. Some couples wanted to just do the Bump, as in the dance, not do bumps of cocaine. Rum and Coke was plenty for many. But in the sexually liberated seventies, everyone wanted to come together and share in the disco fantasy.

"People are out for social contact," a central New Jersey disco owner named Bob De Santis told the *Courier-News* of Bridgewater in 1978. "It's the boy-meets-girl thing. That's what our business is all about. They're tired of movies and television. For five or six dollars, they can buy better entertainment if they go out dancing."

On the dance floor, they expressed themselves doing partner dances like the Disco Meringue and the Latin Hustle, both descendants of swing crazes like the Jitterbug and the Fox Trot. "We keep going back to the thirties, forties, and fifties," De Santis said. Line dances like the Bus Stop—a forerunner of the Electric Slide—became the rage (and a wedding reception staple), while solo freestyle moves appealed to those who just wanted to do their own thing.

"People danced to match their personalities," remembers Deney Terrio, who hosted the legendary TV disco competition Dance Fever beginning in 1979. "It was so much fun because everybody was attuned to the mood and the music."

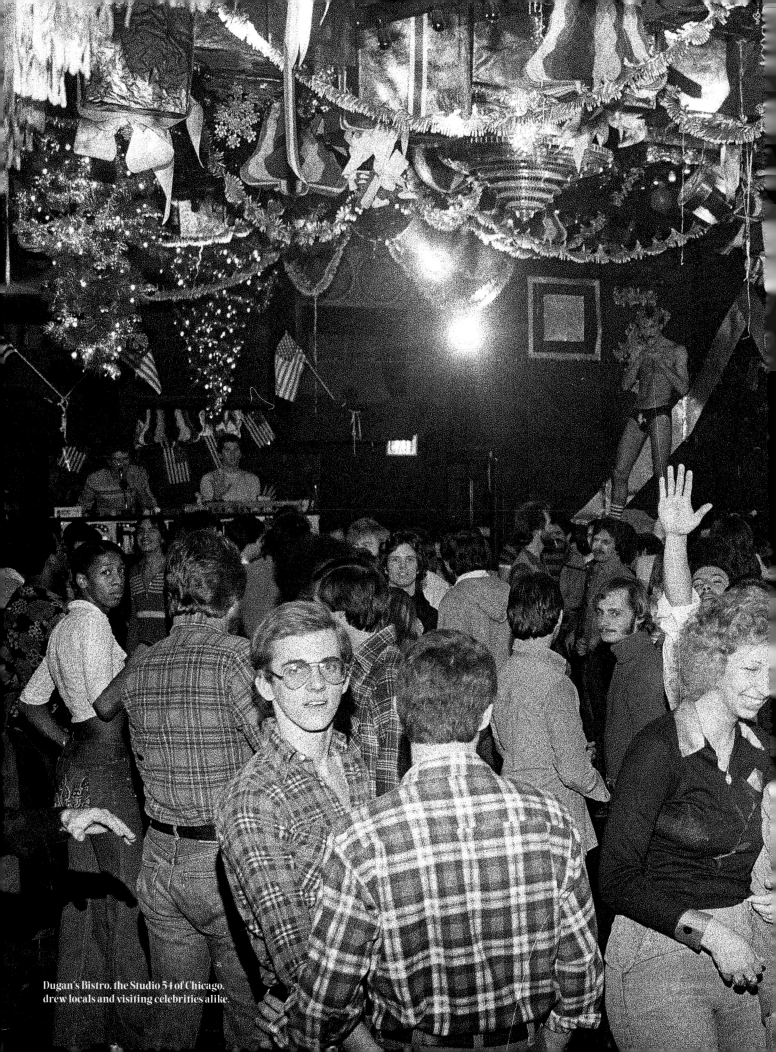

Dugan's Bistro, the Studio 54 of Chicago, drew locals and visiting celebrities alike.

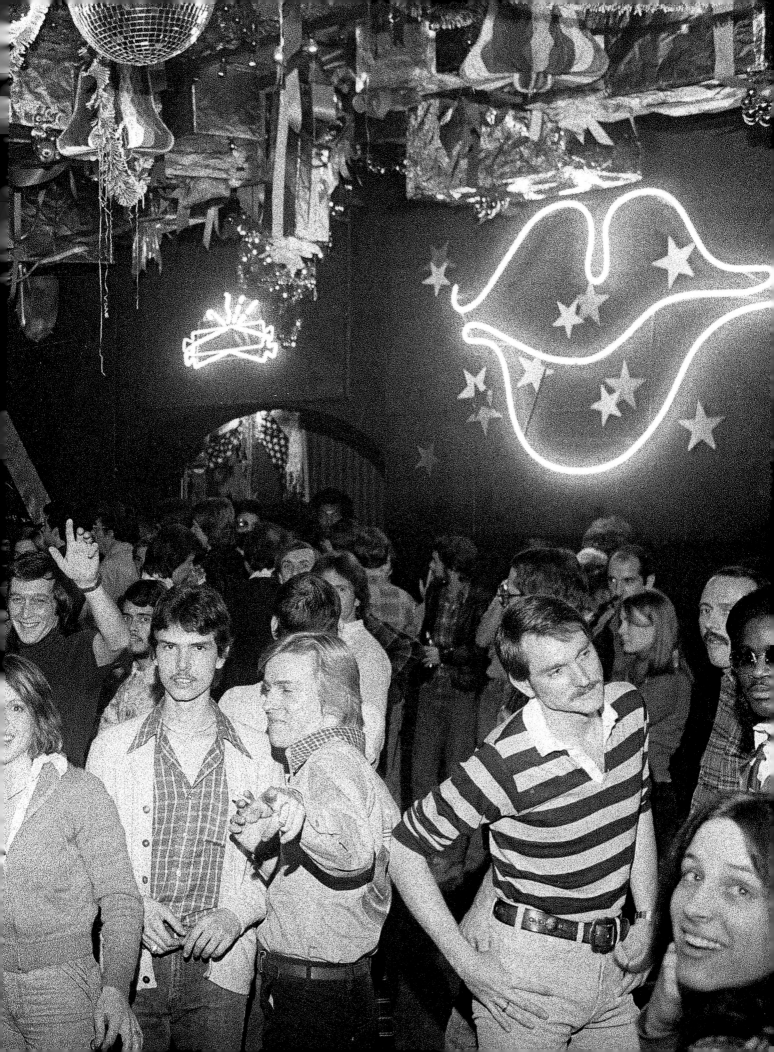

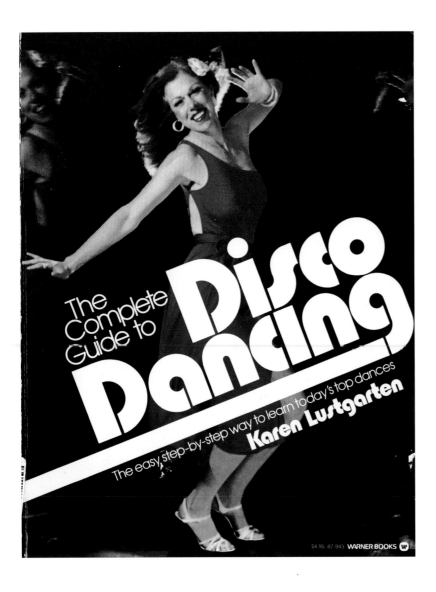

Neophyte Fred-and-Gingers were so in tune to the disco mood that they were willing to "take the time" and "do it right," to quote the S.O.S. Band song, and take dance lessons. Whether at a branch of the Fred Astaire Dance Studio or at a local community center, couples flocked to disco classes for fun and because it was a way to spice up their lives, on and off the dance floor. As Terrio puts it, "Back then, dancing was foreplay." Apparently, when Musique sang the words, "push, push, in the bush," they weren't talking about foliage.

Singles bars and other local establishments, like Gatsby's Nitery in Cedar Rapids, Iowa, and Todaro's Party Center in Akron, Ohio, seduced customers by bringing in teachers from Arthur Murray, the famed dance studio, and a bastion of ballroom dancing. Step-by-step Murray guides were tucked into *Discopedia Vol. 1* and *Vol. 2*, two soundalike greatest-dance-hits albums from a cover band called Mirror Image. Those who did take the full Arthur Murray dance course might shell out almost $1,500 for a year's worth of in-person lessons.

Numerous how-to disco books were published to reach those who couldn't afford such prices. For a paltry five bucks, K-tel International's *Let's Disco!* paperback— put together with the help of the In-Step School of Dance in Minneapolis—offered "a complete instructional system for disco dancing." Karen Lustgarten, touted as "the most exciting and accomplished pioneer of disco dancing on the West Coast," created *The Complete Guide to Disco Dancing*, in which she taught readers the "peek-a-boo turn," the "waist cross," and "the rope."

As Pollack wrote in *The Disco Handbook*, "Have pity on those who cannot dance, for they are doomed to never experience the full impact of the disco."

Los Angeles had Osko's on La Cienega Boulevard, which Hollywood nostalgia expert Alison Martino remembers as "the holy grail of disco clubs in Los Angeles."

The 30,000-square-foot nightspot, with an egg-shaped DJ booth and an elevator operated by a man in a gorilla suit, was as close to a New York—style disco as could be found in the city. As one observer put it, Osko's was "a veritable Studio 54 West."

Both *Thank God It's Friday* and the low-budget horror film *Jennifer* were filmed there, as were any number of seventies cop shows. The cover of the 1979 album *Disco Nights* by G.Q., too, was shot outside. Although the space-age building was razed in the early nineties to make way for Loehmann's, its memory lives on.

Others in LA remember most fondly Studio One, which opened in 1974, on La Peer in West Hollywood. "It was one of those places that a lot of people went to," says designer Bob Mackie. "Everybody who came to LA would go there and stand in line to get in. We did the *Carol Burnett Show* Christmas party there one year, too." Shirtless gay men filled the dance floor, while at the adjoining performance venue, known as the Backlot, such disco acts as Sylvester, Divine, and Village People played before star-studded mixed crowds.

"They had a little nightclub in the back where people like Joan Rivers and Bernadette Peters would do their acts and test new material, and then we'd all go dance. That was always fun," Mackie remembers. Other A-list performers—Liza Minnelli, Chita Rivera, Eartha Kitt, and Wayland and Madame—performed there, too.

It was a place to dance and to people watch, but a documentary called *Studio One Forever* suggests that the disco meant a lot more than boogying and stargazing to the queer community. "Climbing the staircase and entering the hallowed hall gave its young LGBTQ patrons a sense of freedom and acceptance during a time of rampant homophobia and police harassment," the film's promotional material

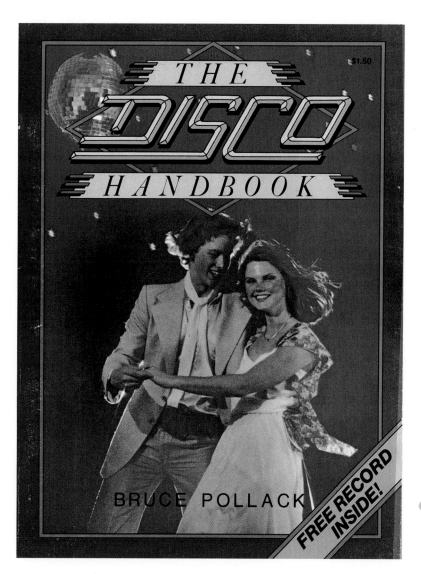

notes. Studio One remained open until 1994. At a 2019 benefit there called "Back to the Backlot," classic diva Freda Payne sang, and remembered what it was like forty years earlier.

In August of 1979, gossip doyenne Rona Barrett reported that disco fever "just won't go away" in a cover story of her magazine *Rona Barrett's Hollywood*. "It seems that the disco phenomenon knows no bounds," she wrote, predicting that "disco roller skating is just beginning to happen." ABC News reported that sales of skates were up 50 percent over 1978, thanks to the advent of smooth polyurethane wheels, and the number of rinks in America had tripled by then, most new ones tricked out with amazing sound and light systems. "Cher," Barrett dished, "has become one of the budding movement's main aficionadas."

"I used to go disco roller skating every week with Cher in Reseda," remembers actor Wesley Eure, best known as the star of the Saturday morning adventure series *Land of the Lost*. She would rent out the Sherman Square Roller Rink and pack the place with famous friends. "It was by invitation only. We would all have little skimpy shorts on, and every celebrity you can imagine was there." Among the glitterati-on-wheels were Desi Arnaz Jr., Jeff Bridges, Jack Nicholson, and Ringo Starr. "It was disco time and roller skating was the thing."

"I used to roller skate when I was little and I wanted to do it again," says Cher. "I rented a place in Reseda and, all of a sudden, people just started coming by word of mouth. It became a hot ticket, and it was good."

Truly such clubs as the Empire Roller-disco in Brooklyn, New York, and Flipper's Roller Boogie Palace in West Hollywood, California, were drawing enormous crowds in those days. "It was an awesome, awesome spot," Nile Rodgers, the founder of

Chic, said of Flipper's. "I used to skate down from Sunset on La Cienega," he told the *New York Times* in 2021. "Clams on the half shell and roller skates," indeed.

In 1978, twenty-eight million Americans visited skating rinks. "The skating phenomenon is so widespread that calling it a mere fad is to underestimate it," the *Times* noted, adding that a Gallup poll ranked roller skating as the fifth most popular participation sport among teenagers. By the fall of 1979, there were two disco-on-wheels movies, *Skatetown U.S.A.* and *Roller Boogie*, in theaters, hoping to goose those figures even more, and perhaps do for roller-disco what *Saturday Night Fever* had done for dancing. *Xanadu* would roll onto screens in 1980.

Meanwhile, in the Netherlands, a group called Dolly Dots was singing—in English— "it looks just like a disco but it's more than a disco" in a musical ode to the trend, "(They Are) Rollerskating." Back home, Cher was gliding her way not only through the San Fernando Valley but also through the video for her song "Hell on Wheels."

Although the album on which that infectious Cher song appeared, 1979's *Prisoner*, didn't sell many copies, few believed that disco—on or off skates—was a passing fancy. "Every disco convention, every disc jockey gathering, every indication tells us disco is here to stay," John Lombardi, the owner of a Florida teen disco called Warehouse West, told the *Fort Lauderdale Sun-Sentinel* in 1978. It was too big, too beloved, too entrenched in popular culture to disappear. For a while, everybody wanted to boogie.

From left, Karen Lustgarten's *The Complete Guide to Disco Dancing*. A magazine ad for feminine hygiene on the dance floor. Bruce Pollack's *The Disco Handbook* came with its own record.

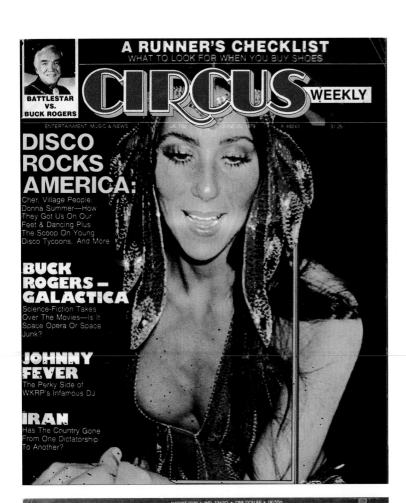

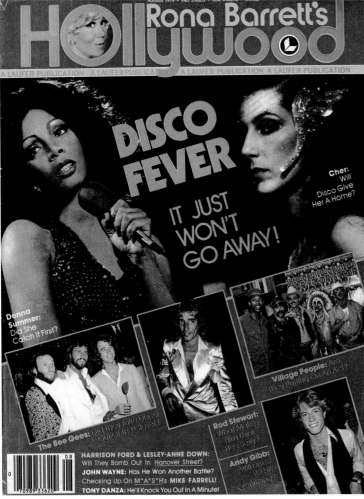

Cher on the cover of *Circus,* top.

Donna Summer on the gossip mag *Rona Barrett's Hollywood.*

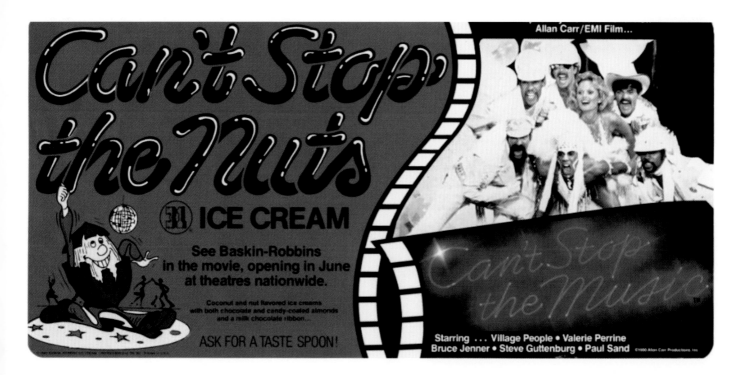

Disco for Kids

Some called "Disco Duck" the first nail in disco's coffin. But for many kids, the 1976 novelty song was their disco initiation.

Put on wax by radio DJ Rick Dees and His Cast of Idiots, the record became a Number 1 pop sensation, bolstered by Dees's appearances on such popular shows as *American Bandstand, The Midnight Special*, and *The Brady Bunch Variety Hour*. Whether fowl or just plain foul, the feathered earworm opened the floodgates for disco music and merchandise aimed directly at children.

In 1978, Robin Gibb teamed with the Muppets to record *Sesame Street Fever*, for instance. The album cover parodied his band's mega-hit *Saturday Night Fever* soundtrack with a white-suited Grover standing in for John Travolta, and Ernie, Bert, and Cookie Monster subbing for the Bee Gees. "We expect the children in our audience will enjoy having a disco album of their own," Sesame Street Records president Arthur Shimkin said at the time.

Selling 750,000 copies, the funky platter gave the world "Doin' the Pigeon," "Trash," a dance remix of "Rubber Duckie," and the title track which included Count Von Count "counting in disco." It was certified gold. *Sesame Street Fever* was so popular, in fact, that a follow-up album, *Sesame Disco*, was released the next year with a certain furry blue carb-lover lamenting "Me Lost Me Cookie at the Disco." Meanwhile, the children's label Peter Pan Records released *Disco Fever for All Ages*, featuring such songs as "Hokey Pokey Disco" and "Bunny Hop Disco."

Not to be outdone, Disney released *Mickey Mouse Disco* in 1979. The album featured funky versions of "It's a Small World" and "Zip-A-Dee-Doo-Dah," and such tracks as "Disco Mickey Mouse" and "Macho Duck." It was a bigger hit than either *Sesame Street* record.

Accompanied by an extensive ad campaign and a seven-minute cartoon short that accompanied the feature *Herbie Goes Bananas* in theaters, *Mickey Mouse Disco* sold nearly two million copies. "Walt Disney's little rodent is a disco superstar," wrote Jack Garner of the Gannett News Service in 1980. The album, he reported, "was the big surprise in the recording industry this year."

If a song about a macho mallard seems odd, it really wasn't at the time.

Consider that the audience for Village People—a band that sprang from the gay underground of New York City—was often peppered with children oblivious to the group's origins. "On our national tour in 1979, it was every mom and pop and their kids sitting next to leathermen and drag queens," remembers David Hodo, the original Hard Hat. "It was a big stew pot," he says. And in that stew pot was plenty for kids to consume.

Baskin-Robbins created Can't Stop the Nuts, a limited-edition ice cream flavor inspired by the Village People movie *Can't Stop the Music*. Kids ate it up.

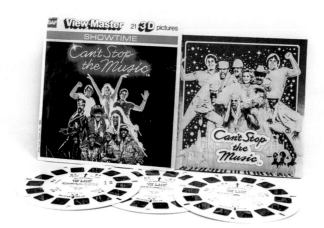

The band's youngest fans could collect official Village People trading cards, play a plastic Village People guitar (even though none of the guys played one on stage), celebrate "those marvelous macho men in 3-D" with *Can't Stop the Music* View-Master reels, wrap their little mouths around a Village People-inspired ice cream flavor called Can't Stop the Nuts at Baskin-Robbins, and even dress up as their favorite leatherman or Native American for Halloween in plastic masks and flame-retardant coveralls from the costume company Collegeville.

At the height of disco's popularity, even the breakfast table went disco.

Count Chocula, Frankenberry, and Boo Berry cereals pressed flexible "The Monsters Go Disco" records on the back of their boxes. "What are we going to do to cure our Saturday night blues?" Boo Berry asks. "I've got the answer, let's go disco!" says Count Chocula. "I'm so handsome all the girls will Hustle with me!" Frankenberry gushes.

At a dance contest, the ghouls sing, "Dance a new craze sweeping the country, Monster Mania! Monster Mania!" and then meet superstar singer Donna Disco. The club's DJ, a Wolfman Jack soundalike, pronounces the trio, "Bigger than disco, baby!"

Kids carried to school disco-themed lunchboxes, including a trio of Bee Gees kits—one for each brother in the group. These aluminum artifacts are now included in the pop culture collection of the Smithsonian. In class, teachers got their students moving with a 1977 *Disco for Kids* album featuring songs by Walter Murphy, who became a disco star a year prior with "A Fifth of Beethoven." After school, *Saturday Night Fever* trading cards turned the R-rated movie into G-rated cardboard collectibles.

The youngest Gibb, Andy, who came up at the height of Bee Gees mania, not only had his own set of trading cards, he also was rendered in miniature by the toy company Ideal. The Andy Gibb doll promised hours of pretend "disco dancin' with the stars" as it rode a "Dancin' Disc" that allowed the figure to glide across the floor. As the box read, "Happy Disco Dancin'!"

Another doll—less well known, but today more covetable—was Disco Wanda.

Created by Shindana Toys of Los Angeles, a socially conscious company established in 1968 to help rebuild after the Watts riots a few years earlier, the African-American fashion doll and her Latina friend Disco Juanita arrived in 1978.

"Shindana's goal was to create a trendy doll that reflected disco culture," says toy historian Debbie Behan Garrett. "Children, too young for in-person disco entertainment, could use their imaginations to get a feel for the dance-scene excitement."

Another company, Durham of New York, rebranded its 11½-inch fashion doll Charly in 1979 as "Disco Charly" with a mirror ball on the package. Also that year, toy giant Mattel introduced Starr, "the most popular girl in school," outfitted in "silvery disco bib-top shorts." Kids who bought Starr got a free "disco purse" to wear themselves, while supplies lasted.

Meanwhile, Kenner had Darci Cover Girl. Not only did the "beautifully poseable" 12½-inch fashion doll have a strapless silver jumpsuit and a one-shouldered "Disco Gold" ensemble with gold-lamé parachute pants, gold mules, and cuff bracelets, she had somewhere fabulous to wear them. She and her friends could dance the night away at the Darci Disco, a playset that included a miniature mirror ball, a working spotlight, and a tiny jukebox and pinball machine.

At the time, even Charlie Brown's beloved pup Snoopy was leading kids to the disco. The cartoon canine expanded his Joe Cool persona to include Disco Snoopy. Dressed in a suit, one paw in the air, the dance-floor dog adorned T-shirts, Saturday Night Beagle pillowcases and Peanuts bedsheets, Colorforms play sets, and any number of card-store desk accessories. How could kids resist a boogying beagle?

On TV, the prehistoric superhero Captain Caveman and his trio of sidekicks foiled a disco jewel theft on a 1978 episode of *Captain Caveman and the Teen Angels* called "Disco Cavey." Popeye went disco fifty years after his 1929 creation with an episode of *The All-New Popeye Hour* called "Spinach Fever." The heavily forearmed sailorman and his skinny girlfriend Olive Oyl enter a dance contest at the Slipped Disco, where Wimpy is the DJ and Mr. Disco, Popeye's rival Bluto dressed like John Travolta, makes a play for Olive.

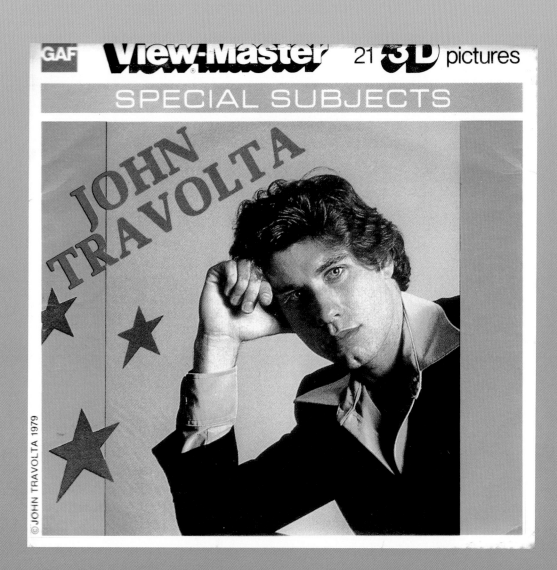

Children could love disco in their own way with a disco lunch box, disco mug, and disco View Master sets celebrating the movie *Can't Stop the Music* at left, and above, *Saturday Night Fever* star, John Travolta.

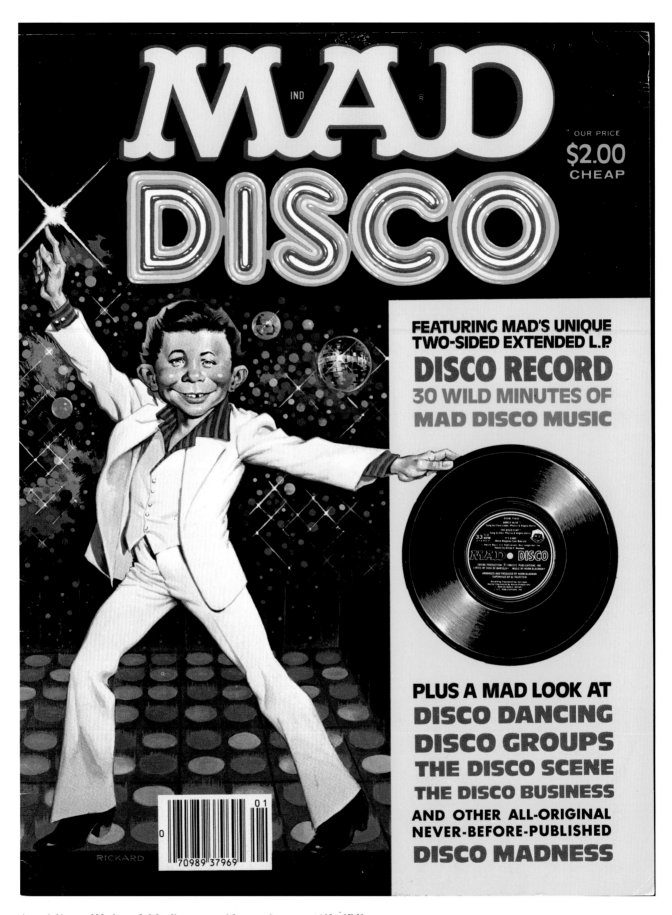

A special issue of *Mad* spoofed the disco craze with magazine mascot Alfred E. Neuman on the cover, dressed as Tony Manero. MAD DISCO SPECIAL (1980) cover art by Jack Rickard.

At right, *Mad* spoofed *Saturday Night Fever* with hilarious results. MAD #201 (September 1978). "*Saturday Night Feeble*" by Mort Drucker and Arnie Kogen.

"I just love this disco craze," she squeals.

Ethel Merman did, too, when she appeared on the 1979 season premiere of *Kids Are People Too*, the so-called "grown-up show for kids," to promote *The Ethel Merman Disco Album*. The Broadway baby rebranded a "Disco Mama" in *TV Guide* ads shared billing with *Superman* Christopher Reeve and gymnast Cathy Rigby. The following year, Diana Ross endured a "Love Hangover" while dancing with giant crayon-colored birds on *The Muppet Show*.

The youth-media blitz didn't stop there.

The January 1979 issue of *Dynamite* devoted page after page to the disco phenomenon, telling young people how to throw their own "Disco Dynamite" party at home. "Get set to sizzle at the hottest spot ever to make the disco scene," the publication teased, assuring its readers, "You don't need a fancy place, fancy clothes, or a fancy face."

Kids could play the Too Cool to Boogie game, transform any party space into a disco with aluminum foil and Christmas lights, bake a "Record-Breaking" disco cake and cool down with Sundae Fever frozen desserts. Even someone with two left feet could be "the disco host with the absolute most…All you need to do it right is a little bit of Disco Dynamite."

The ultimate validation came in 1980 when *Mad* magazine spoofed the disco craze by dressing Alfred E. Neumann up as Tony Manero. The thirty-two-page special issue—the brainchild of *Mad* writer Dick DeBartolo, an avowed disco lover—included a salute to the "Disco Owner of the Year," a *Mad* history of dancing, disco versions of Mother Goose rhymes, and a tear-out flexible disc that featured such songs as "Barely Alive," "Sorry, No Words," and "The Disco Clap." "It's a floppy vinyl record—emphasis on FLOP," DeBartolo wrote on his blog to commemorate the issue's fortieth anniversary.

The disco standalone came about, he explained, because he had written "a lot of disco satires, which just kept piling up on the editor's desk. Finally, I told *Mad* publisher Bill Gaines that if we didn't do something with them soon, disco would be on its way out."

DeBartolo wasn't wrong. Timing was everything, especially given the short attention spans of young people.

The biggest name in dolldom, Barbie, and her friends have gone disco at various points in toy history, for instance. In 1989, Dance Magic Ken could not only switch his hair color, but also his wardrobe. "Suit changes from tuxedo to ballet to disco," the box read. A 1994 Dance Moves Barbie was a vision in Lurex at the Disco Dance. Four years later, during a wave of seventies nostalgia in the nineties, Mattel released a 70s Disco Barbie doll in a white bell-bottom pants suit and rainbow-striped shirt that was "just right to boogie the night away!"

Today, these are all Disco-llectibles. Whether Snoopy desk accessories or DISC-O mugs with an "O" for a handle, they're worth a small fortune—if not always in dollars then in nostalgia value. A 2008 Celebrate Disco! Barbie doll, for instance, now sells for hundreds of dollars on eBay. A 2002 Disco Stu action figure from *The Simpsons*, maybe twenty bucks.

But who wouldn't want both? As the late great songwriter Allee Willis, a consummate tchotchke collector who cowrote the Earth, Wind & Fire classics "Boogie Wonderland" and "September," said in a 2009 tribute to disco collectibles, "I love anything disco!" Her vast holdings, enshrined in an online "Museum of Kitsch," included disco mugs, lunchboxes, 'fro picks, and even a three-piece set of disco-print luggage. "They fit just enough polyester for the weekend," she noted.

Willis's feelings about such merchandise mirrored her feelings about the music. "I will proudly defend disco until the day I die," Willis said. To her, and to kids who grew up listening to her hits, even a silly "Disco Duck" is fun and all it was ever quacked up to be.

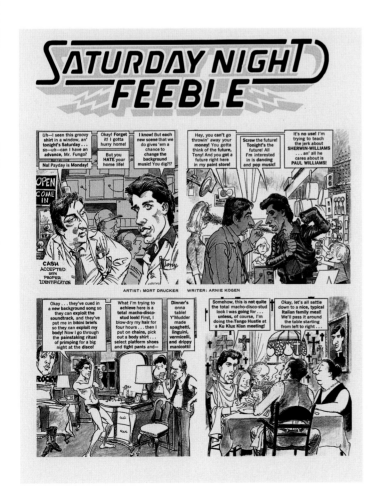

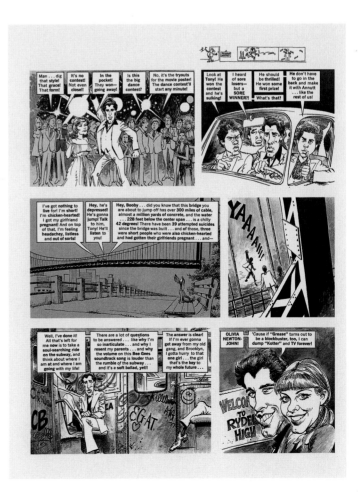

Disco Dining

For real disco food, you have to go to New Jersey.

There you'll find disco fries—one of the Garden State's greatest gifts to the culinary world. Since the heyday of Studio 54, knackered snackers have stopped at all-night diners in search of mozzarella cheese–slathered, brown-gravy–drenched French fries on their way home from New York City.

Think of disco fries as Parkway Poutine and know that eating a plateful of them after drinking and dancing until the wee hours is a roadside ritual that has stood the test of time. They are renowned for their hangover-preventing properties.

"They're a *great* drunk food," says Drew Lazor, a Philadelphia-based writer who, in 2016, penned the definitive ode to the disco side dish for the high-tone food magazine *Saveur*. It was an all-Jersey issue, one that granted disco fries status as an unofficial state food, right up there with Taylor ham, as pork roll is referred to in northern New Jersey.

Although slung in numerous locations—even at the LLanerch, the Upper Darby, Pennsylvania, diner featured in the 2012 film *Silver Linings Playbook*—disco fries can be traced back to the Tick Tock Diner in Clifton, New Jersey. Located on Route 3, straight out of the Lincoln Tunnel, just twelve miles from the discos of Manhattan, the 340-seat diner happily lays claim to the title of the dish's birthplace.

"This was the originator!" a third-generation server told Lazor back in 2016.

Although the disco fries tradition is mostly upheld today by old-school diners, a modern food truck operation based in Brick Township, New Jersey, called Romano's Disco Fries has been taking the dish to new heights with chef-worthy toppings like cheesesteak and pulled pork.

Their mobile kitchen is decorated with a mirror ball, silhouettes of disco dancers, and the words "It's a Jersey thing."

Disco fans don't need to go to Soprano-Land to get disco fries, though. The website foodnetwork.com offers various recipes for making them at home including versions by celebrity chefs Valerie Bertinelli and Tiffani Thiessen.

Disco fries, the best post-boogie indulgence. At right, afternoon discos for underage dancers.

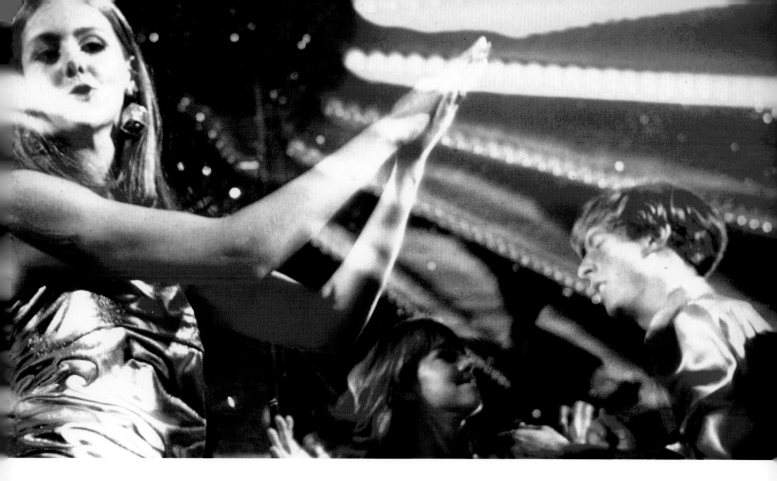

Teen Discos

In August 1978, a nightclub called Guys and Dolls opened in Hempstead, New York. The place had loud music, great lighting, and lines out the door. What made it different from other discos was the house rule: Anyone over seventeen had to be accompanied by someone twelve to seventeen. Guys and Dolls, as the New York Times reported, was the first full-time teen disco on Long Island.

The popularity of *Saturday Night Fever*—R-rated upon its 1977 release but later edited into a more kid-friendly PG version—fueled a tide of disco appreciation among those who were entirely too young to drink, and not just in this suburban club thirty miles from Manhattan.

The coolest, most fashionable teenagers may have tarted themselves up to look older, gotten a fake I.D. in case anyone checked, and snuck into adult discos. Fashion designer and *Project Runway* judge Michael Kors, for instance, has bragged about ditching his senior prom to go to Studio 54. For everyone else his age, though, there were teen discos to offer young people excitement at 120 beats per minute, and they spread like wildfire.

By early 1979, an estimated two dozen teen discos were opening each week across the country, according to a story in the *Record* of Hackensack, New Jersey. A respected suburban publication, the paper reported that underage hot spots were giving kids a wholesome place to go. "I used to hang out on the streets, get into trouble, break into homes. You name it, I've done it. But now I'm into discos," a Cliffside Park teenager told the paper in April of that year.

From the Strawberry Patch in Wayne, New Jersey, to the Odyssey in Los Angeles and Warehouse West in Sunrise, Florida, teens were boogying in spaces that, in theory, were alcohol-, drug-, and smoke-free. Even in Iowa.

"Non-alcoholic disco establishments have sprouted like weeds in the city and its suburbs," the *Des Moines Register* reported in March 1979. There was Arnold's in Missoula, Montana, the Music Box in Green Bay, Wisconsin, and, in New York, North 40 outside Ithaca, DePalo's Dugout in White Plains, and the Milky Way Lounge in Edgemont.

Not all these clubs catered only to teens, of course. Many teen discos were adult discos that allowed kids in during the afternoon. But by letting young people get a taste of what their older brothers and sisters, and sometimes even their parents, were enjoying, they were preparing them to become full-fledged disco devotees as adults. There were complaints, lawsuits, and ultimately closures, but teen discos were a hit.

For parents, dropping their kids off at a nightclub during the day was like sending them on a playdate. Better for teens, overdressed in Qiana shirts and Candies mules, to dance their hearts out at two o'clock on a Sunday afternoon and get kicked out at dusk than get into trouble. "This is a good experience for the kids to break into adulthood," one father waiting for his son outside Guys and Dolls told the *Times*.

These underage discos, as one thirteen-year-old girl interviewed by the *Times* put it, "fill a real vacuum in a teenager's life. It's a great place to socialize; otherwise we'd have to go ice skating or hang out on the street corner." Obviously there were other options, but the hottest music in the land was hard to resist. Dancing to disco music not only let them feel grown up, but it also gave them a cultural identity.

"Where the generation of the sixties had long hair, Chicago, and Woodstock, the products of the seventies had nothing to clearly call their own. They desperately needed a shared activity, scorned by their elders, which could bring them together as a group. At the disco, they have forged a generational banner," wrote Bruce Pollack in *The Disco Handbook*.

Just ask Thomas Castiglia, a fifteen-year-old boy from Franklin Square, Long Island, interviewed by the *New York Times* in 1978. "Disco music is great," he said. "Rock stinks, and it's outdated because you don't dance to it." Still, his love was not without a price. "I once got beat up in school for liking disco," he admitted. "They're just jealous," his friend said.

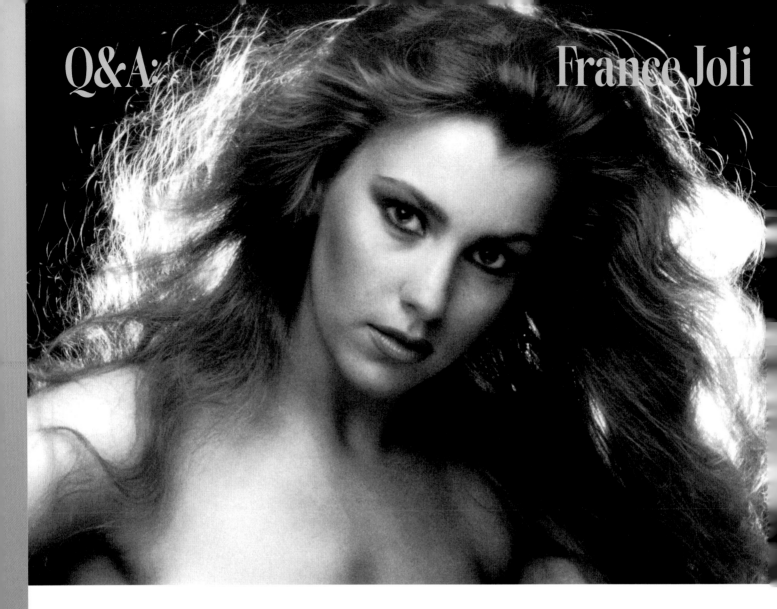

She was just a kid when she recorded the sultry 1979 disco hit "Come to Me," but that song was the end of France Joli's innocence. The Canadian singer's whirlwind success quickly took her from dancing with her friends at a teen disco in suburban Montreal to performing on the mainstage of a New York beach resort at what was called the "most ambitious event undertaken in the history of the barrier beach communities of Fire Island."

Sixteen at the time, but oh-so-sexy-looking, Joli sang before five thousand mostly gay men that night—not to mention Farrah Fawcett, Lee Majors, Andy Warhol, the Ritchie Family, and Village People—and was featured on the cover of the July 14, 1979, issue of *Fire Island News* under the banner headline, GREATEST FIRE ISLAND PARTY EVER. Not a bad debut.

That fall, "Come to Me" went to Number 15 on the *Billboard* Hot 100, boosted by Joli's appearances on American television—including a special starring a certain ski-nosed comedy legend. In 1981, her third album, *Now*, spawned another timeless dance-floor sensation, "Gonna Get Over You." Joli released a dance version of fellow Canadian singer Leonard Cohen's classic "Hallelujah" in 2012, and continues to perform. Audiences still gladly come to her.

FDC: "When you were a teenager was disco as big in Canada as it was in America?"

FJ: "It wasn't as big as, let's say, New York or Miami. But Quebec and Montreal had a big disco scene. I lived in Dorion and there was a Friday night dance, starting, at like, seven o'clock or something. It was for kids. I remember the whole week, we would chat with our friends saying, 'What are you going to wear to the dance?' It was like a mini discotheque without booze. But the freedom we felt just dancing the night away. Not a worry in the world. It was all about which guy is going to ask me to dance with him. It was such a good time."

FDC: "When you hit it big with 'Come to Me,' were you prepared for success?"

FJ: "I didn't know what the hell was happening to me. I recorded 'Come to Me' when I was fifteen. It was tailor-made for me. There was a certain vibe when the song was being recorded. Back then, we had all the musicians in the studio. Everybody was saying, 'Oh, my God, you've got something big here!'."

FDC: "Where did you, at fifteen, find the depth of emotion that you put into the record?"

FJ: "I had been singing Barbra Streisand songs since I was really young. My mom told me that she saw me in my room alone, when I was four years old, lip-syncing a French song. The end of my jump rope was my microphone. Even though I didn't understand the words, I had a connection to the music. 'Come to Me' reached me deeply, and the fact that it was written especially for me had a lot to do with it. It was mine and I owned it."

FDC: "When the song became a hit, what was it like performing it live?"

FJ: "It's hard to describe. People were crying. People wanted to touch me. At one point, somebody wanted to cut off a piece of my hair. That's when you think, 'What have I done to deserve this, except sing my song?' Then, suddenly, you feel this big pressure on you. Everything you do, everything you say, becomes more important. I was so young. I didn't even know who I was. But at the same time, it was wonderful to be idolized and to be loved."

FDC: "Tell me about the night on Fire Island when Donna Summer canceled, and you went on instead."

FJ: "I didn't know what I was getting into. I was so young. I had never been to a gay community, let alone an island full of beautiful men. Everyone said, 'You should go, it's a great opportunity.' 'Come to Me' was already a hit there. When I went up on stage, people were singing and screaming and clapping. I swear to you, it

was a fairy tale. That sounds very corny. But I was flying. It was two forty-five in the morning, we had a perfect mood, a perfect night, a beautiful breeze, the ocean was doing its thing. Singing in front of five thousand gay men was the beginning of my love affair with the gay community. There are so many things that started for me that night. It was my first record, my first American performance. It was my first everything! The appreciation I felt was humongous."

FDC: "When you were promoting the record, you did the talk show circuit. What was that like?"

FJ: "It was nerve-racking because I knew those shows were important. I was just so frightened. But they gave me a little kick in the ass, and I went on stage. I remember sitting in the greenroom on one, and I looked at this woman and thought, 'Oh my god, is she ever pretty!' It was Bo Derek. I didn't even know her. I also remember doing 'Come to Me,' and Merv Griffin said, 'You're so successful at such a young age. What are you going to do with all your money?' The only thing I could say was, 'I'm gonna buy myself a Lamborghini!'"

FDC: "How did you land the gig of cohosting *The Midnight Special*?"

FJ: "I performed in Las Vegas, with Wolfman Jack hosting, in a revue. It was Peaches & Herb, Tuxedo Junction, and me at the Riviera hotel. Wolfman Jack said, 'You have to come on my show.' Being on *The Midnight Special* was like, 'I can't believe I'm here.' You don't want to screw up when a million people are watching you."

FDC: "What about that Bob Hope special?"

FJ: "That was an experience—not only meeting him in person, but also rehearsing. I still have the actual written speech that we did together. When you meet a legend like that, you wonder what the hell is happening because they look at you like you're a phenomenon. But you don't look at yourself like that. And then they asked me to be Cinderella in the Macy's Parade. I mean, are you kidding me? I was Cinderella! When I look back at all the things that I've done and the people that I met, I'm still in awe to this day."

FDC: "Back in the day, who was the most famous person you rubbed elbows with?"

FJ: "The most popular person I met and rubbed more than elbows with was Michael Jackson."

FDC: "More than elbows!!! What else of Michael's did you rub?!?"

FJ: "I had such a crush on him. Oh, my God. We were recording in the same studio. He had Studio A, of course, and I had Studio B. When he would take a break, I'd make sure that I had my break at the same time. I was very much in awe of him and Quincy Jones. One day, I was singing a song called 'Mad About the Boy' and who comes into my studio? Michael, and he sits down and listens to me. It was quite the experience. We talked often and had lunch together. My best memory was when he was filming the video for 'Beat It.' He was in his trailer, and I went in and sat around with Michael and his entourage for an hour or so. Then he came and put his arms around me and said, 'You *are* the girl who sang that song, right?' and he started singing 'Come to Me' in my ear. He was singing 'Come to Me' to me! That's when I fainted. It was just so magical. He took my number and asked me to go to Las Vegas, but I couldn't go because I had commitments with shows. And it ended there."

FDC: "Did you ever go to Studio 54?"

FJ: "I was at Studio 54 when I was sixteen. I performed there more than a few times. I was not a participant in the disco era as a girl who goes to clubs to let loose. I was a participant as a performer, and I was always surrounded by people who were protecting me. I saw the whole scene from backstage, but I did see quite a bit. There was a big drug scene, and alcohol, and all that sex. I remember there was a certain area I was walking towards, and somebody said, 'You can't go in that hall. You can't go back there.' That's the way it was."

FDC: "What do you remember about the music you heard there?"

FJ: "The music was so romantic. The strings, the horns, it was like a symphony with a beat. The arrangements were absolutely amazing, and some really great musicians played on the great disco tracks. Disco is some of the most beautiful music that has ever existed."

FDC: "What was it like for you as a performer when disco started to wane?"

FJ: "When 'Come to Me' came out in 1979, it was the beginning of the end for disco. Not necessarily that disco was dying, but it was taking other forms, something else was coming into style. When you're known as a disco artist, you want to continue

with the same recipe. But it was like, 'I had a niche and now that niche is not good anymore? Where do I go now?' We wanted to be hip. That's why we chose a song like 'Gonna Get Over You,' which was a transition to wherever music was going. But after that, it was hard, frankly."

FDC: "Looking back, do you have any regrets?"

FJ: "I did not always do the right thing for my career. I was offered a role on *Three's Company*. Can you imagine being on *Three's Company*? I was offered *Grease 2*, which Michelle Pfeiffer did. There were so many opportunities that we didn't take because of the nonexperienced people I had around me. Who knows, it might have been a flop, it might have been good. I don't know. But there were big opportunities, that's for sure."

FDC: "What are your memories of Disco Demolition Night?"

FJ: "It was a rejection of not just the music, not just the content, but also of the people who recorded it and the people who loved it. People were bringing Marvin Gaye albums to burn that night. Stevie Wonder. Roberta Flack. You weren't allowed to listen to it or love it. But a lot of people who had this peer pressure loved disco secretly. That's why today whenever you go to a birthday party, a wedding, any celebration, you hear disco music. All those rockers, they know all the lyrics to the songs. I see it when I perform."

FDC: "How do you describe the disco era to those who weren't there?"

FJ: "Disco was freedom. That's what I loved about it. People dressed the way they wanted to dress. They moved the way they wanted to move. They acted the way they wanted to act, and there was no judgment. You were free to do whatever you wanted to do."

FDC: "That's why it continues to appeal to new generations."

FJ: "Exactly! With kids today, either you like it or you don't, but the whole culture isn't judged anymore. Their parents liked disco music, and now they appreciate it. Listen to Dua Lipa! Her tracks are *so* disco!"

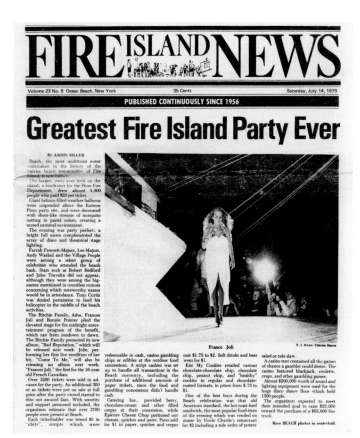

France Joli, performing at the ultimate Fire Island, New York, disco party, on the cover of the local paper. At left, an early portrait of the singer.

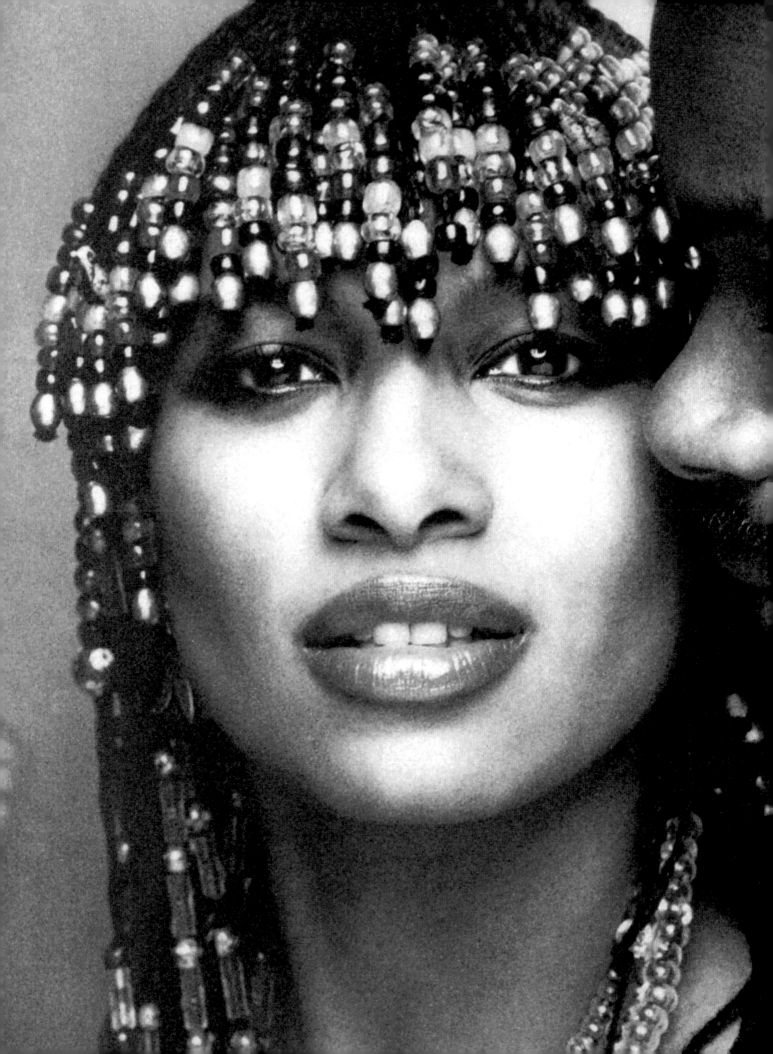

Must-Hear Disco Playlist:

"AFTER DARK" by Pattie Brooks

"ALL THE WAY LOVER" by Millie Jackson

"AT MIDNIGHT" by T-Connection

"BABY I'M BURNIN'" by Dolly Parton

"BOOGIE MOTION" by Beautiful Bend

"BOOGIE OOGIE OOGIE" by A Taste of Honey

"(BOOGIE WOOGIE) DANCIN' SHOES" by Claudja Barry

"BORN TO BE ALIVE" by Patrick Hernandez

"CALIFORNIA" by Raffaella Carrà

"CAN'T DANCE" by Charlotte Crossley, Sharon Redd, and Ula Hedwig

"CHASE" by Giorgio Moroder

"COME INTO MY HEART" by USA European Connection

"CONTACT" by Edwin Starr

"COPACABANA (AT THE COPA)" by Barry Manilow

"DA YA THINK I'M SEXY?" by Rod Stewart

"DANCE (DISCO HEAT)" by Sylvester

"DANCE LITTLE DREAMER" by Bionic Boogie

"DO OR DIE" by Grace Jones

"EVERY 1'S A WINNER" by Hot Chocolate

"GET DOWN" by Gene Chandler

"GET OFF" by Foxy

"GOT TO BE REAL" by Cheryl Lynn

"GOT TO HAVE LOVING" by Don Ray

"THE GROOVE LINE" by Hoatwavo

"HAPPINESS" by the Pointer Sisters

"HEAVEN MUST HAVE SENT YOU" by Bonnie Pointer

"HOT BUTTERFLY" by Bionic Boogie and Gregg Diamond

"HOT SHOT" by Karen Young

"I'M A MAN" by Macho

"I'M EVERY WOMAN" by Chaka Khan

"I CAN'T STAND THE RAIN" by Eruption

"I LOVE AMERICA" by Patrick Juvet

"I LOVE THE NIGHTLIFE (DISCO 'ROUND)" by Alicia Bridges

"I WANT YOUR LOVE" by Chic

GRACE JONES PORTRAIT BY NORN CUTSON

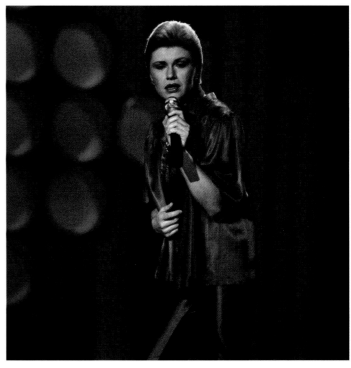

ALICIA BRIDGES

"I WAS MADE FOR DANCIN'" by Leif Garrett

"I WILL SURVIVE" by Gloria Gaynor

"IF MY FRIENDS COULD SEE ME NOW" by Linda Clifford

"IN THE BUSH" by Musique

"INSTANT REPLAY" by Dan Hartman

"KEEP ON JUMPIN'" by Musique

"LAST DANCE" by Donna Summer

"LE FREAK" by Chic

"LET'S ALL CHANT" by The Michael Zager Band

"LET'S START THE DANCE" by Hamilton Bohannon

"LOVE AND DESIRE" by Arpeggio

"LOVE MASTERPIECE" by Thelma Houston

"MACARTHUR PARK" by Donna Summer

"MACHO MAN" by Village People

"MISS YOU" by The Rolling Stones

"ONE NATION UNDER A GROOVE" by Funkadelic

"PICK ME UP, I'LL DANCE" by Melba Moore

"RASPUTIN" by Boney M.

"ROMEO & JULIET" by Alec R. Costandinos

"RUNAWAY LOVE" by Linda Clifford

"SAN FRANCISCO (YOU'VE GOT ME)" by Village People

"SEPTEMBER" by Earth Wind & Fire

"SHAKE YOUR BODY (DOWN TO THE GROUND)" by the Jacksons

"SHAKE YOUR GROOVE THING" by Peaches & Herb

"SOUVENIRS" by Voyage

"SPANK" by Jimmy "Bo" Horne

"STAR LOVE" by Cheryl Lynn

"TAKE IT TO THE ZOO" by Sunshine

"THANK GOD IT'S FRIDAY" by Love & Kisses

"THEME FROM 'WHICH WAY IS UP'" by Stargard

"YOU AND I" by Rick James

"YOU MAKE ME FEEL (MIGHTY REAL)" by Sylvester

"YOU STEPPED INTO MY LIFE" by Melba Moore

"Y.M.C.A." by Village People

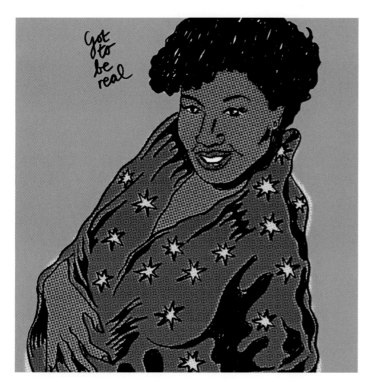

CHERYL LYNN PORTRAIT BY SINA SHAMSAVARI

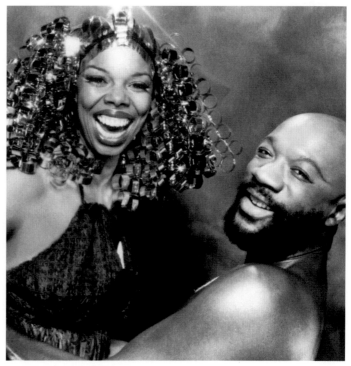

MILLIE JACKSON AND ISAAC HAYES.

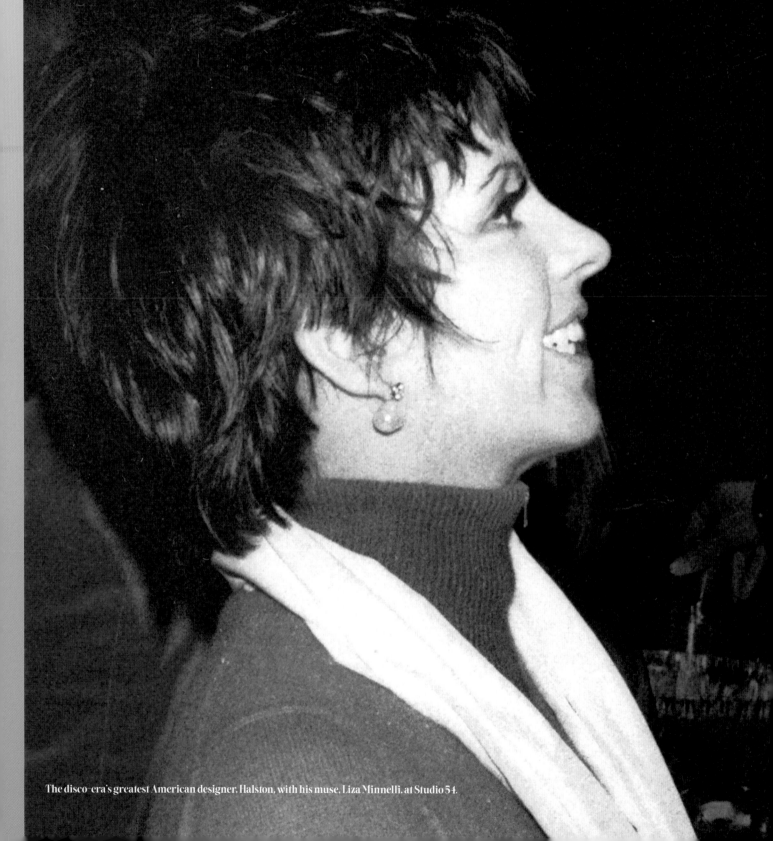

Chapter 5
Halston, Gucci, Fiorucci..

The disco-era's greatest American designer, Halston, with his muse, Liza Minnelli, at Studio 54.

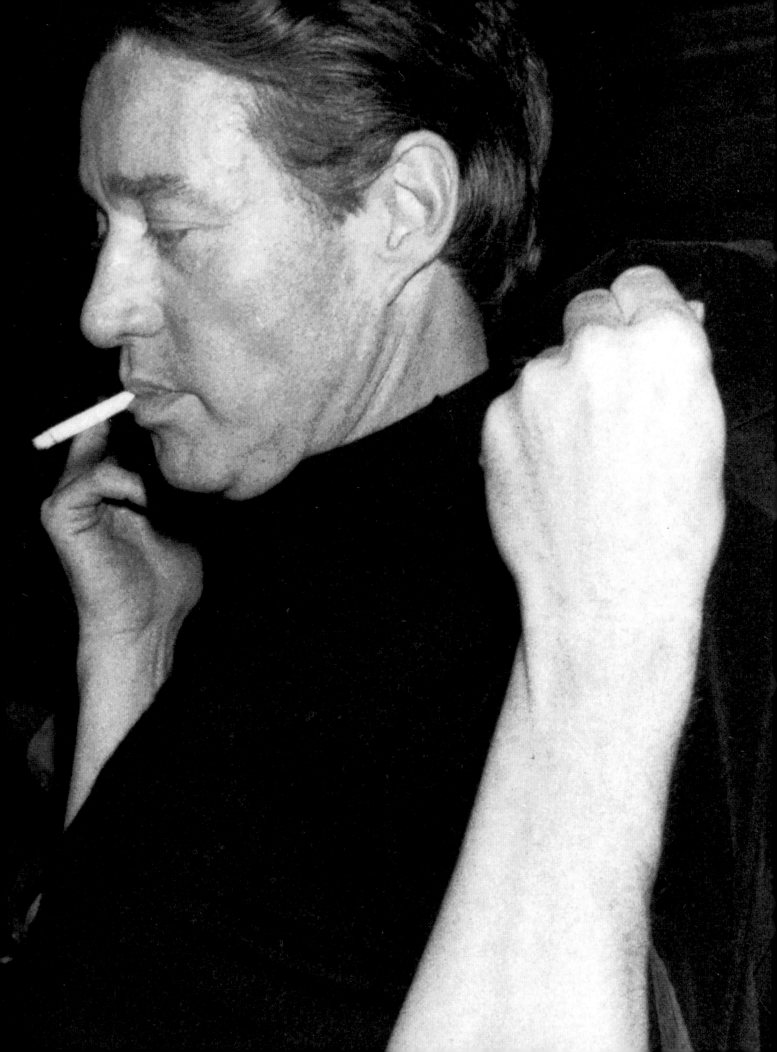

"

HE WEARS THE FINEST CLOTHES, THE BEST DESIGNERS, HEAVEN KNOWS...

—Sister Sledge

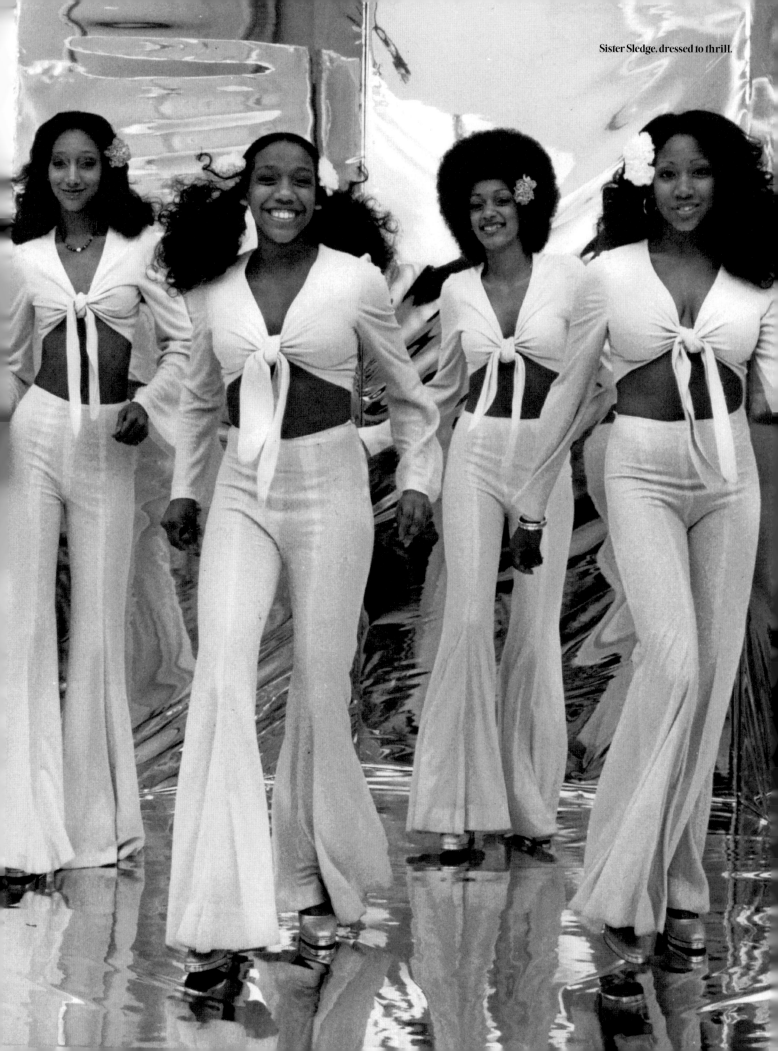

Sister Sledge, dressed to thrill.

FASHION FOR MEN/WINTER $1.50

GQ
GENTLEMEN'S QUARTERLY

LIVING IT UP!

FUN-FILLED GOOD TIMES GUIDE

HOW TO PARTY
**THE GAMES,
THE SOUNDS,
THE DRINKS,
THE FOOD**

WHAT TO WEAR
**FEEL-GOOD CLOTHES
STEPPING OUT IN STYLE
KICKY FOOTWEAR**

Gentlemen's Quarterly magazine.

The rise of the disco as a see-and-be-seen meeting place gave fashionistas a reason to look sharp again. After years of dressing down, they finally had a place to wear their finest finery.

The sixties were predominantly jeans and T-shirts and love beads," remembers singer Cory Daye "But in the seventies, it was about glitz and glamour. Looking the part was important, and everybody did." As Liza Minnelli famously said, "Studio 54 brought glamour back to New York that we haven't seen since the sixties. It made New York get dressed up again."

Truth be told, disco made Cleveland get dressed up again, too.

Gloria Vanderbilt jeans, Diane von Furstenburg wrap dresses, Pucci-print blouses, body-hugging Missoni knits, slim Yves Saint Laurent pantsuits—they all caught on.

"One did not hit the clubs dressed for the factory or the secretarial pool. These nights required costuming," observed Robin Givhan, the Pulitzer Prize–winning fashion critic for the *Washington Post*, in her 2015 book *The Battle of Versailles*. "Women styled themselves in cocktail dresses that plunged to X-rated depths and that flew up high on the dance floor. Men became peacocks dressed in madly patterned trousers and colorful shirts that reflected the spotlights and the glow of testosterone."

In 1977, *Time* magazine reported, "The new boogie bunch dress up for the occasion, with shoulders, backs, breasts, and midriffs tending to be nearly bare. Outside of a few old-style 'meat racks'—mostly homosexual hangouts—few disco freaks turn out in jeans, shorts, T-shirts, or sandals. Designers like Halston make women's clothes just for dancing. 'The dress becomes your dancing partner,' he says, and photographer Francesco Scavullo claims that the 'young and exciting fashions in the discos are the only clothes today."

In a November 1978 *Life* magazine story titled "The Delirium of Disco," Albert Goldman noted that "The disco world prides itself on being totally liberated from old dress codes."

The new dress codes meant wearing always sexy, sometimes colorful clothes that expressed individuality, inspired joy, and countered the jaded cynicism of an era marked by the Vietnam War, Watergate, an oil crisis, high crime, economic distress, and cultural unrest.

Nowhere was this corrective more apparent than at Studio 54, where the fashions reflected evening-length ecstasy, and the clothes were as chronicled as the celebrities wearing them.

"On any night of the week, it looks like a combination of Carnival in Rio and Halloween," wrote Jacquelyn Nicholson in the August 1979 issue of *Rona Barrett's Hollywood*. "Celebrities and socialites jostle for space with punks in black leatherette, boys in silver lamé diapers, and starlets in see-through plastic jeans."

No matter the style, these were clothes to be seen in.

"People would dress to go to Studio," says Fern Mallis, the fashion industry mover and shaker. "They wore party clothes—shiny, glittery, sequined, sexually provocative—but there wasn't just one look. People would be glammed up in the most beautiful black tie, coming from some extraordinary charity benefit, but there were also people in jeans and T-shirts who looked fabulous, too. It was a bit of a costume party. You never knew what you'd see." Women of the seventies justified these new, more suggestive clothes, wrote Diana

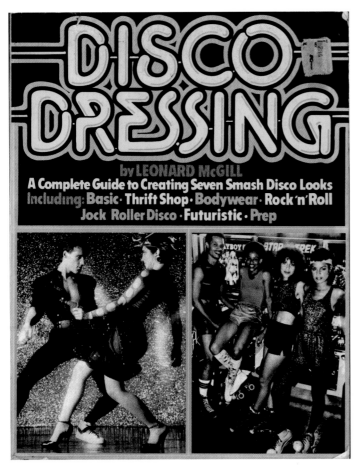

DISCO DRESSING

by LEONARD McGILL

A Complete Guide to Creating Seven Smash Disco Looks
Including: Basic · Thrift Shop · Bodywear · Rock 'n' Roll
Jock Roller Disco · Futuristic · Prep

Mankowski, an online fashion historian, "by redefining feminism to include the idea of sexy self-determination. Disco fashion allowed these women to express a kind of overt sexuality, if they so chose, without having to resign themselves to being sex objects."

"A lot of disco fashion had to do with body exposure," says fashion historian Valerie Steele of the Fashion Institute of Technology in New York. "If it wasn't actually taking off your clothes, it was wearing clothes that would slide on your body and reveal parts of your body. All those Stephen Burrows dresses were very body-conscious, and somewhat sheer, and would slide off your shoulder or off your hip."

As for men, Steele says, "I have intense memories of going to gay discos and all these guys wearing micro-shorts and nothing else, except buff bodies and maybe some jewelry."

These "disco chics," as Goldman called them, might take to the dance floor wearing only a well-worn jockstrap—or nothing at all—or choose an elaborate outfit from "a costume closet that contains enough disguises to outfit a professional spy."

The choice was theirs. He mentions one pair of Studio 54 regulars whose ensembles might be surgical scrubs one night and Orthodox Jewish attire another. "Less imaginative types turn up in the latest creations from Halston, Giorgio Sant'Angelo, and Issey Miyake," he wrote in *Life*. It's one of the few times designer clothes could be called "less imaginative."

Disco lovers clothed themselves to the nines because "dressing is as much a part of disco as the music, lights, and dancing," wrote Leonard McGill in *Disco Dressing*, his 1980 fashion guide. As designer Betsey Johnson explained to him, "At a disco, you don't talk, you can't hear anything, so clothes become a wonderful form of communication."

The range of disco looks ran the gamut from World War II–era ankle-strapped nostalgia to twenty-first century futurism. McGill isolated trends as diverse as fifties rock 'n' roll revivalism—camp shirts, leather jackets, and jeans—and satin-shorted athleticwear, complete with wrist- and headbands. Both continued to flourish in the eighties as new wave and aerobics caught on. "In an age when physical appearance and conditioning have become obsessively important," Goldman wrote in *Life*, "Disco provides a perfect arena for the exercise and display of all those carefully nurtured and cultivated bodies." Nurtured and cultivated back then meant skinny. "The Breakfast of Champions in those days was Tab and a cigarette before you went to Fiorucci," says fashionista Patrick McDonald, who was a frequent Studio 54 reveler.

Truly, the Lycra leggings and shimmering bodysuits worn on the dance floor had their origins in activewear—ballet togs and swimwear. Disco dancers had to be able to sweat in the clothes and still look fabulous; they needed to be able to do the Bump and maybe do a bump.

As Mankowski put it, "Disco attire was about embracing the glamour and individuality of the scene in an outfit that was comfortable to dance in and that stood out just enough to attract a potential dance partner."

Dancing, of course, wasn't all disco lovers had in mind.

Clothes reflected a new sexual freedom. "The essence of the era was love the one you're with," says fashion designer Stephen Burrows. "It didn't matter whether it was a girl or a boy, if you loved them, you loved them and you expressed yourself with them."

"Clearly it was an era of lots of sex and drugs and rock 'n' roll, and its heyday was pre-AIDS, when everything seemed possible, and everybody was beautiful," says Mallis. "Disco crystallized it all—the music, the attitude—for a generation."

The designer most associated with the era was Halston. Born Roy Halston Frowick, a Depression-era baby from Iowa, he first made his name as a milliner at Bergdorf Goodman in the fifties and sixties. Halston created Jackie Kennedy's much-imitated 1961 pillbox hat. He went on to create many of the seventies' most signature high-fashion looks. His bias-cut day-into-eveningwear was disco fashion at its purest and most iconic, and his design partnership with his muse Liza Minnelli was legendary.

A glutton for publicity, Halston was one of American fashion's first household names, thanks to many TV appearances. He became so closely aligned with disco because he went to Studio 54 almost every night. "Famed for his batwing silhouettes, halter necks, and swaths of silk fabric, his designs have become synonymous with the decade," wrote Phoebe Shardlow of British *Elle* in 2019. Today, Halston remains what *The Guardian* called the "'70s disco designer" and a legendary, frequently reexamined presence in the fashion world. His legacy only grows thanks to projects based on his life. TV titan Ryan Murphy brought the designer's legend to television via the 2021 miniseries *Halston*, with Ewan McGregor in the title role.

But those, like Mallis, who knew Halston personally say his association with disco had little to do with his actual designs. "He wasn't dressing people for disco at all. He was way above that," she maintains. "Disco fashion came more from the younger designers of the era—the Clovis Ruffins of the world, and Stephen Burrows."

Although not as widely known as Halston, Burrows was so associated with disco that a 2013 retrospective of his designs at the Museum of the City of New York was called "Stephen Burrows: When Fashion Danced." He and his muse, the model Pat Cleveland, were frequently seen at Studio 54, and he showed his clothes along with Halston and other top-name American designers at the famous Versailles fashion show of 1973.

"My clothes were all about movement and dancing," Burrows says, and that association began long before disco. "I started out loving the mambo, which is what got me into designing," he says. "I created outfits for my dance partners in high school." Although he still prefers mambo to disco, Burrows remains enraptured by the athleticism of dancers. "The seventies was a great era in fashion because it was a turning point in the way people dress," he says. "A more casual way of dressing took over."

The disco era was a particularly good time in fashion for people of color like Burrows and women like Norma Kamali. Black and female designers made huge strides, bringing with them a daring and undeniable joyousness. "The energy and all that was coming together changed American fashion. It was powerful and visually beautiful," says Kamali, one of the most influential American designers of the seventies and eighties.

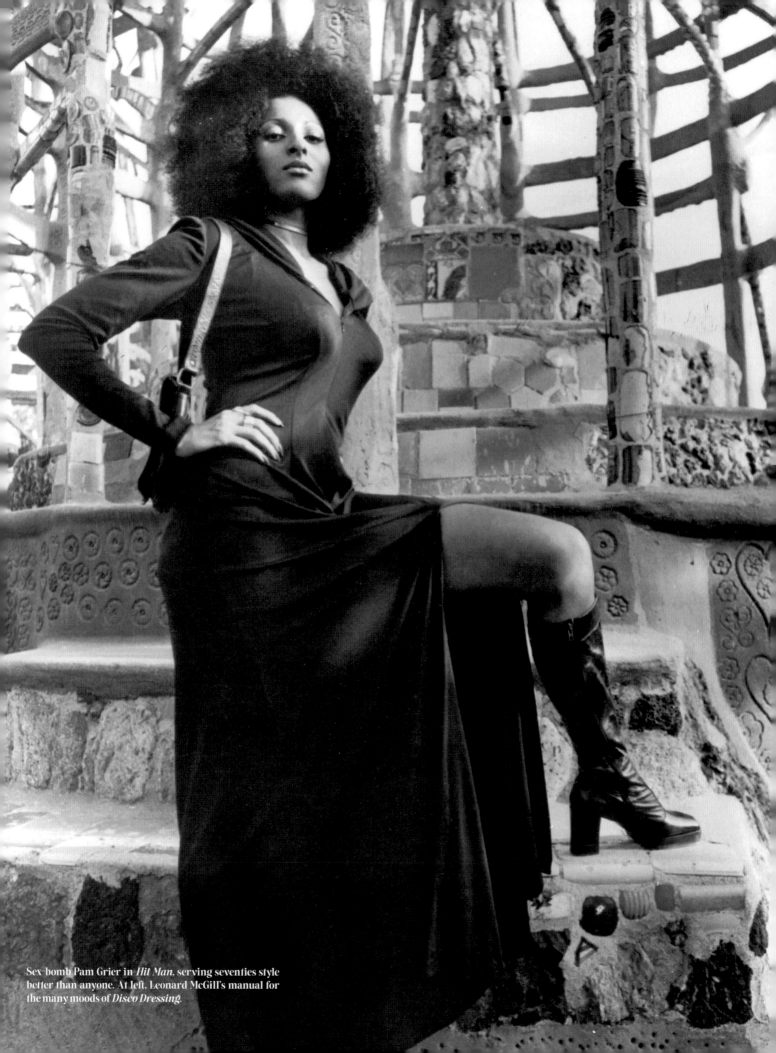

Sex-bomb Pam Grier in *Hit Man*, serving seventies style better than anyone. At left, Leonard McGill's manual for the many moods of *Disco Dressing*.

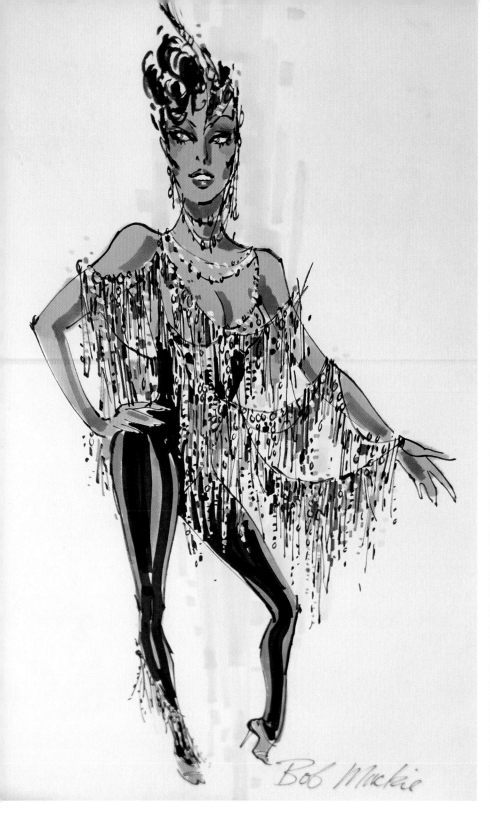

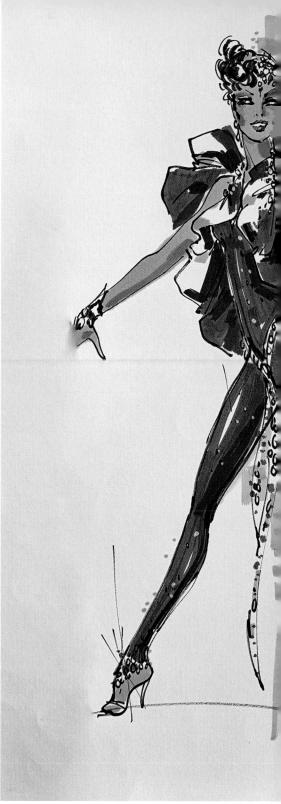

Never-before-seen disco diva sketches from the archives
of legendary costume couturier Bob Mackie.

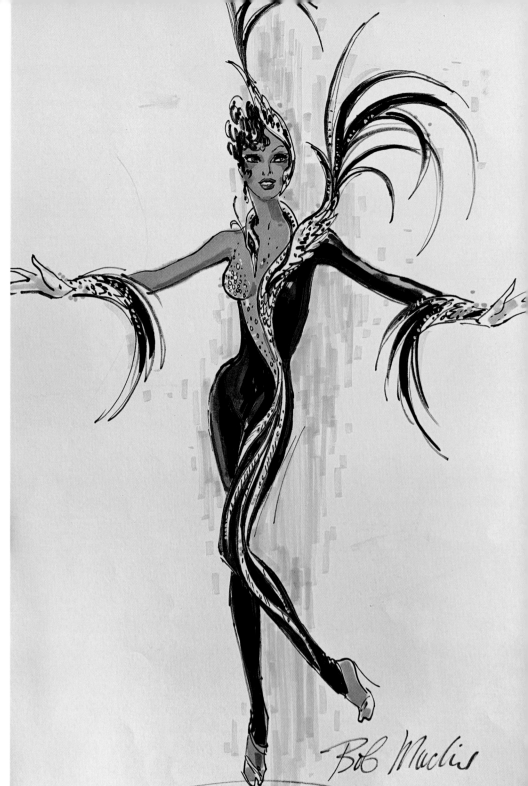

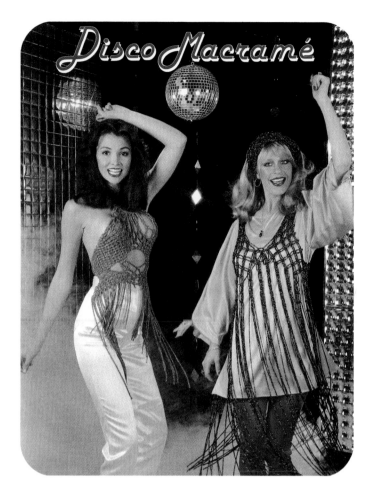

Disco Macramé

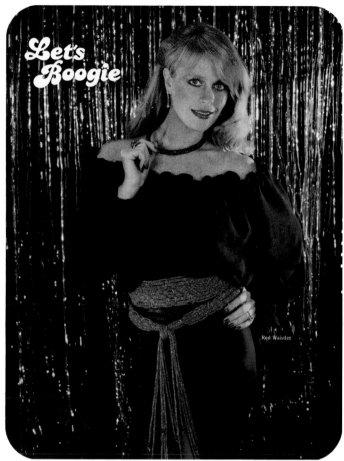

Let's Boogie

Red Waistlet

The mix of styles—a man in a silver spacesuit by Larry LeGaspi, who dressed KISS, dancing next to a Halstonette, as that designer's women were known—was what was so new. Someone with the right flair could dress like the women of LaBelle or la belle epoque and be equally lauded. From hot pants to no pants, sartorial expression was encouraged. As designer Bob Mackie says, "Margaret Trudeau would be sitting there in a dress with no underwear on."

Clubs in other parts of the country witnessed a more watered-down version of disco style than the gynecologically enthusiastic version on display at Studio 54. But middle America was not immune to seventies fashion's advances.

"Disco caught on everywhere," says Deney Terrio, the *Saturday Night Fever* choreographer and host of the TV competition *Dance Fever*. "There were guys in Oklahoma buying white suits because women wanted them to look like John Travolta with the shirt open and the chains."

In straight clubs, disco style was "more conventional" than at Studio, says music critic Jim Farber. "It was men and women dressing up for each other, men taking women out in a courtly way. There were specific dances that you were meant to learn and imitate."

Guys began dressing with purpose, whether it was a white-polyester suit with a black shirt, or slim-fitting, boldly patterned polyester Nik Nik shirts. Suits were often three-piece styles with wide lapels and wide or flared-leg trousers. Skintight designer jeans were must-haves. A puka necklace and a pair of aviator glasses

didn't hurt either. As McGill wrote, "Put a guy who keeps his body in reasonable shape in a pair of jeans, boots, and a muscle-hugging shirt, and you've got macho."

One didn't have to be rich and famous to take part in the disco dressing trend, either.

At the height of disco's popularity, there were DIY booklets filled with instructions for creating Disco Macrame accessories, from scarves to belts to ponchos, and Simplicity patterns to sew disco fashions at home—stretch fabrics only, of course. Mackie saw some of his disco designs turned into patterns for McCall's.

As for what Claudja Barry would call "boogie oogie boogie woogie dancing shoes," they might be cheap sneakers or Ferragamo platforms—or platform sneakers—but the look was always calculated to grab the eye.

"The use of strobe lights and glitter disco balls made metallics a feature of Studio 54 style," wrote Caroline Cox in her 2008 footwear history, *Vintage Shoes*. "Because of the shimmering light effects they produced when dancing, rhinestones, diamanté, and mirror were used as a way of embellishing strappy shoes."

Platforms became synonymous with disco. The most infamous pair was created in 1972 by Harold Smerling, with a glass aquarium containing a live goldfish in each platform. Less deadly—for fish and their wearers—were platform wedge shoes. They offered height and, relatively speaking, comfort. A girl could dance in a pair of Kork-Ease platforms.

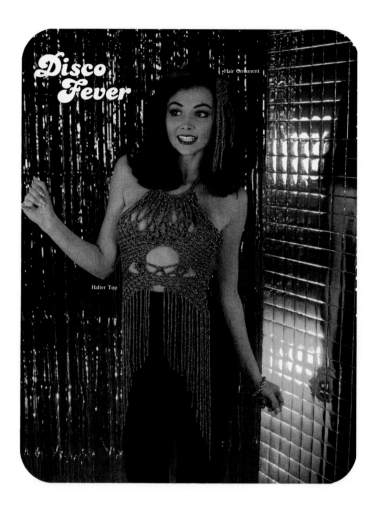

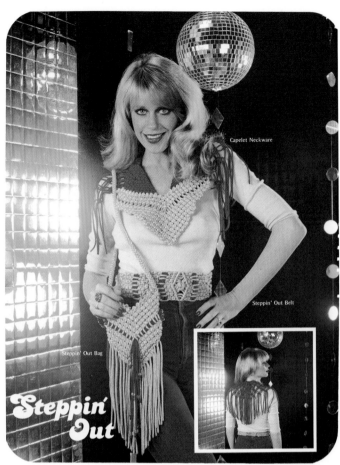

Such shoes, Cox noted, "could be seen on the feet of the hippie elite . . . or doing the Hustle on the disco floor." Although podiatrists called them "supremely dangerous," Cox says, "women could not be put off" and wore platforms throughout the seventies. These were "steppin' shoes" as singer Cheryl Lynn called them, and men wore their own versions, too.

The clothes of the seventies reached most people via mass media. If Halston was Studio 54's designer of choice, Mackie was the go-to guy for disco duds in Hollywood. Designing clothes seen by millions every week on TV variety shows, Mackie helped solidify disco style in the minds of Americans. His nude-illusion dresses with just enough strategically placed sequins for modesty's sake became a hallmark. One need only watch Cher and Tina Turner sing "Shame, Shame, Shame" on TV in matching dresses with kinetic carwash fringe to know what disco was supposed to look like.

"Everybody that I made clothes for had these little disco outfits," Mackie says. His renown was so big that record company executives began to send-up-and-coming singers his way for a disco makeover, even before they'd recorded anything. "All of these unknown girls who could sing were being sent to me to dress them up as disco divas," Mackie remembers. "But nothing ever happened with them. None of those girls ever got a job doing anything."

Cher's enduring success, of course, more than made up for those unworn disco designs.

For her, Mackie designed some of the most iconic disco outfits of all time—particularly the winged headdress and matching gold bikini that she wore on the cover of her 1979 album *Take Me Home*. A tribute to sci-fi artist Frank Frazetta, the Space Age Valkyrie look was the kind of getup only the Oscar-winning actress and singer could pull off.

"It was a little more fantasy than usual," Mackie says, but it became an avatar of disco-era sexiness. "Sometimes wings become iconic when you wish they wouldn't," he jokes. But his disco-era designs live on. "Whenever Cher goes out on tour, they still do a big disco number," he says. "When she comes out in a costume they remember, they start applauding before they even hear the music. It's crazy."

Even away from the stage, disco designs, including Mackie's, have continued to exert their influence on fashion decades later. "When Tom Ford went to Gucci, he was very influenced by Halston and the seventies," says Steele. "There was a kind of loose, sexual aesthetic in those really influential Gucci years. He was looking back at the great hypersexual period prior to the AIDS crisis, and that sort of 'dancer from the dance' era."

Cher's glittering presence on television brought the allure of disco to the American masses, and further fueled the hottest trend gripping the nation. Even folks whose idea of Saturday night fever was staying home to watch *The Carol Burnett Show* could get down and get funky as Burnett took Cinderella—and her wicked step-siblings, the Pointer Sisters—to the hottest club in the kingdom. That mini-musical was just one of many special disco episodes of seventies television turning living rooms into Studio 54.

Four DIY styles from the guidebook *Disco Macrame*.

Disco Jeans

Levi's were for rockers. Designer jeans were disco jeans, and in the late 1970s, tight-fitting denim was flying out the doors of department stores like few other fashion items. Trend-savvy customers snatched up thousands of pairs a week in 1979. *The New York Times* quoted a Saks Fifth Avenue spokesman who said, "The designer jeans business is the pant business of America."

Anderson Cooper's beloved mother, socialite Gloria Vanderbilt, started the whole thing when she licensed her name to Murjani and saw it embroidered above a swan on the backs of millions of pairs of jeans. Soon, every designer worth his top-stitching, from Oscar de la Renta to Geoffrey Beene, joined in. The holdout was Halston, who, as quoted in Steven Gaines's Calvin Klein biography, *Obsession,* said, "Only a pig would put his name on blue jeans."

Bad call, Roy. Labels like Cacharel, Sasson, Bonjour, Sergio Valente, and Jean-Paul Germain, who enlisted Village People as models in his magazine adverts, were doing bang-up business. After only a year in the jeans market, Jordache was shipping $3 million worth of product a month. They weren't kidding when they claimed, "Day or night, Jordache has the fit that's right." Vanderbilt jeans were selling $25 million a year. Ralph Lauren, $30 million.

These designer jeans "helped resurrect the denim business," Sasson president Paul Guez, boasted to the *Times* in 1979. "People are getting into shape and my jeans are designed to fit like a second skin." A market report that year quoted a Goldman Sachs analyst who explained that upscale denim pants "go along with the trend to dressing up, and they're a way for upwardly mobile people to gain status." On and off the dance floor, they were a hit.

"With the whole designer jeans thing, America took the lead with denim and turned it into a fashion item," says Fern Mallis, whose resume includes a stellar stint as the executive director of the Council of Fashion Designers of America.

Designer jeans officially became wedded to disco when Studio 54 licensed its name for a line of jeans in 1979. The slim-fitting pants, designed by Norma Kamali, had the number 54 embroidered on the back pockets. Magazine ads showed a naked man (or woman) stepping into a pair. The brand's catchphrase, written by Peter Rogers, who had penned the iconic line "What becomes a legend most?" for Blackglama, was, "Now everybody can get into Studio 54."

Talk about cheeky.

At about that time, Calvin Klein entered the market after he was approached at Studio 54 by a representative of Puritan, a large clothing manufacturer. He soon made a deal for his own line of designer jeans. In 1980, Klein began running TV spots for his jeans, directed by photographer Richard Avedon, and featuring Brooke Shields. In the most notorious commercial, she breathily said, "You know what comes between me and my Calvins? Nothing."

The implication that a fifteen-year-old girl was going commando caused an outcry from conservatives. But such provocation sold plenty of jeans. "The controversy backfired," Shields told *People* magazine in 2021. "The campaign was extremely successful."

Klein had been selling 125,000 pairs a week at $35 a pair, according to the *Times,* and that was before the ads. Designer jeans were only a fraction of the three hundred million pairs of jeans sold each year, but when it came to hype, they had all the heat.

The designer jeans craze became so much a part of popular culture that *Saturday Night Live* spoofed it in February 1980. Gilda Radner, as her character Rhonda Weiss, slipped into a pair of tight-fitting jeans with a Star of David embroidered on each pocket, and danced to a song with the lyrics "She's an American princess and a disco queen, she's the Jewess in Jewess Jeans." The tagline was, "You don't have to be Jewish, but it wouldn't hurt." The pants themselves might, though. Jewess Jeans, the announcer said, were "guaranteed to ride up."

The satiric spot delighted Avedon. "You can't buy that kind of publicity," he said.

An ad by Gordon Munro and Peter Rogers for Studio 54 jeans. Crafted by Norma Kamali, they were the ultimate in designer denim, if you could get into them.

©M. Hoffman & Co., Inc., manufacturers, Boston, Mass. 02114

Now everybody can get into Studio 54.

STUDIO
54
JEANS

For men and for women.

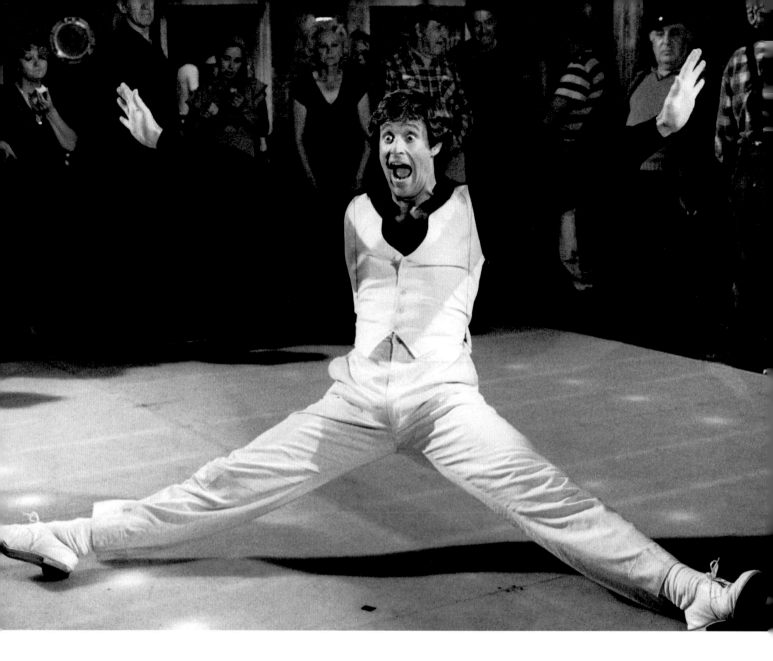

The Brotherhood of the Traveling White Suit

It is one of the most iconic costumes in the history of motion pictures, and, by far, the most emblematic fashion ensemble of the entire disco era. It is the white flare-legged, pick-stitched polyester suit and black wing-collar shirt worn by John Travolta in *Saturday Night Fever*, and the look has become shorthand for an entire decade of men's style.

Costume designer Patrizia von Brandenstein knew what she was looking for when she set out to attire dance-floor heartthrob Tony Manero. "The whole point had to be that it wasn't a designer suit, it was worn by a Brooklyn kid who could barely afford to go out on a Saturday night, but spends 80 percent of his income on clothes," she explained in *Dressed: A Century of Hollywood Costume Design*, a 2007 survey by fellow designer Deborah Nadoolman Landis.

Von Brandenstein found the suit—and bought three of them for Travolta—in a mom-and-pop men's store called Leading Male in Bay Ridge, Brooklyn, not far from 2001 Odyssey, the real-life neighborhood disco where Saturday Night Fever's dance scenes were shot. "We wanted a white, three-piece suit: dressy, inexpensive, and polyester," she told the *New York Post* in 2023. Although one producer wanted a black suit, he was overruled.

"Heroes wear white," she said. "It's as simple as that."

Each suit cost less than $200.

The costume designer tailored the pieces to accommodate Travolta, even removing the labels from the inside jacket pockets so they wouldn't distract the movie audience. Black cotton-blend shirts by Pascal of Spain were augmented with elastic panels and attached to each pair of pants, so they'd stay perfectly tucked no matter the actor's moves on the dance floor.

If Travolta sweated through one suit—polyester doesn't breathe—he changed into another, von Brandenstein recalled, and one was always at the cleaners getting ready for the next day's shoot. In all, there were five white suits—two worn by stuntmen, three by the actor.

One of Travolta's was reportedly stolen decades ago. A second was purchased for $2,000 at a 1978 charity auction by film critic Gene Siskel, who called *Saturday Night Fever* his favorite movie. It sold for $145,000 at Christie's in 1995, four years before Siskel's death. The third was given as a gift in 1981 from Paramount president Don Simpson to collector Brian Wasserman, who sold it forty years later to an American lawyer named Brad Teplitsky.

Having been authenticated by Travolta, that third suit went on the block at Julien's Auctions in April 2023. The opening bid was $25,000. The iconic white polyester suit and the accompanying black shirt, worn while Tony Manero danced to "More Than a Woman" and, with a black eye, rode the subway in *Saturday Night Fever*, ended up fetching a whopping $260,000.

That huge sum was no surprise to Martin Nolan, executive director of the auction house. Travolta's polyester suit, he said, "defines disco and is truly a piece of cinematic dreams and one of the most prized pop culture artifacts to ever come to auction."

Still, von Brandenstein, who went on to win an Oscar in 1985 as a production designer for *Amadeus*, is amused by the whole thing. "It's pretty funny," she told the Post. "It was not only the suit, it was John wearing the suit. The two made for an ideal combination."

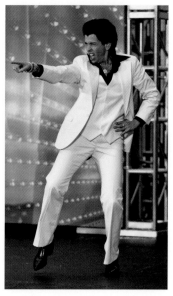

At left, Robert Hays dons the iconic white suit from *Saturday Night Fever* in the 1980 film comedy *Airplane!* Above, Disco Stu from *The Simpsons*. Hoda Kotb dressed as John Travolta for Halloween 2019 on the *Today* show. At right, the Funko Pop action figure version of "Disco Nightwing."

Nightwing: Fly, Robin, Fly

When Dick Grayson, better known as Batman's sidekick Robin, flew the belfry in 1984 and reimagined himself as the grown-up, stand-alone superhero Nightwing, he got a makeover. His new look was a bright-blue-and-yellow form-fitting spandex costume with a high winged collar and plunging neckline. Sadly, the fashion police of Gotham City went gunning for him.

Immediately dubbed "Disco Nightwing," the character's makeover was derided by the most earnest of Bat-fans. Disco music was out of style and so was Nightwing's attire. Even today, some still debate the look. But a 2005 comic book explained his disco-flavored duds by saying that Alfred Pennyworth, the old bat who was Bruce Wayne's fusty-but-trusty butler, had designed the costume, not the youthful and hip former Boy Wonder.

The explanation may have helped. Disco Nightwing since has been embraced.

There now are such toys as Funko Pop and retro-style action figures celebrating his high-collared likeness, and cartoon art of the superhero mimicking Tony Manero's finger-point pose from *Saturday Night Fever*. He is known today as much for his killer glutes as for his crime-fighting skills—it must be the dancing—and even the toughest critics have come around. "In retrospect," *Screen Rant* posted in 2019, Disco Nightwing "was kind of chic for a superhero."

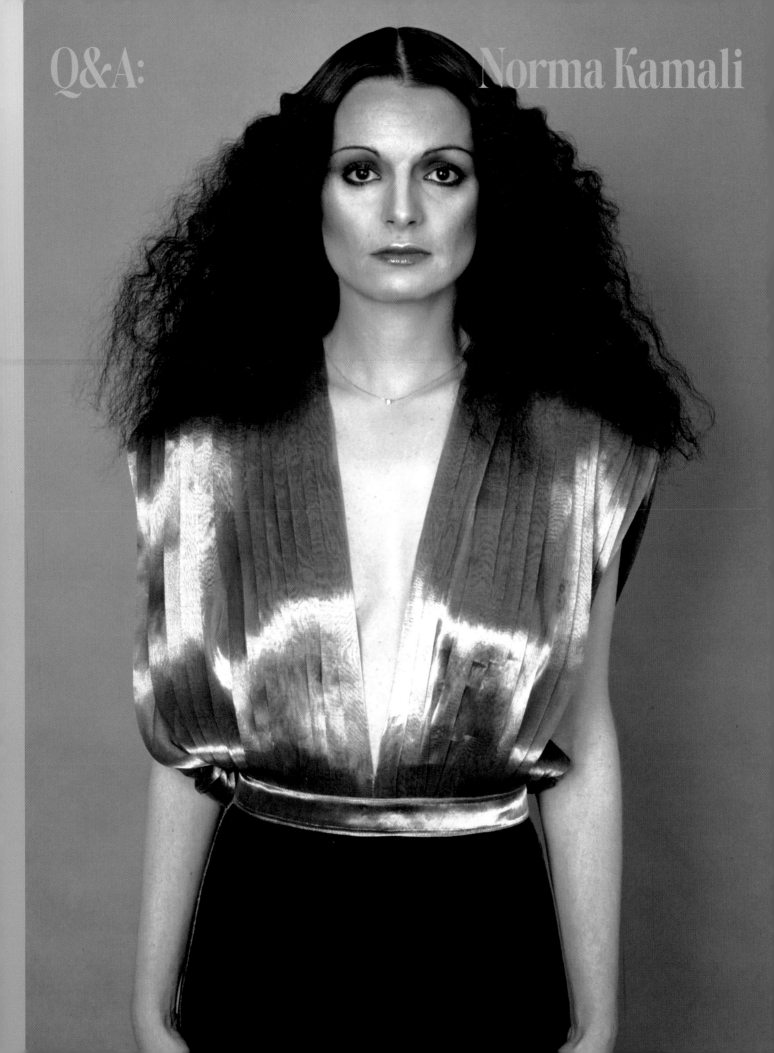

The scarlet bathing suit that Farrah Fawcett wore on all eight million copies of her 1976 cheesecake poster? Norma Kamali designed it. The shoulder-pad fad of the eighties? That, at first, was her, too. As for the "athleisurewear" trend so popular during the Covid quarantine, Kamali prefigured it by four decades with an entire wardrobe made of sweatshirt material. And she was designing gender-fluid clothes before that expression entered the vernacular.

During the Studio 54 era, she dated the club's cofounder Ian Schrager. The nightlife impresario turned hotelier is still her best friend, and introduced Kamali, at sixty-five, to the man she thinks of as her soulmate. These days, Kamali advocates wellness. "I still have not taken a drug in my life and I don't drink alcohol," she says. But at the height of disco, Kamali was, at the very least, hedonism-adjacent. She'd grown up on New York's Upper East Side and graduated from the Fashion Institute of Technology. Who better to dress the crowds at Studio 54?

As for music world celebrities, Kamali has dressed everyone from Donna Summer to Megan Thee Stallion. She continues to gather new fans as she charts fresh territory, as always, nailing the zeitgeist better than anyone. Wherever people are dancing, Kamali is always there.

FDC: "You were at the center of the action during the disco era. What was your life like then?"

NK: "It was very schizophrenic because I was living with Ian. But I never went to Studio 54. I was busy enjoying the fact that I'd found the life I wanted to live. I loved making clothes. I loved being creative. I preferred to be behind my sewing machine. I knew everything that was going on at Studio and my clothes were fully represented there, so I *was* a part of it. But I was sewing until midnight. I was just loving, loving, loving what I was doing."

FDC: "You must have gone to Studio 54 sometimes."

NK "I would go when Ian was doing a special party. He had such a creative crew around him, and he would always ask me, 'What do you think about this or that?' I was on Fifty-Sixth Street, and he was on Fifty-Fourth Street, I would just walk over before we went home, pick him up and see what was going on. So, I was there a lot, but not at midnight."

FDC: "What was it like designing for Grace Jones?"

NK: "Ian contacted me to do Grace's costume for the first New Year's Eve at Studio. She had maybe six guys with her in that show, so I made her a gold-lamé thing and things for the guys. It was fun, obviously, doing costumes for Grace Jones. There are people who invent themselves, and it's so powerful. The invention is so precise and so clever and so mesmerizing that you get pulled in."

FDC: "How did you create your sleeping bag coats and how did they end up on the doormen at Studio 54?"

NK "I was a big camper. We would go up the Delaware River to a place called Narrowsburg. We would sleep in sleeping bags in tents and it would get cold. In the middle of one of those cold nights, I had to go out into the woods to go to the bathroom. I wrapped my sleeping bag around me and, as I was walking back I thought 'This would make a really great coat.' When we got home, I took the sleeping bag I was using and cut it up into a coat. It was khaki canvas with geese flying on it and it was amazing. So, I bought a ton of sleeping bags and I cut them up and I started selling them. Steve Rubell saw me wearing mine and said, 'I need something like that because it's so cold out at the door.' That's how they ended up on the guys.

"There's a funny little note to that: People thought that wearing a sleeping bag coat was a way to get into Studio 54. Of course, I didn't tell them that it may not help. There were a lot of sleeping bag coat purchases that didn't get past that door."

FDC: "How did dance influence your clothing designs?"

NK "Understanding what dance feels like and the movement of the body really defined what the clothes were going to look like. You couldn't have a bodice with boning. It had to be free. You had to be able to move in it and you had to be able to sweat in it. Working out was not what was happening. Disco dancing was what was happening. That was the beginning of clothing connected to physical movement for the everyday person."

FDC: "Why do you think people took to disco the way they did?"

NK "On the dance floor, it's very hard to hide how you feel. When a song comes on, it just lifts you out of yourself. You're no longer in control of what's going to happen. The music just takes you. There's no plan there. The enthusiasm and the energy come from the deepest place in your soul, the most expressive place in yourself. That's the power of a song to lift us and take us away."

FDC: "Did the sexual revolution of the seventies affect fashion?"

NK "One hundred percent! I don't think anybody wore underwear. I don't think it *existed* in anybody's wardrobe. No bras, no panties, it was just not going to happen. The freedom of that psychologically was incredible. You weren't encumbered by anything. Women were free, anybody who felt trapped in a secret was free. Why would you keep underwear on?"

FDC: "How did you come to work on *The Wiz*?"

NK "Joel Schumacher, who wrote the screenplay, called me and said this movie version of *The Wiz* was being created. They asked me if I wanted to do some costumes for the Emerald City scene. I was like, yes! So, I had red, green, and gold glitter everywhere for months, covering every part of my company. The dancers in the movie were amazing. It was so much fun and such a creative experience. It was shot right where the World Trade Center was, so there was a wind tunnel all the time. I used parachute fabric, and the wind just blew them up and it was majestic, really fantastic."

FDC: "Was the Emerald City presented to you as a disco scene?"

NK "Not directly. But we're talking about shiny gold, shiny red, and shiny emerald-green costumes. Disco was in the air. It was just a given that that's what you would see. I don't think I would have been asked, especially considering what I was doing at the time, if I wanted to do something else. They expected me to sparkle it up."

FDC: "What did the clothes in your store look like back then?"

NK "My customers were going to Studio 54 morning, noon, and night. It wasn't just the sleeping bag coats. I was making clothes out of Lycra and that wasn't the norm. Studio 54 made it the norm. I had these dance dresses that had big, full skirts, and you could sweat in them and move in them. They were in great colors—neons and brights. They would just fill the dance floor. I did a lot of things that were body conscious, like cat suits. That's what people wanted."

FDC: "Why do you think Studio 54 exploded the way it did?"

NK "The city was in a very depressed state. There were a lot of empty apartments. There was a lot of sadness, a lot of hard times. But people who felt out of place in their hometown would come to New York and find their place. There was an incredible slew of creative people who came to New York then. And there needed to be a place for this creativity during the day and during the night. Studio 54 was a stage for any kind of creativity, whether it was in the clothes you were wearing, or your roller-skating skills, or your dance skills, or celebrities meeting other celebrities. It was just the place where all of this incredible energy came together. It didn't last a long time. But that moment was so incredible and impactful that it lives on and will continue to live on."

FDC: "How does it feel to see roller-disco parties returning to places like Central Park and Rockefeller Center these days, and young performers like Lizzo and Dua Lipa making very disco-sounding records?"

NK "Personally, I really look to the future. I don't look back. But I love the fact that the joy that disco gave us is here for this generation, whether it's the Millennials and Gen Z, because they need joy. Big time. They don't know that freedom and so I think they're taking to it. We're in an incredibly familiar space right now, especially in some big cities. We're in a time again where it's dark and we're looking for a light. That was why we needed disco. Here we are now, and it looks like, intuitively, these artists are realizing this is the right music at this time."

FDC: "When you see movies or TV shows depicting the seventies—like Ryan Murphy's *Halston*, for instance—do they capture the era as you remember it?"

NK "Some of these representations are a little too dark. This was the beginning of fashion in New York as a commercial entity, designers were becoming celebrities, and becoming as important as Europe. The energy and all that creativity coming together should be celebrated in a beautiful, special way. It's not the darkness we should remember, it's the light."

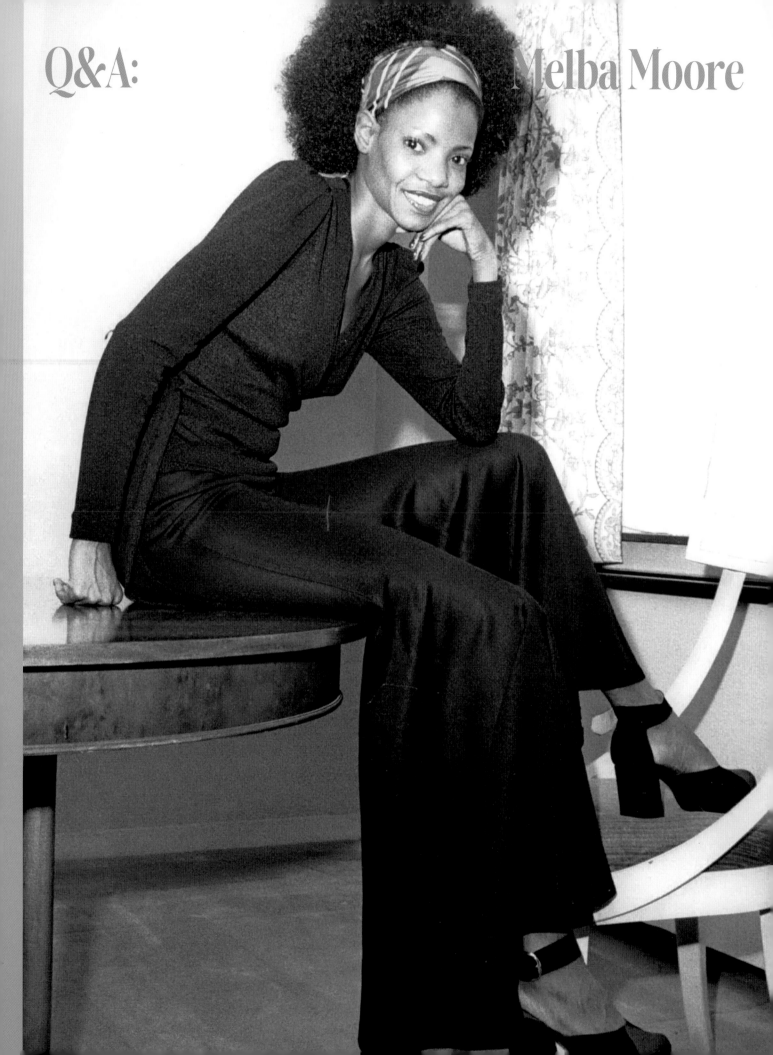

Melba Moore

How could Melba Moore not have been a singer?

Her father was big band leader Teddy Hill and her mother, Gertrude Melba Smith, used the stage name Bonnie Davies when she sang professionally. Moore grew up in Harlem, but when her mother remarried—to a jazz pianist—the family moved to New Jersey. There, Moore naturally studied music, first at Newark Arts High School, then Montclair State College.

At twenty-two, she found herself in the original Broadway cast of *Hair* and, three years later, won a Tony Award for her work in the 1970 musical comedy *Purlie*. As the seventies progressed, she made a few movies, starred in a TV variety show with then-beau Clifton Davis, and became a recording artist, creating the LPs *I Got Love* and *Look What You're Doing to the Man.*

Hits came when she signed with Buddah Records and turned out a string of popular albums including 1975's *Peach Melba* and 1976's *This is It,* featuring the title track that established Moore as a disco artist. She released her most recent album, *Imagine,* in 2022.

FDC: "Music was definitely in your blood, as they say . . ."
MM: "I got a foothold in music because of my family and then I majored in music in college, and I taught music. So I've always been focused on music, music, music, music. Whether it's the American Songbook, jazz, R&B, blues, or gospel, I'm comfortable with all of those. But my natural voice and my training was classical."

FDC: "How did you decide which type to focus on?"
MM: "I had a classical voice, but I wanted to sing R&B. My voice teacher didn't know how to teach me that. You go to school to study Beethoven and Bach and Mozart. But I said let me see if I can train myself to do these other things, but with the attitude and the experience and discipline and training of classical. That's the approach that I still take to it."

FDC: "How did disco music figure into all this?"
MM: "It happened because I met Charles Huggins, who became my husband. He got me my record deal with Buddah Records. So he really spearheaded the business aspect of my career. At around the same time, Geoffrey Holder was doing *Timbuktu* on Broadway, and he was going to star Eartha Kitt in it. But he wanted me in it, so I was able to do that, too.

"When I fell in love and got married, I was prepared to take whatever opportunities came to me in music. Charles brought me Van McCoy, who was still having success from 'The Hustle' all over the world. My then-husband went and got me the man who started the disco era."

FDC: "That partnership with Van McCoy led to 'This is It,' which is a disco classic. As a singer in the seventies, was there pressure to record disco music?"
MM: "Your music had to fit radio, but clubs had really developed a strong way of influencing what songs would be successful. People were coming to clubs to dance, but that had a big effect on radio. So you had two different very strong reasons why you should try to do disco. That's why even Ethel Merman did disco. She had already had her career, but she wanted to be a part of what everybody was falling in love with, which was disco music."

FDC: "Did you fall in love with disco music?"
MM: "I loved disco. I was young and in the clubs, and ecstatic about having a disco hit."

FDC: "How did you come to record your 1979 smash 'Pick Me Up, I'll Dance'?"
MM: "We got involved with Gene McFadden and John Whitehead. They had written so many international hits. They created 'Pick Me Up, I'll Dance' from the ground up for me. They had arranged and made 'You Stepped into My Life' which also was a huge hit for me that year. It was written by the Bee Gees, but they arranged it and tailor-made it for me and my little voice. I say 'little' because when you hear Candi Staton or Mavis Staples, my voice is little. I'm a soprano and they're altos."

FDC: "But on songs like 'This is It,' you belt with the best of them!"
MM: "You can't sing in your light voice if you sing R&B music. You have to belt. It's just that my voice is so high, it doesn't sound like that. McFadden and Whitehead made the music very suitable for my style of voice, so that I could fit into the dance genre. The record companies—Buddah Records, then CBS Records, and finally Capitol Records—allowed me to keep having successful dance music out. But also record some wonderful ballads."

FDC: "At the time of your international hits, were you touring the globe?"
MM: "When we were beginning, the record company would create promotional tours around the world. You would go and perform your songs in certain clubs, and on television, to promote the record. So I did those. But I'm still looking forward to going on real European tours. The only place that I've been to continually is the UK."

FDC: "Do you find your European fandom to be different from your American one?"
MM: "They're more students of the music, not just fans who enjoyed it. We have so much more music in America because it's our national product, but there they seem to treasure it more. They get into the behind-the-scenes aspects of it, who wrote it. They want to know more about your life as well as your songs. And they don't throw them away. When the songs get old, they still love them."

FDC: "When the American media turned on disco, did you feel pressure to stop singing it?"
MM:"No. When someone says, 'When did you stop doing disco?' I say, 'I didn't. I kept on, but you were probably listening to something else.' I continued to do dance music, but it wasn't called disco. In dance music, you have songwriters and producers who know my work and want to produce me. Now that music is digital, it's instantly global and much more diverse. But if you're not in my lane, you might not know that I have anything out there. Really, I've never stopped. I've diversified. I have music in a lot of categories and now I have a new album."

FDC: "You're talking about *Imagine,* and I know you're very proud of it."
MM: "The proudest thing I am about it is that it was spearheaded by my daughter. She brought me all the songs. I was doing other things, but she said 'Ma, you really want to listen to some of these songs.' So I did and I said to her, 'These songs are wonderful, but I don't know if I can even sing them.' She said, 'Why don't we go into the studio, and you try one.' After a while, we had recorded about twelve or thirteen songs. We started to sequence them and mix them and see what we had, and we really had a musical journey of my life. The album really reflects the fullness of a long life. Because I'm very mature right now."

FDC: "You wouldn't know that you were 'very mature' from looking at you!"
MM: "I've grown but I've stayed healthy. You work out, you keep your muscles and your blood pressure and everything working properly. The other things are fine-tuning. I've worked on not allowing myself or my voice to erode. In some cases, things did tear me down. But God jumped back up again. You have to learn how to play your own instrument."

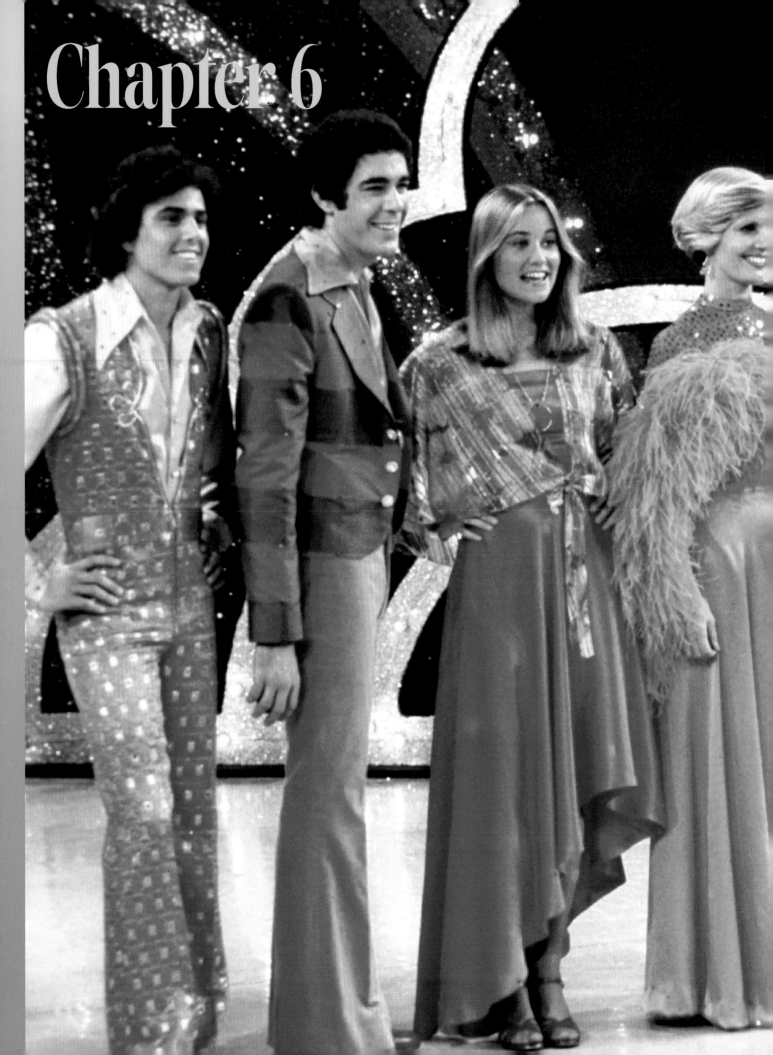

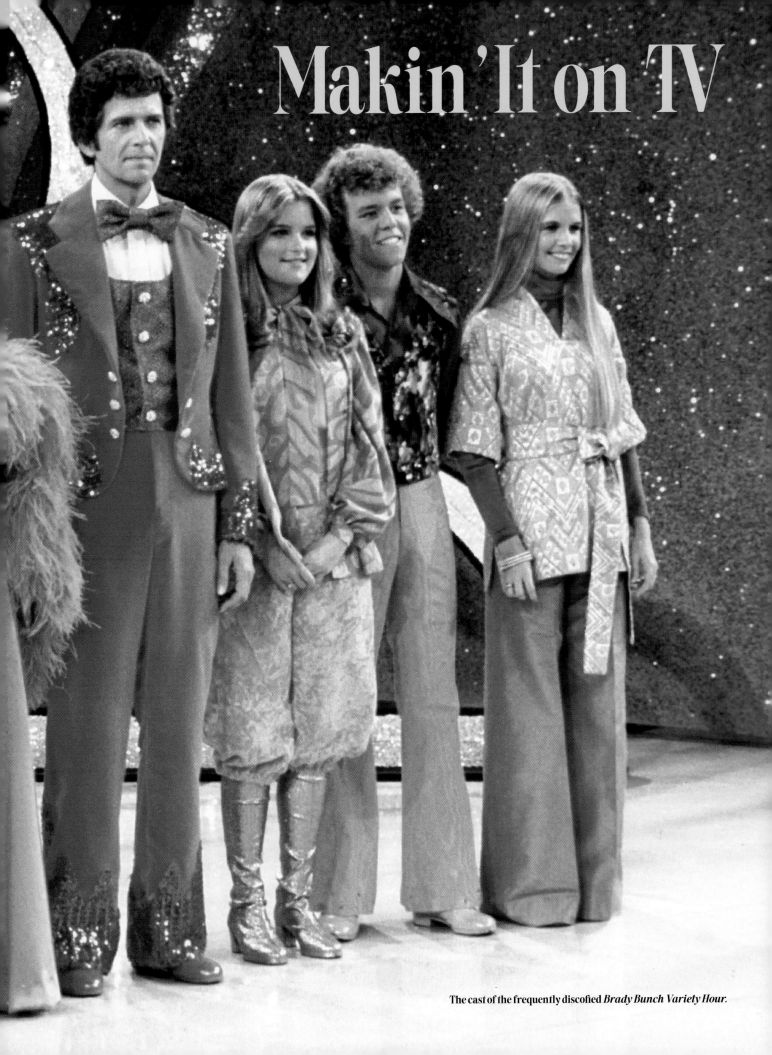

Makin' It on TV

The cast of the frequently discofied *Brady Bunch Variety Hour*.

ON THE WAVES
OF THE AIR,
THERE IS
DANCIN' OUT
THERE...

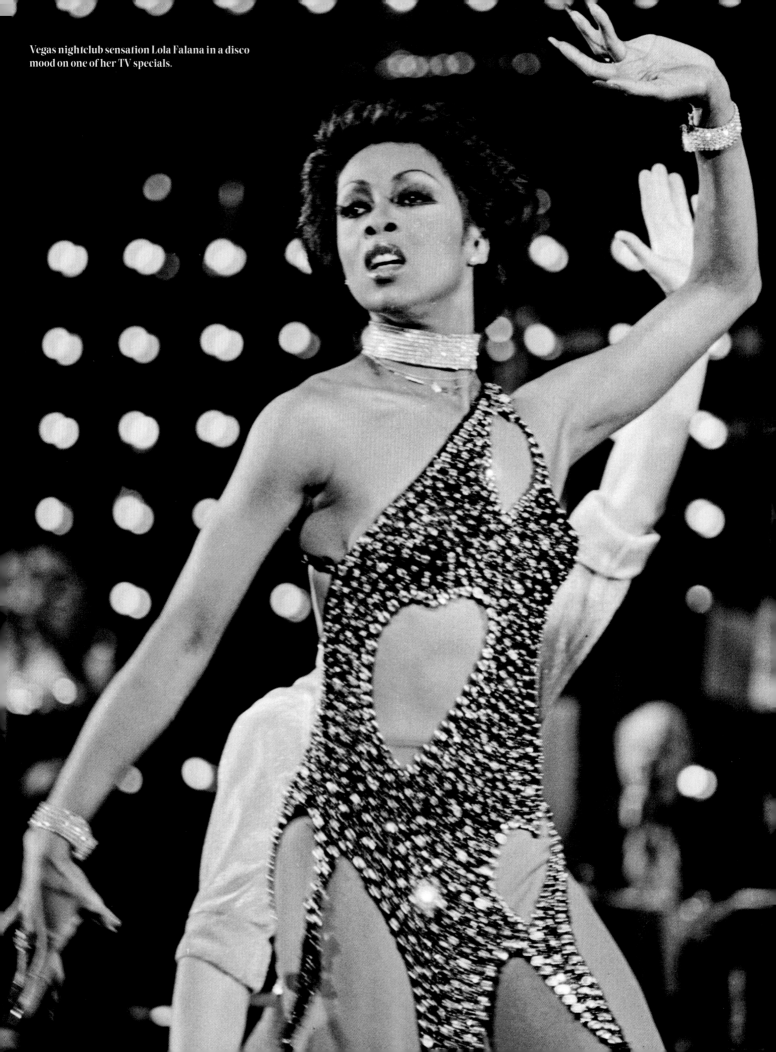

Vegas nightclub sensation Lola Falana in a disco mood on one of her TV specials.

Disco didn't just flavor seventies television, it infiltrated almost every genre.

From commercials featuring leggy showgirl Joey Heatherton in a halter jumpsuit hustling Serta Perfect Sleeper mattresses to an infamous, one-off special featuring Playboy centerfold models on roller skates, TV brought big-city glitz and bell-bottomed glamour to audiences who would never, ever be allowed past the velvet ropes of Studio 54.

The glut of disco programming meant there were disco awards telecasts, disco variety shows, disco sitcoms, disco dance contests, and very special disco-themed episodes of such established shows as *Charlie's Angels*, *WKRP in Cincinnati*, and even *Barnaby Jones*.

Disco, once heard only on music shows like *Soul Train*, found itself in prime time. For a few years in the late seventies, the excitement was enormous and, in retrospect, served an especially important function. "TV made disco important to those who'd never been inside one," says veteran critic Mike Hughes, who wrote for Gannett News Service in those days.

Quite simply, TV fueled disco fever.

The on-air wave didn't sit well with squares. Columnist Jack O'Brian, who after the Beatles appeared on *The Ed Sullivan Show* in 1964 warned that rock 'n' roll would "encourage young people to forget neatness, ignore barbers, bypass cleanliness, and turn into a nation of slobs," complained in 1978 that "disco shows [were] cluttering off-time TV." He suggested that the more innocent 1965—1966 music show *Hullabaloo* be revived in place of these new, sexy disco programs. But contemporary audiences didn't want to do the Frug; they wanted to do Le Freak, and TV let them do it night and day in the comfort of their own living rooms.

From Saturday morning cartoons, where Popeye and Olive Oyl succumbed to "Spinach Fever" on a 1978 episode of *The All-New Popeye Hour* to afternoon soap operas, which saw the opening of the Campus Disco on *General Hospital* and Erica's Disco on *All My Children* in 1979, to the most family-friendly talk shows, disco reigned supreme.

Evelyn "Champagne" King kept her whole body burning, to paraphrase her hit "Shame," on the squeaky-clean *Mike Douglas Show*. A teen band called Apollo—featuring Kerry Ashby, son of Motown founder Berry Gordy—one afternoon informed Dinah Shore's audience, "It's your duty to shake your booty," as they sang their soon-forgotten song "Astro Disco" on *Dinah*.

Meanwhile, *The Merv Griffin Show* booked disco acts all the time. Johnnie Taylor sang "Disco Lady" on the show in 1976. Sylvester presented Griffin with a copy of his gold record for the album *Step II* in 1978. On May 18 and 19 of that year, the talk show host held "A Two-Day Salute to *Thank God It's Friday* and the Resurgence of Nightlife in the '70s" to quote an ad for the episodes. Donna Summer, Paul Jabara, and Joey Travolta—John's older brother—headlined the first night, Village People, the second. The movie, starring Summer, opened that Friday.

Those two nightlife episodes of *Merv*, one of which included a disco dance contest, led to a pilot being shot for *Dance Fever*. Hosted by Deney Terrio, and later Adrian Zmed, the syndicated 1979—1987 show was the *Dancing with the Stars* of its day and was huge for promoting not just disco dancing to the mainstream but also Black disco talent to white audiences. On *Dance Fever*, Grace Jones, Sarah Dash, Chaka Khan, and Pattie Brooks appeared alongside such TV funnymen as Arte Johnson, Ron Palillo, Martin Mull, and Hervé Villechaize.

Solid Gold, which ran from 1980 to 1988, featured a who's who of musical performers including the disco artists Maxine Nightingale, Freda Payne, Sister Sledge, Peaches & Herb, Viola Wills, and the Bee Gees. Andy Gibb, the fourth brother, cohosted from 1980 to 1982.

Variety shows and specials—always eager to embrace popular music—especially loved disco. It was not uncommon, on any given night in the disco era, to see Ann-Margret, backed by chorus boys, putting a Las Vegas spin on Vicki Sue Robinson's "Turn the Beat Around," Goldie Hawn, surrounded by gymnasts, exercising to Village People's "Y.M.C.A.," Shirley MacLaine saluting "*le disco*" at the Lido in Paris by gyrating to Chic's "Dance, Dance, Dance," or Lesley Ann Warren singing Donna Summer's "Last Dance" to a pig on *The Muppet Show*.

Cher and Tina Turner, in matching fringe Bob Mackie dresses, brought Shirley & Company's "Shame, Shame, Shame" to primetime on a 1975 installment of CBS' *Cher*. *Donny & Marie* gave ABC audiences the Osmond siblings performing squeaky-clean Mormon versions of such songs as "Disco Inferno" and "Boogie Oogie Oogie" during its 1975—79 run. Even *The Carol Burnett Show* got hip with an original two-act musical called "Cinderella Gets It On!" that featured the Pointer Sisters singing "Dancing at the Disco Tonight" in 1975.

No variety show, though, did disco more memorably or more regularly than the 1976—77 *Brady Bunch Variety Hour*. One episode saw the cast, as their fictional sitcom characters, dressed in *Wizard of Oz* costumes singing "Car Wash." Another had the Bradys in silver sequins la-la-la-ing their way through "The Hustle." Visitors to this metaverse ran the gamut from Farrah Fawcett to Redd Foxx, Milton Berle to folk singer Melanie. Even Saturday morning character Kaptain Kool (Michael Lembeck) and his band of Kongs found themselves in the mix.

"All of the guest stars who came on really thought I needed a straitjacket," admits Sid Krofft, the always off-kilter puppeteer-turned-TV-producer responsible for *Donny & Marie* and *The Brady Bunch Variety Hour*, not to mention such mind-blowing Saturday morning fare as *H.R. Pufnstuf*. "But they all followed me into the craziness. I made sure every guest star got their moment and made sure that they would remember being on that show."

Krofft was responsible, too, for *The Paul Lynde Halloween Special*, a 1976 one-off that saw the *Hollywood Squares* star and Roz Kelly—Pinky Tuscadero of *Happy Days*—singing a rewrite of Johnnie Taylor's "Disco Lady" retitled "Disco Baby." As they sang, Witchiepoo (Billie Hayes) and the Wicked Witch of the West (Margaret Hamilton) danced with Tim Conway and Florence Henderson while the members of KISS looked on from a perch above.

You couldn't forget that if you tried.

Disco music made these shows seem hipper than they were.

Advertisers hoped disco would grab a younger audience. "If you were going for the youth market, you went for disco," explains Bruce Vilanch, whose many credits include writing for both *Donny & Marie* and *The Brady Bunch Variety Hour*. "We were doing disco versions of 'Toot, Toot, Tootsie, Goodbye'!" remembers Susan Olsen, who played Cindy Brady. "There was a surreal factor to the whole thing. But disco was a real building block of the show."

For plenty of other programs of the era too.

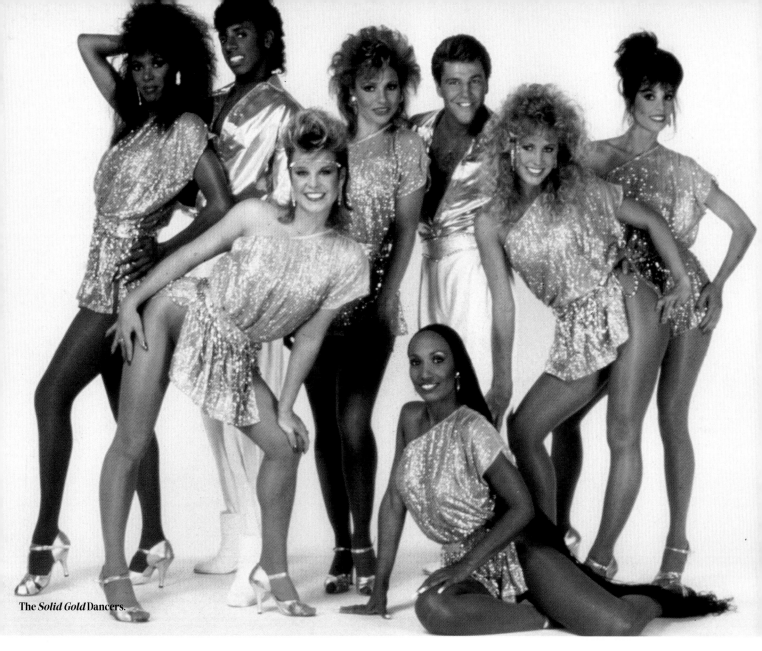

The *Solid Gold* Dancers.

Performers of all stripes went disco—from Lola Falana, who sizzled in her 1975 salute to disco on her first TV special, to Mary Tyler Moore, who fizzled in a 1978 spoof of *Saturday Night Fever* on her short-lived variety show, *Mary*. Even country music star Mac Davis played host to Donna Summer and KC and the Sunshine Band on his 1978 NBC special. "I like to get up now and boogie," he told a Mississippi newspaper.

Billboard explained such overkill in a story headlined "TV NETWORKS SUCCUMBING TO DOMESTIC DISCO FEVER." What Don Cornelius had been doing for Black audiences since the 1971 debut of *Soul Train*—"Bringing the raw funk and passion of Black neighborhood house parties into our living rooms," as Greg Tate wrote in the *Chicago Tribune* in 1994—mainstream shows tried to do as the seventies wore on. Cornelius continued to highlight Black artists. "What we did throughout the disco era was selectively play the best Black dance records and not get swept up in what was being called disco," he told Tate.

Others *were* swept up in the tide of disco TV, however.

On ABC, KC and the Sunshine Band invited viewers to "join the excitement of the discotheque phenomenon" with *Disco '76*. John Travolta was joined by his *Saturday Night Fever* castmates—not to mention Wayland Flowers, Penny Marshall, Cindy Williams, and the Bee Gees—on *Disco Fever!*, a 1977 special touted as "an exciting one-hour Hollywood event, saluting America's disco-mania."

Donna Summer hosted *The Midnight Special* in May 1978, welcoming guest stars Village People, Brooklyn Dreams, and Paul Jabara. The late-night music show

featured a salute to KC and the Sunshine Band. Meanwhile, in daytime, one of TV's oldest and whitest music shows got a makeover in September 1978 after more than twenty years on the air. An ad in *TV Guide* announced, "American Bandstand has a brand-new look and sound! Join Dick Clark and his special guests as *American Bandstand* goes disco!"

"They had to follow the trend," says singer France Joli, who appeared on numerous shows to perform her 1979 smash, "Come to Me." "The music was so popular that they would have missed out if they didn't have anybody from disco on their shows. It was just too big."

Clark had scored enormous ratings in primetime with *Le Disco*, a 1978 NBC special featuring the Spinners, Village People, eighty dancing couples, and a trapeze artist named Jann Ricca—because why not? It was shot in part at Studio 54, and *Billboard* predicted that programmers would be rushing to repeat its success. They were right. Turn on your TV and suddenly there was Disco Tex and the Sex-O-Lettes inviting you to "Get Dancin'."

Regional disco music shows began popping up, too. Bruce Pollack's 1979 guide *The Disco Handbook* listed more than a dozen such programs and suggested that readers "consult your local papers for day and time" to watch *Weekday Fever* in Cleveland, *Studio 78* in Washington, DC, *What's New* in St. Paul, *Feel Like Dancin'* in Montreal, and other shows in markets across the continent. In Toronto, it was *Downright Disco* that attracted big-name acts like Grace Jones. As one music blogger remembered it, "Local shows like these were shakin' ass and getting down and dirty like it's supposed to be done."

The Scene in Detroit asked viewers "Are you ready to throw down!?!" and the kids of the Motor City were. "Watching people our own age dance on TV in our hometown—it was must-see TV for us," remembers Nancy Plominski, a Detroit native who danced on two episodes of the show. "The Scene regulars were like celebrities."

Even *real* celebrities did these local shows. *Disco 23* in Albuquerque, for example, booked War—known for the 1975 hit "Why Can't We Be Friends?"—on an early broadcast. Such shows, *Billboard* noted, were "making waves on local commercial and cable stations throughout the U.S." and syndicators were watching them to find programming to bring to a national audience. Several shows were particularly successful in making the leap.

Disco Magic, shot in Florida, was a standout known for booking big-named acts like Lou Rawls and The Spinners. *Soap Factor Disco*, another popular syndicated program, shot segments in discos across the country. *Kicks* boasted such guests as Charo and High Inergy. *Hot City*, which aired on Metromedia stations, promised "a transparent dance floor pulsating with laser beams, sizzling with non-stop music" and guest appearances by Patrick Cowley, Martha Wash, and Linda Clifford. The show did so well that affiliates began airing it twice a week.

Showcasing musical acts on these eclectic shows was a much more natural way to bring disco to television. But networks tried everything. When they weren't platform-shoehorning disco plotlines into established shows, particularly crime dramas, they were creating new disco-flavored sitcoms. "Everybody tried to get into it in some way or another," Hughes remembers. Even *Supertrain*, the notoriously costly 1979 NBC flop that was a laugh-free Love Boat set aboard an atomic-powered locomotive, had a disco car with a light-up dance floor.

Some shows rerecorded their theme songs with new disco arrangements.

Guiding Light and *Edge of Night* gave their themes up-tempo mirror-ball makeovers. "*Guiding Light* fans still refer to it as the show's 'disco opening'," says Michael Maloney, Senior West Coast Editor of *Soap Hub*. In one of disco-on-TV's most meta moments, former *Love Boat* stowaway April Lopez (Charo) returned to the Pacific Princess in 1979 to cuchi-cuchi her way through an "exciting and new" disco version of the show's theme song before teaching Jerry Stiller how to do the New Latin Hustle.

One of disco's biggest influences, when it came to television, was on seventies sitcoms. The trend resulted in various shows—none particularly successful—about Italian American families, all modeled after the dysfunctional Manero clan of *Saturday Night Fever*, only funny.

NBC was the first to try to take the magic of that movie's family dynamic and turn it into a half-hour comedy with *Joe & Valerie*, a 1978 sitcom set in Brooklyn about a young plumber (Paul Regina) and a salesgirl (Char Fontane) who meet at a New York City disco and fall in love. A *TV Guide* ad read, "Joe Pizo figures he can out-dance and out-talk anybody. Tonight at the disco, he meets his match in Valerie Sweetzer." After seven episodes (the eighth one never aired) the series quickly went down the drain. "It was an average show with likeable stars in a tough time slot"—the network moved it twice, in fact—"and it just didn't work," says Hughes. Learning nothing from *Joe & Valerie*, the networks the following year offered up three *Fever*-ish sitcoms—*Makin' It, Flatbush,* and *Angie*—all with working-class Italian American protagonists. Each show featured someone connected to *Saturday Night Fever*.

Makin' It, set in suburban Passaic, New Jersey, cast David Naughton as Billy Manucci, a shy ice cream dipper whose brother Tony (Greg Antonacci) is the undisputed king of the Inferno disco. Ellen Travolta, John's sister, played their mother, Dorothy Manucci, although she was barely older than the actors playing her boys.

Created by Mark Rothman, Lowell Ganz, and Garry Marshall—the trio behind *Laverne & Shirley*—*Makin' It* sprang from the same source material as *Saturday Night Fever*, Nik Cohn's *New York* magazine article, and it had the blessing of the film's producer Robert Stigwood, which was why the show was able to use Bee Gees music. Still, *Makin' It* didn't. It lasted only nine weeks. Three months later, its theme song became a Top 5 pop hit for Naughton. In 2002, *TV Guide* ranked it at Number 40 on its "50 Worst Shows of All-Time" list.

Flatbush, set in that Brooklyn neighborhood and featuring Joseph Cali, who had played Tony Manero's buddy Joey in *Saturday Night Fever*, was touted as a good-natured ethnic comedy. But upon its debut, the show was criticized for its gross portrayals of New Yorkers. One particularly offended critic called the show's male characters—a gang called "The Fungoes"—a "stereotypical bunch of hyper-sexed greaseballs in tight shirts who do nothing but hang around together on street corners."

Brooklyn Borough President Howard Golden said his office had received dozens of calls protesting the show. According to the *New York Times*, he alerted CBS and complained that the sitcom "portrays one of Brooklyn's oldest and ambitious neighborhoods in an unrealistic and unflattering light." Anyone watching the show, he said, would think "Flatbush's main population is composed of semi-illiterate and threatening young boys." *Flatbush* was axed after *three* episodes.

Angie was a star vehicle for Donna Pescow, the actress who played Annette, the good girl in the pieced-rabbit-fur jacket who followed Tony around in *Saturday Night Fever*.

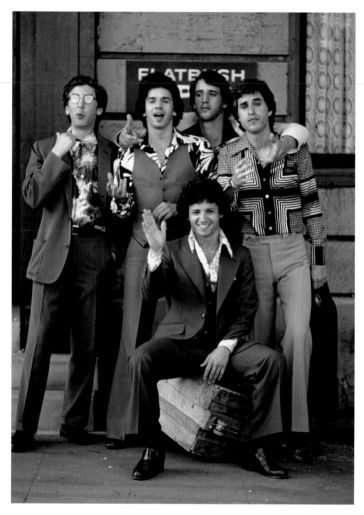

The cast of the ill-fated *Saturday Night Fever*-flavored comedy *Flatbush*.

At right, Char Fontane and Joe Regina of the short-lived sitcom *Joe & Valerie*, top: *CHiPs* star Erik Estrada busting a move, bottom.

About a waitress named Angie Falco who falls in love with a wealthy WASP pediatrician played by Robert Hays, who would have his own *Saturday Night Fever* moment in *Airplane!* in 1980, *Angie* was the most successful of the bunch. It lasted thirty-six episodes, was repeated in syndication and released on DVD.

It has two disco-related installments, but really, *Angie* was about her diner, his office, and their mismatched home lives. Ellen Travolta appeared twice here too. Paul Pape, who'd played Double J in *Saturday Night Fever*, appeared on one episode as Angie's old flame Vinnie Visicio. "Any time they would do a reference to the movie, it was always fun," says Pescow.

Meanwhile on established sitcoms, the embrace of disco usually *began* as fun for the main characters but always ended up causing problems. A *TV Guide* ad for *What's Happening!!* said everything: "Rerun enters disco contest . . . Hustles into trouble!" On *The Jeffersons*, George (Sherman Hemsley) developed "Every Night Fever." Poor Louise.

If the merging of disco-mania and situation comedy was difficult to get right, disco-flavored drama was even harder to pull off. A 1979 teen drama called *California Fever* was a West Coast–set, disco-flavored drama with a theme song that said its young cast, led by Jimmy McNichol and Lorenzo Lamas, would be "burning up the dance floor, burning up the street." But when *Tampa Tribune* TV critic Daniel Ruth reviewed the show he called it a "disgusting, vile, unconscionable waste of time." It lasted ten episodes.

Popular crime dramas found their disco vibe by setting episodes in nightclubs. "They would have a very special disco episode the way *Dragnet* had a very special episode about hippies," remembers pop culture writer Roger Catlin, who was working at the *Hartford Courant* at the time. Shows like *Starsky & Hutch, Police Woman,* and even *Barnaby Jones* wanted to seem in touch with pop culture, and audiences didn't mind the dancing. "People loved all the lights and the action," says Cheryl Ladd, who played Kris Munroe on *Charlie's Angels* and showed off her dance moves in a 1979 episode called "Disco Angels."

"Discos were a really good place to have crimes take place—not just the bright lights but everyone is wearing pretty clothes," says TV critic Mike Hughes. "They're great settings for something bad to happen." And bad things did! Discos were portrayed as venues where all sorts of nefarious activities happened. Disco DJs were psychos. Disco dancers were murderers. Even a TV movie as cornball as 1979's *Amateur Night at the Dixie Bar & Grill* featured a "Disco killer on the loose!" Discos themselves were often fronts for money laundering and other mob endeavors. Dancers were more likely to be bumped off in a TV disco than do the Bump.

The worst thing to happen in a small-screen disco came on *General Hospital* in 1979.

Teenager Laura Webber Baldwin (Genie Francis) was raped by bad boy Luke Spencer (Anthony Geary) at the Campus Disco while the sound of "Rise," trumpeter Herb Alpert's 1979 foray into disco music, was heard in the background. Laura ended up marrying Luke in 1981 in one of TV's most-hyped and most-watched weddings. The show was so hot by then that a Boston-based studio group called the Afternoon Delights released a disco/rap song called "General Hospi-Tale" which sent up and celebrated the show and became a Top 40 hit. "I just can't cope without my soap," they sang.

For a while, everything important on *General Hospital*—tragic or happy—took place at the Campus Disco. "At night, stories of love, romance, and conflict played out there as popular disco hits scored the scenes," remembers Michael Maloney of *Soap Hub.* "During daytime scenes, Richard Simmons, playing himself, taught workout classes to the women of Port Charles there. The Campus Disco was the show's regular hangout. When doctors and nurses completed their shifts, they'd head over there to continue playing out their dramas." But, oh, that rape.

Understandably, disco purists didn't like how nightclubs were characterized on television. Reporting from a March 1979 convention called "Disco Forum V," *Billboard* wrote that music-lovers "were not in favor of the way some melodramas like *Hawaii Five-O* portrayed discos as seamy, vice-ridden places." Still, these episodes made discos intriguing—even while suggesting you were taking your life in your own hands by going to one—and gave audiences the chance to see beloved disco performers on screen. TV didn't always do right by disco, but it did sweep up everyone in the enthusiasm and fuel record sales. Even after Laura's rape, "Rise" went to Number 1 on the *Billboard* Hot 100 chart and won the Grammy for Best Pop Instrumental Performance. No wonder everyone was eager to jump on the disco bandwagon.

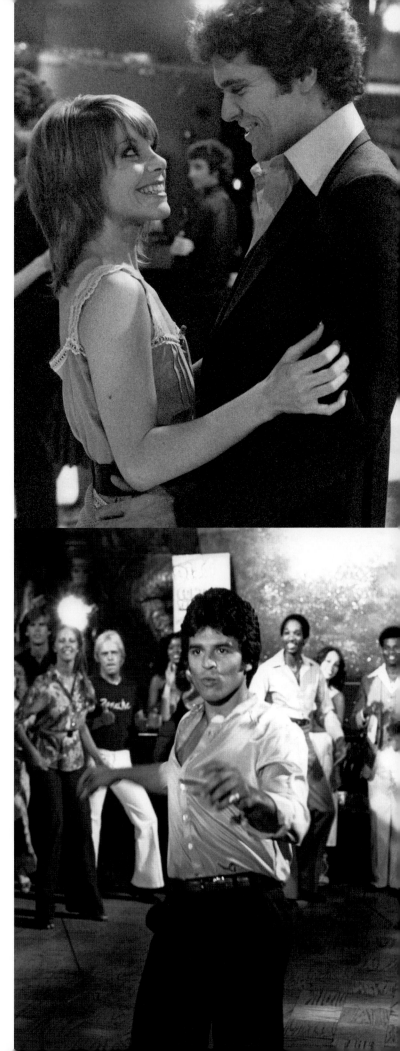

Very Special Disco Episodes

Disco made its way onto established TV shows, sometimes ingeniously, sometimes embarrassingly, beginning in the mid-seventies. Variety shows did it best, but cop shows, sitcoms, Playboy bunnies, an intergalactic beaver, and even Wonder Woman got into the game and danced their way into disco TV history. These are the must-sees.

THE CAROL BURNETT SHOW
SEASON 9, EPISODE 12: "CINDERELLA GETS IT ON!"
ORIGINAL AIRDATE: NOVEMBER 29, 1975

The TV funny lady's long-running variety show was always known for its mini-musicals, and none was more colorful than "Cinderella Gets It On!"—a disco retelling of the classic story about love, loss, and shoes. Featuring the show's ensemble and guest stars the Pointer Sisters, the two-act update cast Burnett as Cinderella, a cheerful drudge who wants to go to a party at the Rock Palace, a disco ruled by prince Elfin John (Tim Conway). She asks her Fairy Godmother Marcus (Harvey Korman in drag) to turn her into "a chick who'll blow your mind, Tina Turner and Cher combined." Long fairytale short, a smoking hot Cinderella shows up, leads the crowd in a new dance called "The Shlump," and wins Elfin's heart. On the way out the disco door at the crack of noon, she loses a platform shoe. The besotted prince goes in search of the footwear's owner, but when he meets Cinderella in her regular guise, he rejects her. Fairy Godmother Marcus saves the day, not by giving Cinders another makeover, but by magically transforming Elfin into a nerdy door-to-door salesman perfectly suited to the title frump.

LOLA!
EPISODE 1
ORIGINAL AIRDATE: DECEMBER 18, 1975

Ads for this four-episode ABC variety show described Lola Falana as a "hand grenade of a woman" and they didn't exaggerate. The singer-dancer-actress exploded onto the American TV scene with this show, after having made a splash on Broadway, been featured in films, and achieved, of all things, stardom on Italian television. Not bad for a girl from New Jersey! She was no stranger to disco, either, having penned her own 1975 hit "There's a Man Out There Somewhere." On the first installment of her variety show, Falana invited viewers to "do the Bump and the Hustle to the disco sound" with her and the Lester Wilson dancers. Critics raved about this "showstopping discotheque number," calling it "sizzling" and "a winner." It was so hot, in fact, that the *Christian Science Monitor* blamed the dancing for the show's ten o'clock time slot. "Obviously, somebody figured that sophisticated disco routines fit better into the late-night hour," their critic wrote. What did he expect from the spokesmodel for Tigress perfume, the Hokey Pokey?

POLICE WOMAN
SEASON 3, EPISODE 15: "THE DISCO KILLER"
ORIGINAL AIRDATE: JANUARY 25, 1977

When a record company executive (Jon Cypher) is murdered, sexy sergeant Suzanne "Pepper" Anderson (Angie Dickinson) assumes the identity of a woman who witnessed the shooting, the estranged daughter of a once-famous big band singer named Lila Mercer (Ruth Roman). Although set in the music industry, the episode has little to do with actual disco—or big band sounds, for that matter. But the title is smoking hot and, as always, so is Dickinson. A few months later, when a Season 1 episode about a dead go-go dancer was rebroadcast, ads promised, "Undercover 'Pepper'—bait for a disco killer!" That installment was even less disco, but that word made the old case sound au courant.

CHARLIE'S ANGELS
SEASON 1, EPISODE 19: "DANCING IN THE DARK"
ORIGINAL AIRDATE: FEBRUARY 23, 1977

To foil an extortion scheme, Jill (Farrah Fawcett) goes undercover as a disco dance teacher, Kelly (Jaclyn Smith) plays detective, and Sabrina (Kate Jackson) poses as an awkward heiress taking dance lessons. With sexy instructor Tony Bordinay (Dennis Cole) on her arm—and her two left feet on his two feet—Bri hits such real-life Los Angeles nightspots as Disco 9000. Later, back at the office, Jill shows Bosley (David Doyle) how to do the Bump, then asks her boss, via speakerphone, "Charlie, do you Hustle?"

THE BRADY BUNCH HOUR
SEASON 1, EPISODE 7
ORIGINAL AIRDATE: APRIL 25, 1977

This variety show starring the seventies' favorite fictional family had many disco moments in its short run: The Hudson Brothers sang "Disco Queen," Tina Turner twirled to "The Rubberband Man," Ohio Players smoked with "Fire." But when the regular cast—few of whom could sing or dance particularly well—went disco, the show was *really* something to behold.

Whether the gang was gyrating through a disco mash-up of "Baby Face" and "Love to Love You Baby," or shaking their you-know-whats to "Shake Your Booty," it was madness. In Episode 7, the series hit the disco motherlode.

The cast sang "Turn the Beat Around," "Enjoy Yourself," "Disco Lucy," and "You Make Me Feel Like Dancing." Then the kids from *What's Happening!!* performed "Dancing Machine," DJ-turned-novelty-act Rick Dees sang both "Dis-Gorilla" and its better-known cousin "Disco Duck." And, because all that wasn't enough, Alice the maid (Ann B. Davis) and her flamboyant boyfriend, played by confetti-tossing comedian Rip Taylor, squeezed the last bit of juice out of "Tangerine" while dancing in enormous disco duck costumes. Drake in concert it wasn't.

STARSKY & HUTCH
SEASON 4, EPISODE 1: "DISCOMANIA"
ORIGINAL AIRDATE: SEPTEMBER 12, 1978

Southern California detectives Starsky (Paul Michael Glaser) and Hutch (David Soul) go undercover at Fever to catch a swivel-hipped sicko named Tony Mariposa (Pierrino Mascarino) who just can't take rejection. Say no to the hairy-chested, gold chain–wearing Tony Manero wannabe when he asks you to dance, and you'll end up dead in the trunk of his Mercedes! "You should have danced with me, Sharon. You should have loved me," he says. Oh, please. Tony's not only a melodramatic murderer, he's also lousy on the dance floor, especially the one in his tricked-out home basement. The soundtrack sizzles, though—"Disco Inferno," "Macho Man," and "Miss You" are heard—and the episode marks the TV debut of Adrian Zmed as Marty Decker, the kind of dancer Mariposa wishes he could be.

WHAT'S HAPPENING!!
SEASON 3, EPISODE 2: "DISCO DOLLAR DISASTER"
ORIGINAL AIRDATE: SEPTEMBER 21, 1978

Cash-strapped Watts teenager Freddy "Rerun" Stubbs (Fred Berry) wants to compete in a disco dance contest at the Parisian Room, but there's one problem: the $25 entrance fee. His two besties Raj (Ernest Thomas) and Dwayne (Heywood Nelson) have only $2.14 between them, so they sell shares in Rerun to raise money. They unload so much stock, though, that if Rerun wins, they'll lose their shirts. Thank heaven, handsome Danny Domino (Ralph Wilcox) outdances round-

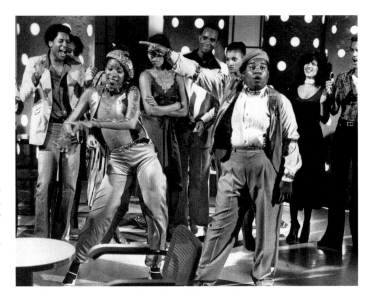

bodied Rerun. "He looked like *Saturday Night Fever*. I look like the Monday Morning Blues," the dejected dancer says. Maybe so, but in real life, Berry was a popping and locking legend—an agile member of the Lockers funk dance troupe—who served as a "dance consultant" on this episode. Nancy Sinclair provided the "disco choreography."

MARY
SEASON 1, EPISODE 3: "SATURDAY NIGHT VIRUS"
ORIGINAL AIRDATE: OCTOBER 8, 1978

After starring in back-to-back classic sitcoms—*The Dick Van Dyke Show* and her own eponymous series—Mary Tyler Moore tried her hand at a new format, the variety show. Critics hated it. Although the short-lived program gave many viewers their first glimpses of Michael Keaton, David Letterman, and Swoosie Kurtz, all fresh faces when cast on the show, it also gave viewers of the third and final episode Moore impersonating Tony Manero—white suit, paint can, disco balls, and all. *Staying Alive* was a less embarrassing sequel than "Saturday Night Virus." Looking back on Mary in 2013, Vulture writer Ramsey Ess described the sketch as "a way-too-long, gender-swapped parody of *Saturday Night Fever* that features multiple disco-dance numbers, relatively few jokes, and Mary Tyler Moore trying really hard and failing really hard to do a John Travolta accent." TV diehards will recognize comedian Dick Shawn, another Mary regular, hustling along with Moore. Footage from the sketch is shown during the end credits of the 2023 HBO Documentary film *Being Mary Tyler Moore*.

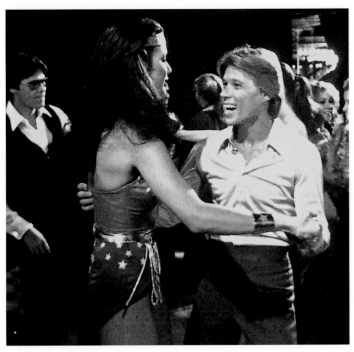

Whether it was Wonder Woman, above, Barnaby Jones, right, or Rerun on *What's Happening!!*, opposite page, everyone was doing the Hustle.

THE NEW ADVENTURES OF WONDER WOMAN
SEASON 3, EPISODE 5: "DISCO DEVIL"
ORIGINAL AIRDATE: OCTOBER 20, 1978

In her human guise as Diana Prince, spinning superhero Wonder Woman (Lynda Carter) slips into the hot Washington DC nightspot Styx to discover that a disco-dancing mind-reader (Michael DeLano) in a white *Saturday Night Fever* suit is stealing classified information through telepathy. "OK, I'll probe his mind and then I'll split. I have a life of my own to lead, you know," the polyester paranormal tells his boss. Hey, they don't call this *The New Adventures of Wonder Woman* for nothing! "Who would suspect a disco fronting for a black-market information broker?" Diana says. Well, everyone watching the show. But what this episode lacks in suspense, it makes up for in pop culture cross-pollination. Wolfman Jack, the *Midnight Special* announcer and radio and TV personality, plays the club's raspy-voiced DJ, Infra Red, and Dennis Stewart, who drag raced against Danny Zuko in *Grease*, is a dancer who hounds Diana for a Hustle. "Hey baby, you're good! You want to boogie?" he asks. Buddy, this princess has two personalities and neither wants to dance with you.

HAWAII FIVE-O
SEASON 11, EPISODES 12-13: "NUMBER ONE WITH A BULLET"
ORIGINAL AIRDATES: DECEMBER 28, 1978 AND JANUARY 4, 1979

Honolulu-born disco star Yvonne Elliman, whose Bee Gees-penned hit "If I Can't Have You" was featured on the soundtrack of *Saturday Night Fever*, plays Yvonne Kanekoa, an aspiring singer predicted to be "the first native Hawaiian to make it big on the mainland." Business at her brother's disco, Sonny K's, is bustling and the *kumu*, as the mob is known, want a piece of the action. Sonny (Richard Dimitri) can't say no to the thugs who infiltrate the place. How's the disco business on the island? "It's big, it's hot, and plenty money," Sally (Melveen Leed), an old-school Hawaiian club owner, tells Det. Steve McGarrett (Jack Lord). He'll do anything—well, not the Funky Chicken—to prevent a gang war on his island. When the two-part episode originally aired, the soundtrack featured the Bee Gees hits "Stayin' Alive," "More Than a Woman," and "Night Fever," plus "Manhattan Skyline" by David Shire, also on the *Fever* soundtrack. Soundalikes have replaced them on the streaming service, Paramount+.

BARNABY JONES
SEASON 7, EPISODE17: "DANCE WITH DEATH"
ORIGINAL AIRDATE: JANUARY 25, 1979

J.R. Jones (Mark Shera), Barnaby's handsome young nephew, takes the lead in an investigation centered on a disco called Scandals when Felicia (Madeleine Fisher), the former roommate of a dancer named Penny (Sandra Kerns), is murdered. "That disco where she hangs out, she meets a lot of weirdos," says the victim's husband Carl (Dawson Mays). Penny fears she may have been the real target. But she's wrong—the bullet was meant for Felicia after all. Carl had hired Penny's dancing partner, Gary (John O'Connell), to pull the trigger. In the end, Penny is doing the Hustle with Barnaby himself, giving series star Buddy Ebsen, then seventy-one, the chance to remind audiences that he began his career as a hoofer on Broadway. In a *New York Daily News* story a few weeks before the episode premiered, Ebsen had complained, "I'd love to dance as a guest star on a variety show, but no one has asked me."

CHARLIE'S ANGELS
SEASON 3, EPISODE 15: "DISCO ANGELS"
ORIGINAL AIRDATE: JANUARY 31, 1979

When a series of strangulation murders is linked to a beachfront nightspot called Freddie's Disco, the Angels go undercover to catch the killer. Sabrina (Kate Jackson) poses as a writer for *Disco* magazine, Kelly (Jaclyn Smith) as a representative for Angelic Records, and Kris (Cheryl Ladd) as the dance partner of the club's resident hottie, Mario Montero (Gregory Rozakis). "I was a disco fan and I worked with the actor on a few moves," Ladd remembers. From the DJ booth, turntable wizard Harry Owens (Zalman King) spins such hits as "Disco Inferno" and "Dance, Dance, Dance" while oozing over the loudspeaker, "Uncle Harry's watching you!" If that's all he was doing, it would be fine. But Harry is also killing older men who remind him of his disco-disapproving father, who thinks he's a failure for spending his life at "that club for fools who never work." Will Mario's father Hector (Titos Vandis), the so-called Latin Fox who teaches disco dancing at a senior facility, become his next victim? Not if the Angels can stop him. Under arrest, crazy Harry screams, "Without me, they are nothing!" But back at the club, the disco music keeps playing. "I remember it being a long but mostly fun day," Ladd says.

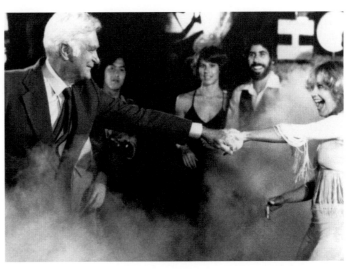

THE LOVE BOAT

SEASON 2, EPISODES 18-19: "ALAS, POOR DWYER/AFTER THE WAR/ITSY BITSY/ TICKET TO RIDE/DISCO BABY"

ORIGINAL AIRDATE: FEBRUARY 3, 1979

Disco dance teacher Joey (Michael Lembeck) has better luck getting cruise director Julie McCoy (Lauren Tewes) to shake her groove thing than Doc Bricker (Bernie Kopell) does with passenger Bitsy Sheldon (Conchata Ferrell). "Bitsy, you give me that *Saturday Night Fever*," he flirts. "Well, take two aspirins and call me in the morning," she replies. Once Joey teaches the cast to dance on deck, Julie announces that "the captain's been getting such a kick out of all this dancing that he wants to do a really funky disco on the last night!" At the farewell party on the Riviera Deck, a reluctant Gopher admits, "Disco isn't my scene, but if they play a slow polka, you'll really see me get down!" Still, Julie persuades him to do the Bump. Joey makes a splashy entrance in full Tony Manero gear and leads passengers in the Circle Hustle. Then his girlfriend Sherry (Lisa Hartman) reveals that she's pregnant. To support their new disco baby, the couple plans to open a dance academy once they get home. "We want you to be the first student at our new disco school," Sherry tells Captain Stubing (Gavin MacLeod).

When the episode first aired, Lembeck watched it at a viewing party with close friends, one of whom was John Travolta. "He'd just become the biggest star in the world, and now he's going to watch me on the dance floor, doing him," Lembeck remembers. "I did the best I could, but he had trained a really long time for that movie. John was rolling around on the floor laughing and I was laughing. It's a really big, wonderful, entertaining, delicious memory for me."

DISCO BEAVER FROM OUTER SPACE

HBO SPECIAL

ORIGINAL AIRDATE: FEBRUARY 23, 1979

With Harry Shearer among the writers, and Lynn Redgrave and Rodger Bumpass (Squidward Tentacles on *SpongeBob SquarePants*) among the cast, this *National Lampoon* comedy mash-up treated early HBO adopters not only to scenes of an intergalactic, semiaquatic rodent with its own disco theme song dancing in New York's Central Park but also an effeminate vampire named Dragula, who, with only a nibble, turns a "mucho macho man" into a marvy mincing Mary. One bite from the sibilant succubus—a bloodsucking "hemosexual"—and the hirsute hard hat gushes, "Say, toots, let's hit the baths! I'll call the other girls!" There's also Alice Playten as a Perrier addict. *Newsday* TV critic Marvin Kitman called it "sick, degraded, perverted" and "the funniest comedy program of the year on any form of television."

THE JEFFERSONS

SEASON 5, EPISODE 21: "EVERY NIGHT FEVER"

ORIGINAL AIRDATE: MARCH 28, 1979

After visiting a new nightspot called Dirty Betty's, George Jefferson (Sherman Hemsley) contracts "disco fever," and, with neighbor Helen Willis (Roxie Roker) as his partner, the everyday dry cleaner becomes an every-night dancing machine. His nickname? Motor Hips. "Disco is my thing and I'm doing it to death," George says. But after being stuck home night after night, his lonely wife Louise (Isabel Sanford) puts her foot down. "When George comes through that door," she threatens, "I'm going to pluck the feathers off that little disco duck." The episode ends with another neighbor, Mr. Bentley (Paul Benedict), walking on an exhausted George's sore back while singing "Shake Your Booty." "People always loved to watch George dance" remembers *Jeffersons* writer-producer Jay Moriarty. "He just gets down and gets into it." Upon Hemsley's 2012 death, cultfilmfreaks.com paid tribute to the actor by singling out this episode. "It's a pop culture fact," they wrote, "that George Jefferson had moves."

SUPERTRAIN

SEASON 1, EPISODE 9: "WHERE HAVE YOU BEEN BILLY BOY"

ORIGINAL AIR DATE: MAY 5, 1979

It was *The Love Boat* crossed with an Irwin Allen disaster movie—a big-budget trainwreck of a TV series that nearly bankrupted NBC. It was *Supertrain* and it was set aboard a chichi choo choo that was so big and so smooth, it had a disco onboard. The cast, led by Edward Andrews and Robert Alda, didn't matter. The nuclear-powered locomotive was the star. From the moment it left the station, *Supertrain* was a super-mess, changing its tone from an adventure dramedy to a romantic comedy after only a few episodes. But the "All-New" *Supertrain* was just as bad. Sure, there were fun guest stars—Dick Van Dyke as a would-be hitman, Rue McClanahan as a feminist journalist, Zsa Zsa Gabor as a diamond-studded

socialite—but the series limped to its last stop. On the final episode, "Where Have You Been Billy Boy," there's a dance contest, and a performance by Disco Flo & The Rhythm Skaters, a Las Vegas roller-disco group who are as forgotten as this series. "Can you imagine a train with a disco? Give me a break!" said Ilene Graff, who played a crewmember named Penny on the show, in 2022. Then again, she added, "People do all sorts of things on the subway. If you're a really good roller-skater, I guess you can handle any venue." Even a futuristic train going two hundred miles per hour.

CHIPS

SEASON 3, EPISODES 1-2: "ROLLER-DISCO"

ORIGINAL AIRDATE: SEPTEMBER 22, 1979

While roller-skating robbers are wreaking havoc at the beach, California Highway Police officer Frank Poncherello (Erik Estrada) is drafted to be entertainment chairman for the CHP's annual "Skate with the Stars" benefit. Meanwhile, in this two-part episode-on-wheels, teen singing idol Leif Garrett, known for the 1978 disco hit "I Was Made for Dancin'," plays teen singing idol Jimmy Tyler. There's also a mime on skates, a roller-disco teacher who enthuses, "You'd be surprised how many important people have taken it up!" and a thief in a pair of platform shoes with retractable wheels for making a snatch-and-roll getaway. For the finale, a panoply of seventies stars—Melissa Sue Anderson, Ruth Buzzi, Wesley Eure, Antonio Fargas, Dody Goodman, Nancy Kulp, Dana Plato, Brett Somers, Vic Tayback, Cindy Williams, and Jo Anne Worley among them—take their turns on the rink. "We thought we were in Studio 54," remembers Larry Wilcox, who played Officer John Baker. "Everybody was on roller skates making an ass of themselves in some cases, and others really talented. It was a great couple of episodes." Certainly, it was more fun than when they had to deliver a baby in a discotheque in Season 2.

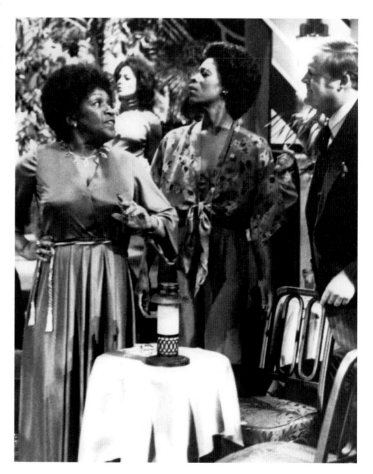

The Jeffersons came down with a bad case of "Every Night Fever," above. Opposite, a stand-up cutout of die-hard rocker Dr. Johnny Fever dressed for his worst nightmare on *W.K.R.P. in Cincinnati*.

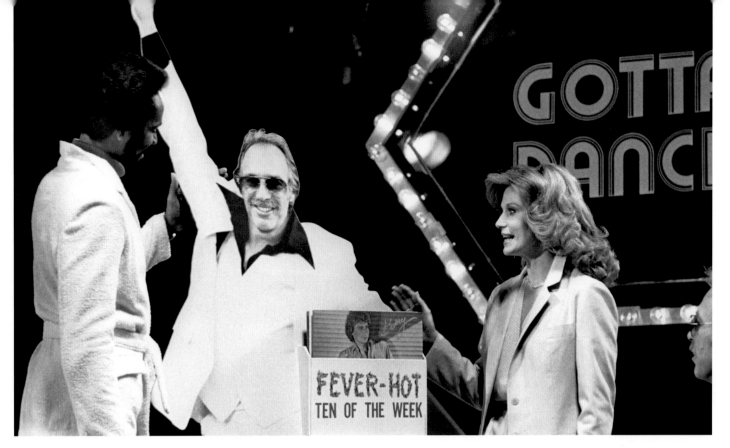

PLAYBOY'S ROLLER-DISCO & PAJAMA PARTY
ABC SPECIAL
ORIGINAL AIRDATE: NOVEMBER 23, 1979

Richard Dawson of *Family Feud* was the host, and Chuck Mangione, Wayland Flowers and Madame, and Village People were the entertainment. But the real draw of the show was *Playboy* founder Hugh Hefner and five "future playmates" in all their jiggling glory. No wonder the *Boston Globe* called it "the sleaziest special of the year." Other critics called the show a "wild affair," and teased "This should prove to be some party!" At the Playboy Club in Chicago that night, it was. Keyholders wore their "most alluring bedroom attire" to a screening that included a "Best Jammies" contest, fifty-cent "Bedtime Story" drink specials, door prizes, disco dancing, and breakfast. One St. Paul, Minnesota, anchorman, though, was so infuriated by what he saw onscreen that he criticized the special *during* its broadcast. "For those of you who may have turned off your television sets in disgust," he harumphed during a newsbreak, "I want to assure you we'll be back in thirty minutes with the local news." *Newsday* TV critic Marvin Kitman had a better take: "You come to laugh at shows like *Playboy's Roller Disco & Pajama Party* and you wind up with a sense of awe and history. This is what it was like in the final days of the Roman Empire."

EISCHIED
SEASON 1, EPISODE 7: "THE DANCER"
ORIGINAL AIRDATE: NOVEMBER 23, 1979

A swivel-hipped serial killer (Christopher Connelly of *Peyton Place*) dons a wig, fake mustache, and a white Tony Manero suit before heading off to a disco to prey on gorgeous women in "The Dancer," the seventh episode of this short-lived NBC crime drama starring Joe Don Baker (*Walking Tall*) as New York City chief of detectives Earl Eischied. Originally airing opposite the *Playboy* special (above), this lurid installment gave viewers a Hustling huntsman who tattoos his beautiful victims to make them look ugly and then rapes and murders them. TV listings didn't exaggerate when they called him a "deranged disco dancer." Bibi Besch (*Star Trek II: The Wrath of Khan*) also appears.

ANGIE
SEASON 2, EPISODE 16: "THERESA'S GIGOLO"
ORIGINAL AIRDATE: FEBRUARY 4, 1980

A down-to-earth Philadelphia waitress who marries into money, Angie Falco (Donna Pescow of *Saturday Night Fever*) worries when her mother Theresa (Doris Roberts) decides to take a dance class. "Disco lessons at my age?" Theresa asks at first. But soon her rallying cry becomes "C'mon let's boogie!" Before long,

she's competing in a disco contest at the studio with Gianni (Tim Thomerson)—a dance partner of whom Angie does not approve. The younger Falco calls him a "blond counterfeit Italian." Earlier in the season, Angie did the disco dancing, hustling with Maxie, played by recurring guest star Adrian Zmed. The agile actor had disco danced on *Starsky & Hutch* (see page 150). "I was the poor man's John Travolta," Zmed told me in 2023.

THE LOVE BOAT
SEASON 4, EPISODE 7: "THE HORSE LOVER/SECRETARY TO THE STARS/JULIE'S DECISION/GOPHER AND ISAAC BUY A HORSE/VILLAGE PEOPLE RIDE AGAIN"
ORIGINAL AIRDATE: NOVEMBER 22, 1980

The Village People board *The Love Boat* and immediately launch into one of their hits. "I knew if we sang 'In the Navy' long enough, we'd get here," quips Alex Briley, the band's G.I. "They seem like a regular bunch of fellows," Captain Stubing (Gavin MacLeod) observes. The guys have a horse called Magic Night entered in the Acapulco Steeplechase, so they sing "Magic Night" from *Can't Stop the Music*, and the passengers go nuts. Later, Felipe Rose, the Village People Native American, competes in the horserace against Gopher (Fred Grandy), who's riding Captain Stubing—the horse he and Isaac (Ted Lange) bought, not MacLeod. Spoiler alert: Magic Night is "the winner by a feather." In the end, Rose trades his headdress for Captain Stubing's cap. "I always wanted a kinky lid like this!" the singer says. In its TV listings, the *Vancouver Sun* described the episode's unlikely plot and added, "This is not made up."

WKRP IN CINCINNATI
SEASON 3, EPISODES 13-14: "DR. FEVER AND MR. TIDE"
ORIGINAL AIRDATE: FEBRUARY 7, 1981

Radio disc jockey Dr. Johnny Fever (Howard Hesseman) takes a TV gig to pay his alimony, but to his horror, it is as the host of a disco-music program called *Gotta Dance*. "I can't play this stuff!" the dyed-in-the-denim rocker says. But his producer (Mary Frann) won't let him out of his contract. Instead, she gives him new clothes. "I'm supposed to wear these? What if people are eating while they're watching?" he complains. Later, Fever says, "I don't do disco." But when he gets a taste of real fame as his disco alter ego, Rip Tide, he starts wearing a rhinestone-studded jacket, a metallic tank top, and satin pants, and enthusiastically introducing "Xanadu." He may have sold out, but Rip's a smash. "He's the hottest thing to hit Cincinnati since Rosemary Clooney," says radio colleague Les Nessman (Richard Sanders). It turns out that Fever may be suffering from disco-induced schizophrenia. In the end, though, Tide is trounced when Fever plays a rock song on the disco show and is fired. "Like the man says, it's got to be rock 'n' roll music if you want to dance with me," a victorious Fever says. Whatever.

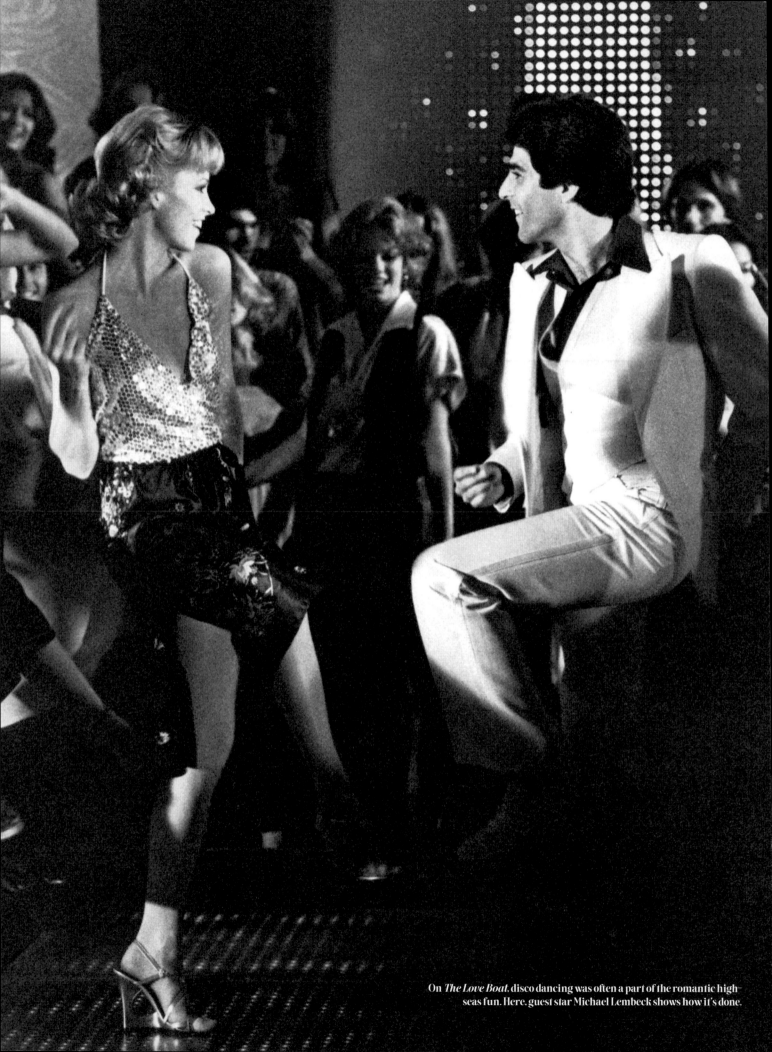

On *The Love Boat*, disco dancing was often a part of the romantic high-seas fun. Here, guest star Michael Lembeck shows how it's done.

Classic TV Themes Gone Disco

Disco hits could be drawn from anywhere – even primetime television. Whether it was the seriously funky "Theme from S.W.A.T." by Rhythm Heritage in 1975, the supremely silly "Flintstone Disco" by the Universal Robot Band in 1977, or the inexplicably misspelled "Fantasy from Mortishia to Gomez Addams" by Destination in 1979, you could dance to your favorite show and, as those robots sang, have a "yabba dabba *dooba* time" doing it.

"MARY HARTMAN, MARY HARTMAN" BY VARIOUS ARTISTS, 1976—77

The theme to Norman Lear's syndicated nighttime soap opera spoof was discofied by Sammy Davis Jr., Floyd Cramer & the Keyboard Kick Band, and The New Marketts. But two other outfits found the greatest success with the song. The all-female band The Deadly Nightshade cracked the Top 100 with their version in 1976. It included such typically mundane dialogue as "Would you like some coffee? Is freeze-dried all right?" Meanwhile, Vince Montana, a member of MFSB and founder of the Salsoul Orchestra, produced a rendition credited to Sounds of Inner City. He enlisted the crackerjack Tom Moulton to craft a more-than-six-minute mix of the song. Every version—even Cramer's—was way too hip for Fernwood, Ohio.

"THOSE WERE THE DAYS" BY SAMMY DAVIS JR., 1977

His 1972 appearance on *All in the Family*, in which he kissed lovable bigot Archie Bunker, is legendary. But Sammy Davis Jr.'s 1977 disco version of the show's theme song, not so much. The consummate Vegas entertainer recorded a dance version of "Those Were the Days" for an album called *Sammy Davis Jr. Sings the Great TV-Tunes*. The disco rendition leads off an eclectic stream of themes: a gospel version of "Movin' on Up" from *The Jeffersons*, a funky "And Then There's Maude" from *Maude*, an easy-listening "Love is All Around" from the *Mary Tyler Moore* show. None are as well-remembered as Davis's 1976 version of "Keep Your Eye on the Sparrow," the theme to *Baretta*.

"DISCO LUCY" BY WILTON PLACE STREET BAND, 1977

When a couple of music publishers suggested that musician Trevor Lawrence record a dance version of the *I Love Lucy* theme, he formed the Wilton Place Street Band and "Disco Lucy" was born. The familiar melody and the record's exuberant call to "dance, dance, Disco Lucy!" made it a surprise hit of 1977. "When you do these things, you never know what's going to happen to them," Lawrence said in 2022. The track peaked at Number 24 on *Billboard*'s Hot 100. "Somebody said that Lucy was in Florida, and she wanted a copy of the record, so I had to go find her one," he remembered. Even Desi Arnaz, Lucy's former husband on-screen and off, approved. "I like it," the Cuban conga player said at the time. "It's tongue-in-cheek to a certain extent," Island Records publicist Steven Rea told Knight Newspapers in 1977, "but with the highest musical integrity." Lawrence, who had played sax with the Butterfield Blues Band at Woodstock, went on to cowrite the 1982 Pointer Sisters smash "I'm So Excited." Meanwhile, a different "Disco Lucy" was released by the New York Rubber Rock Band in 1976 as a medley with a song called "Desi's Samba." It disappeared faster than Aunt Martha's Old-Fashioned Salad Dressing.

"DR. WHO" BY MANKIND, 1978

Inspired by the 1977 success of Meco's disco *Star Wars*, producer Don Gallacher put together Mankind to create a disco version of the theme to *Doctor Who*, the hit British sci-fi series starring Tom Baker. (He was the fourth doctor, the one with the scarf.) The band performed the tune, complete with a twirling TARDIS, on *Top of the Pops*. According to Dave Thompson's 2013 guide *Doctor Who FAQ*, the "spacey, dancey, thumpy version" was the first *Doctor Who*–related song to chart, hitting Number 25 in Britain. The song, and other related tracks, were remixed and reissued on blue vinyl to celebrate the show's fiftieth anniversary in 2013. "These were the sounds I could only dream about in 1978," Gallacher said.

"TWILIGHT ZONE/TWILIGHT TONE" BY MANHATTAN TRANSFER, 1979

Before hitting it big with their 1981 cover of "The Boy From New York City," the jazz vocal group Manhattan Transfer released a disco reworking of the theme to the 1959—1964 sci-fi classic *The Twilight Zone*. Featured on their 1979 album *Extensions*, the song incorporated the famous *Zone* tones with original lyrics raving about how chillingly fabulous the original was. "Out of nowhere comes this sound, this melody that keeps spinning 'round and 'round . . ." You get the idea. One problem: the record credits Bernard Herrmann, who'd written *a* theme to the *Twilight Zone*, but not the one everyone knows. French modernist composer Marius Constant did and, according to a 2019 *Slate* investigation, made only $700 for his trouble. Let it be known that it was Constant's four notes—not Herrmann's—that propelled "Twilight Zone/Twilight Tone" to Number 4 on the *Billboard* disco charts and Number 30 on the Hot 100.

"LOVE BOAT THEME" BY JACK JONES, 1979

Anyone who has seen *The Love Boat* knows the iconic 1977—1986 TV show's theme song, sung by Jack Jones for the first eight seasons of the show. But few remember that the crooner released a disco version of the song. The track, which featured background singers emoting "Love Boat! Love Boat!," kicked off his 1979 album *Nobody Does It Better*. Sung with "energy and well-syncopated rhythm," as one review said, the disco remake of the TV theme worked. Unfortunately, the album also included a dance version of "Wives and Lovers," a remake of the Burt Bacharach/Hal David song for which Jones in 1964 beat out Ray Charles, Andy Williams, and Tony Bennett for the Best Male Pop Vocal Performance Grammy. Critics didn't warm to that one. As one Spokane, Washington, writer proclaimed in 1979, "That song is a classic and it was never written to be sung like this." An album review in the *Pittsburgh Post-Gazette* was even meaner: "For fans of this middle-of-the-road giant, nobody *can* do it better. For everyone else, nobody can do it duller."

"THINK!" BY MERV GRIFFIN, 1984

Merv Griffin wasn't just the singer of the 1950 novelty hit "I've Got a Lovely Bunch of Coconuts," a popular TV talk show host from the sixties to the eighties, the creator of two of America's most enduring game shows—*Jeopardy!* and *Wheel of Fortune*—and the producer of the hit disco TV show, *Dance Fever*. He was also a composer.

In 1963, he wrote what would become his most famous song, a lullaby for his son called "A Time for Tony." When Griffin renamed it "Think!" and repurposed it as the *Jeopardy!* theme the following year, it became iconic. The pop culture earworm is still heard during the final round of *Jeopardy!* today, but few remember that a disco version of the song, clocking in at about two minutes long, was included on Griffin's 1984 album *Escape*.

The dance rendition was no hit, but Griffin didn't care because the original was such a windfall. "That little thirty seconds has made me a fortune!" he told the *New York Times* in 2005, two years before his death. While the disco version of "Think!" is forgotten—not to mention Griffin's 1976 dance composition "Frisco Disco"—the TV theme continues to generate royalties, now estimated at $100 million. As they say on *Jeopardy!*, "What is a cash cow?"

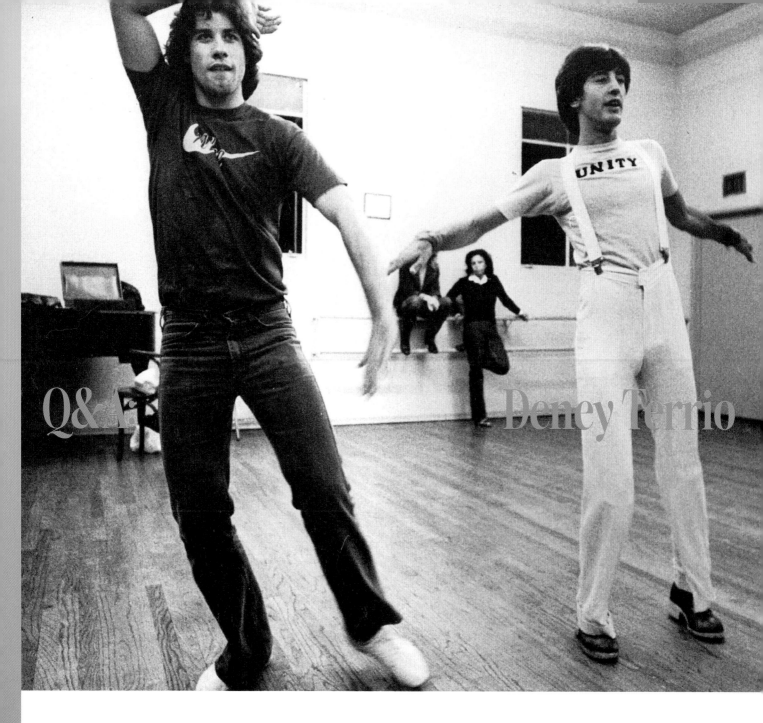

Deney Terrio is the King of Disco Television and if it hadn't been for him, the King of Disco Movies—John Travolta—might never have soared to the heights he did in *Saturday Night Fever*. Since the early 1970s, the choreographer and on-air personality has reigned supreme on the dance floor, first as a member of the pop-and-lock dance troupe known as the Lockers, then as Travolta's dance coach, and finally as the host of *Dance Fever*, the syndicated TV competition which ran for eight years beginning in 1979.

Few entertainers—especially those who don't sing—are as synonymous with the genre as he is. Terrio, who grew up in Florida before making his name in Hollywood, was so disco he even played what he calls a "disco wolf" on *The Love Boat*. "A big stretch," Terrio says. These days, he still frequently sets sail, spreading disco love and dancing up a storm aboard disco-themed cruises. "It's that four-four beat that just pounds you," he says.

Disco choreographer and *Dance Fever* host Deney Terrio rehearses John Travolta for his breakout role in *Saturday Night Fever*.

FDC: "How did your career as a performer begin?"

DT: "I had been dancing in clubs. I used to win all the dance contests in California. Someone I knew said, 'I want you to meet Toni Basil.' So I went to the Summit Club, and I grabbed this girl, and we started dancing and the whole dance floor cleared. The next thing you know, I looked up and there was Toni Basil. She looked at me and said, 'You're in.' So my first gig was with the Lockers. I was the token white Locker. I was on a special called *Roberta Flack: The First Time Ever* in 1973."

FDC: "How did you get the job teaching John Travolta how to disco dance?"

DT: "I was living up in the Hollywood Hills with a couple of soap opera people. We were down by the pool one day and this girl who had the same manager as John said, 'John got a script for a new movie called *Tribal Rites of the New Saturday Night*. You should see if you can get involved with this.' So she set up a meeting with his manager. I went to his office with this big reel-to-reel tape player, but I couldn't get it to work. The guy started giving me the blow-off. So I started moving his furniture. I thought he was going to call the cops. I turned on his stereo and found 'Jungle Boogie' and I started doing Russian leaps and clock splits and knee drops. When I got through, he called Paramount and said, 'I don't know what this guy is doing, but it's really fantastic.' About a week later, John walked in."

FDC: "What was working with Travolta like?"

DT: "He was still doing *Welcome Back, Kotter*. He'd never done anything like this. And he really wanted to learn this form of dance. It was the first time I'd ever done any choreography, so I just taught him what I knew. The famous point that he does? I learned that in the dance contest. When John did that move with the finger up, I said, 'OK, we've got to keep that.' Of course, that ended up on the poster. One day, Robert Stigwood, the producer, gave us a call and said, 'I'm coming in to see how you're doing.' John came to me, and said, 'I can't do it. Can you do it alongside me?' So the two of us did the routine, the step back and the splits. Stigwood went crazy."

FDC: "Your participation in *Saturday Night Fever* was soft-pedaled by the studio, yes?"

DT: "They really tried to keep me out of the picture. They didn't want anybody knowing that somebody taught John Travolta how to disco dance. When they fired the director John Avildsen and brought in John Badham, they moved everything to New York and they brought in Lester Wilson, who was a Broadway choreographer. Travolta said to Lester, 'Let me show you what I was taught' and Lester just said, 'Let's keep it all in.' He did a wonderful job staging it. But by the time John got to New York, he was already a beast. He could dance to anything. It was a beautiful thing to watch."

FDC: "Is it true that his dancing was originally going to be a smaller part of the film?"

DT: "They tried to cut that out when he was doing the film with John Badham. They said, 'We're just going to shoot you from the waist up and do a few shots.' John Travolta said, 'If you do that, I'm walking. I spent five months learning these disco routines and you're not going to cut them out.' Stigwood came in and said, 'Whatever John wants, give it to him'."

FDC: "Do you think *Saturday Night Fever* was the reason disco became a national pastime?"

DT: "I do. We had been doing all this dancing in New York and California. There were so many underground clubs before the movie happened. It was starting to die down in the clubs. But when *Saturday Night Fever* came out, it caught on everywhere. Suddenly, there were guys in Oklahoma buying white suits. Women wanted guys to look like Travolta with the shirt open and the chains. It started these incredible trends—clothing trends, music trends. *Saturday Night Fever* was huge."

FDC: "How did that experience lead to *Dance Fever*?"

DT: "Merv Griffin was doing a couple of disco-themed shows in the summer of 1978. *Thank God It's Friday* was just coming out. Donna Summer, whom everybody loved, was on the Thursday show. The Commodores and all the other acts in the movie wanted to be on that episode with her.

"The producer said, 'I don't know what we're going to do with the Friday show.' I said, 'Why not have a dance contest?' He looked at me and said, 'How am I going to do that?' So, I called up the clubs and I got all these dancers from different states and brought them in. The judges were Bill Wardlow from *Billboard* magazine, Neil Bogart of Casablanca Records, and Regine who ran clubs in New York. I was just on the sidelines.

"The next morning, I was in bed, and I got a call. The producer said 'You've got to come in, we're shooting a pilot. We're going to do a dance show just like we did last night. We got the highest ratings we've had in thirteen years! So he held the dancers over. I came in and hosted it and the show just took off."

FDC: "*Dance Fever* was a really big hit . . ."

DT: "We had seventeen million people a week watch that show. At one time, we had more of an audience than Johnny Carson did. People liked it because it was like watching *Saturday Night Fever*, only in real time with real people from the streets. We also had three celebrity judges like Sammy Davis Jr., George Chakiris from *West Side Story*, Donald O'Connor, Tina Turner, so it just clicked."

FDC: "What's it like for you to watch *So You Think You Can Dance* and *Dancing with the Stars*?"

DT: "I hate to brag, but I'm going to brag. If we hadn't done *Dance Fever*, I don't think any of these other shows would have worked out. Nobody had ever seen anything like *Dance Fever*—a dance contest with three celebrity judges and a musical act. It was the first of its kind and a prelude to all these other shows. I do like *Dancing with the Stars*. The dancers on the show are phenomenal."

FDC: "I love that the trophy on the show is a disco ball . . ."

DT: "It's a symbol of the ballroom. If you watch any of those ballroom competitions, they'll have those disco balls up there for the lights to bounce off. It's not just for disco."

FDC: "But we still call it a disco ball and now it's an emoji, like shorthand for a great party."

DT: "Talking about emojis, a friend of mine sent me one of this little guy doing the finger point from *Saturday Night Fever*. We were just doing that move to make the film look good and make some money. Now it's an emoji. I still scratch my head to this day, and still remember, me and John, two young guys, in the studio and going into the clubs. It's just amazing."

FDC: "Have programs like *Dancing with the Stars* introduced a new generation to disco?"

DT: "I just did an event called the World's Largest Disco up in Buffalo. I do it every year. We get thirteen thousand people from all over the country. It's huge. When we first started about twenty years ago, there were people in my demographic. This past year, 60 percent were in their late twenties and early thirties. Young people are really starting to get into that music. If you go on TikTok, you see kids dancing to 'Stayin' Alive.' They throw seventies parties. The music is timeless."

FDC: "What are those disco-themed cruises like?"

DT: "Things start at ten or eleven o'clock in the morning and go all day. For fans, it's like going back in time. These people look like they're nineteen again in the way they're moving and dressing. It's a phenomenal thing to watch this music take them back. They're recreating the best time in their lives."

FDC: "Was the disco era the best time of your life?"

DT: "*Moneywise*, it was the best time of my life. But it's like I still live in that world. I listen to new music and everything, but when I go do these shows, I see these people, often the same people. When I get on that stage, I'm young again. That's my shot of adrenaline to keep me young. I've got to look good, so I stay in shape, and I still have a full head of hair, which helps. I may not do the splits anymore, but I can still kill it and people still go crazy when I start dancing."

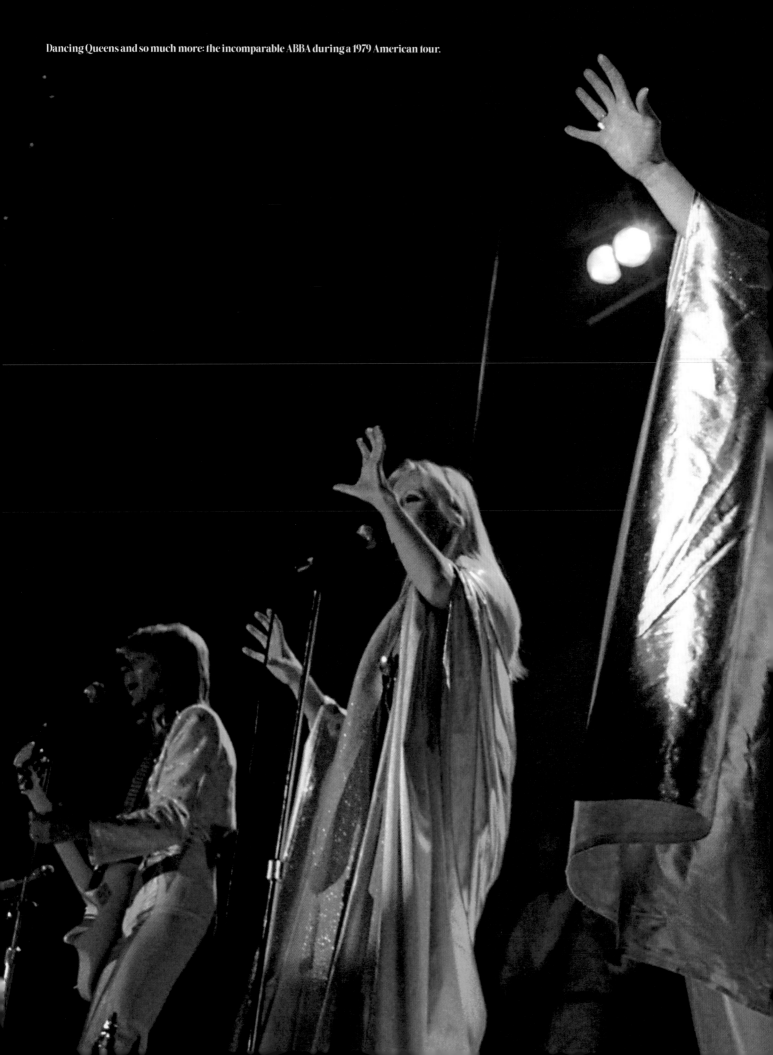

Dancing Queens and so much more: the incomparable ABBA during a 1979 American tour.

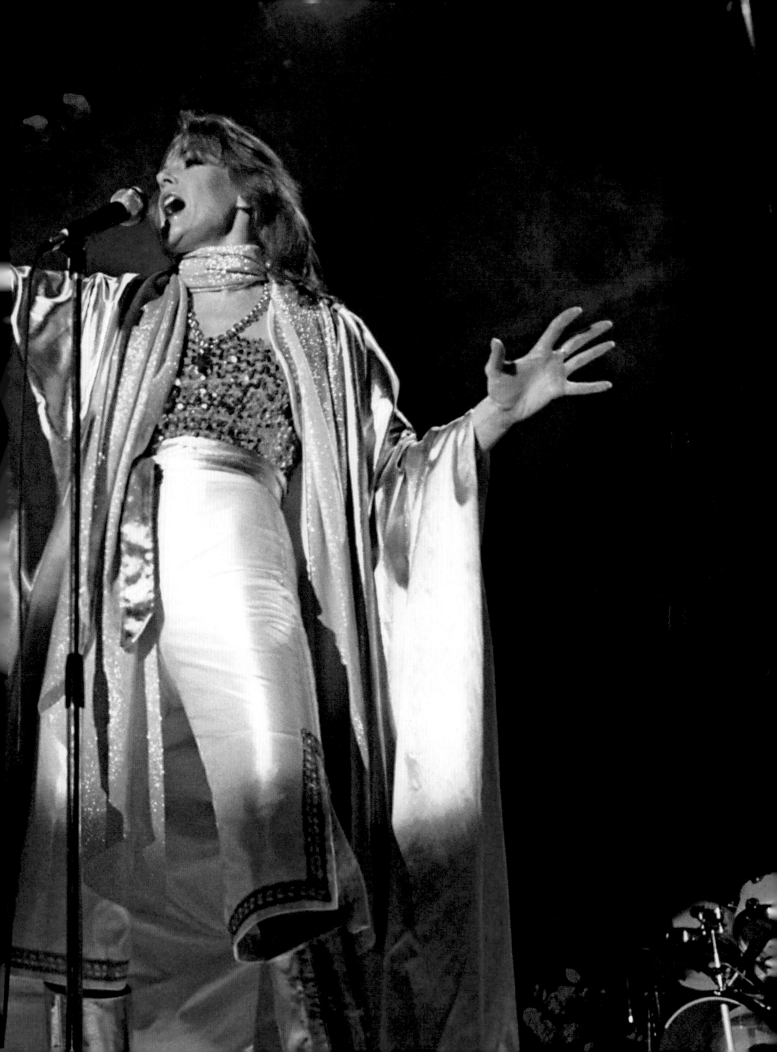

Must-Hear Disco Playlist:

"AIN'T NO STOPPIN' US NOW" by McFadden & Whitehead

"AND THE BEAT GOES ON" by the Whispers

"BAD FOR ME" by Dee Dee Bridgewater

"BODY SONG" by Sylvester

"BOOGIE WITH ME" by Poussez!

"BOOGIE WONDERLAND" by Earth Wind & Fire and The Emotions

"THE BREAK" by Kat Mandu

"COME TO ME" by France Joli

"CUBA" by Gibson Brothers

"DANCE WITH YOU" by Carrie Lucas

"DANCER" by Gino Soccio

"DISCO NIGHTS (ROCK-FREAK)" by G.Q.

"DOCTOR BOOGIE" by Don Downing

"DON'T CRY FOR ME ARGENTINA" by Festival

"DON'T LET GO" by Isaac Hayes

"DON'T STOP 'TIL YOU GET ENOUGH" by Michael Jackson

"FASHION PACK (STUDIO 54)" by Amanda Lear

"FLY TOO HIGH" by Janis Ian

"FORBIDDEN LOVE" by Madleen Kane

"FOUND A CURE" by Ashford & Simpson

"FUNKYTOWN" by Lipps Inc.

"GET IT UP FOR LOVE" by Tata Vega

"GONE, GONE, GONE" by Johnny Mathis

"GOOD TIMES" by Chic

"GOTTA GO HOME" by Boney M.

"H.A.P.P.Y. RADIO" by Edwin Starr

"HARMONY" by Suzi Lane

"HE'S THE GREATEST DANCER" by Sister Sledge

"HEART OF GLASS" by Blondie

"HELL ON WHEELS" by Cher

"HOLLYWOOD" by Freddie James

"I GOT MY MIND MADE UP" by Instant Funk

"I JUST KEEP THINKING ABOUT YOU BABY" by Tata Vega

"IN THE NAVY" by Village People

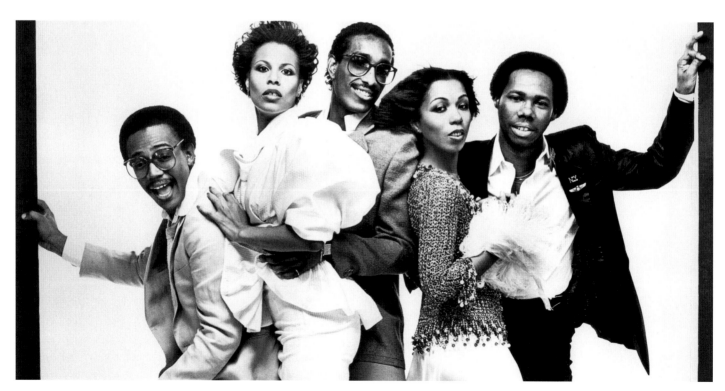

THE MEMBERS OF CHIC IN THE PHOTO STUDIO

"IS IT LOVE YOU'RE AFTER" by Rose Royce

"IT'S A DISCO NIGHT (ROCK DON'T STOP)" by The Isley Brothers

"I'VE GOT THE NEXT DANCE" by Deniece Williams

"KEEP ON DANCIN'" by Gary's Gang

"KEEP ON JUMPIN'" by Musique

"KNOCK ON WOOD" by Amii Stewart

"LADIES NIGHT" by Kool & The Gang

"LADIES ONLY" by Aretha Franklin

"LET ME TAKE YOU DANCING" by Bryan Adams

"LOST IN MUSIC" by Sister Sledge

"LOVE MAGIC" by John Davis and the Monster Orchestra

"MAKIN' IT" by David Naughton

"MONDAY TUESDAY...LAISSEZ MOI DANSER" by Dalida

"MOVE ON UP" by Destination

"MY KNIGHT IN BLACK LEATHER" by Bette Midler

"OOPS UP SIDE YOUR HEAD" by Gap Band

"POW WOW" by Cory Daye

"PUT ON YOUR ROLLER SKATES" by Stargard

"RELIGHT MY FIRE" by Dan Hartman

"RING MY BELL" by Anita Ward

"RISE" by Herb Alpert

"THE SECOND TIME AROUND" by Shalamar

"SHOOT ME (WITH YOUR LOVE)" by Tasha Thomas

"TAKE ME HOME" by Cher

"THERE BUT FOR THE GRACE OF GOD GO I" by Machine

"THIS IS HOT" by Pamala Stanley

"THIS TIME BABY" by Jackie Moore

"TOO HOT" by Kool & The Gang

"VOULEZ-VOUS" by ABBA

"WANT ADS" by Ullanda McCullough

"WE ARE FAMILY" by Sister Sledge

"WHAT CHA GONNA DO WITH MY LOVIN'" by Stephanie Mills

"YOU GONNA MAKE ME LOVE SOMEBODY ELSE" by the Jones Girls

"YOU MUST BE LOVE" by Love & Kisses

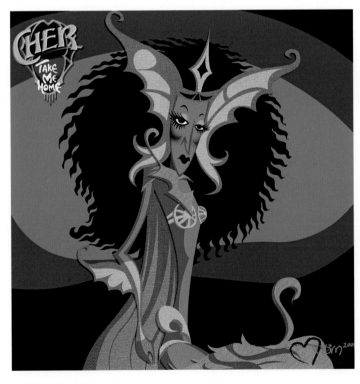

CHER PORTRAIT BY NORN CUTSON

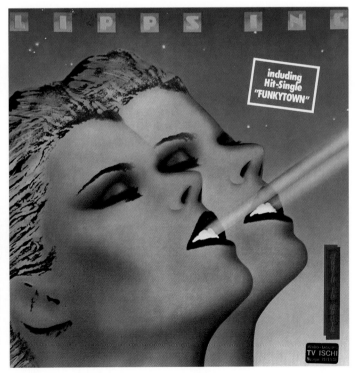

LIPPS, INC. ALBUM COVER

Chapter 7

Charo manages to "cuchi-cuchi" her way into the disco movement with the host of *The Merv Griffin Show*.

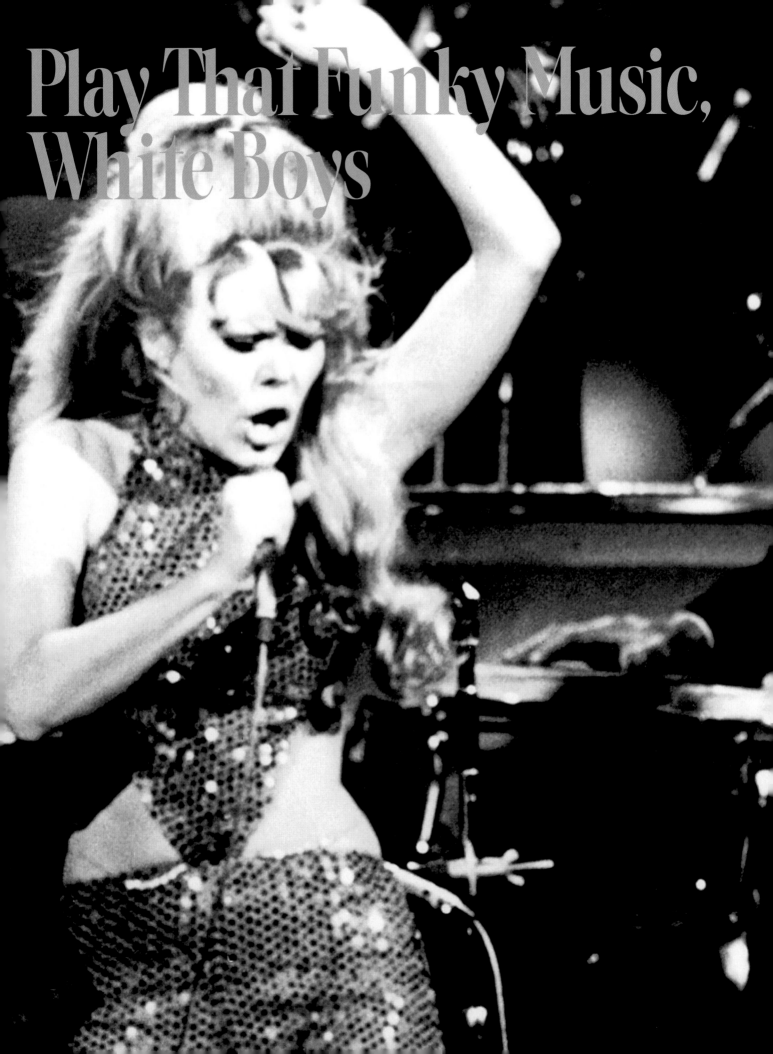

Play That Funky Music, White Boys

"

IF YOU'RE THINKIN' YOU'RE TOO COOL TO BOOGIE, BOY, OH BOY, HAVE I GOT NEWS FOR YOU.

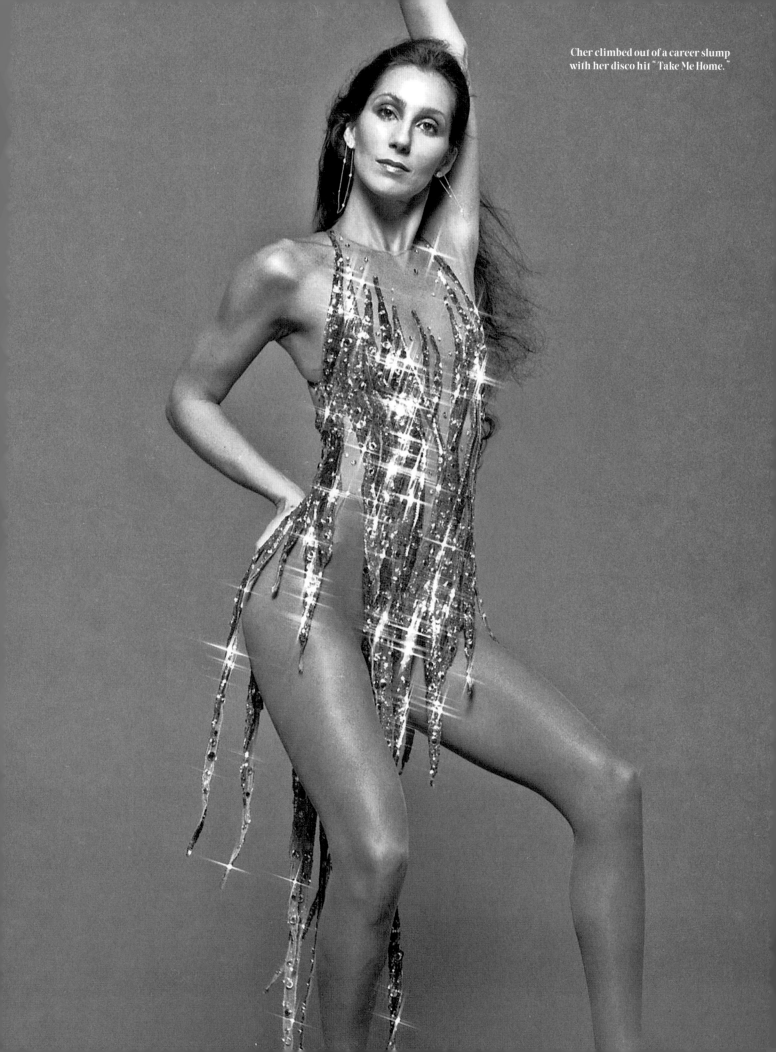

Cher climbed out of a career slump
with her disco hit "Take Me Home."

Classical music conductor Arthur Fiedler—whom the *New York Times* eulogized in 1979 as "a man whose grace and charm made him Boston's leading citizen and a worldwide symbol for 50 years"—once called disco "a marvelous, insistently rhythmic dance form to which all manner of music can be adapted from Bach to the Bee Gees."

He was promoting his album *Saturday Night Fiedler* at the time, but still. If Fiedler and the Boston Pops Orchestra could make an enjoyable disco record, *anyone* could. At least that was the belief as the seventies wore on.

It didn't matter if you were a porn star or a baggy-pants comedian, you could potentially have a disco hit. As Ron Lofman writes in *Goldmine's Celebrity Vocals: Surprising, Unexpected and Obscure Recordings by Actors, Sports Heroes and Celebrities*, "The rise of disco in the seventies . . . provided entrance for many new non-singers." Everyone from Marilyn Chambers, whose oral skills did not involve singing in the adult classic *Behind the Green Door*, to actress Grace Lee Whitney, who played Yeoman Janice Rand on the original *Star Trek*, tried their hands at disco.

Even Raymond J. Johnson Jr.—the fast-talking, fedora-wearing alter ego of improv comic Bill Saluga—had his own record, "Dancin' Johnson," in 1978. A veteran of the Ace Trucking Company, Saluga mixed his signature banter—"You can call me Ray, or you can call me Jay, but you doesn't hasta call me Johnson"—with disco schtick like "I just wants to boogie!" Such disco novelties weren't often major hits, but they kept the performers' names in boldface type.

Perhaps the greatest non-singer to triumph as a disco performer was the TV personality Monti Rock III, who was a fixture on chat programs in the sixties and seventies. A former hairdresser and consummate raconteur, he reimagined himself in 1974 as Disco-Tex. Backed by a band of "Sex-O-Lettes," he turned his flamboyant, nonstop, stream-of-disco-consciousness into the hit "Get Dancin'" and its 1975 follow-up "I Wanna Dance Wit' Choo (Doo Dat Dance)," both of which charted in America.

"At the time, I had no idea what disco was," Rock says. "But the record gave me credibility." In 1977, he was cast in *Saturday Night Fever* as the DJ at the 2001 Odyssey disco with his name on the marquee outside the club.

Entertainers who were singers—particularly those a little past their sell-by dates—realized that going disco might be a way to seem current again. "A recording made to show versatility," as Lofman wrote, "can sometimes provide a whole new career." Or at least provide a new lease on an old one. The squarest acts in show business may have had little to lose, but they were among the earliest to recognize disco's fountain-of-youth potential.

Al Martino, for instance, recorded a disco version of the Italian-American hit "Volare" in 1975. The following year, the easy-listening trio The Lettermen reimagined their 1961 hit "The Way You Look Tonight," a Dorothy Fields/Jerome Kern standard first sung by Fred Astaire in the 1936 musical *Swing Time*, as a disco song. Also in 1976, squeaky clean movie icon Frankie Avalon released a 12-inch disco remake of his 1959 chart-topper, "Venus." It reached Number 46 on the *Billboard* Hot 100, offering hope (if not proof) that going disco could work wonders. As Shel Kagan put it in *Circus Magazine*, "Disco has revived some shaggy careers, however much their old fans may protest."

Percy Faith, one of the kings of Easy Listening, included dance versions of "Hava Nagilah" on his 1975 album, *Disco Party*. Pianist and pops conductor Peter Nero offered up an album of *Disco, Dance, and Love Themes of the '70s*, featuring up-tempo versions of Carole King's "Jazzman" and Bad Company's "Feel Like Makin' Love," that year. Even "champagne music-maker" Lawrence Welk recorded an album that featured a fizzy elevator-music version of Van McCoy's "The Hustle." Welk's favorite accordionist, Myron Floren, followed up with an entire *Disco Polka* album featuring sultry dance versions of "Wait 'Til the Sun Shines Nellie" and "I Want a Girl (Just Like the Girl That Married Dear Old Dad)."

Before long, such Las Vegas stalwarts as Frank Sinatra, Wayne Newton, and Charo joined the party. Newton gave Dancer and Prancer a run for their antlers in 1976 with "Jingle Bell Hustle," a disco version of the holiday classic. In 1977, Ol' Blue Eyes recorded a disco version of Cole Porter's "Night and Day," while the Spanish bombshell (and frequent *Love Boat* passenger) turned her catchphrase "Cuchi-Cuchi" into a dance-floor sizzler with the help of the Salsoul Orchestra. "The disco genre increased their profiles, paid a lot more bills, and broadened their fan bases in many cases," says James Arena, the author of such books as *Legends of Disco* and *First Ladies of Disco*.

Liza Minnelli brought the spirit of Studio 54 to her 1977 album *Tropical Nights*. Ads read, "She's made some very new material hers and hers alone" and they didn't exaggerate. The records *were* hers alone—no one bought them. For decades, *Tropical Nights* was available only in Japan. All thirty-five minutes of it finally came to CD in 2002.

Another showroom icon, Connie Francis, rerecorded her 1960 hit "Where the Boys Are," cowritten by Neil Sedaka and Howard Greenfield, in the disco style. It was part of her 1978 comeback after personal tragedy—she'd been raped in a Howard Johnson's Motor Hotel several years earlier. "Now I feel like working again," Francis said. She worked. The record didn't. Sedaka himself tried his hand at disco, too, that year, with the title track from his album *All You Need Is the Music*. But the song, which he also wrote with Greenfield, was no hit. At a press conference after a 1978 Atlantic City concert, the singer made sure his fans knew that his album featured only *one* dance song. He hadn't gone disco, he insisted.

Others who more openly embraced the genre, though, just seemed to be having fun.

The deliciously schmaltzy Barry Manilow sang of love, murder, and madness in his hit 1978 story-song "Copacabana." Today, it's a disco classic. Rick Wakeman of the British prog-rock band YES released a disco version of Gershwin's "Rhapsody in Blue" on his 1979 solo album *Rhapsodies*. It didn't have the legs that "A Fifth of Beethoven" by Walter Murphy & the Big Apple Band had in 1976, but critics praised the record's "beautiful arrangements." Pants-packing Welshman Tom Jones certainly seemed to be having fun with his version of the Australian disco hit "Love Is in the Air" on his 1979 album *Rescue Me*.

Carol Burnett Show regular Vicki Lawrence, who'd had a Number 1 hit in 1972 with "The Night the Lights Went Out in Georgia," included several disco tracks on her 1979 album, *Newborn Woman*. The usually pensive Janis Ian saw her danceable 1979 single "Fly Too High," cowritten by Giorgio Moroder, included on the soundtrack of the teen drama *Foxes*. Even soft-rock icon Karen Carpenter went disco with "My Body Keeps Changing My Mind," one of several dance tracks recorded in 1979 for an eponymous solo album that was shelved until 1996.

"You can't blame more mature artists of the time for giving it a whirl," says Arena. "Their work in the genre was often viewed as a bit campy even then, but it gave them a chance to perform in a lively setting and maybe some younger people may have discovered their voices. I'm sure the dollar signs and the desire to stay relevant were big motivators. But disco was what people wanted to hear at the time. And, as an artist, you're inclined to give people what they want."

Even country stars went disco. Grand Ole Opry contralto Connie Smith recorded a cover of Andy Gibb's "I Just Want to Be Your Everything" in 1978. "Whispering Bill" Anderson had a Top 5 country hit with "I Can't Wait Any Longer," a sexy disco track on which he sounds like, well, Barry White-Bread. And Ronnie Milsap, tipping a cowboy hat to Wild Cherry and KC and the Sunshine Band, got it up and running with his funky disco hit "Get It Up" in 1979.

Some diehard rockers, of course, railed against disco's hold on the popular imagination. In 1978, for instance, Bob Seger sang, "Don't try to take me to a disco. You'll never even get me out on the floor" in his song "Old Time Rock & Roll." Perhaps the Michigan-born singer just couldn't dance. But some of the biggest names in the business did jump on the disco bandwagon and have major success on the dance floor.

They realized that the surest way to stay current in the late seventies was to have a club hit. "For a while, you had a better shot of getting attention in the media and on the charts if your song was an exciting disco production," says Arena. They had to "play that funky music, white boys"—to quote Wild Cherry's 1976 hit—or seem hopelessly old-fashioned.

Thus, the Rolling Stones recorded "Miss You" from their 1978 *Some Girls* album and it was a smash. To this day, Mick Jagger won't admit the song was disco. "'Miss You' wasn't *disco* disco. It was influenced by it, but not it," he still contends. But history disagrees. A 2012 *Rolling Stone* readers' poll ranked the track at Number 5 on a list of the Best Disco Songs of All Time, right between Donna Summer's "Last Dance" and The Trammps' "Disco Inferno." It doesn't get more "*disco* disco" than that.

Rod Stewart's foray into the genre, "Da Ya Think I'm Sexy?" from the album *Blondes Have More Fun*, was mammoth. It hit Number 1 in both Britain and America in 1979. But its success was not without repercussions. Some fans considered Stewart and other disco-dabbling stars to be traitors. Stewart addressed the topic in his 2012 memoir, *Rod: The Autobiography*. "Some regarded disco as the bitter enemy, and wondered what I was doing, consorting with the other side," he wrote. Still, "Da Ya Think I'm Sexy?" remains one of his biggest-selling records.

Even former Beatle Paul McCartney had a disco hit. The song was "Goodnight Tonight," a non-album single with the Wings that was released in March 1979. The song, McCartney said, was too different from the rest of the album, *Back to the Egg*, to be included on it. Perhaps it was just *better* than the rest of the record. *Rolling Stone* cracked that *Egg* was "the sorriest grab bag of dreck in recent memory." But fans loved the disco single "Goodnight Tonight." The song was an international hit and sold more than a million copies in America. The 12-inch version was finally included on *Back to the Egg* when the album came to iTunes in 2007.

The Kinks reluctantly recorded the disco track "(Wish I Could Fly Like) Superman" for their 1979 album *Low Budget* after some heavy-handed persuasion by Arista founder Clive Davis. "It was kind of a joke," front man Ray Davies has said, but a modest hit.

Even the Beach Boys caught the disco wave. They stretched their song "Here Comes the Night," written by Brian Wilson and Mike Love for the 1967 album *Wild Honey*, into a 1979 dance track that clocked in at more than eleven minutes long. The British music magazine *Smash Hits* was unimpressed with the sound, which it described as "electro-burble," and said, "It's OK, but there are plenty of better disco tracks about." *Newsday* music writer Wayne Robins suggested the revamped version was damned, predicting it would "satisfy neither disco dancer nor Beach Boy loyalists, who can be largely expected to be anti-disco anyway."

The record's producer Bruce Johnston, though, took on all such "anti-disco" naysayers in an interview with an Illinois newspaper. "Rod Stewart isn't doing badly with his song, is he? I liked the Rolling Stones' record 'Miss You.' I figured there was a little room there for the Beach Boys," he said. But Johnston added that the Boys' "disco experiment" was a one-and-done. "'Here Comes the Night' is the first and last disco record they will ever make," he said. "A lot of radio stations were scared away."

Radio did like "I Was Made for Lovin' You," the 1979 disco hit by the hard-rock band KISS, however. Cowritten by lead singer Paul Stanley, Vini Poncia, and Desmond Child, who'd go on to cowrite such hits as Ricky Martin's "Livin' la Vida Loca," the song became a worldwide hit and sold more than a million copies in America. A disco-flavored record from KISS was a stretch, perhaps, but not by that much. KISS founder Gene Simmons (the one with the tongue) had been dating Cher for three years by then, both recorded for the disco-heavy record label, Casablanca, and KISS already had the platform shoes.

But like "Da Ya Think I'm Sexy" and "Miss You," "I Was Made for Lovin' You" didn't sit well with the band's base. "Rock fans saw it as a major betrayal," says longtime music critic Jim Farber. "But it's a good disco song and way better than most KISS songs."

When Elton John tried his hand at disco with the 1979 album *Victim of Love*, it was a case of too little, too late. Although produced by powerhouse disco producer Pete Bellotte, best known for his work with Donna Summer, the record contained nothing written by John and just didn't click. "The album we made might have worked had I not decided that I wasn't going to write any songs for it. I'd just sing whatever Pete and his staff writers came up with," John wrote in his 2019 memoir *Me*. What they chose—songs like "Born Bad," "Street Boogie," and a disco remake of the 1958 Chuck Berry classic "Johnny B. Goode"—was an odd fit.

"Not everything on *Victim of Love* was terrible—if the title track had come on at Studio 54, I'd have danced to it," John said. He blamed the album's failure mostly on its timing. "It was released at the end of 1979, just as a huge backlash against disco started in the States, with particular venom reserved for rock artists who had dared to dabble in the genre. *Victim of Love* sank like a stone on both sides of the Atlantic."

Perhaps because the genre was often perceived as a woman's game, female megastars of the period were not quite as roundly rejected when they went disco.

Dolly Parton—famous but not yet the legendary icon she would become—wanted to appeal to more than just her country fans. Thus, she included a disco cover of "Higher and Higher" on her 1977 album *New Harvest . . . First Gathering*. As Parton expert Randy L. Schmidt says, "It's about as close as you could get to disco and still have a banjo in it."

The editor of *Dolly on Dolly*, a 2017 compendium of Parton profiles (including an *Out* magazine cover story that I wrote in 1997), Schmidt notes that, at the time, the singer was working with Sandy Gallin, the high-powered talent agent who was no stranger to Studio 54. "He realized Dolly's crossover appeal," Schmidt says. Together, they gave the disco world "Baby I'm Burnin'" from Parton's 1978 album *Heartbreaker*. The record company released an extended remix of the song—backed with "I Wanna Fall in Love"—as a 12-inch disco single pressed on Barbie pink vinyl. On the cover were the words "Dance with Dolly!" and fans were only too happy to oblige. As one music critic wrote, "Do you like Dolly Parton and disco? What a combination if you do!"

In retrospect, the disco makeover worked because Dolly remained Dolly even on the dance floor. As Schmidt says, "'Baby I'm Burnin' is an example of 'You can take the girl out of the country, but you can't take the country out of the girl.' It may sound like Studio 54, but you've got some Smoky Mountains in there, too."

For many it was a passing fancy, but Parton never severed her ties to dance music. "Star of the Show," from her 1979 album *Great Balls of Fire*, is "similarly energetic," as Schmidt says. In 1997, she released a dance version of the Cat Stevens classic "Peace Train" remixed by various DJs, including superstar Junior Vazquez and, once again, she was queen of the discos.

Cher, too, made disco work for her. In 1979, she released two full albums—a disco album called *Take Me Home* in January and a more new-wave–sounding one called *Prisoner* in October. The cover of *Take Me Home* featured Cher wearing a gold-winged headdress and a matching bikini by superstar designer Bob Mackie.

Cher insisted that the *Take Me Home* album be as much rock as disco. "I like rock 'n' roll and I can't give that up. It would be like cutting off one of my arms," she told the influential music journalist Lisa Robinson in May 1979. But it was the disco title track, cowritten by hitmaker Bob Esty, that was the smash. Esty had coproduced "Last Dance" for Donna Summer the year before, and "Take Me Home" is almost as iconic a disco song. In fact, disco proved Cher's salvation.

Before the release of *Take Me Home*, Cher admitted, "My career was really in the toilet." She hadn't had a hit since "Dark Lady" in 1974. After leaving MCA, she explained to Robinson, her next label Warner Brothers didn't know what to do with her. But *Take Me Home*, which was released on Casablanca and featured on the 1979 TV special *Cher . . . and Other Fantasies*, changed all that. It set Cher off on a solo concert tour that has never really ended. In her *Classic Cher* show, which opened in Las Vegas in 2017, she sang "Take Me Home" in flamboyant disco finery and crowds went crazy.

Cher's second album of 1979, *Prisoner*, was not a hit. Although some critics liked it—"The music is upbeat, danceable rock 'n' roll with arrangements as full and lusty as Cher's voice," to quote one positive review—others just didn't relate to it. "I don't think I really care if what I'm doing makes sense to everybody else. If it makes

Disco music played in the classical style by the Boston Pops on
the eight-track tape of *Saturday Night Fiedler*.

sense to me, that's all that's important," Cher said at the time. As for the tabloids, who seemed to delight in slagging her artistic choices, she jabbed, "You can't dance to the *National Enquirer.*"

But few danced to P*risoner,* either. The record just didn't sell.

Still, the album is responsible for one of the greatest roller-disco artifacts of all time: the video for "Hell on Wheels." The lavishly produced clip is a smorgasbord of camp deliciousness that includes drag queens, mustachioed truck drivers who look like seventies porn stars, and Cher in zebra-striped cut-to-there aerobics gear with matching skates. The singer's love of roller-disco was well known, particularly in Los Angeles, where she would host weekly skating parties filled with celebrities. "She loved doing those parties and inviting everyone in," Mackie remembers. Suffice to say, the "Hell on Wheels" video is so disco it makes a Village People concert look like a meeting of the Women's Christian Temperance Union.

Aretha Franklin's foray into disco was a flop. The 1979 album *La Diva* was produced by Van McCoy of "Hustle" fame and featured strong vocals from the Queen of Soul. It was supposed to be a comeback record, but it did little to help her out of a career lull. While two singles—"Ladies Only" and "Half a Love"—did chart, Franklin's album went nowhere.

Another icon had better luck. Barbra Streisand partnered with Donna Summer for the ultimate disco duet, "No More Tears (Enough is Enough)," written by Paul Jabara and Bruce Roberts. It was released on her album *Wet* and Summer's album *On the Radio,* a greatest hits compilation. Streisand followed "Tears" with "The Main Event/Fight," another disco track written by Jabara and Roberts, the title song from her 1979 boxing comedy *The Main Event.* Streisand clearly was proud of "No More Tears," as she performed the song on her 2012 concert tour as a tribute to Summer, who died that year.

As for Bette Midler, who has committed to vinyl everything from a raunchy version of the "Hawaiian War Chat" to the saccharine schmaltz of "From a Distance," it's a puzzlement why she refuses to embrace her disco past as Parton, Cher, and Streisand have.

Midler was asked by *Parade* magazine in 2021 if there were any songs she regretted recording. "Everybody's bound to do some stinkers," she said, "like 'Married Men.' Please God, shoot me now! 'My Knight in Black Leather'—save me!" Both were disco songs from her eclectic 1979 studio album *Thighs and Whispers.*

That record made it to Number 65 on the album charts, but, forty-two years later, Midler still took no pleasure in having sung either song. "That was the label saying, 'You've got to record this,'" she complained, even though it had been her idea to record a disco version of "Strangers in the Night" back in 1976. But fans are glad for that record company pressure.

"My Knight in Black Leather" was hilarious in 1979—especially when Midler enthused, "You know, he smells just like a brand-new car!"—and it's hilarious now, and just as toe-tappingly infectious as it always was. You'd think someone who understood camp enough to include a "Disco Memories" segment in her 1983 stage show *De Tour* would be able to own up to her contribution to the genre. Honestly, if you can dress as a mermaid in a wheelchair and sing a nostalgic medley of "We are Family," "I Will Survive," and "She'll Be Coming 'Round the Mackerel" in the early eighties, you should be able to embrace the fabulous silliness of "My Knight in Black Leather" in the twenty-first century.

But Midler wasn't wrong in 1979 when she suggested that the clock was ticking on disco's moment. "The new wave thing is going to be bigger than anything else next year. The ground swell is building everywhere," she predicted in an interview quoted in James Spada's 1984 biography *The Divine Bette Midler.* "I think I should jump on every musical bandwagon!"

Those who jumped on the disco bandwagon so late in game did have trouble connecting with the record-buying public. Helen Reddy's album *Reddy,* for instance, included several disco-flavored tracks, particularly the single, "Make Love to Me." But reviews generally panned the whole enterprise from the feminist icon best known for the anthem "I Am Woman."

Another superstar, Martha Reeves, who'd recorded the classic "Dancin' in the Street" with the Vandellas in 1964, also returned in 1979 with "Skating in the Streets"—plural—but critics weren't rolling with it, either. Setting something old

to a new beat just wasn't cutting it anymore. "The whole concept seems a sad attempt to resurrect an artist by capitalizing on not one but two crazes—disco and roller skating," complained *New York Times* music critic John Rockwell. "If Miss Reeves has something to say today, she should say it with new songs."

Someone who *did* have something to say was Debbie Harry.

The front woman of the new-wave act Blondie had a new song in 1979 that pointed the way to the future of pop music more keenly than the rest. A band aptly called "snarly" by one critic, Blondie was ingenious enough to bridge disco and punk, and please both audiences with a track off their album *Parallel Lines.* That song, of course, was "Heart of Glass."

One of the biggest acts to emerge from the late-seventies New York City underground, Blondie was known for emotive, retro-tinged punk rock. But Harry appreciated all types of music and encouraged the band to record a demo track they referred to as "The Disco Song." She later said it was inspired by the 1974 Hues Corporation hit "Rock The Boat." After some reworking with a drum machine and synthesizers—and giving it what the album's producer Mike Chapman called "a Donna Summer vibe"—"The Disco Song" became "Heart of Glass."

"To Chris Stein and me, it sounded like Kraftwerk, which we both loved," Harry said forty years later in her memoir, *Face It.* "It's disco, but at the same time, it's not."

To punk diehards in Blondie's fanbase, though, it *was* disco, and the song's runaway chart success was not without pushback. First the Stones, then KISS, now Blondie. As David Hamsley wrote in his 2015 book *To Disco, With Love,* rock-lovers "considered Blondie to be their property, so when the group released the very disco-sounding 'Heart of Glass' in early 1979, fans were shocked and felt the group had sold out." Even some of the band members saw it that way. Blondie bassist Nigel Harrison supposedly called the song a "compromise with commerciality," while the band's drummer, Clem Burke, at first refused to play it live.

But the way Harry saw it, a punk band like Blondie recording a disco record was quite a transgressive act—which is what punk was all about in the first place. "That song pissed off a lot of critics," Harry admitted. "But, as Chris the Dadaist likes to say, it made us punk in the face of punk." What it really did was expose rock and pop audiences to new sounds. Blondie not only prefigured the electronica that would dominate the eighties, but also brought reggae and rap to the American mainstream for the first time. The band's fifth studio album, *Autoamerican,* released in November 1980, incorporated both influences, and led to two of the band's biggest singles, "The Tide Is High" and "Rapture."

"We were doing what punks do, which is break down walls," Harry wrote in *Face It.* "Rapture" became the first song with a rap in it to go to Number 1 on the pop charts. Grandmaster Flash later said Harry "tremendously opened the door."

Meanwhile, another Blondie single, "Call Me," produced by the legendary disco producer Giorgio Moroder for the soundtrack of the movie *American Gigolo,* was the biggest hit of 1980. In 2017, *Billboard* said the song was "so catchy that it stands the test of time." As for "Heart of Glass," the magazine pronounced it, "one of the greatest dance songs ever made."

If 1979 was *the* watershed year for disco's popularity, it was also a turning point. Diana Ross, who had a disco hit with "Love Hangover" in 1976 hired Chic masterminds Nile Rodgers and Bernard Edwards to write and produce her tenth studio album, *Diana,* but then decided to distance herself from disco. She had the album remixed before putting it out in 1980. Vocals were punched up, extended instrumental breaks were removed.

"*Diana* was still a disco album, but it now had a punchier sound that would anticipate the harder-edged dance-pop of the following decade," Nick Levine wrote in a fortieth anniversary tribute to the record in *The Telegraph* in 2020. The record, featuring the singles "Upside Down," and "I'm Coming Out," sold ten million copies and became, as Levine put it, "the most highly regarded and biggest-selling album of her career."

But Ross wasn't completely wrong about musical tastes changing. Even the music critic in Greenville, South Carolina, was hip enough to report in 1979, "A new wave of observers says now that this will be disco's last big year before it gives in to something new."

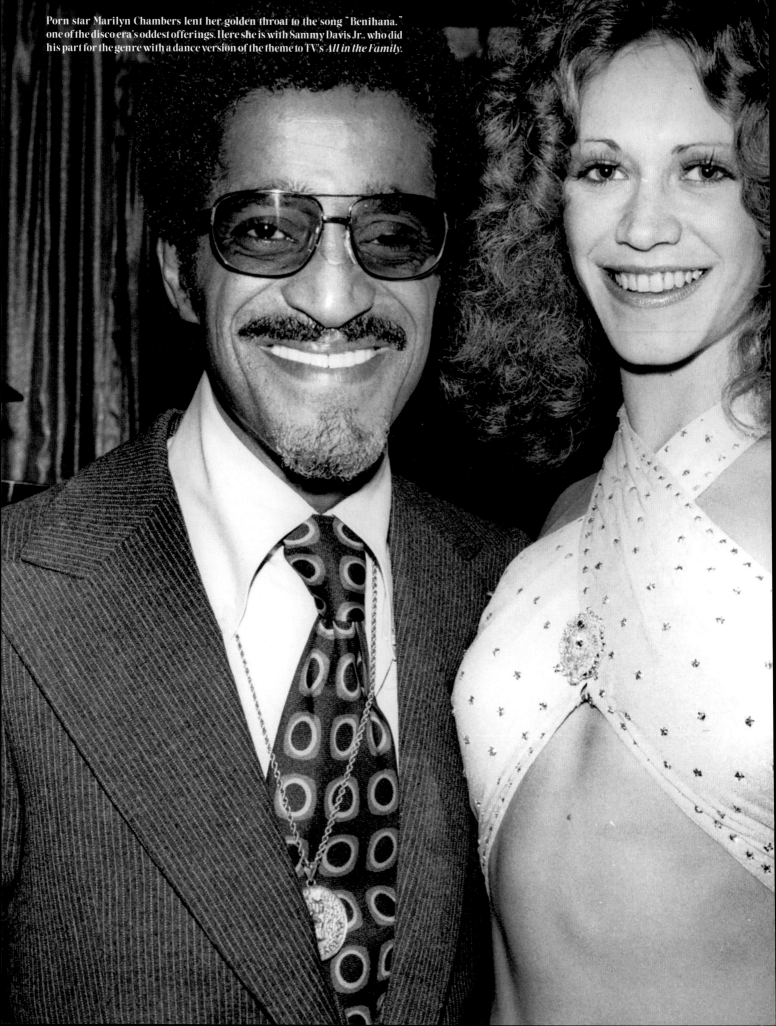

Porn star Marilyn Chambers lent her golden throat to the song "Benihana," one of the disco era's oddest offerings. Here she is with Sammy Davis Jr., who did his part for the genre with a dance version of the theme to TV's *All in the Family*.

Disc-Originals

These songs, some by serious musicians, some by the most unexpected of disco dabblers, were oddities even in the seventies. But, today, all is forgiven. Now these bandwagon boogaloos are "wonderfully weird"—thanks, Buzzfeed—and should be cherished as such.

"DISCO TREKIN'" BY GRACE LEE WHITNEY (1976)

Grace Lee Whitney will forever be remembered as Yeoman Janice Rand, a role she played on *Star Trek: The Original Series* and in various other Trek-related properties over the years. But nothing quite compared to her 1976 foray into dance music with a 45 called "Disco Trekin'." The track, cowritten by Whitney and her second husband, Jack Dale, is up-tempo, ethereal, and as one latter-day critic put it, "uniquely bad." But Trekkies ate it up – and the record's B side, "Star Child" – at fan conventions in the Seventies. "When I performed them, I got the loudest, longest ovation I have ever received in my life," Whitney wrote in her 1998 memoir, *The Longest Trek: My Tour of the Galaxy. Star Trek* inspired other dance floor love over the years. In 1978, the Universal Robot Band joined the Federation with "Disco Trek," a reworking of Alexander Courage's original *Star Trek* theme. Fourteen years later, the Austrian electronic band Edelweiss sampled the TV tune for the European dancefloor smash *Starship Edelweiss.*

"A FIFTH OF BEETHOVEN" BY WALTER MURPHY AND THE BIG APPLE BAND (1976)

He was a twenty-four-year-old commercial jingle writer when a record producer with whom he was collaborating suggested Walter Murphy update classical music for the disco era. Thus was born one of the most unlikely songs ever to become a smash. Murphy's reworking of Beethoven's Fifth Symphony—cheekily renamed "A Fifth of Beethoven"—hit Number 1 on the Billboard Hot 100 charts on October 9, 1976. "I suppose there's a Beethoven Society somewhere ready to punch me in the mouth," Murphy told the Associated Press. "But nobody has said anything yet." The following year, the song was included on the soundtrack to *Saturday Night Fever,* forever cementing its stature as a dance masterwork. A composer for film and television, Murphy was nominated for an Oscar for Best Original Song in 2013 for his work on the film *Ted.* In 2020, "A Fifth of Beethoven" found new fans as the theme song of the Hulu limited series *Mrs. America.* The following year, it was on the *House of Gucci* soundtrack.

"AIN'T GONNA BUMP NO MORE (WITH NO BIG FAT WOMAN)" BY JOE TEX (1977)

R&B singer Joe Tex had a million-selling hit in 1967 with a composition called "Skinny Legs and All." But he's best remembered for a disco track about a very different type of lady. The song was "Ain't Gonna Bump No More (With No Big Fat Woman)" and it was a cautionary tale warning thin men not to dance outside their weight class. "Man, she did a dip, almost broke my hip," Tex complained in the 1977 hit. By song's end, the woman "done knocked" him down twice, despite his desperate pleas that she find herself a "big fat man." He learns, as the Burger King ads said back then that "It takes two hands to handle a Whopper." Although the antithesis of body positivity, the song was an international hit and made it to Number 12 on the Billboard Hot 100 charts. "It's bad English, but dandy body language," one critic raved. Not everyone was pleased with its success, however. "When the record came out, I got a little static," Tex told *Rolling Stone.* "Women would come up and say, 'Why you make that record? You talkin' 'bout me!'" His solution was to incorporate Big Fat Woman dance contests into his concerts. The prize? A hundred bucks. "Once we started giving away cash money," he said, "They started easing off." In those days, a C-note bought a lot of post-show snacks.

"BENIHANA" BY MARILYN CHAMBERS (1977)

She'd already been a squeaky-clean model on boxes of Ivory Snow detergent and the triple-XXX star of the notorious 1972 adult feature *Behind the Green Door*, so fans knew Marilyn Chambers had range. But when the porn princess cut her first record—a breathy 1977 disco track reminiscent of both Donna Summer's orgasmic 1975 classic "Love to Love You Baby" and the Andrea True Connection's 1976 hit "More, More, More"—audiences didn't know what to make of it. Cowritten by Michael Zager (who'd find success later that year with "Let's All Chant"), "Benihana" never charted and didn't make Chambers the mainstream star she'd hoped to become. "I'd like to be someone like Sammy Davis Jr. who can sing, dance, act—everything," Chambers, twenty-five, told Robert Hilburn of the *Los Angeles Times* in April 1977. But she was philosophical. "A lot of people never get to do all the things I've gotten to do," she said. "If it all had to stop now, I've been so fulfilled." Sadly, it did. Chambers died in 2009 at fifty-six.

"CUCHI-CUCHI" BY CHARO AND THE SALSOUL ORCHESTRA (1977)

On an album filled with such aural oddities as "Speedy Gonzalez," "Cookie Jar," and a disco cover of the Rolling Stones' "Let's Spend the Night Together," nothing was quite as infectious as the title track. Recorded in June 1977 at Sigma Sound Studios in Philadelphia, it turned Charo's sexy-funny catchphrase into a dance hit. The lyrics are laughable—in the best way possible—informing listeners that not only do "all the rooster and the chicken want the same thing," but also "porcupines, very careful, want the same thing." Even "Johnny Carson and my sister want the same thing." That thing? Why it's "Cuchi-Cuchi," of course. On Halloween that year, the Las Vegas entertainer was booked to sign copies of the album at the Korvette's flagship on Fifth Avenue in Manhattan. "Even for non-fans, it's well worth a hearing," one New Jersey newspaper critic wrote of the album. Another gushed, "Charo has become the biggest sensation in the U.S. since Chiquita Banana."

DISCO BILL BY BILL COSBY (1977)

Before he was America's TV dad and before he was accused of sexual misconduct—to put it mildly—Bill Cosby was a stand-up comic, and a beloved one, at that. His comedy albums, like *To Russell, My Brother, Whom I Slept With*, sold millions of copies and won him a Grammy every year from 1965 to 1970. He recorded musical spoofs as well, and in 1977 Cosby turned his attention to the dance craze sweeping America with the album *Disco Bill*. Critics raved, particularly about his Barry White satire "A Simple Love Affair" and such double entendre-laden tracks as "Boogie on Your Face" and "What Ya Think 'Bout Lickin' My Chicken." The Kansas City Star gushed, "Man does it work!" while the Liverpool Echo in England awarded it "ten out of ten for fun!" But Canada was divided by *Disco Bill*. The music critic at the *Leader-Post* of Regina, Saskatchewan, wrote "Not only is this a funny recording, it is also some of the best disco music heard by this reviewer." But the music critic at the Citizen in Ottawa wasn't having it one bit. "As a singer," he wrote, "Bill Cosby is a lousy comedian." Who was right? Well, let's just say that Cosby didn't win a Grammy for this one.

"FROM NEW YORK TO LA" BY PATSY GALLANT (1977)

"I'm a star in New York, I'm a star in LA," Patsy Gallant sang in 1977. But the cities where she really was a star were Montreal and Toronto. Dubbed "Canada's own disco queen," Gallant often sang in French, but her 1977 English-language disco single "From New York to LA" was her only record to make any real noise outside the Great White North. The song charted throughout Europe, and, while ignored by radio in the States, reached listeners via club play and appearances on such American programs as The Wolfman Jack Show. "From New York to LA" was not without controversy. The song was based on a 1964 Quebecois anthem "Mon Pays c'est L'Hiver" by Gilles Vigneault, and haters complained that Gallant had "prostituted" the song into a disco hit. Her fans, though, loved it and were sweet on her follow-up single, "Sugar Daddy." Gallant won the Juno Award for Female Vocalist of the Year in both 1977 and 1978. Although lean years followed her disco heyday, Gallant later lived and worked in Europe for more than a decade. A documentary on her life, simply titled *Patsy*, was released in 2016.

"NIGHT AND DAY" BY FRANK SINATRA (1977)

The Washington Star noted a "strange change in Frankie" and asked, in June 1977, "What on earth's happened to Old Visine Eyes?" The timelessly bitchy but now defunct newspaper was referring to Frank Sinatra's disco version of the immortal Cole Porter tune "Night and Day." Produced by jazz guitarist and arranger Joe Beck, the single was a startling turn for the Chairman of the Board to say the least. Still, the track found some success. "It's breaking Black," Beck said at the

time, meaning R&B stations were playing the song. When Sinatra performed it live that year at the Latin Casino in Cherry Hill, New Jersey, the *Philadelphia Daily News* called his foray into disco "quite the happy surprise." Today, the song, and one other dance track, a disco arrangement of "All or Nothing at All," a big band song Sinatra originally recorded in 1939, survive on digital platforms in a collection called *Reprise Rarities Vol. 3*. Both songs, as one critic put it, "reflect the burgeoning disco sound of the era."

"DISCO CLONE" BY CRISTINA (1978)

It was a disco song that made fun of disco, appropriating every convention from four-on-the-floor bass to dramatic orchestral flourishes, while simultaneously complaining about the uniformity of the music and its fans. "I don't know the name of the girl I brought home, but the face was familiar, she's a disco clone" went the lyrics. But "Disco Clone" was an original. Although Cristina initially thought the song was "so bad that it could be a Brechtian pastiche," she came around to appreciate it as much as her fans did. "It turned out to be an eccentric and funny record—insane, enthusiastic, impassioned, amateurish," she told *Time Out New York* in 2004. Kevin Kline, an actor then known only to Broadway afficionados, is heard on one version. Upon her death of Covid at sixty-four in 2020, the *New York Times* said Cristina "cut a unique figure—a hyper-literary, well-to-do, seen-it-all performer who taunted club music culture with songs that could be read as wry parody or progressive updates." It turns out the Harvard-educated chanteuse was anything but a clone.

"RASPUTIN" BY BONEY M. (1978)

The band members were Caribbean, based in Germany, but their most infamous record was about a Russian. Got that? The group was Boney M., and the song, "Rasputin," was an irresistible dance-track-cum-history-lesson about the Siberian-born mystic Grigori Rasputin, a holy man known for his sexual prowess and his connections to Emperor Nicholas II. The track, which reinforced Rasputin's reputation as "Russia's greatest love machine," was a huge international hit. Who could resist the quirky charms of a disco record about the prodigiously endowed legend, even if it did play fast and loose with history? Not many. Boney M. went on to sell more than a hundred million records and continues to perform today, although without any of its original members. None of their songs, though, has the staying power of "Rasputin." A Canadian DJ once aptly called it "an awful song that gets everyone up dancing." Like Rasputin himself, a man who survived several assassination attempts before he was killed in 1916, the song won't die. In 2021, it was remixed after underscoring a viral TikTok challenge, and was streamed millions of times that year alone. In 2022, the song was revived again in a promotional clip for the FX horror comedy, *What We Do in the Shadows*.

ROMEO & JULIET BY ALEC R. COSTANDINOS (1978)

Dance music's first concept album, *Romeo & Juliet* was the brainchild of French producer Alec R. Costandinos. Five acts on two sides of vinyl, the record set Shakespeare's tragic love story to a disco beat. "Need I say to you, he's a Montague," Juliet is warned. "But oh, how I love him," she opines. Well, spoiler alert, it doesn't go well for those two crazy kids. But it did for Costandinos. An architect of the "Euro-disco sound," he coaxed "The Hunchback of Notre Dame" out of his belltower and onto the dance floor in 1978. "The music—stirring symphonic disco—is Costandinos at his best," raved the *Los Angeles Times*. He scored his best-known hits with the group Love & Kisses, including 1977's "I Found Love (Now That I've Found You)" and the 1978 title track to the film *Thank God It's Friday*. Both climbed to the top of Billboard's various disco charts. But Romeo & Juliet was the real groundbreaker. Allmusic.com critic Jason Birchmeier called the album a "conceptual masterpiece," a "true landmark" that "showed that disco could be just as literate as it was hedonistic."

"DARIO, CAN YOU GET ME INTO STUDIO 54" BY DANA AND GENE, 1979

Poor Dario. He's willing to spend his last dime on his girlfriend. But the only thing she wants is something money can't buy—to get past the tyrannical doorman at the most exclusive disco in New York City. Written by August Darnell of Dr. Buzzard's Original Savannah Band and recorded by two anonymous session singers, "Dario" was catchy but couldn't find a major label willing to release it. Neil Bogart of Casablanca Records told producers Ritchie Cordell and Kenny Laguna they needed Steve Rubell to sign off on it. But when the duo finally reached the elusive Studio 54 founder, he said, "I think it's boring." Their hopes of a chart hit were dashed, but the record did find a home on a small label in England. Darnell recorded it with his subsequent band, Kid Creole and the Coconuts, and included the track on the 2003 rerelease of the group's 1980 debut, *Off the Coast of Me*.

"LOVE RUSH" BY ANN-MARGRET (1979)

She nearly died when she fell twenty-two feet from a raised platform during a Lake Tahoe showroom performance in 1972, then, three years later, almost drowned in a torrent of baked beans during an onscreen nervous breakdown in the hallucinatory movie musical *Tommy*, yet some critics still say Ann-Margret's 1979 disco single "Love Rush" was the worst thing to ever happen to her. Written by seventies hitmaker Paul Sabu, the son of *Elephant Boy* actor Sabu, the song was recorded in Toronto, mixed in Los Angeles, and rushed to stores on a tide of boldface gossip column announcements that the Golden Globe–winning actress had "gone disco." Fans of the Swedish-born, ginger-haired spitfire ate it up and took the song to Number 8 on the Billboard dance charts. Aaron Gold of the *Chicago Tribune* gushed "Ann-Margret's 'Love Rush' disco single has been so successful that Ocean Records has asked her to record an album with the same name." "Miss Hyphen Margret"—as one particularly dismissive critic called the Grammy- and Oscar-nominated actress—opened her May 1980 TV special, *Ann-Margret: Hollywood Movie Girls*, with the song. Audiences liked the show, but there was no rush on "Love Rush" after its prime-time exposure. The album took twenty-seven years to make it to CD.

SATURDAY NIGHT FIEDLER BY THE BOSTON POPS (1979)

When Arthur Fiedler and the Boston Pops Orchestra in May 1979 stunned classical music lovers with *Saturday Night Fiedler*—a suite of music combining five songs from the soundtrack of *Saturday Night Fever*: "Stayin' Alive," "Night Fever," "Manhattan Skyline," "Night on Disco Mountain," and "Disco Inferno"—the conductor proclaimed that "the youngsters had done it again!" Purists said that he had gone too far to pander to current tastes. But the maestro didn't agree, telling the *New York Daily News*, "People should be more flexible. Some contemporary music fans shy away from classical music. Then you've got the snobs, the longhairs, who won't listen to contemporary music. That's all wrong." When the album—which had a disco medley called "Bachmania" on the flipside—was released that summer, fans saw Fiedler, eighty-four, on the cover in a white custom-made three-piece suit. Although one critic wrote "Take a back seat, Sister Sledge!" Fiedler's disco moment didn't last long. He died on July 10, 1979, just as the record was hitting the stores.

"STARS ON 45" BY STARS ON 45 (1981)

The Beatles broke up in 1970, but eleven years later their music was topping the charts in a way they never intended. A group of Dutch soundalike musicians, under the direction of record producer Jaap Eggermont, formerly of the band Golden Earring, in 1981 created a mash-up of Fab Four classics, set them to a disco beat, and mixed in snippets of Shocking Blue's 1970 "Venus," the Archies' 1969 "Sugar, Sugar," and more recent hits "Funkytown," "Boogie Nights," and "Video Killed the Radio Star." Released six months after John Lennon's assassination, it was an odd tribute. One Florida radio station fielded a call from a listener who said, "I want to report a crime. I just heard a disco Beatles song!" But most people found the medley irresistible. "Stars on 45," or, to use the song's full title, "Medley: Intro 'Venus' / 'Sugar Sugar' / 'No Reply' / 'I'll Be Back' / 'Drive My Car'/ 'Do You Want to Know a Secret' / 'We Can Work It Out' / 'I Should Have Known Better' / 'Nowhere Man' / 'You're Going to Lose That Girl' / 'Stars on 45'," became a worldwide hit. It rocketed to Number 1 on the *Billboard* Hot 100 in America on June 20, 1981. "I'm living in a fairy tale," Eggermont said at the height of his success. An album, *Stars on Long Play*, followed. A house version, "Stars on '89 Remix," arrived eight years later.

"DOMINIQUE" BY THE SINGING NUN (1982)

Whether she was billed as Soeur Sourire, Sister Smile, or simply the Singing Nun, Jeanne-Paule Marie "Jeannine" Deckers had a sister act, but it was no comedy. The Belgian singer-songwriter scored super-success in 1963 with a sing-song French-Belgian ditty called "Dominique." Deckers should have been rolling in dough—there were nearly one hundred versions of the song, according to the *New York Times*—but because of a legal snafu, her recording contract gave all the proceeds to her record company and her religious order and left the nun with almost nothing. Sister Luc Gabriel, as she was also known, quit the order in 1966, began a loving relationship with a woman but insisted they were not lesbians, and in 1982, still trying to pay off her debts (including those from a failed autism center), released a disco rendition of "Dominique" on 45. The song, backed with an alternate synth-version called "Dominique (electronique-nique-nique)," fizzled. Three years later, Deckers, fifty-two, and her partner committed suicide, overdosing on barbiturates. Books, plays, and films have told versions of her tragic story. The best known is the highly fictionalized 1966 Debbie Reynolds vehicle, *The Singing Nun*, which featured nine of her songs. Nun, or rather, none, were disco.

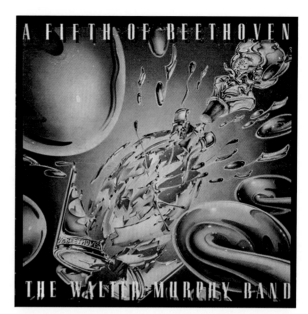

THE WALTER MURPHY BAND ALBUM A FIFTH OF BEETHOVEN

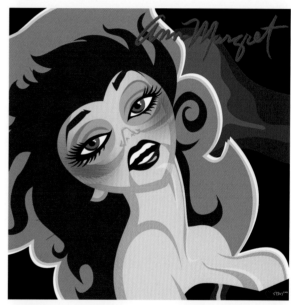

ANN-MARGRET PORTRAIT BY NORN CUTSON

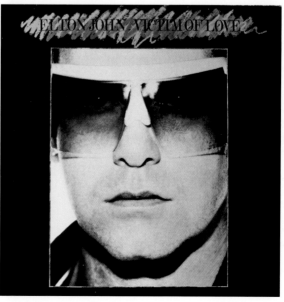

ELTON JOHN'S FIRST FORAY INTO DISCO, *VICTIM OF LOVE*

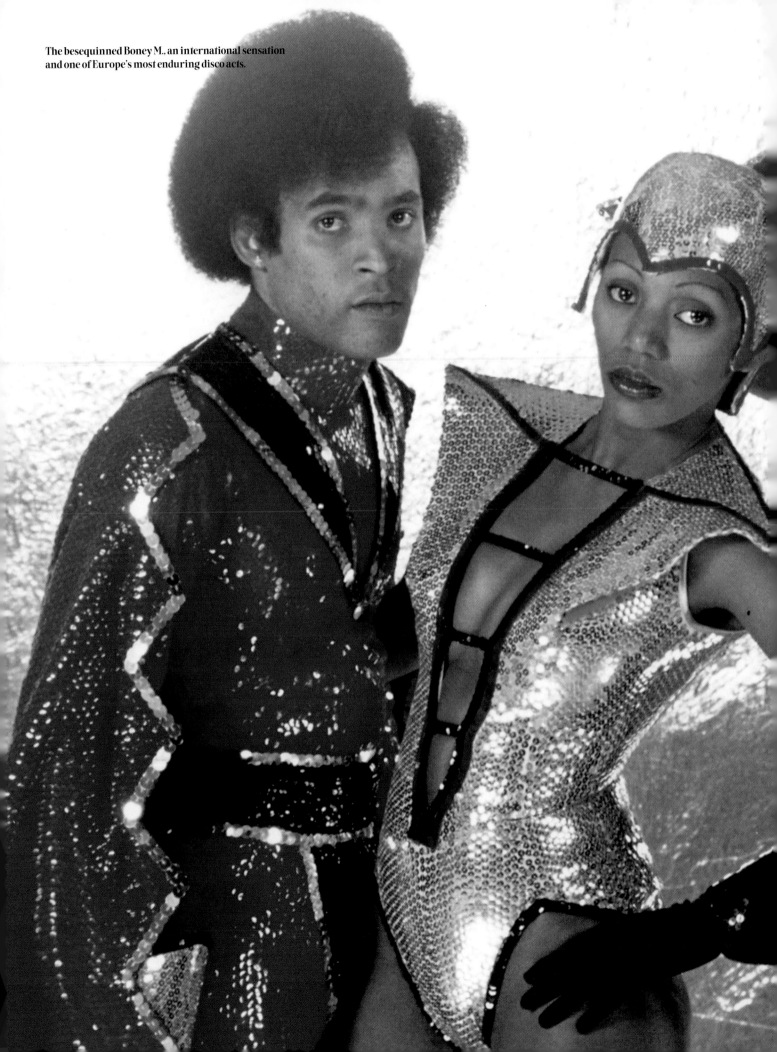

The besequinned Boney M., an international sensation and one of Europe's most enduring disco acts.

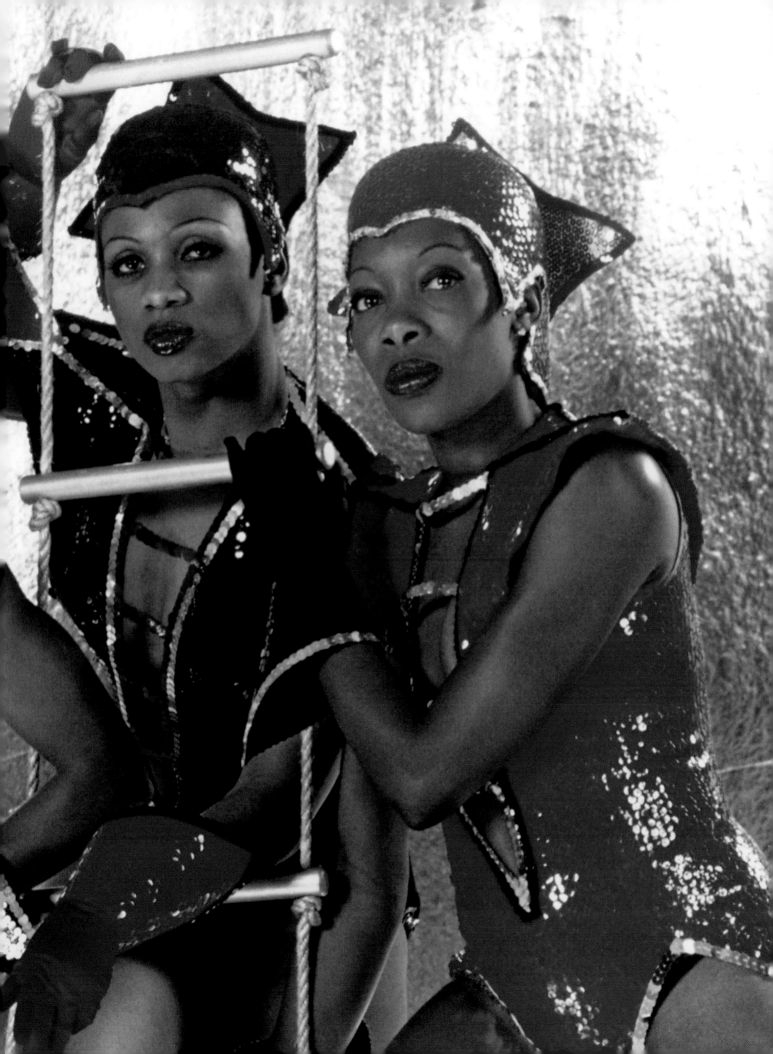

Disco on Broadway

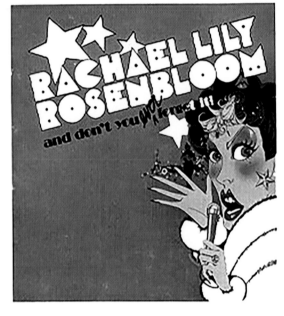

If the relationship between Broadway and disco had a Facebook status, it would be "It's complicated." As pop culture critic Elisabeth Vincentelli puts it, "Broadway has a complicated history with disco. Before that, it had a complicated history with rock. It has a complicated history with anything that steps away from the Great American Songbook and Tin Pan Alley."

Simply put, shows written to keep audiences in their seats and music composed to get them on their feet is a difficult merge. "It's music designed to make you shake your butt, which is something you can't do when your butt is planted in a seat," says *Time Out New York* theater critic Adam Feldman. But that hasn't stopped many from trying, and all but a few from failing.

Rachael Lily Rosenbloom (and Don't You Ever Forget It) is regarded as Broadway's first disco musical and it remains one of its most notorious disasters. A 1973 collaboration between disco songwriter Paul Jabara, who went on to win an Oscar for "Last Dance," and playwright Tom Eyen, who later wrote the Tony-winning *Dreamgirls*, it never officially opened.

Playbill covers of disco musicals through the years from the first, *Rachael Lily Rosenbloom,* **above, to 2023's** *Here Lies Love,* **on the following pages.**

Although *Rachael Lily Rosenbloom* featured a cast of future stage superstars—including Anita Morris, Carole Bishop, André De Shields, and, in the title role, Ellen Greene—and could boast the music business titans Robert Stigwood and Ahmet Ertegun as producers, the show was so convoluted even the most knowledgeable audience members couldn't figure it out.

The esteemed *New York Times* theater critic Frank Rich, in a 1983 column on the allure of Broadway bombs, for instance, recalled the show as "a musical fantasy of surpassing lavishness that made no sense, at any level, from beginning to end."

He saw the show's final performance and said the crowd resembled the gobsmacked audience watching "Springtime for Hitler" in *The Producers.* His most vivid memory was the cast wearing little more than silver-lamé G-strings, trying so hard to please that he said it was "as if they were performing *Guys and Dolls.*" After seven previews, *Rachael Lily Rosenbloom* became fodder for flop fanatics. Stigwood, a man *Newsweek* dubbed "the Ziegfeld of the disco age," closed the show before it officially opened. The poor girl was forgotten by all but the most ardent disco devotees until a concert revival was staged at New York's 54 Below—the cabaret beneath Studio 54—in 2017. For one night, it was 1973 all over again.

By 1978, disco was the hottest trend in America. Casablanca Records toyed with the idea of turning *Sphinx*—a 1977 disco album about the Crucifixion by Alec Costandinos—into a Broadway show. The musical, an anonymous record company executive said at the time, would mark "the first time in Christian history that you can dance to the Stations of the Cross." It never came to fruition.

Still, various Broadway shows couldn't resist incorporating disco into their scores.

Platinum, which opened in November 1978 at the Mark Hellinger, starred Alexis Smith as a holdover from Old Hollywood attempting a comeback by recording a disco album. The musical featured Bob Mackie costumes and a book cowritten by Bruce Vilanch. In it, Lisa Mordente—Chita Rivera's daughter—sang "Disco Destiny." The *New York Times* critic Richard Eder noted a supposed new dance style called "discotap" mentioned in the show but was unimpressed by the whole enterprise. *Platinum* closed after twelve previews and thirty-three performances.

Despite its abbreviated run, Vilanch is convinced that *Platinum* had one long-lasting effect. "One of the people who came to see the show was Ethel Merman," he remembers. "The next thing we know, Merman has recorded an album of all her hits gone disco. It's an iconic trash classic! But when I hear her, I just think, 'Why, Ethel, why?'"

The musical *Ballroom,* Michael Bennett's follow-up to *A Chorus Line,* opened its brief run at the Majestic Theatre that December. It not only had a mirror ball as its logo but also featured a hustle performed to a frenetic song called "More of the Same." The disco tune, sung by Lynn Roberts and Bernie Knee, came right before Dorothy Loudon's everlasting eleven o'clock number, "Fifty Percent." A rare misfire for the director, the show ran only three months.

Just as *Ballroom* was about to close, the Marvin Hamlisch/Carole Bayer Sager musical *They're Playing Our Song* premiered in February 1979 at the Imperial. With a book by Neil Simon, the show had a scene set in "Le Club." Where better for Robert Klein (as the Hamlisch-inspired character) and Lucie Arnaz (the Bayer Sager of the show) to hear the hit song they'd written together? With a smidge of disco flava in its arrangements to make the score seem au courant, the show was a success, running almost 1,100 performances.

It took another musical, however, for Broadway to go full-tilt boogie.

In June 1979, *Got Tu Go Disco* opened at the Minskoff with Irene Cara—still a year away from *Fame*—in the lead as Cassette. Yes, that's right, Cassette. The character was a shopgirl by day and a club queen by night. Warhol superstar Baby Jane Holzer was also in the show. But the real calling card was casting Marc Benecke and Bob Pettie, the actual doorman and barman of Studio 54, making their Broadway debuts. "He couldn't even play himself," pop culture commentator Michael Musto said of Benecke.

Justin Ross Cohen, a more seasoned performer, played Pete, the disco king, and he remembers "a kind of madness" to the proceedings. "It was my first real, substantial supporting role in a Broadway musical, and it was all very exciting at

the start. The dancing, the music, it was hot," he recalls. "Then things started to get really strange."

Behind-the-scenes personnel kept changing, for instance. "One day, you didn't know who was choreographing the show; the next, who was directing. And there were drugs *everywhere*. It was just chaos," Cohen says. That didn't sit well with Patti Carr, a veteran of twenty Broadway shows who played a character named Antwerp in *Got Tu Go Disco*.

"She was our grand dame, our Maggie Smith, if you will," Cohen says. In one rehearsal, he says Carr became so incensed by what she considered a lack of professionalism—a castmate showed up with a white cocaine mustache—that she had an anxiety attack. "Patti started to shake, and said, 'Never in my life have I encountered this kind of behavior.' Then her eyes rolled back, and she went down. The paramedics came and took her away, and I thought, 'Oh my God, *Got Tu Go Disco* killed Patti Carr!' But she came back the next day."

After opening night, Irene Cara reportedly did not come back, however. "Miss Cara seems embarrassed," Eder wrote in his *Times* review, and perhaps she was. The *New York Daily News* had called the show "pure trash." After the first official performance, as Cohen remembers it, Cara's understudy went on for the rest of the run. One the show's few good notices called it "a campy howl." But it wasn't enough. *Got Tu Go* was gone after nine previews and eight performances. "It was shocking that this show even made it to Broadway," says Musto. "If it were a nightclub, you wouldn't even try to get in."

Soon after the production closed, recording artist Pattie Brooks released an almost nine-minute version of the title track as a 12-inch single and included the song on her album *Party Girl*. It never became the dance-floor classic it could have been. Still, as Feldman says, "*Got Tu Go Disco* is spoken of very fondly among a certain group of aging show queens."

In his review of the show, Jacques le Sourd, a drama critic for the Gannett News Service, explained not only why the musical didn't succeed but also why disco and Broadway would always be strange bedfellows. "*Got Tu Go Disco* is clearly not the definitive statement on the disco experience," he wrote. "Disco must be experienced; it is not a spectator sport."

"It's really hard to translate the magical experience of being in a fabulous nightclub, which is what I live for and have spent my life documenting, into a play, because nightlife is immersive," says Musto. "You're part of the show."

Decades later, critics were reiterating that point, noting that such off-Broadway undertakings as *The Donkey Show*, a 1999 musical that merged disco classics and Shakespeare—one critic called it "A Donna Summer Night's Dream"—and *Here Lies Love*, a 2013 collaboration between David Byrne and Fatboy Slim about Ferdinand and Imelda Marcos, succeeded in merging disco and drama precisely because they were staged as immersive experiences.

Audiences weren't mere spectators at those shows but spent the entire performance on their feet dancing their hearts out, not applauding politely from their seats. Both shows received enthusiastic reviews, all praising the shows' attempts to recreate a Studio 54 feeling for theatergoers. "*The Donkey Show* was a great deal of fun," remembers *Time Out*'s Feldman. "Everyone was drinking, and it was really high energy."

As the twentieth century ended, the ultimate dance-floor movie found its way to the boards.

In September 1999, a stage version of *Saturday Night Fever* opened at the Minskoff starring James Carpinello, in his Broadway debut, as Tony Manero. The show featured not only the classic Bee Gees songs of the film, but also other disco hits. Broadway veteran Bryan Batt played Monty, a disco DJ described as "the Snatch Hound of Bay Ridge." The role, played by Monti Rock III in the film, was beefed up and Batt was given two songs.

"To get to sing 'Disco Inferno' eight times a week was heaven," Batt says. "But, on the flip side, I also had to sing 'Disco Duck.'" For his efforts, he received some of the show's best notices. "I was afraid the next day there would be tacks in my platform shoes," he remembers. "The show wasn't as well received by the critics as we hoped, but the audiences loved it." Donna Pescow, who played Annette in the

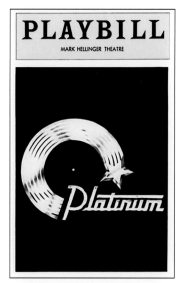
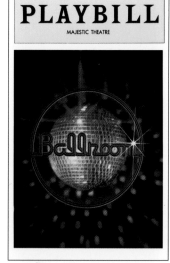
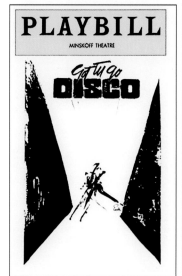

movie version, remembers the night she saw it. "People were dancing in the aisles. They were so invested in being a part of the show. I was blown away." *Fever* ran for more than five hundred performances, and long after it closed on Broadway, the crowd-pleaser continued stayin' alive on tour, on cruise ships, and in Europe.

Is ABBA really a disco act, or just the sole entry in a four-person Swedish category called, well, ABBA? Some would argue the latter. They are their own genre. But "Dancing Queen" is a fixture on any good disco playlist, so who is to split wig hairs over a Broadway musical? When *Mamma Mia!* opened in 2001, replacing the record-breaking musical *Cats* at the Winter Garden Theatre, it was staged with the irresistible glitz of a mirror ball. An import from London's West End, it was a sea of sequins, sparkle, and seventies bell-bottoms. The gushingly positive review in the usually cynical *New York Times* praised the costumes as "disco drag." If the goal of ABBA's music was to get audiences on their feet, dancing, and cheering, then *Mamma Mia!* was *definitely* a disco musical. As it turned out, it was the most successful disco musical of all. The show ran for fourteen years and spawned two movies and a Cher album.

A stage version of *Xanadu*, the nostalgic roller-disco movie from 1980, came to Broadway in 2007. It was brilliant, but not quite the success that *Mamma Mia!* was. Set in Los Angeles and on Mount Olympus, the musical was written by Douglas Carter Beane—the screenwriter of the drag classic *To Wong Foo, Thanks for Everything! Julie Newmar*—and was both a love letter to the Olivia Newton-John/Gene Kelly film, and a very hip send-up. One character describes the show as "children's theater for gay forty-year-olds."

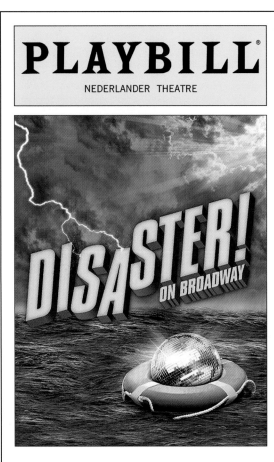

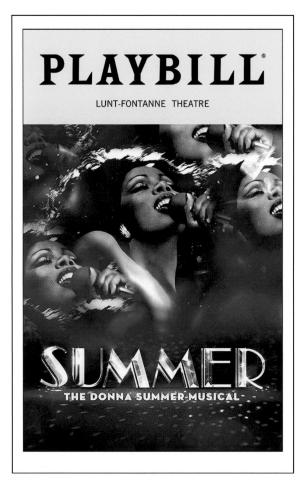

The movie music by Electric Light Orchestra was augmented with more songs from the band's catalog, which resulted in the formidable twosome of Jackie Hoffman and Mary Testa singing "Evil Woman" with no scenery left unchewed. Reviews were positive for the writing and the cast, which included Kerry Butler, Cheyenne Jackson and his thighs, and Tony Roberts. *Xanadu* was nominated for four Tony awards and ran for more than a year at the Helen Hayes.

When the 1994 Australian drag road movie *The Adventures of Priscilla, Queen of the Desert* arrived on Broadway in 2011, the score was a pop jukebox that included such disco classics as "It's Raining Men," "Don't Leave Me This Way," "I Love the Nightlife," "I Will Survive," "Shake Your Groove Thing," "Boogie Wonderland," "Hot Stuff," and "Go West."

The show won a Tony Award for its costumes by Tim Chappel and Lizzy Gardiner, the design duo who'd snatched an Oscar for the movie's fanciful frocks seventeen years earlier. Buoyed by reviews like that of *Times* critic Charles Isherwood, who said the show was "performed with gleaming verve and infusions of bawdy humor," Priscilla ran almost 550 performances, including previews, at the Palace. Australian actor Tony Sheldon, who was nominated for a Tony for the Broadway version, went on to play the role of Bernadette, the trans character, almost two thousand times in productions around the world.

In 2014, actor Anthony Wayne, who'd joined the cast of *Priscilla* in mid-run, had his own disco moment when he created *Mighty Real: A Fabulous Sylvester Musical* about the androgynous one-name diva behind such hits as "Dance (Disco Heat)," "You Make Me Feel (Mighty Real)," and "Do Ya Wanna Funk?" Although Isherwood called the show "slender but musically vibrant" in the *Times*, he said Wayne did "lusty honor to a singular performer who one fondly hopes is even now crooning away before an enraptured audience at some discotheque in heaven." It was a pleasure because it was more a concert than a bio-musical.

A short-lived 2016 Broadway musical called *Disaster!*, which spoofed the disaster-movie genre and employed some disco music to do so, also garnered critical favor. The show worked, Feldman says, because it was clever and supremely silly. Despite a stellar cast—Faith Prince, Rachel York, Kevin Chamberlin, and *Xanadu*'s Butler—the show's one Tony nomination went to actress Jennifer Simard who, as the *New York Times* put it, played "a guitar-slinging nun with a soft spot for slot machines." Disco songs included in the score were "Hot Stuff," "Knock on Wood," "Never Can Say Goodbye," and, appropriately enough for a disaster epic, "I Will Survive." But the show didn't survive. *Disaster!*—the creation of the very funny writer-performers Seth Rudetsky and Jack Plotnick—closed after about a hundred performances, including previews, at the Nederlander Theatre.

Much less well-received, despite its impressive creators, was the 2018 off-Broadway musical *This Ain't No Disco*. Its songs were written by Stephen Trask of *Hedwig and the Angry Inch* and Peter Yanowitz of the Wallflowers; the book was by *Jersey Boys* alum Rick Elice; and its director, Darko Tresnjak, had won a Tony for *A Gentleman's Guide to Love & Murder*. But critics hated it right down to the Steve Rubell character played by Theo Stockman. Ben Brantley of the *Times* called it a "tone-deaf, cliché-clogged rock opera" set in "the wilting salad days of Studio 54." *This Ain't No Disco*, he concluded, "just ain't no fun."

Perhaps the most ambitious attempt to bring disco to Broadway was 2018's *Summer: The Donna Summer Musical*, a jukebox show that originated the year before at California's La Jolla Playhouse. *Summer* used the singer's many hits to tell a somewhat sanitized version of her life story. The cast was all-female—even the mustachioed actor playing disco hitmaker Giorgio Moroder was a woman—and provided the first glimpse many audience members had of Ariana DeBose, who'd go on to win a Best Supporting Actress Oscar as Anita in the 2021 remake of *West Side Story*. She had appeared in *Hamilton* and *Pippin*, but "Disco Donna" was her showiest Broadway role. LaChanze and Storm Lever embodied older and younger versions of Summer in the musical, which played more than three hundred performances at the Lunt-Fontanne.

Audiences loved *Summer*. But critics still felt that disco and Broadway were hard to combine. Vincentelli theorizes why: "Each disco song is an eleven o'clock number, a mini journey" she says. "It's hard to build a whole series of disco numbers that are different enough and put them into a story." She believes that *Mighty Real: A Fabulous Sylvester Musical* came closest to getting it right, but even that suffered because it was not immersive. "An audience, all facing the same direction, makes it difficult for a show with this kind of music to succeed," she says. But as she wrote in the *New York Times* upon the *Summer*'s opening, "No more tears for the show's producers: Nostalgia-loving women and gay men are filling the seats."

When and how the creators of future off-Broadway and Broadway musicals will incorporate dance music into their scores remains to be seen. But it is unquestionable that they will try, hoping to come up with the next *Mamma Mia!* or even the next *Xanadu* or *Summer*. Boy George did his best in 2003 with the musical *Taboo*, set in the London club scene of the eighties and nineties. Overly ambitious and underappreciated, it lasted a little more than a hundred performances at the Plymouth Theatre. If his tunes can be made into a stage production that many remember fondly, despite its short life, why not, say, an Erasure musical? A very danceable one named *Oh L'Amour* is in the works, in fact.

In 2023, the "disco musical" *Here Lies Love* prepared for a Broadway run, a decade after its off-Broadway premiere, by removing orchestra seats at the Broadway Theatre and turning that section of the theater into a dance floor. Producers, it seemed, had finally learned their lesson. Sadly, the remodeling wasn't enough to ensure a lengthy run. As lavish and immersive as this version of the show was, *Here Lies Love* closed after only 33 previews and 149 regular performances.

Broadway Show Tunes Gone Disco

"From the beginning of disco, such big-band and Broadway hits as 'Brazil,' 'Tangerine,' and 'Baby Face' have been disco-ized to great success," *Hartford Courant* critic Henry McNulty noted in 1979. It was in a column called "Vinyl Freaks," but you can't have everything. He wasn't wrong. The lavishness of Broadway music makes it the perfect candidate for a disco redo. Here are the best disco show tunes.

The disco single of "Saravá," the title song of the Broadway musical of that name, was sold in the lobby at intermission.

"ZING! WENT THE STRINGS OF MY HEART" BY THE TRAMMPS, 1972

Four years before they set the charts on fire with "Disco Inferno," the Philadelphia-based vocal group the Trammps scored their first hit with an up-tempo version of the catchiest show tune of 1934, with Earl Young's deep voice featured. Written by James F. Hanley for the Broadway revue *Thumbs Up!*, the number later became associated with Judy Garland when she sang it in the 1938 film *Listen, Darling* and added it to her repertoire. Garland's the greatest, but this version remains the zingiest.

"SMOKE GETS IN YOUR EYES" BY PENNY MCLEAN, 1975

Best known for fronting Silver Convention—the German studio act who hit the disco stratosphere with "Fly, Robin, Fly" and "Get Up and Boogie"—Penny McLean included a dance version of Jerome Kern's "Smoke Gets in Your Eyes" on her 1975 solo album, *Lady Bump*. First heard in the 1933 musical *Roberta*, the jazz standard, with lyrics by Otto Harbach, was first a hit for Paul Whiteman and his Orchestra and then, in the fifties, for the Platters.

"SEND IN THE CLOWNS"/ "WHAT I DID FOR LOVE" / "TOMORROW" BY GRACE JONES, 1977

Produced by the legendary Tom Moulton, Grace Jones's debut album, *Portfolio*, yielded the club hit "I Need a Man" and a timeless version of "*La Vie en Rose*." But the record is infamous for its A-side, an uninterrupted trio of showtunes reimagined for Studio 54: "Send in the Clowns" from Stephen Sondheim's 1973 *A Little Night Music*, "What I Did for Love" from Marvin Hamlisch and Edward Kleban's 1975 *A Chorus Line*, and "Tomorrow" from Charles Strouse and Martin Charnin's 1977 *Annie*. When Jones asked, "Isn't it queer?" her most ardent fans knew the answer.

"STRANGER IN PARADISE" BY ISAAC HAYES, 1977

The popular 1953 musical *Kismet*, by George Forrest and Robert Wright with melodies borrowed from the nineteenth-century classical composer Alexander Borodin, returned to Broadway in 1978 in an all-Black reimagining called *Timbuktu*. Lavishly staged by Geoffrey Holder and starring Eartha Kitt and Melba Moore, it was a modest hit. The previous year, Isaac Hayes had released a funky reworking of the show's best-known song, "Stranger in Paradise," on his *New Horizon* album. It's hotter than Mali in May.

"WHAT I DID FOR LOVE" / "IF EVER I WOULD LEAVE YOU" BY ROBERT GOULET, 1978

Grace Jones may have beaten him to *A Chorus Line*, but Robert Goulet's version of "What I Did for Love" is a manic three-minute-and-fifty-second Vegas-on-vinyl extravaganza that needs to be experienced. His 1978 album, *You're Something Special*, also featured a disco rendition of "If Ever I Would Leave You" from *Camelot*. Goulet was the original Lancelot in that 1960 Lerner and Lowe musical about King Arthur. Eighteen years later, he was Dance-a-lot and still as handsome as ever.

"SARAVA" BY SARAVA, 1978

Roadshow Records released a disco version of the Broadway musical's title track on a 12-inch single before the show opened, then sold copies in the lobby after it did. Based on the successful 1976 Brazilian film *Dona Flor and her Two Husbands*, *Sarava* was written by N. Richard Nash and Mitch Leigh, and starred Tovah Feldshuh. The title song, backed by "You Do," also from the show, are all that exists on vinyl. The musical closed after six months. An original Broadway cast album was never released.

"FIDDLER ON THE ROOF (MEDLEY)" BY THE SALSOUL ORCHESTRA, 1978

If you're going to discofy the ultimate Jewish musical, the Salsoul Orchestra figured in 1978, you might as well do it as a mash-up for the whole *mishpachah*. The group took songs from *Fiddler on the Roof*—"Matchmaker," "Sunrise, Sunset," and "If I Were a Rich Man," among them—and mixed them with the folk song "Hava Nagila," the movie "Theme from *Exodus*," and more. The medley is the standout track on *Up the Yellow Brick Road*, an album which also featured "Ease on Down the Road" from *The Wiz* and a jaunty *West Side Story* jumble. Not until the 2004 release of Gwen Stefani's "Rich Girl" would dance floors see such roof-fiddling again.

"THEY'RE PLAYING OUR SONG" BY DANTE'S INFERNO, 1979

The 1979 Neil Simon musical, *They're Playing Our Song*, with music and lyrics by Marvin Hamlisch and Carol Bayer Sager, had disco flourishes in its score. But it took Dante's Inferno, a trio led by former Archies front man Ron Dante, to turn the title track into a full-on thumper. Their 1979 LP also featured a disco "Ain't Misbehavin'," the title track from the 1978 Broadway musical revue about Fats Waller. Dante's backup singers asked, "One never knows, do one?" And it was true. Who could have known the "Sugar, Sugar" singer would be so sweet on disco?

"BEGIN THE BEGUINE" BY JOHNNY MATHIS, 1979

The smooth-voiced singer included a disco version of "Begin the Beguine" on his 1979 album, *The Best Days of My Life*. The Cole Porter tune was introduced in the 1935 Broadway musical *Jubilee* and became an American classic with versions by Frank Sinatra, Ella Fitzgerald, and Elvis Presley, before Mathis brought it to seventies dance floors. Mathis also released well-reviewed disco versions of other vintage show tunes in 1979 including "Night and Day," "That Old Black Magic," and "To the Ends of the Earth." Forty years later, Julio Iglesias borrowed the rhythm from Mathis's disco "Beguine" for his hit Spanish-language version of the song.

"DON'T CRY FOR ME ARGENTINA" BY FESTIVAL, 1979

Before there was Madonna's 1996 dance version of *Evita*'s most-requested song, there was Festival's. And, in 1979, it was both high-flying and adored. The brainchild of Boris Midney—the innovative producer behind the hit "Boogie Motion" by Beautiful Bend—Festival released an entire Eurodisco *Evita* album. It featured seven songs from the landmark Andrew Lloyd Webber/Tim Rice Broadway musical about Eva Peron, wife of Argentine dictator Juan Peron. The 12-inch single of "Don't Cry for Me Argentina" had "Buenos Aires" on the flipside. Even without Patti, it was a party.

"MEMORY" BY MENAGE, 1983

Grizabella the Glamour Cat—played first by Elaine Paige in London; then by Betty Buckley on Broadway—sang "Memory," the one truly unforgettable song from *Cats*, Andrew Lloyd Webber's long-running 1981 musical version of T.S. Eliot's *Old Possum's Book of Practical Cats*. But it took the cats from Menage to turn the haunting ballad into an aerobically charged seven-minute-plus disco single in 1983. The hit song was played in hotspots from here to the Heaviside Layer. Remember?

"I AM WHAT I AM" BY GLORIA GAYNOR, 1983

Gloria Gaynor had already cemented her place in the hearts of gay men with her 1978 disco smash "I Will Survive," but she truly sealed the deal five years later when she turned "I Am What I Am"—the first act finale from Jerry Herman's groundbreaking drag musical *La Cage aux Folles*—into a closet door–busting dance-pop anthem. When the show won Best Musical and four other Tony Awards in 1984, Gaynor's version was already a club hit in America and had charted around the world. Fun fact: A Hi-NRG version of the musical's title song was released in 1983 by the Italo-disco outfit Le Jeté.

"ONE NIGHT ONLY" BY SCHERRIE PAYNE, 1984

Performed twice in *Dreamgirls*, the 1981 Tom Eyen/Henry Krieger smash, "One Night Only" is, at first, a heartbreaker sung by Effie (Jennifer Holliday), then a disco triumph sung by Deena (Sheryl Lee Ralph) and the Dreams (Loretta Devine and Deborah Burrell). When Sylvester covered the song in 1983, he chose the slow version. The following year, though, Scherrie Payne—a former member of the Supremes, the real-life girl group that inspired the musical—brought "One Night Only" to the dance floor with backing vocals by Cindy Birdsong, *another* former Supreme. Twenty-two years later, a new generation of fans danced to remixes of Oscar-winner Jennifer Hudson's 2006 movie version of the song. But Payne's take on the song remains disco's best.

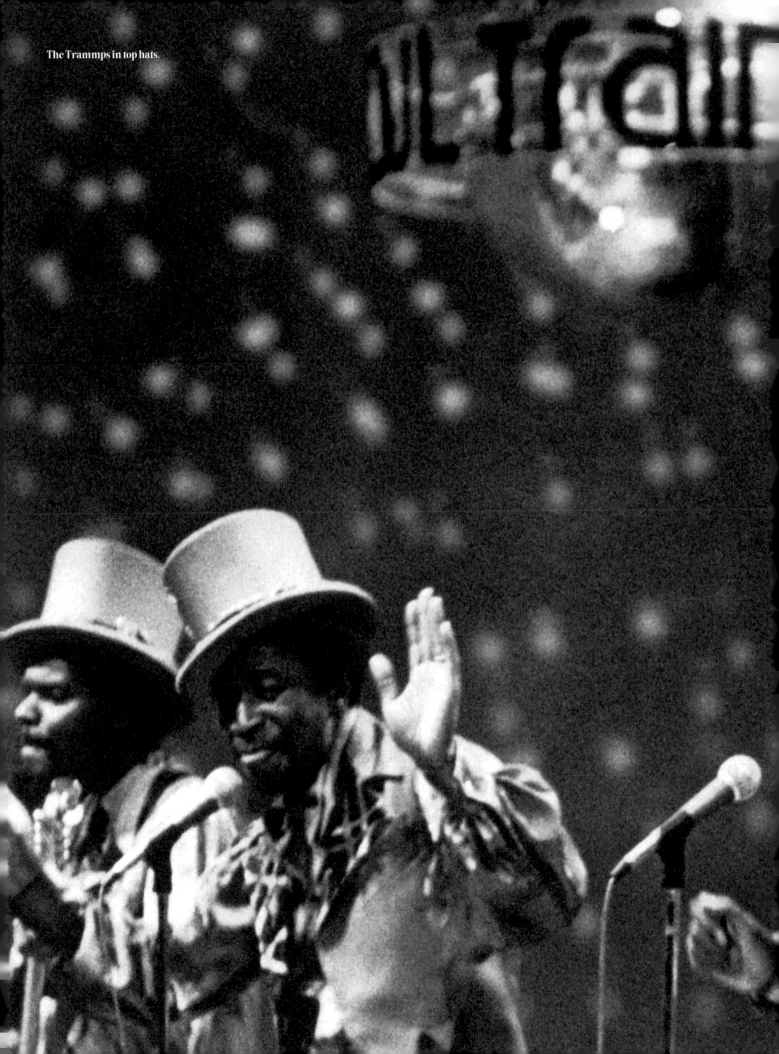

The Trammps in top hats.

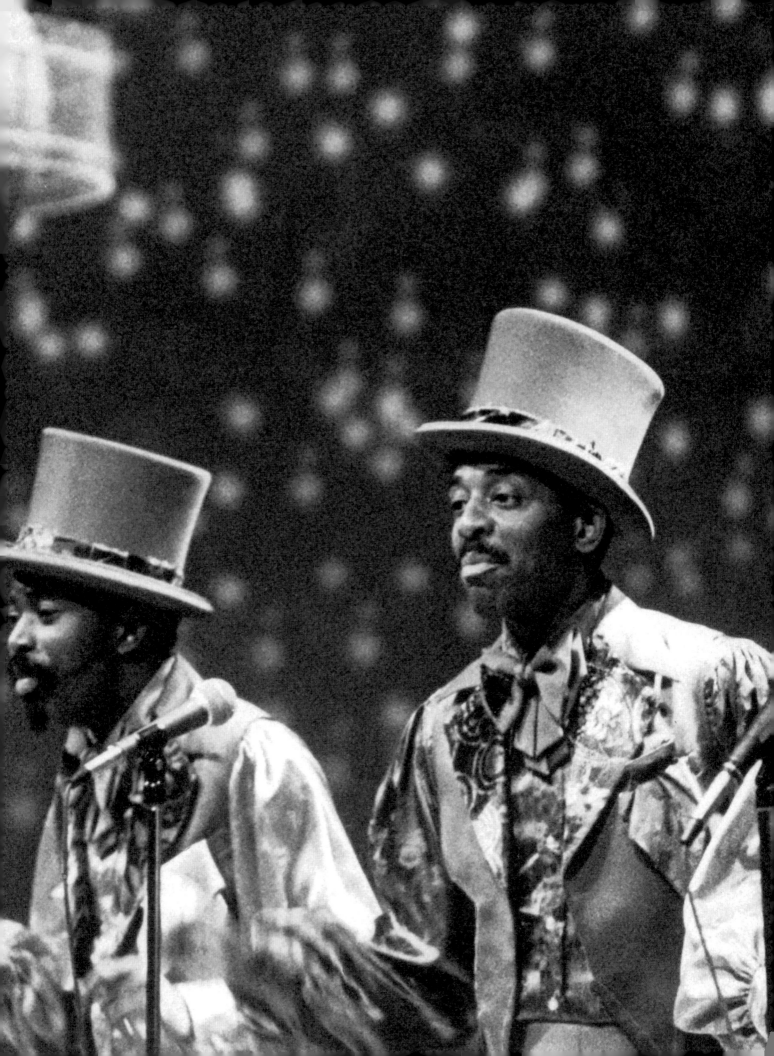

Something for the Boys: The Ethel Merman Disco Album

In 1979, Ethel Merman recorded fourteen of her most famous show tunes and producers set them to a thump-thump beat. The result was the strangest vinyl artifact of the entire era—*The Ethel Merman Disco Album.*

A dance floor reimagining of such classic show tunes as "I Got Rhythm," "There's No Business Like Show Business," and "Everything's Coming Up Roses"—songs Merman made famous in the landmark musicals *Girl Crazy, Annie Get Your Gun,* and *Gypsy*—the record marked the most unlikely foray into disco music by any superstar. It was so shocking in its day that the *Boston Globe* in 1979 decreed, "If they can allow this revolutionary revamping to take place, then not even the National Anthem is immune to disco surgery."

The Merm—a leading lady for half a century before Studio 54 opened its doors—gave the project her all. To trumpet the album, she did every gig she could get, often performing in a wind-catching caftan and always bellowing as no one else could. "I'm going to plug the hell out of the album," she told one reporter. "I still move pretty well, if you haven't noticed. What is it they call it now? Gettin' it on down."

In her most high-profile appearance, Merman joined Johnny Carson on *The Tonight Show,* handing out ETHEL BOOGIE T-shirts. "I am doing, I think, one of the most exciting things in my life," she told the famed talk show host, explaining that she had collaborated with arranger Peter Matz, best known as the musical director of *The Carol Burnett Show.* "I'm just thrilled with it," she gushed. "What he has done with these songs, it is unreal. Wait until you hear all of these numbers. It's not to be believed!"

She wasn't kidding. *The Ethel Merman Disco Album* was *really* not to be believed.

Although full-page ads in trade papers christened the seventy-one-year-old Broadway diva with the foghorn voice, "The Queen-Mother of Disco" and crowed, "Donna Summer, eat your heart out!" the album was *not* given a royal welcome and Summer didn't quake in her Candies.

"Lady, I may be the Queen of Disco, but you're its Diva," she reportedly told Merman.

Merman's own record company wasn't nearly as supportive. Although Herb Alpert, co-founder of A&M, told the *Los Angeles Times,* "It's almost as if disco was made for her voice," the label released only half thte tracks she had recorded. Those seven songs were plenty enough for critics to sink their teeth into and they did, mercilessly.

"This album is everything you were afraid it would be," one reviewer warned. "Merman sings the way she always does, sounding like she has nothing to do with the background at all," another chided. "Just when we thought disco had stooped to its lowest point, along comes Ethel with the travesty to end all travesties," pronounced one particularly punishing wordsmith. "Even the staunchest disco fan is hereby defied to try and make it through the entire LP," he challenged. A Pittsburgh critic likened the album to "seeing Fred Astaire dancing the Freak."

The best review, such as it was, came from John Rockwell in the *New York Times.* "Miss Merman still has a remarkably healthy-sounding voice. And although the disco arrangements are pretty prosaic, she manages to infuse the project with enough ruddy good cheer to subvert at least some of the cynicism."

Merman remained upbeat.

"Anybody I've spoken to about this project thinks it's the greatest thing since 7-Up," she said, claiming that even Irving Berlin approved. When she played a tape for the then ninety-three-year-old composer over the phone, he reportedly said, "Christ, Ethel, this is the best version of 'Alexander's Ragtime Band' I've ever heard. I don't care if it *is* disco!"

Staunch fans were loyal, if a bit skeptical, as they forked over $4.39 for the album and Merman signed hundreds of copies during a lunchtime appearance on August 13, 1979, on the third floor of Korvette's on Fifth Avenue at Forty-Seventh Street in New York City. "I'm no disco singer," she told a *Daily News* reporter covering the event. "This is *not* your average contemporary disco. This is *Broadway* disco!"

Merman did not add disco—Broadway or otherwise—to the setlist of her concert appearances, of which she was still doing about two dozen a year. "I certainly don't intend to lock myself into disco," she said. "But it'd be fun if it went over big. I'd like to see my posters up on the kids' walls—now that's something I haven't had yet." Although one Green Bay critic did call her a "hep oldster," an Ethel Merman disco youthquake never happened.

"There were plenty of unlikely stars jumping on the disco bandwagon and having huge hits," pop cultural observer Michael Musto remembered in 2021. "But they all worked with producers who understood what a disco record sounds like. You couldn't just have Ethel Merman singing as she always did and then add a backing track to it. Why put this woman through such humiliation?"

The album quickly went out of print, but it wouldn't die.

In 2003, Fynsworth Alley Records released *The Ethel Merman Disco Album* on CD with an additional bonus track, Berlin's "They Say It's Wonderful." By then, critics had softened their views, describing the album as a "camp and cult favorite featuring one of Broadway's most luminous stars." Invitations to the CD release party at a Manhattan nightclub called Spa bore the words, "DISCO ETHEL."

Biographer Geoffrey Mark set the record straight with the 2005 publication of his book *Ethel Merman: The Biggest Star on Broadway.* "It is not true that this album killed disco," he said. "Wounded it, perhaps"

Today, *The Ethel Merman Disco Album* is regarded by some as a camp masterpiece—the *Showgirls* of disco recordings—and video clips frequently make the rounds on social media. Merman's high-energy 1979 performance of "Alexander's Ragtime Band" on the Saturday morning children's show *Kids Are People Too,* set against a sea of disco balls, is three-minutes-and-twenty-seconds of YouTube disco bliss.

Almost forty years after that TV appearance, an LGBTQ theater in Atlanta celebrated the album and the holidays with a 2018 stage show called *The Ethel Merman Disco Christmas Spectacular!* The production was a send-up, but its creator Paul Conroy was sincere in his affection. "She was trying to stay popular and relevant at seventy-one," he said. Today, *The Ethel Merman Disco Album* remains, as Cole Porter would say, "Something for the Boys."

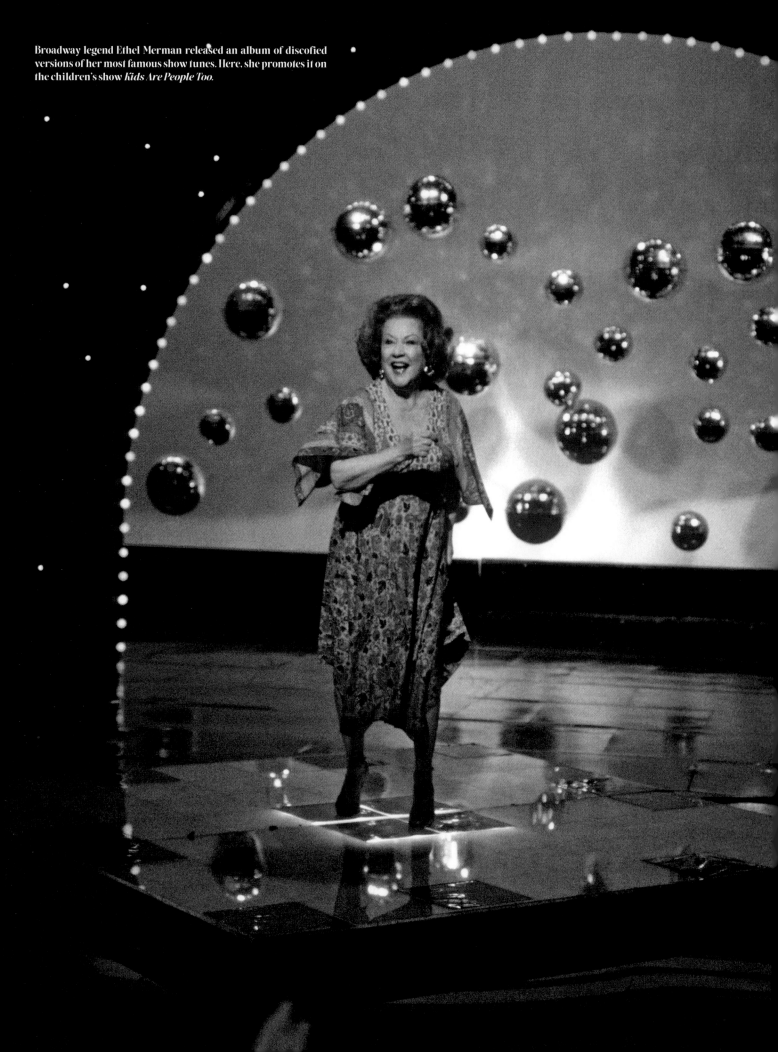

Broadway legend Ethel Merman released an album of discofied versions of her most famous show tunes. Here, she promotes it on the children's show *Kids Are People Too*.

She scored a smash hit with a 1978 disco version of the Broadway classic "If My Friends Could See Me Now" from the 1966 Cy Coleman/Dorothy Fields musical, *Sweet Charity.* But as a kid growing up in New York City, Linda Clifford wanted to be a dancer. Her body didn't cooperate.

"I was pretty clumsy," she admits. "I fell down a lot."

But after studying tap, jazz, and ballet, she got it together physically. It was in "personality classes," though, that she discovered her real talent—she could sing like a bird.

Agents came calling and Clifford soon found herself on local children's programming like *The Merry Mailman Show* with Ray Heatherton, and then on live TV broadcasts from the basement of Macy's in Manhattan's Herald Square. "We would go on and sing and dance and I thought, 'Wow, I like this!'" she remembers.

Later, Clifford auditioned for the Radio City Music Hall Rockettes, and various Broadway shows. "That was my real start in the business, and it led to what I'm still doing now."

In addition to her hit show tune remake, Clifford is known for her 1979 dance version of the 1970 Simon and Garfunkel ballad, "Bridge Over Troubled Water," and her Number 1 dance hit, "Red Light" from the movie *Fame.* Clifford proved—and continues to prove—that any tune can get an audience on its feet if the singer's got the pipes for it.

FDC: "Is it true that you had an uncredited part in the movie version of *Sweet Charity?*"
LC: "A lot of people ask me about that. I had forgotten about it. I did four films, but I had very minor roles. I was really just breaking into acting and doing TV commercials. But *Sweet Charity* happened to be one of the films that I landed."

FDC: "It must have felt great to have your first major success as a recording artist with a song from that show!"
LC: "Isn't that something? It's like everything comes full circle. That song came back around and bit me on the butt. I was like, 'What is happening?'"

FDC: "How did you come to do a disco version of 'If My Friends Could See Me Now'?"
LC: "One of the secretaries at my record company, as we were trying to gather songs for my next album, said, 'You know, I have an idea. Why don't you do a disco version of that song from *Sweet Charity*?' Before she could get it out of her mouth, I thought, no, you can't do that, that's Broadway. Well, thank God the record company did not listen to me. They recorded a track and called me to come in and hear it and I went nuts. I was like, 'Oh my god, that is my song!' So that was a great thing, being connected to the film and then having this happen."

FDC: "When did you find out that the song was a smash hit?"
LC: "I got a call from the president of the record company to tell me that 'If My Friends Could See Me Now' was Number 1 in *Billboard,* and I hung up on him. I did! I said, 'That is not funny.' Bam. I hung up because I knew that could not be true. He called me back and said, 'Don't hang up! Go get a *Billboard* magazine,' which I did. And sure enough, there it was. I couldn't believe it. I hadn't been to any clubs to see people dancing to the song or to see how they responded. I hadn't seen any of that. I was working nightclubs in Chicago, five nights a week for six hours a night. So, I didn't get to see the glamour of discos until I appeared at Studio 54."

FDC: "What was your first visit to Studio 54 like?"
LC: "Oh my God, it was *the* place. I was doing a little promotional tour in New York, and they took me to Studio 54. We went in the back entrance. They got me all the way up in the DJ booth and said, 'Watch this.' They took off whatever song was playing, and they put on 'If My Friends Could See Me Now' and that place went ballistic. I couldn't believe my eyes. People were screaming and jumping and just going crazy. It was an amazing experience."

FDC: "Was disco a golden opportunity for talented performers like you?"
LC: "For women in this business, disco was a big, big deal. When it came along, women were finally given the opportunity to get records out there and be involved in the business, and not just behind the scenes. For years, it had been a guy's business. You had a lot of men out on the road, doing shows, and women didn't get that kind of opportunity until disco came along. It was a huge thing for many of us."

FDC: "How did you choose to do a disco version of 'Bridge Over Troubled Water' in 1979?"
LC: "That song was in my repertoire when I worked in clubs. I sang it as a ballad, like Simon and Garfunkel. When I was looking to do a new album, we wanted to take a song that everyone knew—a song with a positive message—and make it danceable. That was first and foremost in everybody's mind. Being true to the lyrics of the song was so important to me, especially because it had been a ballad. You want the same depth of feeling to come across even though now you can dance to it. You still want them to feel that love and that connection."

FDC: "Wasn't love and connection what discos were all about?"
LC: "Discos were places where everybody—no matter what race, no matter what sexual orientation, no matter what anything—could go and dance and have a good time. You got dressed up. Everybody was looking to forget how horrible a day they had."

FDC: "Disco music gave people hope."
LC: "I would say so, yes. Our songs talked blatantly about love. Everybody having fun together, no matter who you were. Disco gave people a chance to be truly who they were—gay people could come out, be themselves, even if they'd have to go back to their nine-to-five jobs where they could be fired if somebody found out. It was the end of women not having a say in the music business because they were women. And, of course, Black folks. Those groups of people were always pushed down. Always. Disco was their chance to get out and have some fun."

FDC: "How did you feel about Disco Demolition Night in 1979?"
LC: "My heart sank watching it. It was painful. I thought, how could anybody hate music? It just didn't make sense to me—seeing those DJs on TV doing these interviews, and, shortly after, realizing that a lot of the clubs were closing. People were not going out. I wasn't working. A lot of my friends weren't working. They put a stop to that, and they destroyed a form of happiness. They should be ashamed, not going around talking about what they did."

FDC: "They still celebrate the anniversary of it."
LC: "Yeah, I'd like to celebrate it with them. I'm from Brooklyn."

FDC: "That's a very different kind of celebration! Well, you've gotten the last laugh. Lately, you've been performing as one of the 'First Ladies of Disco' with Martha Wash and Evelyn 'Champagne' King. How did those shows originate?"
LC: "Most of the people in this business, we've known each other for ages. Martha Wash and I met forty years ago in Italy. She was still singing background with Sylvester. We were getting booked on the same shows. Then, of course, Evelyn got pulled in. People really love the idea that it's a show with the actual performers who recorded the songs, not a cover band. And the fact that we're not getting any younger means we all better get out there quick!"

FDC: "How do today's audiences react when you launch into 'If My Friends Could See Me Now'?"
LC: "They still go absolutely crazy. There's something in that song that touches people. I'm not the only one out there who has heard, 'Oh, you'll never make it. It's too hard.' Every time I sing that song, I think about those people who said that to me. Instead of backing you up and giving you that extra strength you might need to go out there and do something so unreachable, they'd rather have you just stay home. I think a lot of us have said, 'You know what, I'm going to give it a shot.' The minute I start to sing that song, it's fabulous."

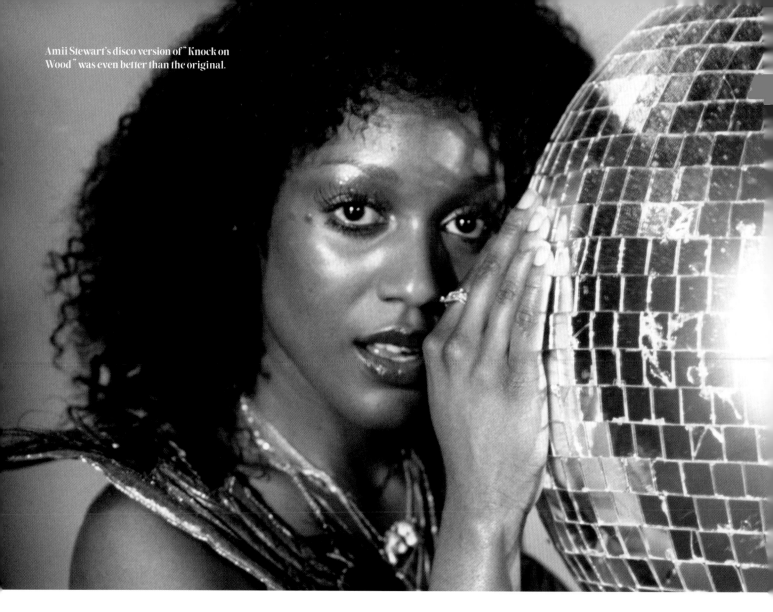

Amii Stewart's disco version of "Knock on Wood" was even better than the original.

Discofied Classics

"DRIVE MY CAR" BY GARY TOMS EMPIRE, 1975

Having climbed the R&B charts with a song called "7-6-5-4-3-2-1 Blow Your Whistle," the American funk band Gary Toms Empire slipped into pop consciousness with a disco version of the 1965 Beatles hit, "Drive My Car." One of the first promotional 12-inch singles to be released, the remake parked briefly at Number 69 on the pop charts.

"BLACK IS BLACK" BY VARIOUS ARTISTS, 1976-1977

The Spanish rock band Los Bravos had an international hit with "Black is Black" in 1966. Ten years later, French Eurodisco pioneer Cerrone included a dance version on his 1976 album Love in C Minor. The following year, he was one-upped by an all-girl Parisian trio called La Belle Epoch with an even better, more vocally driven disco remake. They sang and danced their way across European television to promote it.

"KNIGHTS IN WHITE SATIN" BY VARIOUS ARTISTS, 1976-1978

Eurodisco architect Giorgio Moroder added a "K" to the spelling of the Moody Blues' 1967 hit "Nights in White Satin" and gave it a sultry new lease on life in 1976. He wove the song into a suite with "In the Middle of the Knight," cowritten with Pete Bellotte. It filled a whole album side. Two years later, the French disco act Panama served up another disco version (with no "K") on their album Fire!

"LA BAMBA" BY VARIOUS ARTISTS, 1976-1978

It was a traditional Mexican folk song before Richie Valens turned "La Bamba" into a rock 'n' roll classic in 1958. Since then, everyone from Dusty Springfield to Wyclef Jean has covered it. In the seventies, it was disco fodder—French outfit Chocolat's released their pop-dance version in 1976. Antonia Rodriguez released her brassy salsa-fied take two years later. It was worth the wait.

"CALIFORNIA DREAMIN'" BY VARIOUS ARTISTS, 1977-79

A Top 10 hit for The Mamas and the Papas in 1965, "California Dreamin'" was discofied at least three times. The Canadian disco act Grand Tour was first, in 1977. The Italian disco outfit Colorado added a "g" to their version. Their "Dreaming" charted in Britain in 1978. American singer Cynthia Woodard gave the soul and added handclaps in 1979.

"DAY TRIPPER" BY AMADEO, 1977

The 1965 Beatles hit "Day Tripper" got a bizarre disco revamp—complete with a honey-dripping voiceover about "four guys from Liverpool"—on Amadeo's 1977 album, Moving Like a Superstar. His remake of the Rolling Stones' "Satisfaction" was no less strange.

"GLORIA" BY MIDNIGHT STUD, 1977

"Gloria"—the 1964 spelling lesson by Van Morrison's band Them, not the 1982 Laura Brannigan hit—was set to a thump-thump beat and tarted up with handclaps by the French disco act Midnight Stud and released on Carrere Records in 1977.

"HAVE A CIGAR" BY ROSEBUD, 1977

A searing indictment of the music industry, "Have a Cigar" was a stellar track on Pink Floyd's landmark 1975 album Wish You Were Here. But to really get that Tiparillo smoking, it took Rosebud's 1977 disco version. The song was included on Discoballs: A Tribute to Pink Floyd.

"HOUSE OF THE RISING SUN" BY VARIOUS ARTISTS, 1977

The Animals' 1964 rock hit "House of the Rising Sun" got not one but two disco makeovers—one by Hot R.S., a studio project that used an acronym for the song as its band name, in late 1977, and one by the international disco band Santa Esmeralda a few months later. Hot R.S. was first, but Santa Esmeralda had the edge; they'd already had a disco clap-heavy hit with another Animals tune, "Don't Let Me Be Misunderstood" a few months earlier.

"PIPELINE" BY BRUCE JOHNSTON, 1977

Beach Boy Bruce Johnston had a solo hit in 1977 with a dance remake of "Pipeline," a 1962 smash for the Chantays. His disco version is but a footnote in its history. The surf-tacular song has been covered by everyone from Lawrence Welk to Anthrax.

"BEND ME, SHAPE ME" BY GILLA, 1978

Austrian singer Gilla—Gisela Wuchinger to her mother—swapped sixties groovy for seventies glitter for her 1978 cover of the 1967 American Breed hit "Bend Me, Shape Me." Despite all the bending or shaping, the remake scored only in Switzerland and Australia.

"FEVER" BY VARIOUS ARTISTS, 1978

Three years after finding cult stardom as Columbia in The Rocky Horror Picture Show—and fourteen years before Madonna recorded her dance version of the song—Little Nell Campbell purred her way through a disco cover of "Fever." That same year, Swedish model Madleen Kane released a second disco version. Neither is as well-known as Peggy Lee's 1958 take. But can you dance to her record? No, you cannot.

"IT'S THE SAME OLD SONG" BY KC AND THE SUNSHINE BAND, 1978

A 1964 Motown hit for the Four Tops, "It's the Same Old Song" became new and different when KC and the Sunshine Band released a disco version in 1978. It was not the biggest hit for the Miami-based act, but the Holland-Dozier-Holland catchiness remains.

"KISS YOU ALL OVER" BY BROADWAY, 1978

American rock band Exile wanted to "Kiss You All Over" in the summer of 1978. By Christmas, the disco outfit Broadway was puckering up with their eight-and-a-half-minute dance-floor version. In 1997, dance trio No Mercy brought it back with flamenco touches.

"LAYLA" BY VALVERDE BROTHERS, 1978

When the Valverde Brothers brought the 1970 Derek and the Dominos hit "Layla" to the dance floor it was with plenty of castanets. The song was one of three covers on the 1978 album After Midnight including the title track and disco version of the Four Tops' classic "Standing in the Shadows of Love."

"MACARTHUR PARK" BY DONNA SUMMER, 1978

Donna Summer recorded Barry Manilow's "Could It Be Magic" in 1976, but it was nothing compared to the spell she cast with her version of "MacArthur Park." Working with Giorgio Moroder and Pete Bellotte, the Queen of Disco took the 1968 Richard Harris oddity—Someone left a cake out in the rain? Really?—and turned it into an almost eighteen-minute-long dance-floor masterpiece. Rechristened the "MacArthur Park Suite," the original Jimmy Webb–penned song was blended with two new compositions, "Heaven Knows" and "One of a Kind," and it baked up beautifully. Truly, pop music will never have that recipe again.

"WIPEOUT" BY SMASH, 1978

A 1963 instrumental hit for the Surfaris, "Wipeout" became a beachy keen disco track from Smash in 1978, complete with steel drums and plenty of synth. A radio weather report calling all surfers to the beach replaces the creepy laughter that begins the original.

"BANG A GONG (GET IT ON)" BY WITCH QUEEN, 1979

The 1971 T. Rex classic, written by front man Marc Bolan, has been covered by Blondie, U2, and Power Station. But none quite aerobicized it the way the disco studio band Witch Queen did. It scored on both the pop and disco charts in 1979.

"JOHNNY B. GOODE" BY ELTON JOHN, 1979

The oddest track from his poorly received 1979 disco album Victim of Love, Elton John's dance version of Chuck Berry's hit "Johnny B. Goode" isn't bad: it's a why-bother? Even he could not improve on Charles Edward Anderson Berry's 1958 classic. "Go, go, go?" No, no, no.

"KNOCK ON WOOD" BY AMII STEWART, 1979

Originally a 1966 R&B hit by Eddie Floyd, "Knock on Wood" hit the top of the pop charts with Amii Stewart's cover version. Hers is, bar none, the greatest disco remake of any song ever. Stewart also covered the Doors hit "Light My Fire" on her 1979 debut album. Not to "Knock" it, but "Fire" doesn't hold a candle to "Wood."

"STAIRWAY TO HEAVEN" BY THE WONDER BAND, 1979

Led Zeppelin's 1971 classic—widely considered one of the greatest rock songs ever—found its way to the dance floor thanks to the Wonder Band's 1979 album Stairway to Love. The LP's nearly seventeen-minute A-side was a medley of "Stairway to Heaven," the title track, and another Led Zep song, "Whole Lotta Love."

"ANOTHER BRICK IN THE WALL" BY SNATCH, 1980

With an even more pronounced disco beat than the original, Snatch's 1980 remake of "Another Brick in the Wall" was more pudding and less meat. Certainly, it's less ominous than Pink Floyd intended when it released its dystopian rock opera The Wall the year before.

"DO WAH DIDDY DIDDY" BY A LA CARTE, 1980

Written by Brill Building legends Jeff Barry and Ellie Greenwich, "Do Wah Diddy Diddy" was a chart hit for the Exciters in 1963 and Manfred Mann in 1964. In 1980, A La Carte, a girl group based in Germany, served up a Euro disco version.

"HAPPY TOGETHER (A FANTASY)" BY CAPTAIN AND TENNILLE, 1980

It wasn't long after the Captain and Tennille signed with Casablanca Records that the soft-rock duo threw their seafarer's hat into the disco ring with a four-on-the-floor Indian-flavored remake of "Happy Together," the 1967 Turtles classic. She ululates. A camp "ten."

"I HEARD IT THROUGH THE GRAPEVINE" BY P'ZAZZ, 1980

Gladys Knight and the Pips' 1967 smash "I Heard It Through the Grapevine" was tarted up with conga drums, synth riffs, and plenty of disco claps when P'Zazz released their 12-inch single of the song in 1980. Decades later, Dutch producer Tiësto sampled the 1968 Marvin Gaye version of the song to create the pounding 2018 dance track, "Grapevine."

"IF YOU COULD READ MY MIND" BY VIOLA WILLS, 1980

Canadian singer-songwriter Gordon Lightfoot laid bare his soul in 1970 with "If You Could Read My Mind," a heartbreaking elegy for his own failed marriage. Ten years later, Viola Wills showed how a dance track could be filled with just as much emotion. The disco diva spent her career recording dance versions of such disparate songs as "Both Sides Now," "Always Something There to Remind Me," and "Stormy Weather."

"CAN'T TAKE MY EYES OFF YOU" BY BOYS TOWN GANG, 1982

It was a case of the Jersey Boys meet a San Francisco boy band, when, in 1982, Boys Town Gang recorded a dance version of Frankie Valli's 1967 hit "Can't Take My Eyes Off You." Nine years later, Pet Shop Boys mashed up the song with U2's "Where the Streets Have No Name" for an international hit. Still, Bono asked, "What have we done to deserve this?"

"SUSPICIOUS MINDS" BY CANDI STATON, 1982

Elvis Presley had a number one hit with "Suspicious Minds" in 1969. Thirteen years later, disco diva Candi Staton put her own spin on the track, and it was more old-school soul than anyone might have imagined. The remake was a hit in the UK.

"WALK LIKE A MAN" BY DIVINE, 1985

Three years after tangling with the Boys Town Gang, Frankie Valli and the Four Seasons were back on the dance floor thanks to Divine. The internationally famous drag queen growled her way through the group's 1963 ode to masculinity, "Walk Like a Man." It was something with which she was quite familiar as it turns out.

"THESE BOOTS ARE MADE FOR WALKIN'" BY MAN 2 MAN FEATURING JESSICA WILLIAMS, 1987

Nancy Sinatra's iconic "These Boots are Made for Walkin'" became one of the late eighties' most enduring dance remakes thanks to Jessica Williams and Man 2 Man. With her diva-licious vocals and their Hi-NRG beats, the 1987 cover is nearly as irresistible as the Lee Hazlewood–penned original—and that's no easy feet, er, feat.

Chapter 8

Gotta Have House

House music DJ extraordinaire Frankie Knuckles
manning the turntables on Ibiza, 1999.

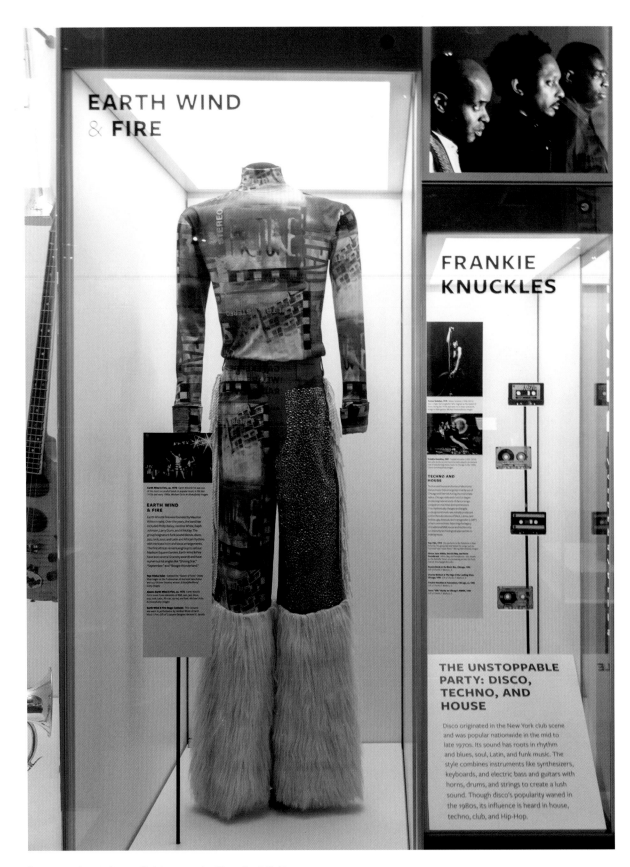

Dance music gets its spotlight moment with an installation
at the National Museum of African American History and
Culture in Washington DC.

Disco Demolition Night—the grotesque radio promotion held in the summer of 1979 at Chicago's Comiskey Park—had a chilling effect on the music industry.

The burning of disco records, the militaristic posturing of shock jock Steve Dahl, the rioting by mostly white, mostly male, mostly straight men, was, if not the official end of the disco era, then a symbolic one.

"Dahl talked people into hating disco," says Jeffrey Schwartz, who, as general sales manager at the radio station WLUP at the time, planned the event. Although the sight of a white mob blowing up Black records is seen today as racist, he maintains that was not the intention. "It wasn't about racism. It just wasn't. I'm shocked people would think that," he says.

For Dahl, the stunt was amazing publicity that thrust him into the national spotlight. "We promoted an event, and they stopped counting after sixty thousand people," Schwartz remembers. "Was it the most successful radio promotion ever, or was it the worst?"

That depends on whom you ask. Disco Demolition Night has long been regarded as one of the Top 100 moments in baseball history by *Sports Illustrated*, and its infamous anniversary is celebrated in some quarters each year.

But for disco performers, it was a kick in the mirror balls. "There was no work for us," remembers Linda Clifford. "These idiots who did this radio show and this whole demolition thing, did they stop and think for one second that we were all just people out there trying to make a living?"

Here's a hint: They didn't.

As the eighties dawned, America turned on disco. With Ronald Reagan marching toward the White House, the specter of AIDS looming, and local government agencies cracking down on nightclubs around the country, people seemed eager to repent for the hedonistic excesses of the 1970s. The party was truly over, morning had come, and it brought a monstrous hangover.

As "just say yes" became "just say no," matters grew worse for the disco movement.

In February 1980, Studio 54 closed with one final blowout: a "going-away party" in honor of Steve Rubell and Ian Schrager. They'd been convicted of tax evasion, having avoided payment on an estimated $2.5 million of club profits, and were being shipped off to do time in federal prison. Everyone from Elton John and Andy Warhol to Jack Nicholson and Sylvester Stallone was there that night to say goodbye to the most profound tastemakers of the 1970s.

Although Studio 54 would reopen in September 1981, with a new owner and the two originators serving only as consultants, the disco was never quite the same. "It was still OK, but it was never going to get that magic back," says nightlife columnist Michael Musto.

At this point, even the genre's biggest proponents had soured on the mass-culture behemoth that disco had become. "By the end, people were pushing the envelope in everything they did, and it became about greed," says original Studio 54 DJ Nicky Siano.

The epic failure of the Village People movie, *Can't Stop the Music*, in June of 1980, didn't help win disco any new fans, at least not in America. The singing-dancing biopic was supposed to be the most exciting Hollywood musical since *Grease*, but it fizzled. "Reportedly made for $20 million, the movie grossed just $2 million at the box office," *Forbes* wrote.

Critics—again, mostly white, mostly male, and mostly straight—were happy to dance, however clumsily, on disco's grave. With few exceptions—in particular, disco chronicler Vince Aletti and *Rolling Stone*'s Dave Marsh, who were the first scribes to note the homophobic and racist undercurrent of Disco Demolition Night—rock writers felt vindicated by disco's death. Writing in Quentin Harrison's 2017 annotated discography *Record Redux: Donna Summer*, pop music historian Michael A. Gonzalez contended that these critics generally "were non-dancing rock snobs who spawned the 'disco sucks' backlash." So-called "canon-shapers"

from rock magazines like *Rolling Stone, Spin*, and *Circus*, he said, had always given short shrift to even the most talented dance musicians.

Most missed the point of disco entirely and were blind to the joy it brought to many fans. These rock critics were infuriated, for instance, that a song like Silver Convention's "Fly, Robin, Fly," with its six-word lyrics, could win a Grammy Award while Steve Miller Band's paean to freedom "Fly Like an Eagle" was snubbed. Rock was art in their eyes; disco was merely commerce. Even the fictional radio DJ Dr. Johnny Fever of the TV sitcom *WKRP in Cincinnati* declared, "Disco is dead. Thank God!" in a memorable two-part episode.

"Disco was about escapism, but it became inescapable," *Rolling Stone* music critic Barry Walters said in a 2002 interview to celebrate the first museum exhibit devoted to the genre, *Disco: A Decade of Saturday Nights*, at the Experience Music Project—now called the Museum of Pop Culture—in Seattle. "In some ways, it defeated its own purposes."

By 1980, disco had become ubiquitous. Even the super-square Lawrence Welk Show featured former Mouseketeer Bobby Burgess and his partner Elaine Balden twirling around the stage to "Last Dance" as part of a salute to Oscar-winning songs.

"Disco became an incredible brand to the point that they were advertising disco kitchen sets," says music journalist Jim Farber. "It was a typical example of a trend becoming too big. Eventually, you're just going to collapse. It's the dinosaur syndrome."

Audiences had been fed too much of a good thing and it backfired. For a great swath of America, the word "disco" itself had become poison. A word that had been applied to everything from skimpy men's underwear to episodes of *Police Woman* and *Charlie's Angels* to seem hip in the seventies was suddenly verboten. "It became uncool to enjoy disco because it was 'too glossy,' that is, 'too gay'," says Musto.

Punk rockers certainly didn't want seventeen minutes of Donna Summer having disco orgasms. They wanted two-and-a-half minutes of Joey Ramone needing sedation. Small-minded people, emboldened by the MAGA-esque fervor of Disco Demolition Night, felt fine expressing their resentment for the vaunted position of Black and queer artists in the dance music pantheon. And many men showed just how uncomfortable they were with a genre of music that had put women front and center. Strong females were the real movers and shakers of the disco era.

"The anti-disco backlash was very strong, and it came from a lot of directions," says fashion historian Valerie Steele. "The great success of disco made it uncool for a lot of people. Something must be exclusive to be really stylish after a while. It can't be too popular."

It all was enough to get disco canceled, as we say today, at least temporarily.

"In the short term, this disco backlash worked," wrote Ben Myers in a 2009 Guardian story called "Why 'Disco Sucks!' Sucked." Record sales, he noted, from "disco's glory days of 1974 to the *Saturday Night Fever*-fueled high of 1978 fell by 11 percent in 1979, and the major US record labels began to look elsewhere for cash cows." "Elsewhere" turned out to be Great Britain.

In the early eighties, the music business embraced a new wave of British technopop artists to bolster record sales. It was dance music—disco-inflected but tarted up in new clothes. *Newsweek* confirmed the arrival of this genre as the official sound of the new decade when it put Boy George and Annie Lennox, an androgynous duo to be sure, on its January 23, 1984, cover along with the headline, "Britain Rocks America—Again."

"There was a sense of panic," says Musto. "It was like, 'Holy shit, how do we replace disco.' But what eventually happened was that MTV and all the fun Cyndi Lauper/Madonna types took over." Although some disco artists managed to stay relevant

in this new climate, it wasn't easy. Grace Jones made the leap from dance-floor diva to art-rock goddess in the early eighties with songs like "Warm Leatherette" and "Pull Up to the Bumper." Donna Summer continued to chart with such dance-friendly tracks as "Love Is in Control (Finger on the Trigger)," "She Works Hard for the Money," and "This Time I Know It's for Real."

But others were too aligned with classic disco to genuinely evolve.

When Village People—the most emblematic of disco acts—reimagined themselves in feudal attire for their rock-flavored album *Renaissance*, they looked preposterous, even if the music was still pretty good. While it was a flop in America, that 1981 album was a big hit in parts of Europe. But their new look, a cross between the neoromantic pirate attire of Adam and the Ants and the costumes worn at a Medieval Times restaurant, was a disaster.

Siano remembers the night when even he had to admit that disco had seen better days. "I was playing at a club called the Buttermilk Bottom in Tribeca. Some guy said, 'They're saying, disco is dead! Nicky, is it true?'" I said, 'Yeah, pretty much.' I really felt it was over."

But Siano wasn't in mourning for very long.

Something new and exciting, rooted in classic disco, was about to take hold of the underground scene, and dancers around the world were eager to embrace it. "I heard a new kind of music that came in on roller blades," Siano says.

This new kind of music was called "house," and it picked up exactly where disco ended. "They didn't want the word, 'disco,' but they still wanted to feel that beat," says Jeannie Tracy, a singer, songwriter, and actress who first found fame as one of Sylvester's background singers in the seventies. As Renee Guillory-Wearing of the disco group The Ritchie Family puts it, "Disco never really died. It morphed into house music and a different generation fully embraced it."

House simply brought dance music back to its roots.

"The disco scene returned to the clubs where it had all first begun," Claes Widlund wrote in 2014's *Disco: An Encyclopedic Guide to the Cover Art of Disco Records*. "With new technical equipment, drum machines, and synths," he said, "the music transformed from disco to . . . disco." As Gloria Gaynor, whose 1974 hit "Never Can Say Goodbye" kicked off the whole movement, once said, disco "simply changed its name to protect the innocent."

The death-to-disco thing, Myers said, was merely "a pyrrhic victory." The music they tried to destroy that night in Chicago "spawned house music and the club scene and impacted upon the then-emerging hip-hop culture."

Without Chic's disco classic "Good Times," "Rapper's Delight" by the Sugarhill Gang might not have become the first hip-hop song to go pop. "Hip-hop basically evolved from disco," music critic Ann Powers pronounced in 2002. It went on to dominate the cultural landscape from music to fashion to language, much as disco had done in the seventies.

"Despite the notoriety of Disco Demolition Night in pop culture history, everyone wasn't suddenly burning their disco records, and in Europe there was no such silly backlash," says author James Arena. "The movement reflected some disco fatigue in the US, but that's the nature of these things. Shortly after the anti-disco headlines faded, Lipps, Inc. went to number one with 'Funkytown.' So much for disco being dead."

Instead, Arena says disco "evolved, incorporating rock, new wave, soul, funk, and other styles, and became known as simply 'dance music' and it lived happily ever after with all the other music genres." The queer community certainly was open to it all. "I was perfectly able to embrace the Sex Pistols and the Clash and still love Vicki Sue Robinson and Evelyn 'Champagne' King," says Musto. "It was all great music, and it was all wonderfully danceable. When you're young, you just want to fucking dance and you don't want to stop."

Simply put, it didn't. In the eighties, the various subgenres of dance music had many names—"garage," "house," "Hi-NRG," "Euro," "techno," "electronica," and more. But it was all as irresistibly beat-driven as disco had ever been. "House music was exactly what disco was in the beginning," Siano says. "Raw, pulsating, fabulous rhythms. It made you want to dance."

The music was pared-down but seductive. As Benji Espinoza of the influential Chicago house music label, DJ International, explained to me in a 1988 interview with the *Detroit Free Press*, "In house music, they give you drums to dance to, a bass to groove with, some strings to create a melody and some vocal samples to sing along with. That's basically it. They just give you the essentials."

The earliest house songs, like Jesse Saunders's 1984 classic "On and On," set the template for what would follow. Such tracks were "the first direct descendent of disco," Icon Music blogger Rory PQ wrote in 2019, and would continue to inspire "new generations of fans, music, technology, and innovation" for decades to come.

"When the American media nuked disco," house music producer Brian Chin told the *Free Press* in 1988, "that didn't happen in Europe. It was not a stigmatizing, scary thing to continue listening to Sylvester or any Black American up-tempo music." In England, fans were mad for the music, as DJs created subgenres like "acid house," "drum and bass," and "trance."

"Disco was incredibly influential on the charts in England all through the eighties," says electronic music historian Richard Evans. "Whether it was disco originals being recycled, or a new soul-funk generation updating the sound, it was incredibly successful over here."

Of course, the American media didn't care any more about house than they had about disco in its earliest years. "It has a lot to do with the span of interest of editors who are basically into rock 'n' roll," Chin said. "They are not afraid to be out of step with what Black people like."

The press remained oblivious while house music brought people of color, women, and gays—the same people who had created disco—back to dance floors. The music established a strong base in urban centers. As producer and promoter Vince Lawrence told NPR in 2023, house music, like disco before it, was "the definition of the word 'intersectional.' House brings everything and everybody together. When you're one with house music, all of the things that separate us kind of fade away underneath the boom, boom, boom, boom."

Word did get out, of course. Prince himself was one of the loudest messengers, trumpeting the arrival of house with his 1987 paean "Housequake." "There's a brand-new groove going 'round, in your city, in your town," he sang.

In Chicago, Frankie Knuckles and Larry Hardy were spinning at the Warehouse, where the genre began and found its name. Ironically, the club was less than four miles from the site of Disco Demolition Night. In Detroit, turntable artists like the Belleville Three—Juan Atkins, Derrick May, and Kevin Saunderson—hatched the subgenre called "techno" at clubs like the Music Institute. At Club Zanzibar in Newark, New Jersey, Tony Humphries was pioneering the "Jersey sound." While, across the Hudson, at the Paradise Garage in New York City, Larry Levan was harnessing the 120-BPM energy of disco and taking "garage music" in new directions.

Dancing at these nightclubs was like a religious experience. As Grace Jones wrote in her 2015 autobiography, *I'll Never Write My Memoirs*, "Disco in its purest sense means that you will come out of a place having gone into euphoria, feeling that you have rejoiced. That's the sense the disc jockey in the clubs was helping the crowds achieve."

Randy Crumpton, a friend of Knuckles, described the scene at the Warehouse to music blogger Krista Marina Apardian: "Throughout the night, you would hear thunderous approval of the music from the crowd as they chanted, 'Frankie! Frankie! Frankie!' and, of course, the Godfather would respond with an even funkier beat, sending the crowd into a greater frenzy. Emotions were high and it was as if Frankie had the pulse of everyone's heartbeat and was playing them like a piano."

His words sounded just like those describing disco at the Loft in 1970. House music gave rise, as the eighties progressed, to a fresh crop of stars producing dance-floor hits on specialized labels like Trax and DJ International. In 1986, Marshall Jefferson released "Move Your Body (The House Music Anthem)," Steve "Silk" Hurley made it cool to "Jack Your Body," and Farley "Jackmaster" Funk not only established a "House Nation" in America, but also had a hit on the British pop charts with "Love Can't Turn Around," a song which borrowed from Isaac Hayes's 1975 disco hit "I Can't Turn Around."

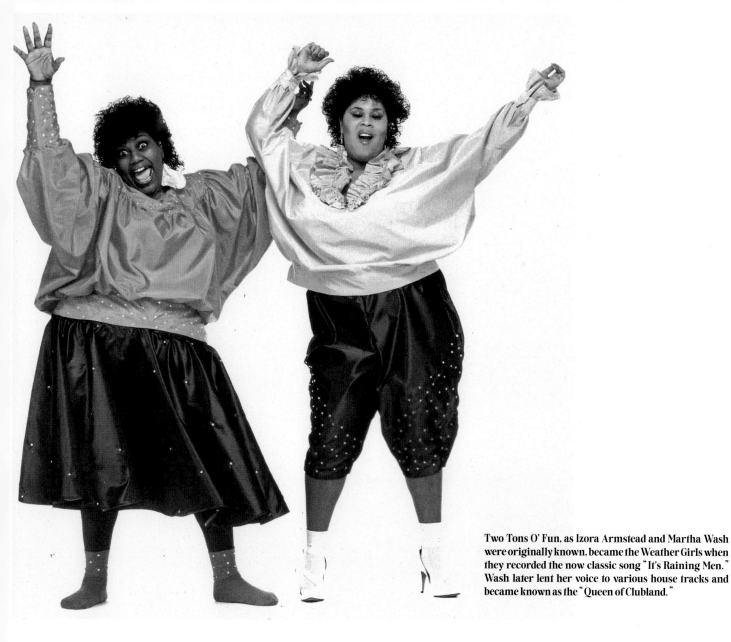

Two Tons O' Fun, as Izora Armstead and Martha Wash were originally known, became the Weather Girls when they recorded the now classic song "It's Raining Men." Wash later lent her voice to various house tracks and became known as the "Queen of Clubland."

As powerful vocalists began to reassert their place on the dance floor, house remixes found a radio audience in America, too. Natalie Cole released a house version of the Bruce Springsteen song "Pink Cadillac" that proved popular in 1988. Roberta Flack, known for her soothing vocals on such early-seventies hits as "The First Time Ever I Saw Your Face" and "Killing Me Softly with His Song," made clubs shake when Hurley remixed a track from her 1988 LP, *Oasis*. The album didn't move many units, but his irresistible up-tempo redo of "Uh-Uh Ooh-Ooh Look Out (Here It Comes)" hit the top of the dance charts in 1989.

A new crop of stars, like Robin S., CeCe Peniston, and Sabrina Johnston emerged. Some house divas were former disco artists like Martha Wash. She began as one of Sylvester's backup singers in the seventies, then scored a hit as one of the Weather Girls with "It's Raining Men" in 1982. In 1990, she was the wall-tumbling voice behind such hits as "Everybody, Everybody" by Black Box, and C+C Music Factory's "Gonna Make You Sweat (Everybody Dance Now)." She was dubbed "The Queen of Clubland" and featured largely on the disco soundtrack of the nineties.

In the years that followed, DJs became superstars. Armed with the latest technology and clever enough to build upon the methodology of disco's pioneers, such talented turntablists as Danny Tenaglia, Ralphi Rosario, and Jellybean Benitez went on to find success as both record producers and recording artists. The mainstream soon came calling.

Frankie Knuckles "became so popular that the Warehouse, a members-only gay club entertaining primarily Black and Latino locals, suddenly had whiter, straighter people in line," Apardian wrote in a 2021 tribute to the DJ called "The Godfather of House Music and How He Invented Dance Music as We Know It." In New York, Musto says, "It became all about Junior Vasquez-driven house, which was like disco but less about the vocals and more about dental drill sounds." But one disco fan's dental drill is another man's club classic.

Were it not for the pioneering DJs of the Loft and the Gallery—and the legendary house music DJs who took up their mantle—there would be no Martin Garrix, no David Guetta, no Tiesto, no Marshmello, no Skrillex, no Calvin Harris, nor any of the international DJs who today earn ginormous salaries spinning EDM records around the world. They are so popular now that when an immersive exhibit dedicated to the legacy of Swedish DJ Avicii, who committed suicide in 2018 at age twenty-eight, opened in Stockholm in 2022, the *New York Times* covered it.

House's ultimate validation came in 2023 when Beyoncé won the Grammy for Best Electronic/Dance Album for *Renaissance*. Accepting the award, she acknowledged the influence such music had on her artistry. "I'd like to thank the queer community for your love and for inventing the genre," she said. That night, adding four more Gramophone statuettes to her previous twenty-eight, she became the winningest artist in Grammy history.

Thanks to the imprimatur of such megastars—and others in the pop music firmament of the twenty-first century—house is rightly being celebrated as the bridge between seventies disco music and contemporary dance pop. As the music blog beatportal.com has decreed, "House music is a feeling, but it is also a many-splendored concrete reality that's woven into the lives of millions of people's lives and that is going to remain the case for a very, very long time."

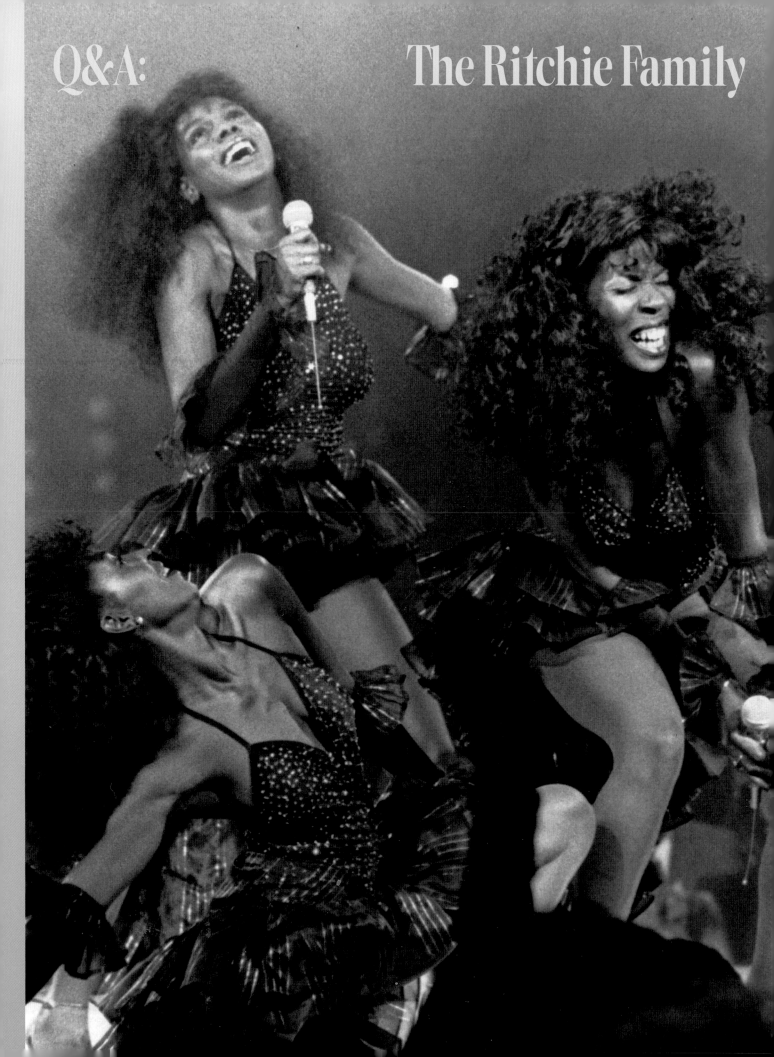

The Ritchie Family

So what if they're not really related. Since 1975, the Ritchie Family has been making beautiful music together. Brought together by Village People mastermind Jacques Morali, Philadelphia-based singers Cassandra Wooten, Gwendolyn Oliver, and Cheryl Mason Jacks first performed disco versions of such thirties songs as "Brazil," "Peanut Vendor," and "Frenesi."

They hit pay dirt in 1976 with a more modern tune, "The Best Disco in Town," which incorporated bits of such popular songs as "Love to Love You Baby," "That's the Way (I Like It)," "TSOP," and both "Lady Bump" and "Lady Marmalade." It was a Top 40 hit around the world and predated similar successful medleys by Shalamar and Stars on 45.

In 1978, Morali unceremoniously dumped the original Ritchie Family members and, soon after, brought in three new performers. The new lineup appeared in the 1980 Village People movie *Can't Stop the Music*, singing the songs "Give Me a Break" and "Sophistication."

But there was good news for fans of the originals. In 2011, Wooten and Mason Jacks (now Mason Dorman) got back together and recruited Renee Guillory-Wearing. (Oliver died in 2020.) The Ritchie Family, getting the last laugh, had a house music hit in 2016 with "Ice."

Whatever the genre's current name, they're still making some of the best disco in town.

FDC: "How did Jacques Morali put the original Ritchie Family together?"

CW: "A singer named Nadine Felder and I had done some background work for Jacques. When he was looking to create the Ritchie Family, he remembered us. Nadine had decided that she was not going to sing secular music anymore. So Cheryl, Gwendolyn and I called Jacques and said we were interested. We went to sing for him and got the gig in, like, fifteen minutes."

FDC: "How did it feel to be a disco group?"

CW: "In the beginning, it was very exciting because things were coming at us fast. Everything was new. Suddenly, we had an opportunity to do some really great things."

CMD: "I didn't have the same experience of having been on the road. Cassandra and Gwendolyn had been in Honey and the Bees. They'd sung with James Brown and were really accomplished performers. I'd done most of my singing in church, so I had to learn a lot and learn it fast. But they were more than willing to help me get up to speed."

FDC: "You had a huge hit in 1976 with 'The Best Disco in Town.' Was it fun singing a song that sampled so many other disco songs?"

CW: "We enjoyed it because all those songs were songs we liked a lot. It was fun to record and to this day, a fun song to perform. It's a unique way of doing a medley."

CMD: "It always reminds me of standing outside a disco. They open the door, and you hear a piece of a song, then they close the door and when they open it again, another song is playing."

FDC: "'Best Disco in Town' made it to Number 1 on the dance charts in America and was a hit on pop charts all over the world. What was global success like?"

CW: "It was incredible. We were thrust on the international stage right from the beginning—Canada, Austria, Belgium, Holland, the Philippines, Australia, South America, Mexico. It was a wonderful experience. Disco really was an international phenomenon. Everybody everywhere was into these big dance clubs. In every country, there was a huge audience for this music."

CMD: "People just wanted to have fun and disco was fun."

FDC: "What was it like working with Jacques and his partner, Henri Belolo?"

CMD: "Working with Henri was a pleasure. He was such a gentleman all the time. Jacques was a little more temperamental and demanding. But we worked well with both."

CW: "In the beginning, it was all peaches and cream. But as time went on, we had some disagreements about how things should be done. Jacques made the decisions about pretty much everything, and we felt we didn't really have enough input. We were like glorified robots."

FDC: "They were not gentle when they let you all go."

CW: "It was very sudden. We didn't have a clue that everything was ending. But when we were called into the offices of Can't Stop Productions one by one, we knew that something was up. They said they had made a decision and wanted to go in another direction. We didn't know, however, that Jacques was going to create another Ritchie Family. That hurt."

FDC: "Renee, you were still in college when this was all going down. Did you ever imagine you would join the Ritchie Family one day?"

RGW: "In 1976, I was going to parties and listening to 'The Best Disco in Town.' But I didn't know the Ritchie Family's other songs. So when they approached me in 2011, I had no idea it was to be part of an internationally known singing group! Once I became aware of their magnitude, I was a little taken aback. But then I was very, very pleased and thankful to have gotten this opportunity. Needless to say, my journey with these ladies has been wonderful."

FDC: "What did disco provide to people?"

CW: "Escapism might be a good word. It felt like people went to the disco to release a lot of tension, have fun, forget about the cares of the day, and just kind of go for it. It felt like 'I can do anything out on that floor.' It really created a spirit, right across the spectrum, and everyone wanted to be in on it. It was really a fun time."

FDC: "Some people claim that disco was a balm for a depressed world."

CMD: "If people were depressed, they had a good way of hiding it."

CW: "It just seemed at the time like everyone was experiencing a new freedom to express themselves without limits. They were more emboldened to enjoy life, especially on the dancefloor."

CMD: "The crowds fed off each other. The heavy beats really shook people up and elevated them and put them in a good mood. I don't remember any fights in the discos."

FDC: "Why do you think there was such a backlash beginning in 1979?"

CMD: "I think it was a jealousy thing. A lot of people who were into rock resented the gaiety of the disco sound. It was really fun, and really light."

CW: "There were traditional artists whose records weren't doing well. They couldn't cross over into disco, so there was resentment. There was also a group of people who thought disco was sinful. They didn't like what they saw and the people who represented disco. So really it was a combination of things that came to a head."

FDC: "How would you describe disco's relationship to today's dance music?"

RGW: "When disco was killed, for lack of a better word, house music came in because young people still wanted those beats. In all honesty, disco never really died. It just morphed into house music. A younger group of people—a completely different generation—fully embraced it. Now you see it coming full circle. Disco has blended with other types of music. We ourselves have experimented with the house sound a little bit with our newer songs, but we keep the essence of the Ritchie Family."

FDC: "Your 2016 song 'Ice' scored on the dance charts. How did that feel?"

RGW: "Oh man, it was just amazing. I hit the ceiling. I'm still trying to embrace just how enormous that was. When we sing it live now, the audience sings it with us. I love that."

CW: "At this point, we have the older Ritchie Family songs, and we love to sing them. But to do a brand-new song with a slightly different sound was pretty remarkable."

RGW: "The lyrics speak to the experiences of the Ritchie Family—that, no matter what our ages, we can dream again and move forward. It became a really special song to me because it helped bring a whole new generation of people to the Ritchie Family."

FDC: "What are your fans like today?"

CW: "Whether they're older or younger, they're still loyal and that makes us very happy. We were in Italy a few years ago and we were so surprised to see all these different generations coming to see us. There were kids asking us to sign albums, and it was like, 'You weren't around for this!' but they like the music anyway. That's the good thing about disco. It definitely has stood the test of time."

Legendary DJS

"A lot of people take that DJ for granted up in the booth," record executive Ray Caviano said in 1978. "But he's literally weaving an evening." The best turntable jockeys, Bruce Pollack wrote in *The Disco Handbook*, did even more than that. Thanks to them, he said, "Spinning records has been elevated to an artform."

LARRY LEVAN

Considered to be perhaps the best club DJ who ever put a needle on a record, Levan began spinning at the Continental Baths in 1973. He built his reputation beginning in 1977 with a decade-long stint at the Paradise Garage, the underground alternative to Studio 54. His DJing was like a religious experience—they didn't call his sets "Saturday Mass" for nothing—and his attention to detail was such that he'd sometimes climb a ladder to polish a disco ball if it didn't glimmer enough. "Larry felt the night needed to be a journey," fellow DJ David DePino said in a 2014 interview. "He told a story." Levan died at age thirty-eight in 1992, but his earthly story continued as his signature sound helped spawn "garage house" and more.

FRANKIE KNUCKLES

A friend of Levan's since they were both teenagers in New York, Knuckles became known as the Godfather of House Music when he relocated to Chicago and began spinning an eclectic mix at the Warehouse in 1977 in Chicago. Through his DJ gigs at clubs around the world and his renowned remix work—for which he won a Grammy Award as Remixer of the Year, Non-Classical in 1997—Knuckles spread the gospel of house and helped popularize disco's progeny globally. His famous remixes include songs by such artists as Chaka Khan, Lisa Stansfield, and Pet Shop Boys. A stretch of Jefferson Street in Chicago was renamed Frankie Knuckles Way in 2004. Knuckles died of diabetes-related causes in 2014.

ROBBIE LESLIE

Leslie began his career behind the turntables in the mid-seventies at the Sandpiper on Fire Island—the weekend destination for New York City's A-list gays—and then worked in many of Manhattan's hottest discos from Studio 54 to the Saint and beyond. He's best known, though, for his work on the road. As a have-records-will-travel DJ, Leslie for decades has spun at high-profile one-off events around the world and is considered the prototype for well-regarded and well-compensated circuit-party DJs. "I'm good at straddling the border between too banal and too progressive," Leslie once said. "I know what the crowd wants and how to deliver."

THE BELLEVILLE THREE

The founding fathers of Detroit "techno" music, the "Belleville Three" are Derrick May, Juan Atkins, and Kevin Saunderson. A trio of DJ-musicians named for the Motor City suburb in which they grew up, the men defined the house sound with songs like "Strings of Life," "Big Fun," and "Techno City." Their skill brought crowds to the Music Institute, the influential Detroit disco, beginning in 1988. Although they had distanced themselves from the collective name for years, they reunited as the Belleville Three and performed together in 2017 at Coachella. "They didn't invent electronic music, but they did give it a soul," wrote *Detroit Free Press* music critic Brian McCollum that year. "A danceable, Detroit-driven heartbeat that over time helped transform the sound of popular music."

JOHN "JELLYBEAN" BENITEZ

Benitez had spun at many of the best-known New York City nightclubs of the seventies and eighties—Hurrah, Le Mouches, Le Jardin, Studio 54, Xenon, and Palladium—before he did something no DJ had done before: He scored his own pop hit as a musician with the song "Sidewalk Talk" in 1984. His sometime girlfriend—and frequent collaborator—Madonna wrote it for him. Benitez had other chart hits, but his greatest success has been as a remixer, working his magic on superstar tracks from Afrika Bambaataa to ZZ Top. Cher's "Believe," Madonna's "Like a Prayer," Whitney Houston's "I Wanna Dance with Somebody (Who Loves Me)," he remixed them all. He continues to keep disco alive via a show on Sirius XM's Studio 54 channel.

Detroit Techno pioneer Derrick May spinning in Copenhagen. 2014.

Must-Hear
Disco Playlist:

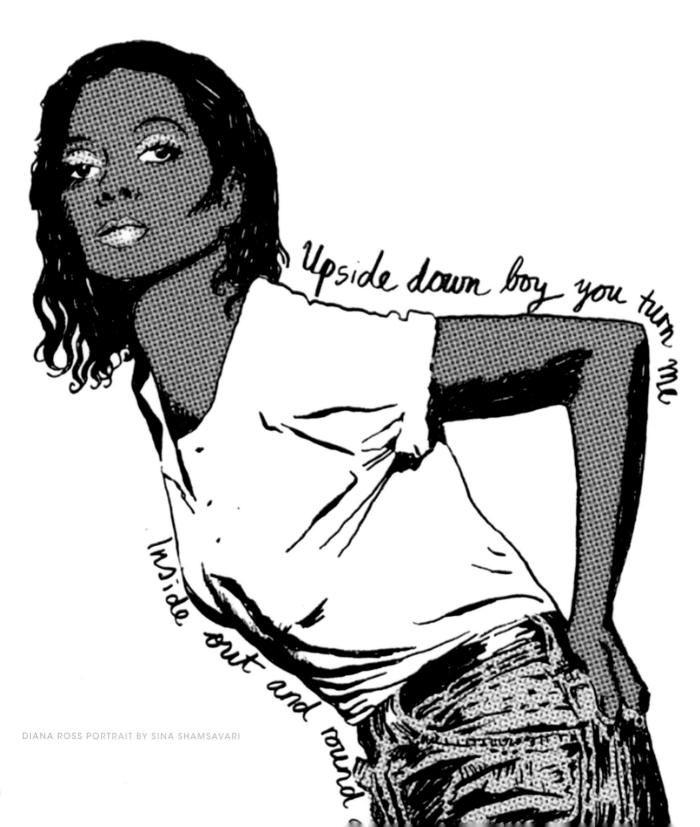

Upside down boy you turn me

Inside out and round

DIANA ROSS PORTRAIT BY SINA SHAMSAVARI

1980-1983

"BOURGIE, BOURGIE" by Gladys Knight and the Pips, 1980

"CAN YOU HANDLE IT" by Sharon Redd, 1980

"CAN'T STOP THE MUSIC" by Village People, 1980

"CELEBRATION" by Kool & The Gang, 1980

"DON'T PUSH IT DON'T FORCE IT" by Leon Haywood, 1980

"FANTASTIC VOYAGE" by Lakeside, 1980

"FEELS LIKE I'M IN LOVE" by Kelly Marie, 1980

"GIVE ME A BREAK" by The Ritchie Family, 1980

"GIVE ME THE NIGHT" by George Benson, 1980

"GONNA GET OVER YOU" by France Joli, 1980

"I'M COMING OUT" by Diana Ross, 1980

"I'M READY" by Kano, 1980

"I NEED YOUR LOVIN'" by Teena Marie, 1980

"IS IT ALL OVER MY FACE?" by Loose Joints, 1980

"KEEP ON SHAKIN' THAT THANG" by Camille Saviola, 1980

"LOVIN', LIVIN' AND GIVIN'" by Diana Ross, 1980

"A LOVER'S HOLIDAY" by Change, 1980

"MANDOLAY" by La Flavour, 1980

"NEVER KNEW LOVE LIKE THIS BEFORE" by Stephanie Mills, 1980

"ON AND ON AND ON" by ABBA, 1980

"STOMP!" by the Brothers Johnson, 1980

"TAKE YOUR TIME (DO IT RIGHT)" by The S.O.S. Band, 1980

"UPSIDE DOWN" by Diana Ross, 1980

"USE IT UP AND WEAR IT OUT" by Odyssey, 1980

"AI NO CORRIDA" by Quincy Jones, 1981

"DANCIN' THE NIGHT AWAY" by Voggue, 1981

"DOUBLE DUTCH BUS" by Frankie Smith, 1981

"GENIUS OF LOVE" by Tom Tom Club, 1981

"GET DOWN ON IT" by Kool & the Gang, 1981

"GIVE IT TO ME BABY" by Rick James, 1981

"LET'S GROOVE" by Earth, Wind & Fire, 1981

"LET'S START II DANCE AGAIN" by Bohannon, 1981

"ON THE BEAT" by the B.B. & Q. Band, 1981

"SHAKE IT UP TONIGHT" by Cheryl Lynn, 1981

"SHE'S A BAD MAMA JAMA" by Carl Carlton, 1981

"STARS ON 45" by Stars on 45, 1981

"SUPER FREAK" by Rick James, 1981

"TRY IT OUT" by Gino Soccio, 1981

"YOUR LOVE" by Lime, 1981

"ATOMIC DOG" by George Clinton, 1982

"BABE, WE'RE GONNA LOVE TONIGHT" by Lime, 1982

"BACK CHAT" by Queen, 1982

"BEAT THE STREET" by Sharon Redd, 1982

"DO YA WANNA FUNK" by Patrick Cowley featuring Sylvester, 1982

"FORGET ME NOTS" by Patrice Rushen, 1982

"IN THE NAME OF LOVE" by Sharon Redd, 1982

"LAST NIGHT A DJ SAVED MY LIFE" by Indeep, 1982

"LET IT WHIP" by The Dazz Band, 1982

"LOVE COME DOWN" by Evelyn King, 1982

"NATIVE LOVE (STEP BY STEP)" by Divine, 1982

"PASSION" by the Flirts, 1982

"PLANET ROCK" by Afrika Bambaataa and the Soul Sonic Force, 1982

"YOU DROPPED A BOMB ON ME" by The Gap Band, 1982

"AIN'T NOBODY" by Rufus and Chaka Khan, 1983

"ANGEL EYES" by Lime, 1983

"BAND OF GOLD" by Sylvester, 1983

"COMING OUT OF HIDING" by Pamala Stanley, 1983

"DEAD GIVEAWAY" by Shalamar, 1983

"HOLIDAY" by Madonna, 1983

"I GOT THE HOTS FOR YOU" by TZ, 1983

"I.O.U." by Freeez, 1983

"IT'S RAINING MEN" by The Weather Girls, 1983

"LET THE MUSIC PLAY" by Shannon, 1983

"SO MANY MEN, SO LITTLE TIME" by Miquel Brown, 1983

"WHEN I HEAR MUSIC" by Debbie Deb, 1983

"WHERE IS MY MAN" by Eartha Kitt, 1983

Chapter 9

Pete Burns of Dead or Alive.

Pete & Jimmy & Marc & Neil & Chris & Andy & Vince & k.d. & Sandra & Sam

"

SHE'S MADE YOU SOME KIND OF LAUGHINGSTOCK, BECAUSE YOU DANCE TO DISCO, AND YOU DON'T LIKE ROCK...

—Pet Shop Boys

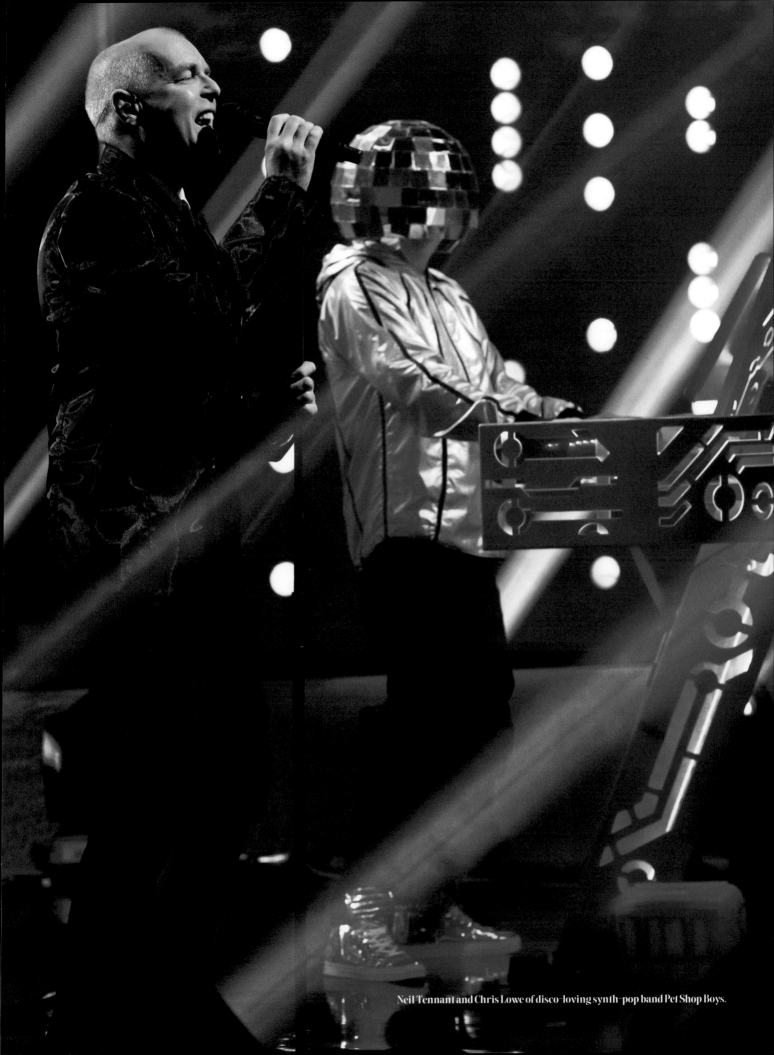

Neil Tennant and Chris Lowe of disco-loving synth-pop band Pet Shop Boys.

While house music was picking up the disco torch in urban American nightclubs, something very different, but just as wonderful, was going on in England.

In the early eighties, the first wave of out-of-the-closet musicians began embracing classic diva-vocal disco, making these songs their own, and bringing them officially into the queer canon.

Some of the most influential and exciting new wave artists made it OK to be out and proud, not only about one's sexual orientation and gender identity, but also about a profound appreciation of disco. There would be no more are-they-or-aren't-they-gay? Village People coyness with the buying public, they said. These new musicians made sure of that, and, in the process, rehabilitated the reputation of disco in America.

Before it was cold, disco became cool again, at least in progressive circles.

"What was targeted for so long, and given such a negative connotation in some circles, became a point of pride when a later generation adopted it," says music journalist Jim Farber.

In 1980, for instance, pioneering nonbinary singer Pete Burns released a single in the UK called "Black Leather" with a band called Nightmares in Wax. It was the kind of relentless post-punk track today found on "Disco Not Disco" compilations. For those who believed that disco sucked, the song was a nightmare in wax, not that the Demolition dudes would ever hear such an underground queer track in America. It was too gay for radio play. But the intended audience found and embraced it.

An explicit paean to rough sex, "Black Leather" included the lyrics "Now that I'm old enough to do what I like, I do big heavy muscle boys on motorbikes." The song was like the *Honcho* magazine remake of Bette Midler's "My Knight in Black Leather." It was aggressively queer, and, to irk disco-hating homophobes even more, it borrowed the chorus from KC and the Sunshine Band's 1975 hit "That's the Way (I Like It)." From Burns's lips, "That's the way, uh huh, uh huh, I like it" sounded like a filthy backroom confession.

In 1984, Burns's new band Dead or Alive released its debut album, *Sophisticated Boom Boom*. The first single was a remake of the entire disco song. A much less Sunshine-y take on "That's the Way (I Like It)," the Dead cover was not quite as overt as "Black Leather" had been, but with a chant of "Keep that, keep that, body strong!" it was definitely Alive.

The "bass-slapping remake," as one critic described it, became a surprise hit in Great Britain, and Burns was on his way to stardom. His fame would peak with the 1985 hit "You Spin Me Round (Like a Record)," a dance classic later heard on the soundtrack of *The Wedding Singer* in 1998 and sampled in Flo Rida's Number 1 song "Right Round" in 2009.

Burns "was the Hi-NRG diva who broke the mold even as it was being cast," Barry Walters wrote in a 2016 *Billboard* magazine tribute to the singer, who had died at age fifty-seven of cardiac arrest. He was, as Walters put it, an often-overlooked LGBTQ innovator and "the new waver who brought blatantly gay Gothic drama into clubland and the US Top 40."

For queer fans—and clubgoers of every stripe—that blatant gayness was empowering. When Burns cast a sexy darkness over the cheery Sunshine Band disco hit, or sang such club hits as "Lover Come Back to Me" or "Brand New Lover," both sizzling examples of the eighties disco subgenre Hi-NRG, he emboldened them to be openly fabulous, to express themselves, sartorially and otherwise, and to proudly dance their shoes off before going to bed at dawn, if that was the way, uh-huh, uh-huh, they liked to spend their nights.

The most flamboyant of the first generation of openly queer British singers, Burns helped to rehabilitate the word "disco" for those who'd felt their favorite music had been branded as desperately uncool. Along with other artists of his ilk, he made it ok to keep loving disco. That kid at the Guys and Dolls teen disco on Long Island who was beaten up in high school in 1978 could hold his head high once more. Disco didn't suck. Haters did.

Granted, in Europe, disco never experienced the intense racist, homophobic, and misogynist backlash it did in America. Queen was confident enough to release their most disco-inspired track, "Back Chat," in 1982. Sure, English punks hated disco as much as New York punks did. But British artists who were making what would soon be called new wave music felt freer to admit that their music was building on disco to create the soundtrack of the eighties.

"I don't think 'disco' should be a dirty word," Neil Tennant of Pet Shop Boys told a Westchester County, New York, newspaper in 1987. "In America, they look back at that late-seventies period and they think of it as being sort of trashy crap, but it's not."

Richard Evans's extensive 2022 history of electronic music, *Listening to the Music the Machines Make* makes the point when he quotes a 1981 *Smash Hits* interview with Duran Duran. "What we're doing is European white disco," said bassist John Taylor. Bandmate Nick Rhodes added, "Disco's pretty good on its own . . . we're just trying to make much more interesting dance music."

Evans notes in the book that other bands were borrowing from disco too. The brass of Spandau Ballet's "Chant No. 1 (I Don't Need This Pressure On)," for instance, echoed Earth, Wind & Fire. The book includes this clip from *New Musical Express* critic Adrian Thrills: "Spandau has taken the spirit of '75—Kool, Fatback, and (especially) Brass Construction—and slammed it, complete with soulful dress, straight into the heart of 1981."

"As I was researching my book, it was interesting how many artists who were making music in the new wave used disco as a touchstone, so much more than punk music, more than any other sort of music, actually," says Evans. New wave may have had the sneer of punk, but Evans says the "pop sensibility" of disco helped popularize the sound. "The dance-floor sensibility of disco is what made new wave so successful," he says.

Anyone who heard songs like Duran Duran's "Planet Earth," M's "Pop Muzik," and Lipps, Inc.'s "Funkytown"—all new wave hits—knew they were the love children of disco and punk. To not admit seventies dance music had whetted audiences' appetites for these electronic songs was folly. Not to acknowledge that disco was an influence on new wave was just a lie of omission. As Eurythmics famously asked, "Would I Lie to You?"

Other artists—almost all from the UK, many of them gay men—also helped disco reclaim its rightful place in the eighties. Lynden Barber, writing in the *Sydney Morning Herald* in 1987, praised the "commercial appeal" of "the gay camp's revival of late '70s disco in the guise of Hi-NRG." Melbourne, Australia–based writer Ben Thompson complimented the breadth of expression, writing, "The good ship Anglo-Electro-Disco proved to be a roomy vessel."

Jimmy Somerville, the influential, politically-charged leader of Bronski Beat, not only sang heart-wrenching songs of young men forced to leave home because of their sexual orientation, as he did on "Smalltown Boy" in 1984, but also covered upbeat songs made famous by the most time-honored disco divas. "Jimmy told me he became a singer because of 'I Feel Love,'" Giorgio Moroder, who cowrote that seminal disco song, told pitchfork.com in 2017.

From the earliest moments in his career as a three-octave countertenor, Somerville reimagined such disco classics as Donna Summer's "Love to Love You Baby" and "I Feel Love" (with his first band Bronski Beat and guest singer Marc Almond of Soft Cell), Thelma Houston's "Don't Leave Me This Way" (with his follow-up group, the Communards), and Sylvester's "You Make Me Feel (Mighty Real)," as a solo artist.

In so doing, Somerville helped bring such music to a new queer generation. The LGBTQ community always loved disco most fervently. But in the eighties, music no longer had to come wrapped in the are-they-or-aren't-they? double entendres of Village People. Somerville's recording "Don't Leave Me This Way" wasn't Diana Ross recording "I'm Coming Out" and then claiming she didn't know it was a gay anthem. Remakes like those of Somerville—and Pete Burns before him—were out and proud declarations of big gay disco love.

"When Jimmy Somerville was doing disco covers, he was reclaiming this as part of our culture. In his view, dance music is part of what makes us gay," says Farber. Somerville himself explained his attraction in a 2015 interview with *The Independent*. "When disco came around the first time, there was this real core of progressive thinking and a positive lyrical content—about freedom, the possibilities of love, change, and expression." Disco, he said, continues to be an "antidote" to fear.

"I Feel Love" stands particularly tall in the gay community. "Even now, millions of gay people love Donna, and some say, 'I was liberated by that song.' It is a hymn," says Moroder.

Music journalist Simon Reynolds says the song marked the beginning of a new era in music. "If any one song can be pinpointed as where the 1980s began, it's 'I Feel Love,'" he wrote on pitchfork.com in 2007. "Within club culture, 'I Feel Love' pointed the way forward and blazed the path for genres such as Hi-NRG, Italo, house, techno, and trance. All the residual elements in disco—the aspects that connected it to pop tradition, show tunes, orchestrated soul, funk—were purged in favor of brutal futurism."

In this new era, other high-profile disco revivalists like Pet Shop Boys and Erasure preached the message of liberation with their embrace of disco classics. As these men embraced their inner divas they snatched disco from the pop culture trash heap, as Tennant said, if not for everyone's empowerment, then their own.

"Some of their interest in dance music was being contrarian," says Farber. "They were going against their own generation of diehard rock fans, saying we're going to take something you think of as frivolous music and make it serious, and they did. The Pet Shop Boys are stupendous."

In the seventies, disco had been the soundtrack of the fight for LGBTQ rights. In the eighties, it became a soothing balm offering relief, one dance-filled night at a time, from the tragedy of the AIDS crisis then ravaging the very same community. Gays needed disco in the eighties more than ever. After an ACT-UP protest, there was solace to be found dancing at the Roxy. Rerecording disco songs was an aesthetic choice, but also a defiantly camp political act in those days—mincing as militancy, dancing in the face of danger.

Take that, Disco Demolition Night!

Andy Bell and Vince Clarke of Erasure released disco remakes as B-sides throughout their careers, like Easter eggs for their staunchest fans. The duo first covered ABBA's "Gimme! Gimme! Gimme! (A Man After Midnight)," in 1986, then Cerrone's "Supernature" in 1989, and Evelyn Thomas's "High Energy" (released as "Hi-NRG") in 1995. Bell, minus Clarke, also recorded in 1993 a cover of the ultimate disco duet, "No More Tears (Enough is Enough)," with the lowercase-loving Canadian songstress k.d. lang playing Barbra Streisand to Bell's Donna Summer. The song appeared on the soundtrack of the movie comedy, *The Coneheads*.

But Erasure's most audacious move was their 1992 EP "Abba-esque." Seven years before the "Mamma Mia!" musical opened in London's West End, Erasure made it hip to love ABBA. Embracing disco kitsch—and knickers-and-knee-boots drag in their video for "Take a Chance on Me"—Erasure opened the door for the Mamma Mia! movies, Cher's *Dancing Queen* album, and a love for ABBA that never ends. (After a forty-year absence from recording, the band was nominated for four awards at the 2023 Grammys.) Erasure's EP was the best kind of sendup, one done with good humor but also a genuine love for the Swedish quartet and disco itself.

Less camp but no less serious about their disco appreciation were Neil Tennant and Chris Lowe of Pet Shop Boys. In a 1996 interview, Tennant admitted disco was an inspiration. In the early eighties, he remembered, "We thought, no one else is doing gay disco, no one is doing New York hip-hop with white vocals." Put both together and you've got "West End Girls," the band's worldwide 1986 hit.

That year, Pet Shop Boys released the first of four remix albums, each called *Disco*. A sequel arrived in 1994. A third volume, including a track written by legendary disco producer Bobby Orlando, landed in 2003. *Disco 4*, a compilation of tracks by other artists on which Pet Shop Boys had collaborated, came in 2007.

Via their music—which they quite aptly described in song as "Che Guevara and Debussy to a disco beat"—Pet Shop Boys acknowledged that loving disco wasn't always easy. In their 1993 song "Can You Forgive Her?" Tennant sings of a troubled relationship, a bloke being laughed at because he likes disco, and a girlfriend who decides she wants "a real man instead."

The group's most forceful statement about disco, though, was their remake of the

Village People hit "Go West." When they performed it at a 1992 AIDS benefit at the Hacienda club in Manchester, the song suddenly seemed to be not only a battle cry for LGBT equality but also a moving elegy for those lost to the plague. In the studio, backed by an all-male chorus, Pet Shop Boys later created a track that was both ethereal and danceable. "Together, we will fly so high; together, tell our friends goodbye" never sounded so inspiring or so heartbreaking.

"When Pet Shop Boys did their version of 'Go West,' it was a big turnaround. The song had always had this implicit thing about pioneering San Francisco gay life," says Farber. "But nobody in their right mind could take the Village People seriously. When the Pet Shop Boys did it, it was like, 'Oh, they actually mean it.' That's a twist because they were usually so ironic. But instead, the Pet Shop Boys version is a very sincere statement. It's very emotional, liberating, and intense. They found what the Village People song was about and made it real."

The Boys proved, as they had always done, that "all that glitters beneath the disco ball need not be fool's gold," as the Canadian columnist James Muretich wrote upon the 1996 release of their album *Bilingual*. Their love of disco forced anyone who loved them to understand and appreciate the music that came before, too. By the mid-nineties, only the most lunkheaded and stubborn of rock critics could miss the important role disco had played on the electronic music they and others had been making for years.

Another performer—this time, American, female, and queer—was making things mighty real herself, and doing her part for disco rehab. On her 1994 album, *Excuses for Bad Behavior (Part One)*, actress and singer Sandra Bernhard sang a revamped "You Make Me Feel (Mighty Real)" as both a tribute to Sylvester, who died at forty-one in 1988, and an ode to gay life in San Francisco in the seventies. New lyrics told a coming-out story. "You walk into the disco, and hit the dance floor, you're a little out of place, but you know you want more," she sang. It was serious, truthful, and empowering—a reflection of the growing clout of the queer community.

These outspoken performers of the eighties and nineties who embraced disco and then built upon it, helped lay the groundwork for future pop performers to do the same. Thanks to such pioneers, a new generation could make their own disco music without a hint of shame. The joyousness that house had brought first to the underground, they could bring to pop.

"The past was dogged with all the bad things about being out. It had been tough for those guys in this country during that period," says Evans. "They were looking to the future, and wanted a soundtrack that was doing the same thing. They wanted something optimistic, bright, loud, and exciting, something with glossy glamour, and they found that in disco."

Queer artists still do.

Sam Smith, for instance, was born fifteen years after Donna Summer's "I Feel Love" topped the charts. But in 2019, the Oscar- and Grammy-winning singer-songwriter recorded his own version of the song. The remake was not only an international hit, but also became the official holiday carol of Target stores that year. A warm embrace of classic disco doesn't get any more mainstream than Christmas adverts airing in prime time every night.

"As a queer person," Smith explained, "'I Feel Love' has followed me to every dance floor in every queer space from the minute I started clubbing. This song to me is an anthem of our community and it was an honor to sing it."

For anyone who had ever felt embarrassed by their love of disco, hearing the song on television was like Christmas morning every day.

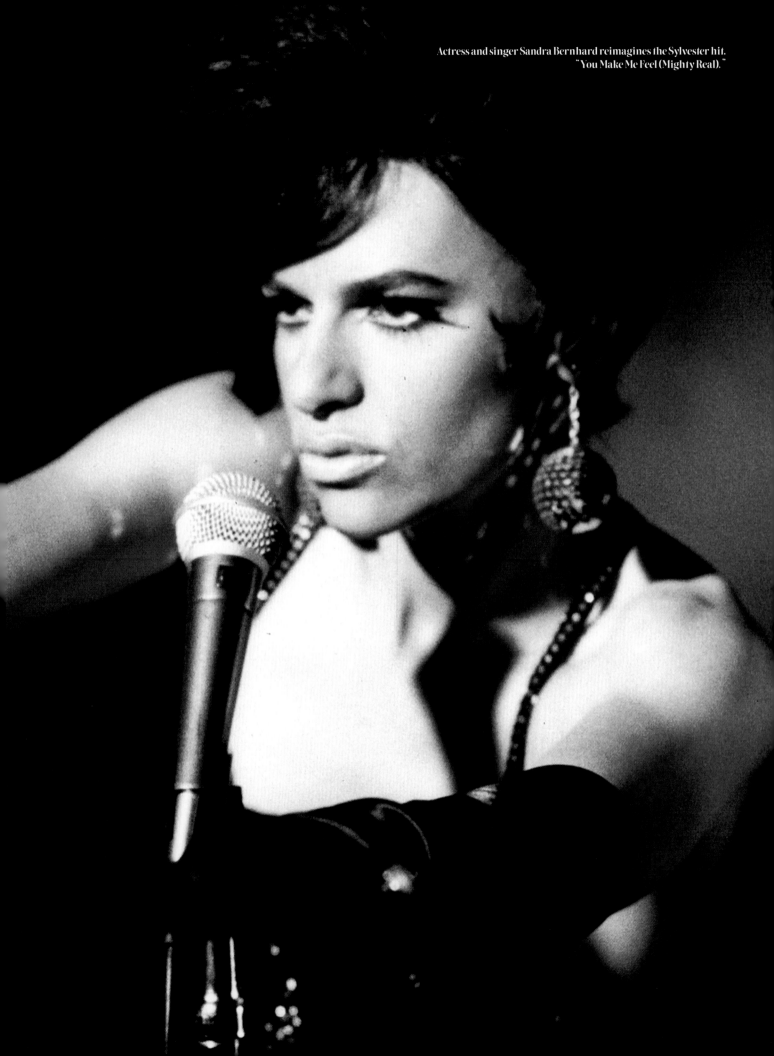

Actress and singer Sandra Bernhard reimagines the Sylvester hit,
"You Make Me Feel (Mighty Real)."

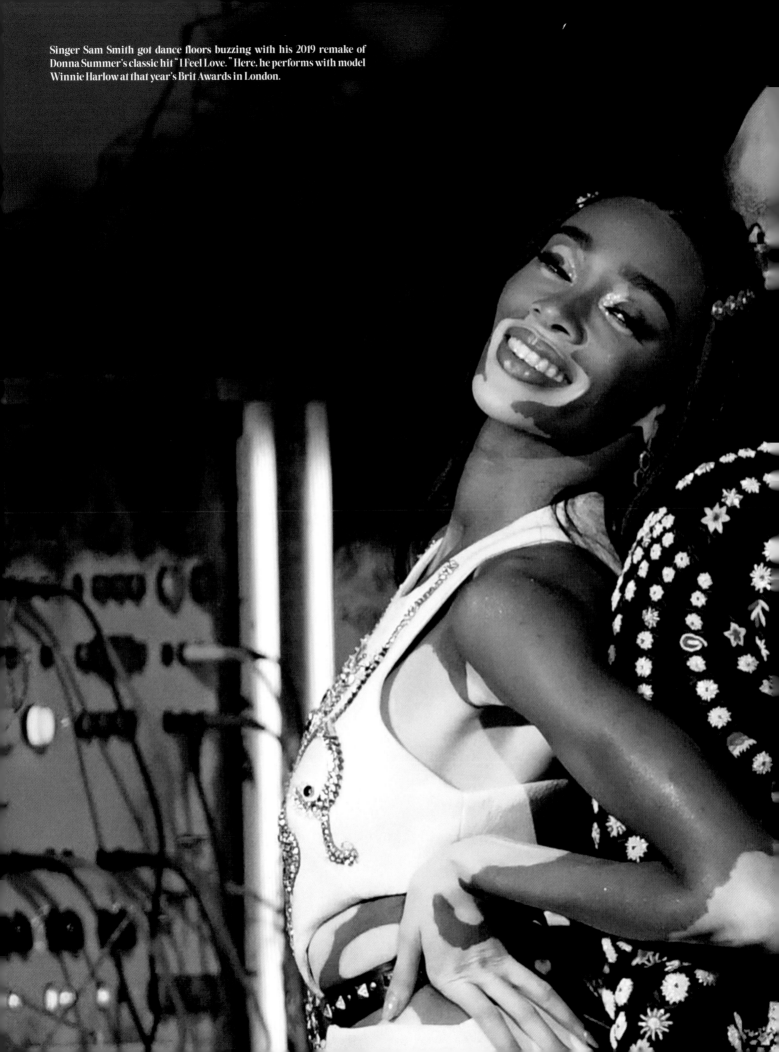

Singer Sam Smith got dance floors buzzing with his 2019 remake of Donna Summer's classic hit "I Feel Love." Here, he performs with model Winnie Harlow at that year's Brit Awards in London.

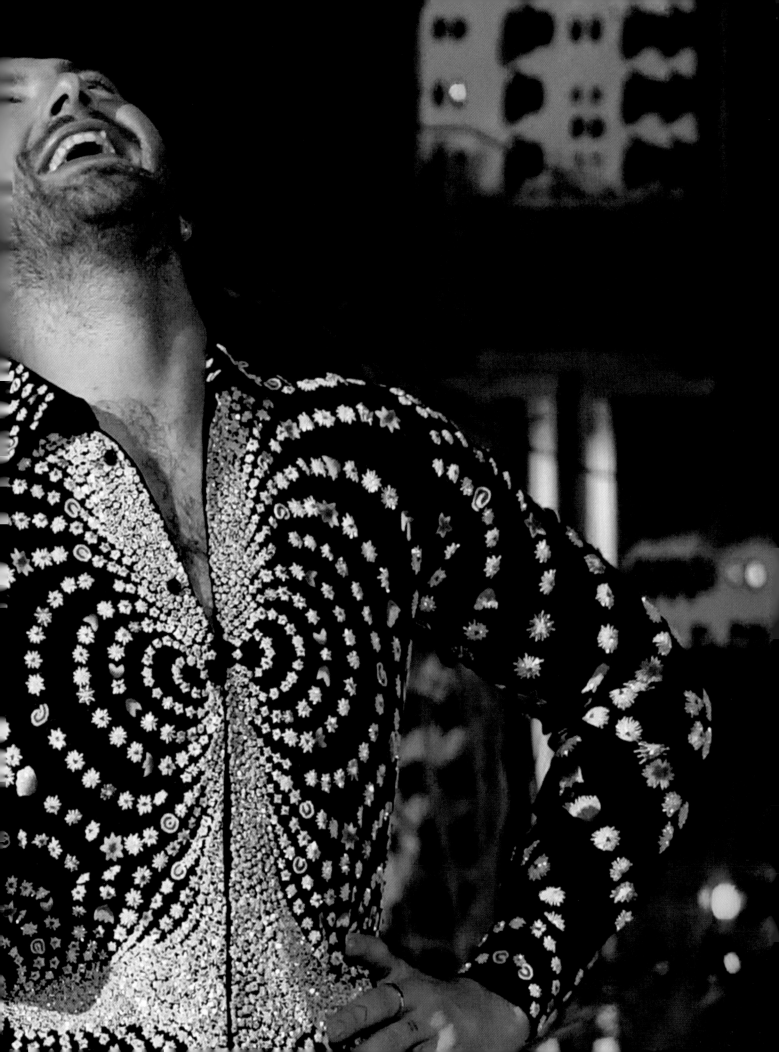

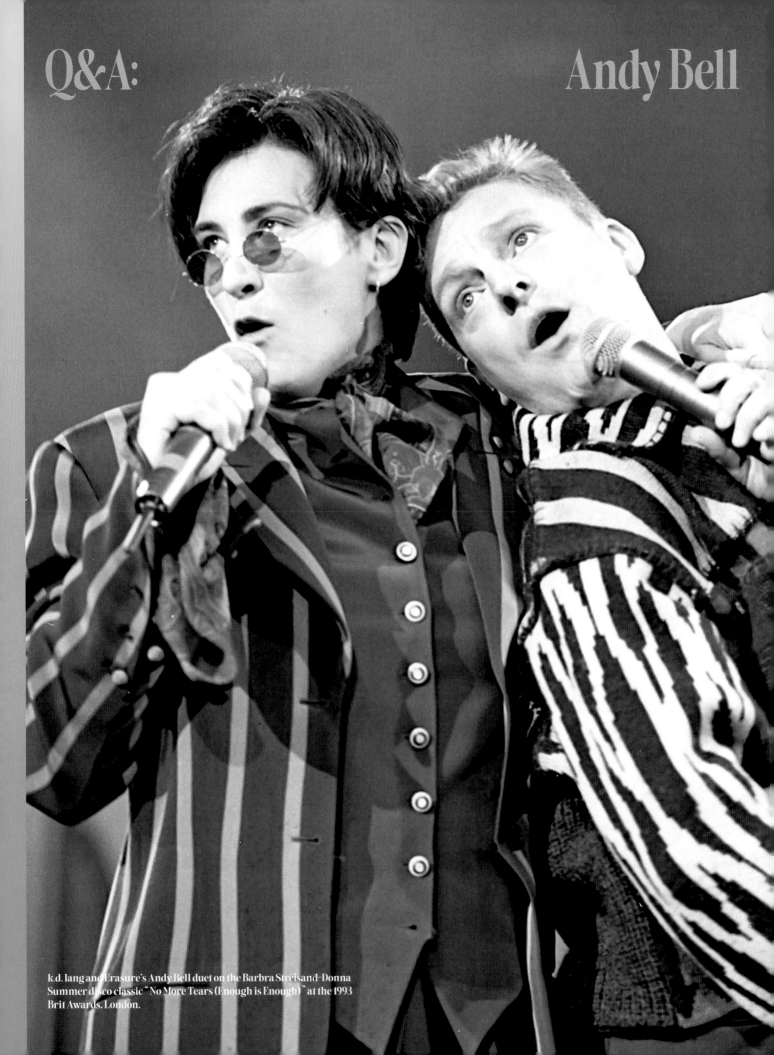

k.d. lang and Erasure's Andy Bell duet on the Barbra Streisand–Donna
Summer disco classic "No More Tears (Enough is Enough)" at the 1993
Brit Awards, London.

As the vocal half of the fabulous British synthpop duo Erasure, Andy Bell has helped define electronic dance music since 1986. With band mate Vince Clarke—a giant of the genre who previously helped found both Depeche Mode and Yaz—Bell has always brought soulfulness to electronic music and helped bridge the gap between disco and EDM.

He may never have won a Grammy, despite the global popularity of such Erasure songs as "Chains of Love," "A Little Respect," and "Oh L'Amour." But as a leading light in the first generation of out gay musicians, Bell is a bona fide LGBTQ icon.

As was the case with many queer kids, dance music, particularly the Hi-NRG sounds of the eighties, offered him a vision of a life more glamorous than the one into which he'd been born in the United Kingdom in 1964. "All I ever wanted was to be Debbie Harry," he once told me. "Like any girl, really." Erasure continues to fulfill such glitter-dusted dreams for new generations of dance music fans.

FDC: "How did disco enter your life?"
AB: "Peterborough, where I grew up, was a really small town. There was not much to do there. I was probably about fifteen or sixteen, and I was allowed to go to bars, with my parents mostly. We had working men's clubs that were affiliated with unions, and they would have disco on Fridays. They would play tracks like 'Shake Your Body (Down to the Ground)' by the Jacksons. Once the music grabbed me, I was compelled to go out onto the dance floor. That was like my first time on the stage, dancing in front of people. Then we had a dance competition in school to 'Boogie Wonderland' by Earth, Wind & Fire. I came in second, but I think they were just being nice to the guy who won."

FDC: "As a young queer boy, why did dance songs resonate? Was it the upbeat lyrics?"
AB: "To me, it was less about the lyrics and more about the flavor and the ambience of the music. What was quite important was the *glamour* of disco. The first *Star Wars* movie had come out and there was lots of space-age imagery that came with it—robotic vocals and girls wearing dresses like little Barbarella figures. Dee D. Jackson was singing 'Automatic Lover.' There was also glamour attached to certain labels, like Carrere and Casablanca Records. I would just *fall into* these record sleeves. Before I'd even been to America, there was this notion of glamour about the places these records came from."

FDC: "What place did dancing hold for you in those days?"
AB: "Being in a club and dancing was a form of expression, where you were allowed to dance man on man. We had a genre of music called Northern Soul in the UK, which was like Philly music, kind of like a white Motown, although it wasn't all white. They would have these dance-off competitions. It was like jousting, a sword fight, an acrobatic competition between two men, which could get quite physical. It didn't necessarily have sexual connotations. If it did, they were below the surface."

FDC: "What was the club scene like when you got to London in the eighties?"
AB: "When I moved to London, I'd hear Sylvester and a lot of the 'High-Energy' artists. It was really thrilling. When Frankie Goes to Hollywood and Bronski Beat came out, it was just an amazing time. It was so exhilarating. I remember being at Heaven and being in the middle of a laser-beam tunnel and dancing to 'Relax' and it was the most empowering feeling in the world."

FDC: "Were you captivated by the great divas of disco?"
AB: "They were incredible! I've always wanted to be one! To me, the high point of those of divas was in the mid-eighties, towards the end of High-Energy music. You'd go to a disco and the whole crowd would be waiting for them and they'd do two or three numbers.
"I remember going to Heaven and waiting for Grace Jones or Hazell Dean or Miquel Brown or Divine to go on. It was such a thrill for us to have these huge stars come, and for us to be in their presence. One person with a backing track and a mic, maybe a couple of dancers, and they commanded the whole room, stepping into the limelight in their ostrich feathers and sequins and just putting on a show. It all probably came out of a tattered suitcase. But it felt like an event."

FDC: "How does it feel when you step into the limelight in your ostrich feathers and sequins?"
AB: "It feels fabulous. You still feel like you're living that teenage dream."

FDC: "Did you ever have contact with the divas of your youth?"
AB: "I saw Grace Jones once, just briefly backstage. It was at the Trevor Horn twenty-fifth anniversary concert in 2004. She was there and I said, 'Can I come and see you?' I went in and she was drinking champagne right from the bottle. I'm shocked she's not a dame in the UK. I'm really shocked."

FDC: "Did you and the first generation of out gay performers—people like Pete Burns, Marc Almond, Jimmy Somerville—feel an obligation to embrace disco and make it your own?"
AB: "I'm sure there are gay goth groups and gay rock groups, but I don't know if it's possible to be a gay artist without doing dance music. Eventually, you're going to get pulled into the fold."

FDC: "Erasure has always done incredible cover versions of songs. In 1989, you remade the disco classic 'Supernature.' What was that like?"
AB: "That was incredible, especially the William Orbit remix. I didn't realize that Lene Lovich had written the lyrics for Cerrone for 'Supernature.' I love that version of 'Supernature'."

FDC: "It's so dystopian! It's our darkest fears of the future, but you can dance to it!"
AB: "It's like 'Let's find the disco at the end of the world,' isn't it?"

FDC: "You had done a cover of ABBA's 'Gimme! Gimme! Gimme! (A Man After Midnight)' in 1986. How did the all-ABBA Erasure EP Abba-esque come about in 1992?"

AB: "It was kind of a throwaway, but I didn't realize that at the time. Vince was living in Holland; I was living in Berlin. We hired this place in Amsterdam and recorded it. I had been thinking of doing a whole album, but I'm so glad we didn't. After that EP, we drowned in ABBA for years. It was like ABBA consumed us and people forgot who Erasure was. But we had so much fun doing it."

FDC: "You're the perfect person to decide this once and for all: Is ABBA truly disco?"

AB: "No, but they have a disco yacht, and they can pull in whenever they want to. They do it extremely well. When you hear *Voulez-Vous*, you can really hear the influence of disco and the *Saturday Night Fever* soundtrack. ABBA were also big fans of the Beach Boys and Phil Spector. When you love music, hearing how those roots combine is fascinating. I love all of those people, and ELO and *Xanadu*, too. Anything that lifts you up, I think is incredible."

FDC: "Not everyone remembers this, but a couple of years after Abba-esque, Erasure did a cover of Evelyn Thomas's 1984 Hi-NRG hit 'High Energy.' It was 1995."

AB: "That was one of our rougher covers. But it just needed to be done. It's such a great song. At the time, I didn't associate myself with clones. I was more on the gender-bending cusp. Hi-NRG music had this affiliation with the clones, but when the HIV crisis happened, it was like the death of the clones. I just felt like nobody was doing these songs anymore. Nobody. I wasn't rescuing it, really, but it's such a shame when the tide goes out on a whole wave of music and doesn't come back in."

FDC: "Do you think today's electronic dance music stands on disco's shoulders?"

AB: "We're all built on R&B and disco. It all melts in together."

FDC: "Why does dance music continue to mean so much to people?"

AB: "I think it's tribal. As long as you have a drum and you have a group of people coming together, it's really powerful. It's a rallying call. There's this energy, this exhilaration that we tap into through dance music. It's like a DNA Activation Code."

FDC: "At the 2023 Grammys, dance music made a huge showing."

AB: "I felt a bit sorry for the rock music team, honestly."

FDC: "Does it bother you that Erasure has never won a Grammy?"

AB: "Sometimes I do get a bit frustrated because I'm just as much of an egomaniac as anybody else. But then, I feel like it's really a nice position to be in to see that we've had some influence. It's not like being a ghost, but being more like a fairy, a magical spirit that comes in and out."

FDC: "You must understand how much you mean to your fans. I'm sure there are gratifying moments."

AB: "We were doing one of these festival tours and I saw this little boy on his dad's shoulders. The kid probably doesn't know the music or anything, but they were there and just having a great time. For me, that's worth everything. I also remember touring in the Midwest. It was maybe 1989. We were playing this really small church, and when the Erasure bus pulled up, all these kids were outside lined up and shouting, 'Gay pride!'."

FDC: "Will there be more wonderful songs coming from Erasure?"

AB: "I've got some fantastic dance tracks up my sleeve right now. I never, ever get tired of making dance records. You just want to do the next one and the next one and get better and better."

FDC: "What, ultimately, does disco mean to you?"

AB: "To me, disco is a portal to heaven. When you're in a club and you're dancing, you're so high on the music, the interaction with people, the laughing with your friends. It's such an exchange on the dance floor. I never want to go home from those places. I would sleep there if I could."

Cover Versions of Disco Songs

Sometimes no matter who's recording them, cover versions just don't click. Rock goddesses Tina Turner and Cyndi Lauper put their own spin on "Disco Inferno" in the Nineties, but neither improved on the Trammps' 1976 original. Other performers, though, have managed to put their own stamp on various disco classics and bring out something new in them.

These are the coolest:

Jimmy Somerville and the members of Bronski Beat.

"BOOGIE SHOES" BY ALEX CHILTON (1979)

Alex Chilton was known as the lead singer of the Box Tops, the sixties vocal group whose song "The Letter" was a huge hit in 1967. But to his fellow singer-songwriters, Chilton was a demigod-like font of inspiration. Their worship made his cover of KC and the Sunshine Band's "Boogie Shoes" completely unexpected. No disco send-up, Chilton's rock version proves that a good song is a good song, no matter the tempo, no matter the genre, no matter the footwear.

"FUNKY TOWN" BY PSEUDO ECHO (1987)

The disco original was barely cold when Pseudo Echo released a rock version of the 1979 Lipps Inc. hit "Funkytown." Their new-wave take charted around the world, reaching Number 1 in the band's native Australia and Number 6 on the *Billboard* Hot 100 in America. Both the disco disc and the rock remake, originally released as a stand-alone single, still keep listeners "groovin' with some energy" on oldies stations today.

"DA YA THINK I'M SEXY" BY REVOLTING COCKS (1993)

The industrial supergroup Revolting Cocks—fronted by Ministry's Al Jourgensen—covered Rod Stewart's 1978 disco hit in 1993. Adding guitar feedback and changing a few lyrics, they cheekily made it their own. "Give me a dime, so I can phone my mother" became, "Give me a buck, so I can buy a rubber." The song's hot-to-trot couple still caught a cab back to that high-rise apartment. But this time, the sexy singer wasn't out of milk and coffee, but K-Y Jelly.

"YOU SEXY THING" BY DEEE-LITE (1994)

Deee-Lite, the downtown New York group that deliciously married Sixties psychedelia and Seventies Disco with their early Nineties hit "Groove is in the Heart," covered the 1975 Hot Chocolate classic "You Sexy Thing" for the 1994 film comedy *Dumb and Dumber*. It was their last shining disco moment. Deee-Lite broke up that year.

"TURN THE BEAT AROUND" BY GLORIA ESTEFAN (1994)

Gloria Estefan filled it with her Cuban-American heat and rode the song to the top of the charts. The cover revived "her Miami Sound Machine days of fatback disco." The song appeared on Hold Me, Thrill Me, Kiss Me, an all-covers LP that also featured another disco hit, "Cherchez La Femme."

"I FEEL LOVE" BY BLONDIE (1995)

A year after "Heart of Glass," New York City punk band Blondie performed "I Feel Love" during a 1980 three-night stand at London's Hammersmith Odeon. It took fifteen years, though, for the band to release their ethereal live version of the Donna Summer classic. "I Feel Love." In 2021, *Far Out* magazine called Debbie Harry's take on the song "a wonderful cover of one of disco's preeminent tracks by one of punk's most golden voices."

"I WILL SURVIVE" BY CAKE (1996)

California alt-rock band Cake had been performing a deadpan version of "I Will Survive" for years before including it on their 1996 album Fashion Nugget. The Cake cover cracked the Top 40 but Gloria Gaynor was no fan. When asked by the St. Louis Post-Dispatch in 2008, the disco diva said, "The one I don't like is the one by Cake, because they used profanity."

"SEPTEMBER" BY KIRK FRANKLIN (2007)

When the hip-hop gospel singer Kirk Franklin covered the Earth, Wind & Fire classic "September," he replaced secular love with the spiritual kind. His 2007 album, Interpretations: Celebrating the Music of Earth, Wind & Fire, was produced by the original band's cofounder, Maurice White, and climbed to Number 15 on the adult R&B charts

"INSIDE AND OUT" BY FEIST (2004)

Leslie Feist was three years old when the Bee Gees released "Love You Inside Out" in 1979. But in 2004, the singer-songwriter, by then using only her last name, scored a hit with a cover version in her native Canada. Renamed "Inside and Out," the track was featured on Feist's second studio album *Let It Die* and nominated for a 2006 Juno Award as Single of the Year.

"TRAGEDY" BY FOO FIGHTERS (2021)

Dave Grohl and Taylor Hawkins, both life-long fans of the Bee Gees, paid tribute to the brothers Gibb when they formed the Dee Gees in 2021. The pseudonymous group released Hail Satin, which included covers of such Bee Gees classics as "You Should Be Dancing," "Night Fever," and "More Than a Woman," plus "Shadow Dancing," a 1978 hit for little brother, Andy Gibb. Their version of "Tragedy" is the real triumph, though. Even the most jaded critics called the project "irresistible.

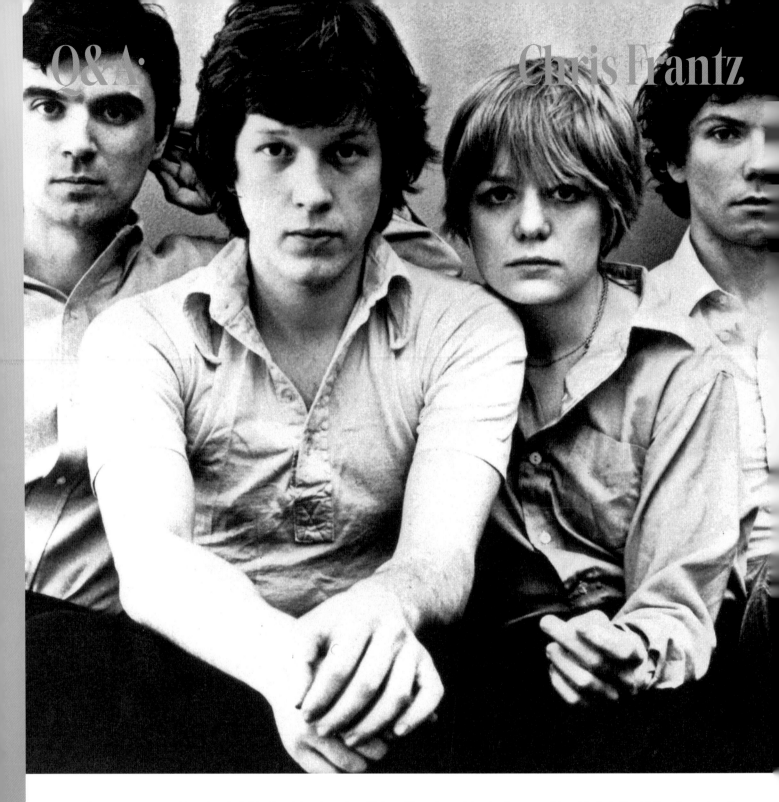

Tom Tom Club was originally a side project for Talking Heads band members Chris Franz and Tina Weymouth. But the husband-and-wife duo's *other* band, rounded out by a revolving cast of musicians including Weymouth's sisters, the ace guitarist Adrian Belew, and Talking Head Jerry Harrison, found mainstream success making dance music.

In 1981, as the heat on disco was cooling, they were on the vanguard of a new kind of dance music. Their back-to-back hits, "Wordy Rappinghood" and "Genius of Love," have become post-disco classics. The latter is one of the most sampled songs of all time, particularly on 1995's "Fantasy," Mariah Carey's ninth Number 1 hit on the *Billboard* charts.

Although considered a "new wave" band in their *Stop Making Sense* days, Tom Tom Club has always been down with disco. They covered Hot Chocolate's "You Sexy Thing" on *Dark Sneak Love Action*, their Techno-influenced 1991 album, which also includes the track, "As the Disco Ball Turns." The band later remade the Donna Summer landmark "Love to Love You Baby" on the 2000 album *The Good, the Bad, and the Funky.* "We always loved dance music," Weymouth says, "because so many of the innovations in music were happening there."

Frantz detailed his long career in music, including his complicated relationship with Talking Heads cofounder David Byrne, in the evocative 2020 memoir, *Remain in Love: Talking Heads, Tom Tom Club, Tina.* Here, Frantz offers a punk-rocker-turned-dance-music-maker's perspective on disco from the genre's heyday to today.

Chris Frantz and Tina Weymouth of Tom Tom Club are backed by their Talking Heads bandmates David Byrne and Jerry Harrison.

FDC: "In the seventies, you moved to Manhattan and cofounded one of the most important bands in punk-rock history. How did you feel about disco in those days?"

CF: "As Talking Heads, we loved disco. In our loft, we used to listen to Giorgio Moroder and Bohannan, KC and the Sunshine Band, Donna Summer, all of them. We were really happy when the Bee Gees got into the whole *Saturday Night Fever* thing."

FDC: "Was your disco appreciation typical of your punk-rock peers?"

CF: "Down at CBGBs, there were a whole lot of people who really bought into the 'disco sucks' mentality. We really liked reggae music and tried to have a reggae band open for us, and both times they got a very cold reception, not because people didn't like reggae but because they didn't like black people very much. I know there are people who want to say, 'Oh, it wasn't racist,' but it was. It was that whole systemic racism thing that people are talking about today."

FDC: "Did you go to discos in those days?"

CF: "We would go to loft parties. They were basically rent parties where the guy who lived in the loft was the DJ. Those were really great parties. It was mostly gay people, but you didn't have to be gay. It was just a really good time. As much as we loved the whole punk scene, we also loved to dance and go out and have a good time. I do remember, though, that a friend of mine got stabbed in the ass one time. We were not always, shall we say, in a safe environment. You always had to be very careful about what you smoked or what you drank in some of those places because you could get dosed with angel dust."

FDC: "Did you ever go to Studio 54?"

CF: "I went to Studio 54 only two times, and both times we got the VIP treatment. We were let in through the back door, so I never had the humiliating experience of waiting in line. One time it was somebody's birthday. The second time, which was actually more fun, was the after-party for the thing that David Byrne and Twyla Tharp did on Broadway called *The Catherine Wheel*. We went to opening night and sat next to Baryshnikov and it was very exciting. And then we all went to Studio 54."

FDC: "How did David feel about the huge success Tom Tom Club was experiencing?"

CF: "The only time David ever mentioned 'Genius of Love,' which was an enormous hit, was at that particular party. When we entered, they were playing that song. He leaned over to me and said, 'How do you get that hand clap sound?' That was the only time he ever mentioned the song. I recently found out that the album was certified platinum. It took forty years, but it has sold a million copies."

FDC: "How did Talking Heads fans feel when you began to make dance music?"

CF: "By 1981, when we formed Tom Tom Club, rock people were a little more tolerant. There were still people who didn't like disco, but groups like Human League and New Order were making dance tracks and nobody said to them, 'Get out!' Uptown was coming downtown, and downtown was going uptown, and it wasn't quite as segregated as it had been."

FDC: "Why did the band decide to record the Hot Chocolate classic 'You Sexy Thing'?"

CF: "Every once in a while we would do a cover as Tom Tom Club, and we just loved that song. It was from an album that Tina and I had in our record collection. I never met Errol Brown, the singer who co wrote it. But we did a lot of work at Compass Point Studios in the Bahamas—we still have a little apartment down there—and a few years ago, we were in a restaurant and a friend introduced us to Errol's widow. It turns out he had been living like a half mile from us, and we never knew it. I would have loved to have hung out with him."

FDC: "In 2000, Tom Tom Club did another disco cover, 'Love to Love You Baby.'"

CF: "Again, it was just one of our favorite songs. Tina used to sing it to our two sons as a lullaby when they were little babies. When we decided to record it, Tina wanted to insert part of a poem in French into the song. We went to the publishers, and they said, 'No way.' So through Nile Rodgers, we got Donna Summer's home number and called her up. Donna said, 'Oh, that would be beautiful.' So we were able to do that. We were always big fans of hers and her producer Giorgio Moroder."

FDC: "Ultimately what draws you time and again to disco?"

CF: "I think it's because there is an overall sweetness to disco, which is the antithesis of the badass attitude of so much rock 'n' roll. Mick Jagger loved disco, but most of his fans, not so much. To be fair, though, there was some crappy disco. The producer of the first Talking Heads album, *Talking Heads: 77*, was Tony Bongiovi, and he had a Number 1 hit with the disco version of the *Star Wars* theme. That record was really cheesy and kind of gave disco a bad name. But then there was the Andrea True Connection's song 'More, More, More.' So, sometimes cheesy is good."

Must-Hear
Disco Playlist:

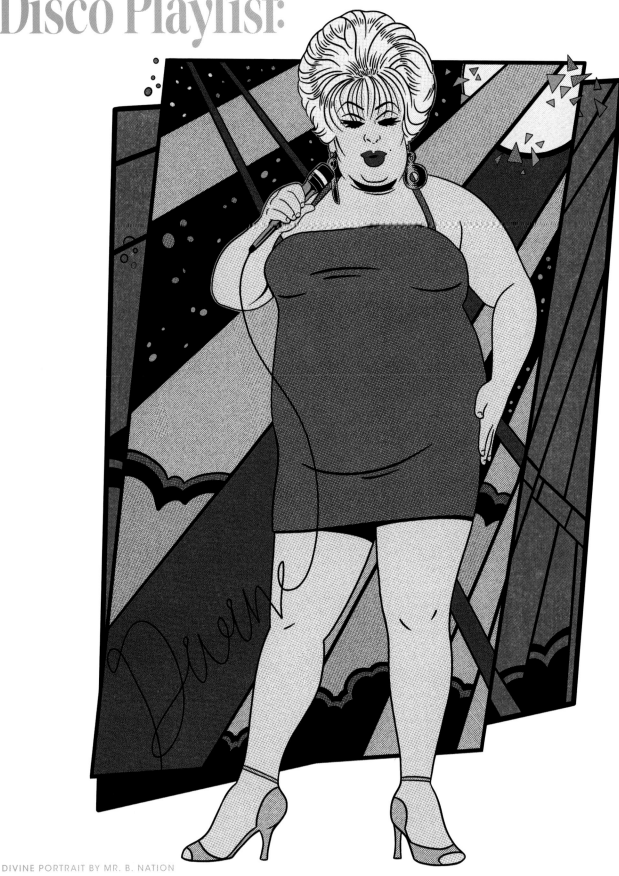

DIVINE PORTRAIT BY MR. B. NATION

1984-1999

"DON QUICHOTTE" by Magazine 60, 1984

"HIGH ENERGY" by Evelyn Thomas, 1984

"I AM WHAT I AM" by Gloria Gaynor, 1984

"NEW ATTITUDE" by Patti LaBelle, 1984

"ON AND ON" by Jesse Saunders, 1984

"THAT'S THE WAY (I LIKE IT)" by Dead or Alive, 1984

"I WONDER IF I TAKE YOU HOME"
by Lisa Lisa and Cult Jam with Full Force, 1985

"ONE NIGHT IN BANGKOK" by Robey, 1985

"AIN'T NOTHIN' GOIN' ON BUT THE RENT" by Gwen Guthrie, 1986

"BECAUSE OF YOU" by The Cover Girls, 1986

"LOVE CAN'T TURN AROUND"
by Farley "Jackmaster" Funk and Jesse Saunders, 1986

"MALE STRIPPER" by Man 2 Man, 1986

"MOVE YOUR BODY" by Marshall Jefferson, 1986

"WORD UP" by Cameo, 1986

"BOOM BOOM (LET'S GO BACK TO MY ROOM)" by Paul Lekakis, 1987

"FASCINATED" by Company B, 1987

"PUMP UP THE VOLUME" by M|A|R|R|S, 1987

"THESE BOOTS ARE MADE FOR WALKING"
by Man 2 Man featuring Jessica Williams, 1987

"YOU USED TO HOLD ME" by Ralphi Rosario, 1987

"BANGO (TO THE BATMOBILE)" by the Todd Terry Project, 1988

"BRING ME EDELWEISS" by Edelweiss, 1988

"GOOD LIFE" by Inner City, 1988

"I GOTTA BIG DICK" by Maurice Joshua, 1988

"PINK CADILLAC" by Natalie Cole, 1988

"THE LOCO-MOTION" by Kylie Minogue, 1988

"THEME FROM S'EXPRESS" by S'Express, 1988

"UH-UH OOH-OOH LOOK OUT (HERE IT COMES)
[STEVE HURLEY REMIX]" by Roberta Flack, 1988

"WEEKEND" by the Todd Terry Project, 1988

"WORK IT TO THE BONE" by LNR, 1988

"HOW TO DO THAT" by Jean Paul Gaultier, 1989

"FRENCH KISS" by Lil Louis, 1989

"THAT'S THE WAY LOVE IS" by Ten City, 1989

"FINALLY" by CeCe Peniston, 1991

"GYPSY WOMAN" by Crystal Waters, 1991

"PEACE" by Sabrina Johnston, 1991

"BRIGHTER DAYS" by Cajmere featuring Dajae, 1992

"DEEPER AND DEEPER" by Madonna, 1992

"DREAM OF ME (BASED ON 'LOVE'S THEME')"
by Orchestral Manoeuvres in the Dark, 1993

"SHOW ME LOVE" by Robin S, 1993

"WHAT IS LOVE" by Haddaway, 1993

"100% PURE LOVE" by Crystal Waters, 1994

"FANTASY" by Mariah Carey, 1995

"LOSING MY RELIGION" by Rozalla, 1995

"IF MADONNA CALLS" by Junior Vasquez, 1996

"BELIEVE" by Cher, 1998

"FEEL IT" by The Tamperer featuring Maya, 1998

"FREAK IT!" by Studio 45, 1999

"I WILL GO WITH YOU (CON TE PARTIRÒ)" by Donna Summer, 1999

"IF EVERYBODY LOOKED THE SAME" by Groove Armada, 1999

"MY LOVE IS YOUR LOVE (DANCE REMIX)" by Whitney Houston, 1999

SYLVESTER, EARTHA KITT, AND CHAKA KHAN PORTRAITS BY SINA SHAMSAVARI.

Q&A: 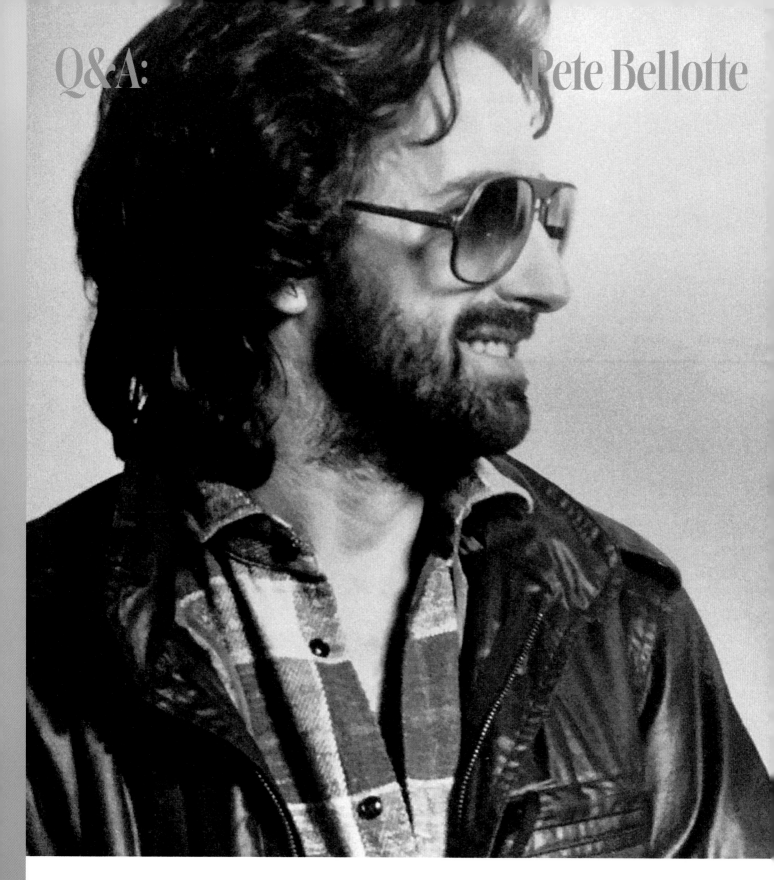 Pete Bellotte

Pete Bellotte had been a guitarist, toured England, and had a hit record there before he was thirty. But he always knew that the job he really wanted wasn't on stage. "I understood that the man behind the glass in the studio, the producer, has the best job," he says. "If a band fails, a producer has another band. When I was in a band, if we failed, that was it."

As a maker of timeless disco music, Bellotte is among a rarefied few. Joining forces with the Italian producer Giorgio Moroder and an American singer named Donna Summer, Bellotte was a driving force behind some of disco's greatest songs including "Love to Love You Baby," "Hot Stuff," and the record generally regarded as the pinnacle of the genre, "I Feel Love." The 1977 smash was inducted into the Library of Congress' National Recording Registry in 2012.

Bellotte recognizes the contribution he made to pop music history, but he still seems just the tiniest bit amazed that people are still loving—and new artists are still recording—disco songs he and Moroder wrote together almost a half century ago. "I had no idea," he says, "that I would be talking about this all these years later."

FDC: "You're from Great Britain. Why did you move to Germany to become a producer?"

PB: "I thought I'd have a better chance there because I hadn't produced anything yet. After I moved to Munich, I ran into a photographer for a magazine called *Bravo*. I told him, 'I can't break into the business. I'm struggling, and not getting anywhere.' He said, 'Give me your number.' Within a week, he phoned me and said he'd just met Giorgio Moroder, who was looking for an assistant.

"I didn't know Giorgio from Adam, but I began working with him as an understudy. We wrote songs together and I spent a year and a half learning what producing was. In 1972, we had a Number 1 hit in England with a bubblegum song called 'Son of My Father' with a band called Chicory Tip.

Then the record company, Ariola, where Giorgio worked, asked me to become a house producer. I told Giorgio I was going to go off on my own, and he was fine with it. Within a year, though, he said, 'Why don't you come back, and we'll be equal partners.' So from A to Z, it took me two and a half years to become a proper producer. I was very, very lucky."

FDC: "What a great story! If you'd gotten a job with someone who didn't make the kind of music Giorgio did, would you have written in a completely different genre?"

PB: "When you're living on soup on weekends, you'll do any kind of music just to get in."

FDC: "In 1974, you and Giorgio teamed up with Donna Summer and the real magic began. What was the key to her brilliance?"

PB: "Donna could slip on the coat of any song she wanted to sing, and it would fit exactly. She was just intuitive. There are thousands of very great singers, hundreds of brilliant singers, but there are only a handful who have a tone. Donna could have been any kind of singer. She had this depth of voice. When you hear her sing, she just builds and builds and builds. She was one of those alchemists who could turn base metals into gold. She was just an extraordinary artist."

FDC: "What was she like in the studio?"

PB: "We had a very peculiar work ethic. None of us smoked. None of us drank. There were no drugs. Not for any virtuous reason, it was just how we were. We were only in the studio to work. Our vice was laughing because we were always joking around and doing stupid things, as youngsters do. But we were very productive. Donna would come into the studio, and she loved talking. She was incredibly funny. We'd have long conversations and then she'd look at her watch and say, 'Oh, is that the time? C'mon, let's go,' and she would go in and sing it in one take. I think she only listened to the song the night before. She always just felt the song straightaway."

FDC: "Did Donna like being called the Queen of Disco?"

PB: "Donna was pretty modest. She would never say I'm a great singer or anything like that. She was very self-effacing, but I think she would have been honored to have been called that. She certainly wouldn't have let it go to her head."

FDC: "When Brian Eno heard 'I Feel Love' in 1977, he told David Bowie that it was the sound of the future. Why does that song still sound like the future?"

PB: "The syncopated beat of the bass is relentless and doesn't really change and then you've got these cascading triplets from Donna and that beautiful voice pouring down on you like confetti. The juxtaposition is magical between her, as the heart, and this relentless machine that doesn't give a damn about anything. It's just going to do its job and it's not stopping for anyone. And there she is just floating above it ethereally."

FDC: "You're giving me goosebumps! Why were disco songs like that so revolutionary?"

PB: "It's because of the structure. This sounds a bit grandiose, but when we did 'Love to Love You Baby,' it was the first 'proper' disco record. It was perhaps the first time that a bass drum had done four-on-the-floor. It's hard to imagine that it was revolutionary, but if you go back and listen, you won't hear anyone else do four-on-the-floor before that. It just made everything instantly danceable. Boom-boom-boom-boom is the heartbeat of excitement. It's primeval. And, of course, there were the hi-hat cymbals. When we used them, we called it pea soup because it will always go, 'psp, psp, psp, psp,' and you can't resist pea soup!"

FDC: "Was disco a producer's genre?"

PB: "The artists didn't really get involved with the recording. The first time Donna got involved in the recording was *Bad Girls*, which was pretty late. Donna would come in, sing the record, and the next time she heard it, it was on the radio. She never heard the mix. She wasn't really interested. We made lots of records with no involvement from the artists at all."

FDC: "Did disco let you spread your wings as a creative person?"

PB: "Yes, we moved forward each time and the records became better and better. By the time we got to 'Bad Girls,' we had done things like 'MacArthur Park,' which was a really sophisticated song, 'Last Dance' written by Paul Jabara, which was another brilliant song. We'd done Barry Manilow's 'Could It Be Magic?' It all let Donna show a much broader spectrum of her incredible protean talent."

FDC: "Speaking of protean talent, Elton John has been your friend since the beginning of both your careers. How did you come to make a disco album with him in 1979?"

PB: "I was at a party in London at John Reed's house and Elton was there. John said, 'Elton wants to make a disco record with you. He doesn't want to write any songs. He just wants to sing it. I said, 'Are you sure that's a good idea?' This was exactly at the time when 'Disco sucks' was everywhere, and it was the wrong thing to do. As I left the party, I thought perhaps he'd had a few too many, but they were serious. I didn't make a great album. 'Victim of Love' is the only decent song."

FDC: "What do you think were the emotions behind the 'Disco Sucks' movement?"

PB: "New York had a big faction of punk music and there was a lot of resentment for something that, in their eyes, was so pathetic and meaningless and bouncy and happy. Disco had no place in their world because they preferred dystopia to utopia. It became incredibly fashionable to be anti-something-so-fun. But that's just the opinion of someone involved in that fun."

FDC: "Did being associated so closely with disco become a scarlet letter?"

PB: "This will illustrate how embarrassed I was by disco at the time: I was in New York recording an album and I was staying at The Plaza. Every morning, I went down to have breakfast and John Lennon was down there having breakfast on his own. I was a big fan, but I thought, I can't go up to him and say, 'I'm that disco guy who works with Donna Summer.' I thought he'd just laugh at me. So I never did. But I recently got a book about Lennon and read that he was absolutely potty about 'Hot Stuff.' If only I'd known that then, I could have gone up to him."

FDC: "How did it feel when America turned on disco?"

PB: "I wasn't upset. I was just philosophical about it. I said to Giorgio, 'the writing is on the wall: disco is over.' But we'd had such a good run that I couldn't complain if a new fashion of music was coming along. That's what music does; it has these periods."

FDC: "How did it feel, only a few years later, when the first generation of out gay musicians, particularly in Britain, began recording cover versions of disco hits? Jimmy Somerville and Marc Almond, for instance, teamed up for the Bronski Beat cover of 'I Feel Love' in 1985."

PB: "It was fantastic how that all happened, especially for a bunch of heterosexuals like us. Without the gay community, we would never have been so big. Neil Bogart of Casablanca knew that. That's how he managed to launch 'I Feel Love' and 'Love to Love You Baby,' going straight to Studio 54 with the records. Bogart understood implicitly how important the gay community was."

FDC: "Some people say that disco never died. What's your take on that?"

PB: "It certainly *did* die. There was a definite fallow period in the eighties and nineties when it was all what we call over here 'shoegazing bands.' They would all look down and it was all mournful, everyone-is-going-to-die music. But then disco came back. We were at a wedding last week and all the young people knew every word to every disco song. It was amazing."

FDC: "Why has it made such a comeback?"

PB: "Disco just brings so much joy and people just lose themselves in the dancing. That's one of the best things about disco music. You can't have a negative lyric on something so upbeat and fun. There's no room for Bertrand Russell in dance music."

FDC: "How does it feel when someone who wasn't born when you were turning out hit after hit in the seventies does a cover of one of those songs today?"

PB: "It's always nice to hear Beyoncé taking on 'Love to Love You Baby,' or Sam Smith doing 'I Feel Love.' It's always quite an honor. The wonderful thing about all the different covers is that every time someone sings one, it's like an endorsement, which is very pleasing. There's a band called Pigs Pigs Pigs Pigs Pigs Pigs Pigs, and they do 'Hot Stuff' as heavy punk rock and it's fantastic. They just played it at Glastonbury and the crowd went bonkers."

Chapter 10
Disco Forever

Madonna emerges from a giant disco ball during her 2006
Confessions tour at Madison Square Garden in New York City.

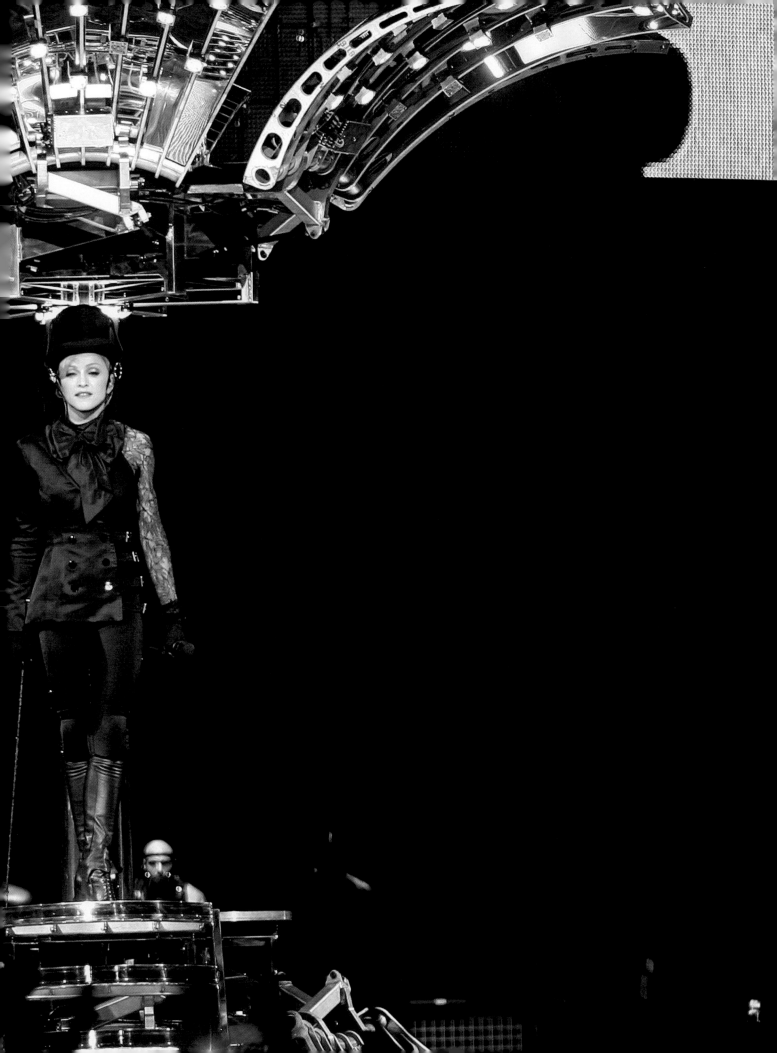

"

WE'VE COME TOO FAR TO GIVE UP WHO WE ARE...

—Daft Punk

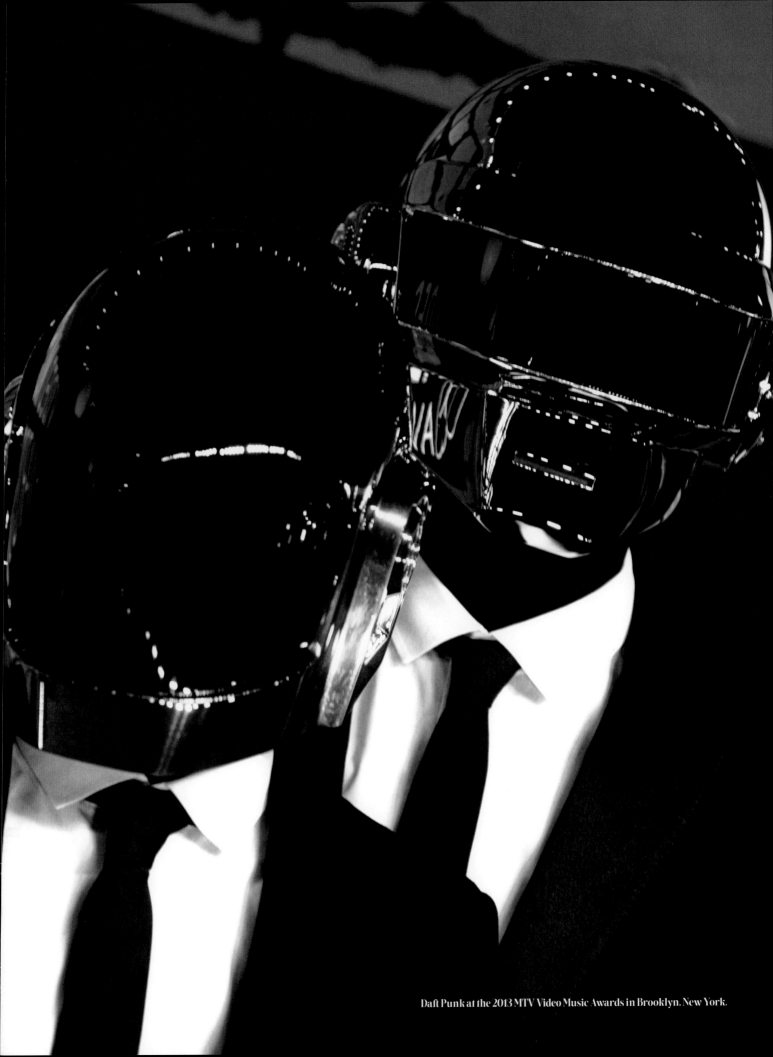

Daft Punk at the 2013 MTV Video Music Awards in Brooklyn, New York.

In 2002, music critic Ann Powers co-curated an exhibition called *Disco: A Decade of Saturday Nights* at Seattle's Experience Music Project, now the Museum of Pop Culture. It was the first serious examination of the genre and solidified disco's place in music history.

Her thesis, rarely echoed at the time, was that disco never died, but instead led to much of what came after. The genre first proved that Black talent could dominate entertainment in America.

Powers made it known that disco's demise in America was not echoed in other parts of the world. "Internationally it never went away," she said, noting that such acts as the Dutch quartet Vengaboys, best known for the 1998 earworm "We Like to Party!," the Swedish group Alcazar, whose biggest hit was 2001's "Crying at the Discoteque," the Australian super-diva Kylie Minogue, who sang "Your Disco Needs You" in 2001, and New York's own Deee-Lite, whose "Groove Is in the Heart" was a sensation way back in 1990, were all making disco music.

Some had paid the price for their association with the sound, to be sure. The era's most successful band, the Bee Gees, for instance, released the album *E.S.P.* in 1987—their first after a six-year hiatus—and it did well everywhere but in the States. "It doesn't make any sense," Warner Bros. Records vice president Bob Merlis said. "It's sold two million copies outside of this country and 250,000 here. I don't get it. It's the same album. This is ex post facto backlash."

The "disco sucks" movement and systemic bigotry in America was to blame.

"I always thought that was crazy," Barry Gibb said in 1988, during a period in the band's career in which the Bee Gees worked behind the scenes on hit songs by other artists like Dionne Warwick and Barbra Streisand but got little radio play in the States themselves. "It's a shame that there should be a period of American music that they should be ashamed of, as opposed to be proud of," Gibb said. "I'm not ashamed of what we did."

Why should he, or any other disco artists, be embarrassed?

In the long run, disco has proven to be the foundation for much contemporary music. Such genres as hip-hop and EDM were built on it. "I don't think you have hip-hop without disco and the pulsating nature of it," says David Wild, a longtime *Rolling Stone* writer who went on to produce the *Grammy Awards*. "Rhythm and Blues and sex—disco brought all those things back to music and led to a larger cultural revolution."

Pop music owes disco a debt, too. Would Madonna's 2005 song "Hung Up," for instance, have been such a smash hit had it not incorporated a delicious chunk of ABBA's "Gimme, Gimme, Gimme (A Man After Midnight)"? Probably not. Thirteen years later, Cher released a whole album of ABBA covers called *Dancing Queen* to much acclaim, filling dance floors like she hadn't since "Believe" in 1998.

Classic disco's redemption became official with the 2013 release of *Random Access Memories*, a groundbreaking album by the electronic duo Daft Punk. The record, featuring collaborations with some of the genre's original architects—Giorgio Moroder and Nile Rodgers, especially—went platinum and topped the charts in more than twenty countries.

At the 2014 Grammys, the French band took home a cache of trophies including Record of the Year for its best-selling single, "Get Lucky," sung by Pharrell Williams, and Album of the Year. "Wow," Rodgers said, when he got his turn at the microphone, "This is the most insane thing ever." Unexpected? Maybe. Daft Punk's coterie of musicians—some in their seventies—beat Taylor Swift, Macklemore, Sara Bareilles, and Kendrick Lamar. But "insane"? Hardly.

Random Access Memories, a recording that critics called a true disco record, was the most high-profile vindication of the once-vilified genre. But the audience was already primed for it. The record's success came at a time when nostalgic fans were embarking on disco-themed cruises and buying tickets to see *Mighty Real: A Fabulous Sylvester Musical* off-Broadway. The musical genre "Nu-disco" was already staking a claim on the playlists of a new generation of listeners. Daft Punk just did it best.

This disco revival, as Pharrell sang in 2013, was "like the legend of the phoenix" and disco was about to fly higher than it had since 1980.

David Mancuso, who died in 2016, would not have been surprised by disco's return in the twenty-first century. The DJ whose Loft parties in the early 1970s created the template for the disco experience once said, "The mirror ball would always reflect the energy of the room."

Perhaps this is why, at the height of the Covid-19 pandemic in 2020, disco revivalism was hotter than ever. "Plenty of pop acts, including Gaga and Doja Cat, have been looking back recently to the glory days of disco—a curious development at a moment when actual dancing in actual clubs is more or less out of the question," wrote *Los Angeles Times* music critic Mikael Wood in 2020. But those who'd danced through the AIDS crisis didn't find it curious at all.

Disco was back because we needed it. With a quarantined, frustrated world sheltering in place, music lovers needed an aural lift to their spirits more than they had in decades. As Paul Schrodt of *Los Angeles Magazine* cleverly put it, "If you're going to panic, you might as well do it at the—or at least while listening to—disco."

During those months, dance music stalwart Sophie Ellis-Bextor began performing live "Kitchen Disco" concerts via Instagram. The English singer subsequently released *Songs from the Kitchen Disco*, a greatest hits album, in November 2020.

Dua Lipa filled the need with a house call of her own with the album *Club Future Nostalgia* that year. "I'm really excited to put this album out now to give people time to live with it and listen to it when they're home," the Albanian singer said. "I hope it will brighten people's day."

Carly Rae Jepsen offered up the disco album *Dedicated Side B* during the pandemic. *Paper* magazine critic Brendan Wetmore highly recommended it, saying "you may not get to blare these pop gems with your friends on Fire Island this year, but pour a glass of wine and Zoom conference with them regardless."

Then there was Australian icon Kylie Minogue, who has become one of dance music's most enduring artists. When she released her fifteenth studio album, much of it recorded at her home during quarantine, she called it *Disco*. Critics gushed. One called "Say Something," the first single, "a dreamy disco anthem," while *Billboard* enthused, "Minogue takes flight on the wings of disco . . . delivering some levity to a heavy moment in history."

Her 2023 disco hit "Padam Padam" was even bigger. "On its release, the single was targeted at older audiences," the *Guardian* reported. "Then Generation Z and the TikTok crowd caught the 'Padam Padam' bug. They loved the infectious retro-glitterball beat."

As this book was being written, dance music was dominating pop music in a way it hadn't in decades. Such disco progeny as Kacey Musgraves's 2018 hit "High Horse," BTS' 2020 K-pop sensation "Dynamite," and Pink's 2023 worldwide smash "Trustfall" were proving disco was as widely adored as it had been nearly fifty years earlier.

Even classic musicians who'd joined the disco bandwagon back in the day were embracing the genre all over again. The dance music act DNCE—led by boy band alum Joe Jonas—joined Rod Stewart for a remake of "Da Ya Think I'm Sexy?" in 2017. And Elton John finally had back-to-back dance hits—decades after his "Victim of Love" disco debacle—with two up-tempo duets: "Cold Heart" with Dua Lipa and "Hold Me Closer" with Britney Spears in 2021.

The ultimate full-circle moment came in 2023 with Miley Cyrus's release of "Flowers." The single was quickly compared to "I Will Survive." The similarities in sentiment between the two anthems, which debuted forty-five years apart, weren't wasted on Gloria Gaynor, who, of course, sang the earlier hit. "Your new song carries the torch of empowerment and encourages everyone to find strength in themselves to persevere and thrive," she tweeted to Cyrus.

Beyoncé brought another disco superstar's legacy to a new generation with "Summer Renaissance." The closing track to her 2022 smash album *Renaissance* references both "Love to Love You Baby" and "I Feel Love" by Donna Summer in its glorious four-and-a-half minutes.

Other modern pop hits, although not set to a disco beat, uphold the dance-dance-dance ethos of the disco era, too. On his 2022 hit "All She Wanna Do," crooner John Legend complains that, even by daylight, his girl "can't get away from the flashing lights." And angora soft singer Taylor Swift, a woman who always adroitly taps into the zeitgeist of her generation, wrote a ballad called "Mirrorball." "I'll get you out on the floor. Shimmering. Beautiful. And, when I break, it's in a million pieces," she sang.

Disco finally has assumed its rightful place in pop culture history.

"Now even alternative rock is pretty much dance music," says pop culture critic Roger Catlin. "It took all this fighting to get to where we are, but kids know what's happening and what's won out is dancing and diversity." Jeannie Tracy, a singer since the seventies, knows from personal experience. "I worked at a club in Florida and it was three thousand kids and they're all twenty-one," she says. "I looked out at them and said, 'I have shoes older than you guys!'"

Truly, EDM—as electronic dance music is called—has grown to become one of the most beloved genres among those too young to ever have heard of any so-called disco backlash.

As RuPaul told the Season 13 cast of *RuPaul's Drag Race*, most of whom sadly could barely tell Donna Summer from Diana Ross, "For the record, disco does not suck." The show's "Disco-Mentary" episode, which first aired in February 2021, was only one example of primetime television harking back to the seventies.

The theme song of the 2020 political drama *Mrs. America* was Walter Murphy's "A Fifth of Beethoven." Ryan Murphy's 2021 *Halston* miniseries cast Ewan McGregor as Studio 54's most famous habitué and evoked the era with such songs as "Relight My Fire" by Dan Hartman, "More, More, More" by the Andrea True Connection, and "Chase" by Giorgio Moroder.

The 2023 true-crime miniseries, *Welcome to Chippendales* featured a high-energy sex scene set to Lime's Hi-NRG hit "Babe We're Gonna Love Tonight." On *The Equalizer* that spring, Queen Latifah's character Robin reminisced about her late father to the Silver Convention hit "Fly Robin Fly." Meanwhile, on promos for Season 4 of the hip horror comedy *What We Do in the Shadows*, a vampire familiar swung across the screen on a disco ball to the sounds of Boney M. singing "Rasputin." And let's not forget that the prize on the popular competition series *Dancing with the Stars* is the Mirrorball Trophy.

Not since the seventies was TV this gleeful while getting down.

After Sam Smith's cover of "I Feel Love" was used so memorably as Target's official Christmas song of 2019, a plethora of commercials went all in on disco too. H&M borrowed "Yes Sir, I Can Boogie" by Baccara. "I Will Survive" underscored a Facebook TV spot during the pandemic. Applebee's cooked up excitement for its "Sizzlin' Skillets" with the sounds of "Hot Stuff." Kohl's co-opted "September." Zyrtec sold allergy medicine with "Funkytown."

Nutella was "Upside Down." Doritos crunched through Anita Ward's "Ring My Bell." JCPenney hyped summer clothes for all ages with "We Are Family." For the fragrance Phantom by Paco Rabanne, it was "Mighty Real" by Sylvester. T-Mobile touted its phone technology with the Bee Gees "Stayin' Alive," while HomeGoods pushed home goods with "Genius of Love" by Tom Tom Club. Meanwhile, TurboTax opened tax season with a "Roller Boogie" ad, complete with old-school skates and a disco ball.

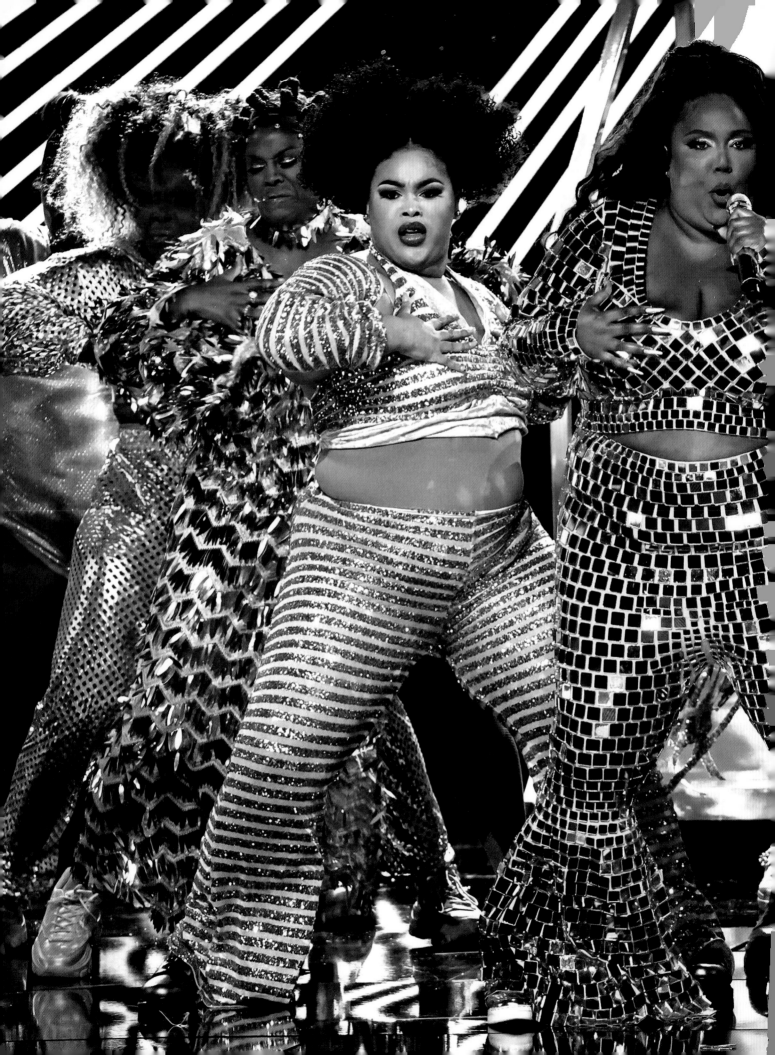

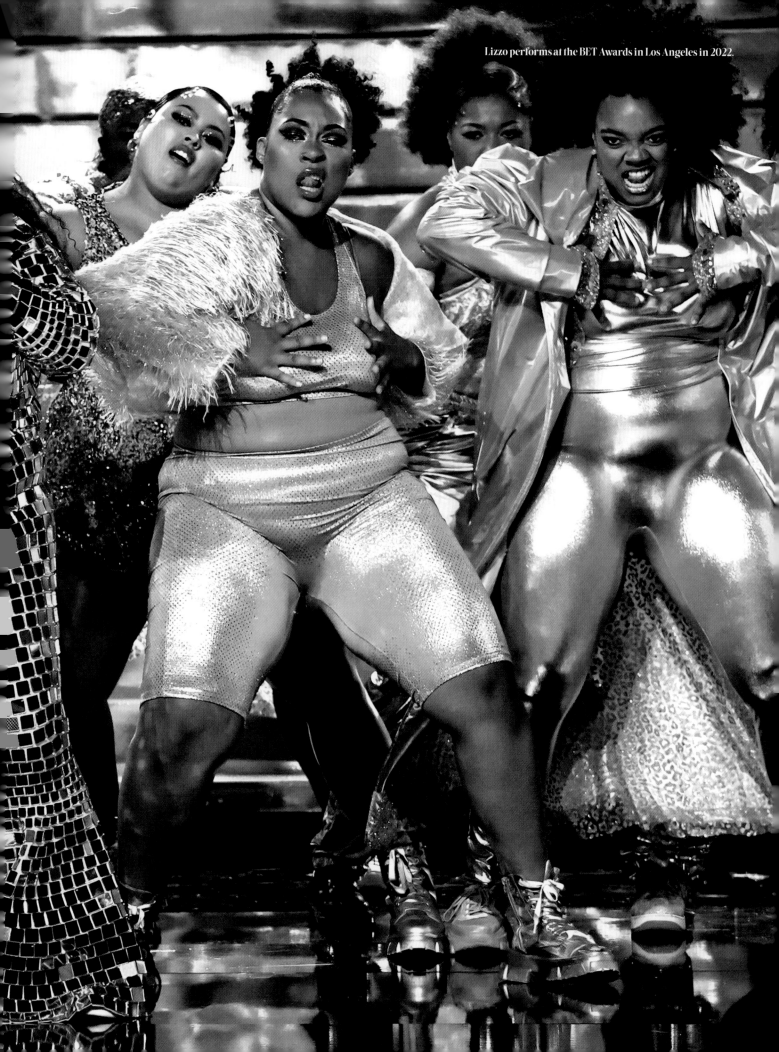

Lizzo performs at the BET Awards in Los Angeles in 2022.

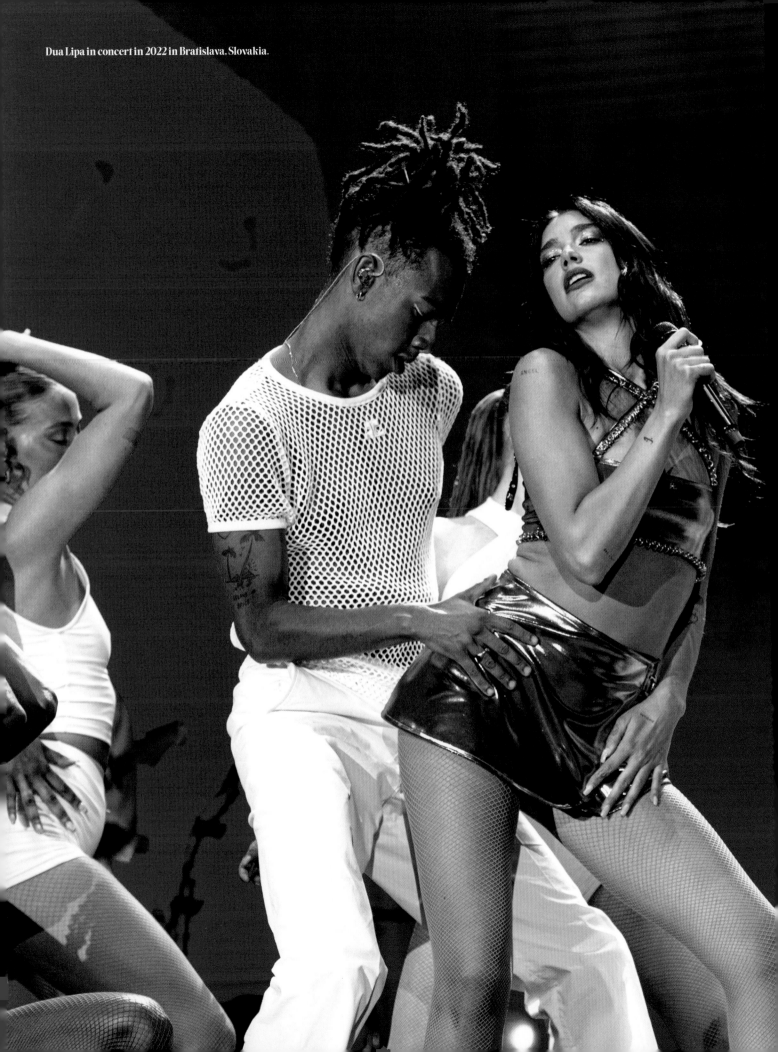

Dua Lipa in concert in 2022 in Bratislava. Slovakia.

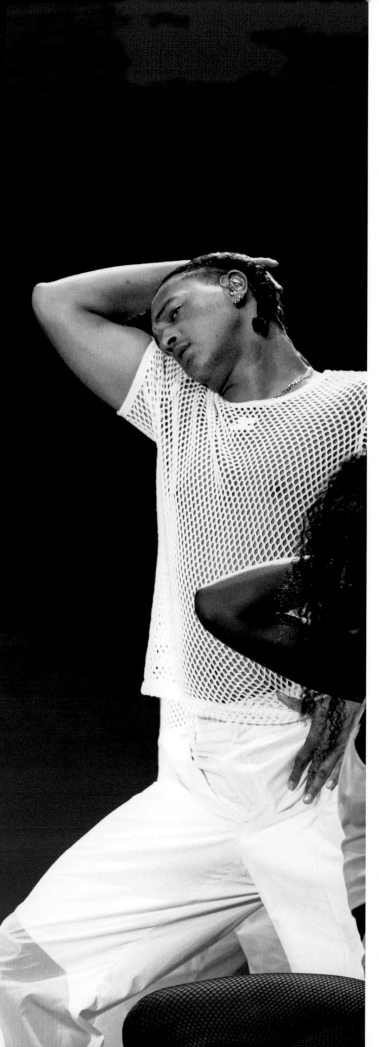

As for roller-disco, it has made a comeback too.

In the 2022 video for "Never Gonna Not Dance Again," Pink vows "One thing I'm never gonna do is throw away my dancing shoes." In her video, she skates around a grocery store that has been turned into a roller-disco.

At the South Coast Botanic Garden in the summer of 2021 and New York's Central Park the following year, the outdoor pop-up rink DiscOasis drew crowds of roller skaters, old and young. In Rockefeller Center, in the heart of Manhattan, and across the Atlantic in London, Flipper's Roller-disco Palace opened seasonal outposts of that legendary Los Angeles roller-disco haven in 2022. It showed a new generation of skaters how it was done back in the day.

Today, disco is everywhere. Even the mainstream magazine *Woman's Day* showed its readers how to make disco jack-o-lanterns to celebrate Halloween 2022. The music itself can be heard everywhere from family functions to supermarkets. As David Noh, a former Studio 54 busboy, noted, "Have you ever gone dancing at a wedding or bar mitzvah where you didn't hear Gloria Gaynor sing 'I Will Survive'? Disco music has never really stopped." And it never will. "Now you can be standing in line at Trader Joe's for eight hours," says writer Michael Musto, "and you can listen to Donna Summer over and over again."

People of color, women, and the queer community now have enough cultural capital to call out the "Disco Sucks" movement for what it was—an attack. But one that ultimately failed. As RuPaul said in 2021, "They tried to kill what we loved, but disco never died. It just changed its name and address. Today, disco reminds you that our souls are connected through spirit, and how together, we can do anything. It do take a village, people."

"The generation that thought disco sucked is dying off," says Wild. "It was one of those bad ideas that's just over. I don't think this generation would understand any of the stupidity that led people to hate disco. Making beats is one of the key aspects of making a hit record today. Just based on my own kids, they 100 percent understand the rhythmic genius of Nile Rodgers and Bernard Edwards, Giorgio Moroder, and Kraftwerk." Disco is getting its due because young people value diversity.

"Modern recognition of multiculturalism has pointed a spotlight on different types of music—disco being one of them," says Andrew Marcogliese, who, for five years, was a dance music programmer for the streaming music service, Pandora. "Over the decades, dance music has served as a courageous response to other toxic parts of the culture . . . a style of music that is inclusive and creates a safe space for marginalized communities to celebrate."

"From disco, you got house, you got techno, you got electronic music in the nineties, and an EDM boom in the 2000s," Marcogliese says. Today, EDM producers create the crème de la crème of chart hits. "Pop stars like Dua Lipa and artists like the Weeknd are borrowing directly from disco," he says. "The modern culture of dance music comes from disco."

In June 2022, one of dance music's biggest pop stars, singer and flautist Lizzo, headlined the *BET Awards* in Los Angeles. She wore a gold mirror-tiled outfit as she sang her latest hit. Standing before a stage-filling projection of a disco ball, she radiated positivity—not to mention her vast talent—and filled the room with joy.

The song, a sonic grandchild of Chic's disco hit "Good Times," proved that disco had taken its rightful place alongside rock and hip-hop. Thanks to artists like Lizzo, disco is being recognized as part of the DNA of contemporary music, as much as (if not more than) any other style of pop music. No one watching her sing and dance that night at the Microsoft Theater could possibly dig in their stilettos and ever again say that disco sucked.

Fifty years after disco began in a downtown loft filled with every manner of New York bohemian—black, white, and brown, gay and straight—the population of the world is comfortable again in its dancing shoes—its "Balenci-encies," as Lizzo calls them—and is boogeying to the disco beat, both old and new. They're shouting that disco is forever and for everyone..

As Lizzo herself would sing, it's "About Damn Time."

At the opening night of DiscOasis—an outdoor mash-up of glitter and greenery at the South Coast Botanic Garden in Palos Verdes, California—a crowd of disco fans strapped on their roller skates for an evening of thumping music, scrumptious food, and some serious rink-rounding action.

The premiere party in July 2021 attracted singer Adam Lambert, who wore a "Disco Fucks" T-shirt, *RuPaul's Drag Race* alums Symone and Gigi Goode, who were too young to remember disco the first time around, and burlesque star Dita Von Teese, who reminisced about going to underage discos at Disneyland and Knotts Berry Farm theme parks after she moved to Orange County at age twelve.

But the man of the hour that night was Nile Rodgers, the cofounder (with Bernard Edwards) of the band Chic, one of the brightest lights in the disco pantheon, and a powerhouse producer-performer with multiple Grammy Awards and a spot in the Rock & Roll Hall of Fame.

Under the swaying trees and the rotating disco balls, the party seemed to vanquish, once and for all, any memories of the disco backlash that had surged in the eighties. It proved that the genre was back—by name—in the twenty-first century, and disco had rolled back into the pop consciousness.

The following year, DiscOasis, by then a proven success, relocated to New York's Central Park, again with Rodgers front and center. Here's what the ultimate "groovemaster" said that first night at the first DiscOasis, an unforgettable disco that the *Los Angeles Times* described as "a wormhole to 1979 just a short trip down the coast from LAX."

FDC: "A night like tonight seems to lay waste to the claim that disco ever died. I hate to bring up a sore subject, but what did the whole disco backlash mean to you?"
NR: "When the whole 'disco sucks' thing happened, it actually made me dig in because people had made millions and millions of dollars off my music, and then, all of a sudden, nobody would call me or even answer my phone calls."

FDC: "I heard that Diana Ross had second thoughts about working with you after that…"
NR: "I always say that if I hadn't signed my contract with Diana Ross before the 'disco sucks' thing happened, I might not have gotten to do the *Diana* album. There was such a backlash that people didn't want to talk to us. But when we did that album, it showed that even though they were saying 'disco sucks,' and saying we were irrelevant, we made the biggest record of her life. Then I met David Bowie and did *Let's Dance*. Then INXS, then Duran Duran, and then Madonna, and it was like 'Okay, I guess disco *doesn't* suck.'"

FDC: "Was your work on the 2013 Daft Punk album Random Access Memories the ultimate vindication of disco?"
NR: "It was obviously a huge moment in my life. But I never really denied the music that I love.

"Most people have never heard this story, but once I was working with Eric Clapton and he said that after he finished that particular record, he was just going to play the blues for the rest of his life. I was like, 'Wait a minute. If I come to a Clapton concert, I'm not going to hear 'Sunshine of Your Love' and all those great Cream songs? I'm not going to hear the great stuff you did with Steve Winwood?'
"He said, 'No.' I went home, and I thought about that, and I said, 'Well, I guess he's earned the right to do whatever the hell he wants to do.' And then I said, 'Well, then, I'm going to play disco and dance music for the rest of *my* life.'"

FDC: "One last thing: Is the story about 'Le Freak' true? Was the song really written after you were turned away at the door of Studio 54, and Chic was going to sing 'Fuck off!' not 'Freak out!'?"
NR: "That's 100 percent true."

Chic front man Nile Rodgers at the opening night of DiscOasis in 2021 at the South Coast Botanic Garden in Palos Verdes, California, left.

At right, rollers and revelers dance the night away.

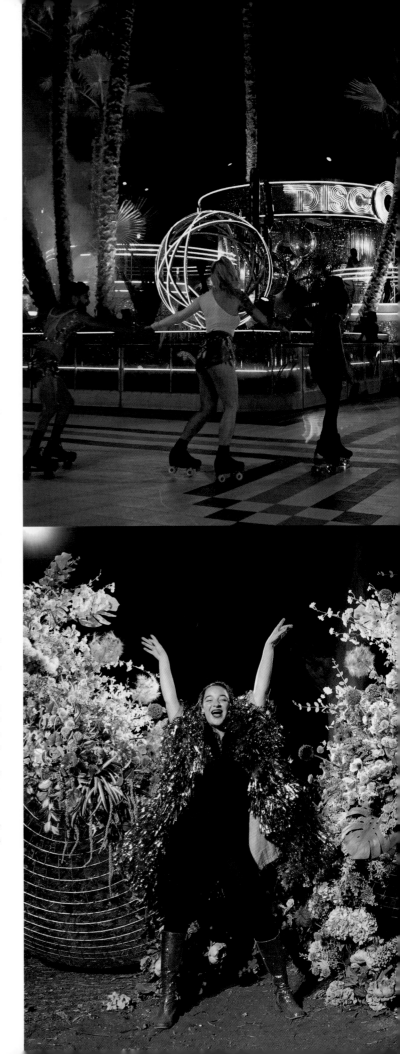

Q&A: Donna Summer

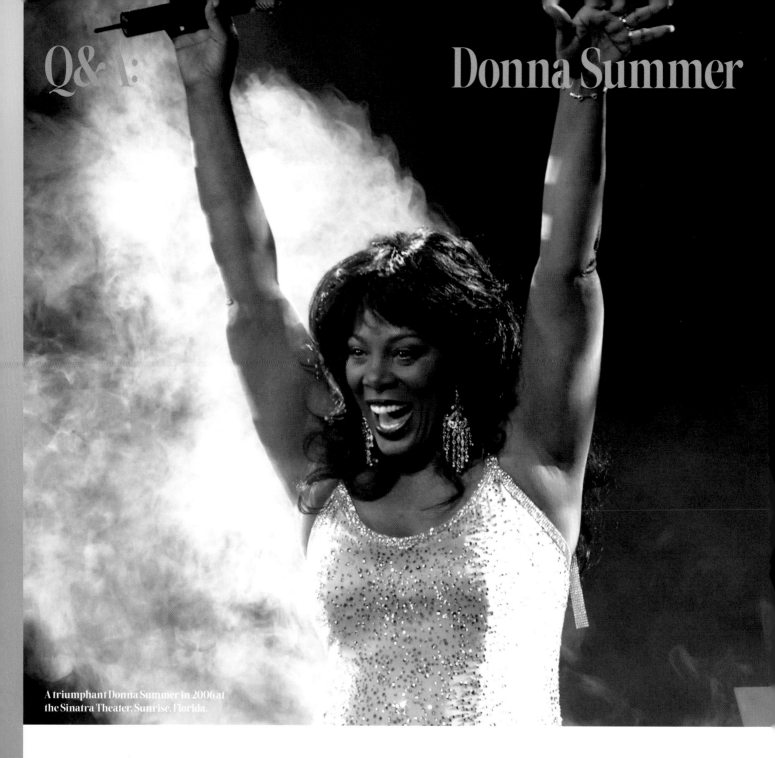

Donna Summer will forever be *the* Queen of Disco and only one person ever begged to differ. That was Sylvester and he thought *he* deserved the title. (He *did* come close.) But for everyone else, Summer reigned supreme in the seventies, and she still does. Ask Beyoncé.

From the 1975 release of her orgasmic single "Love to Love You Baby" to her untimely death in 2012 to her posthumous collaboration with Kygo on a smoking "Hot Stuff" remix in 2020, Summer took dance music to its zenith, time and again.

With a mighty voice, first heard in the churches of her native Boston, and a desire to elevate dance music beyond the dance floor, Summer collaborated with the disco era's most talented producers—Pete Bellotte and Giorgio Moroder chief among them—to create some of the most nuanced, timeless tracks ever.

In June 1999, VH1 aired the special *Donna Summer: Live & More Encore!* To preview that television concert for *TV Guide* and introduce her song "I Will Go with You (Con te partirò)," Summer sat down with me for lunch in a café in her newly adopted hometown of Nashville. Over the course of our two-hour conversation, in between bites of Chinese chicken salad, she talked about raising a family in the Tennessee music capital, the challenges of getting older, her newfound love of painting, and what it means to be the forever Queen of Disco.

As is so often the case, only a few lines from the interview were ever published.

The recordings of our chat on two microcassettes languished for decades in a box in a storage closet. I found them in 2022 when, of course, I was looking for something else. I like to think the deeply spiritual Donna herself guided me to them.

Here, for the first time, is that interview. It is a never-before-seen reminder that Donna Summer "is more than just a disco singer," as VH1 vice president Bruce Gillmer put it at the time. "She's an all-around, well-polished artist who has stood the test of time."

That statement has never been truer than it is now.

FDC: "How does it feel to be called the Queen of Disco?"

DS: "If I have to be the queen of something, I might as well be Queen of Disco. Most people don't get to be called the queen of anything. I appreciate being part of a lot of people's lives. You know, a lot of people went out and danced and had a good time. Now I have to make new titles for myself because this diva thing is getting a little bit old."

FDC: "Are you a diva?"

DS: "In the classical sense of the word 'diva,' yes. People use the word 'diva' so loosely today. It used to be what they called someone like Jessye Norman. I went to see her once. She walked onstage and I am not kidding you, the audience stood and clapped for five minutes before she uttered a sound."

FDC: "Did you ever have a moment like that?"

DS: "I remember one night when I played LA, and the minute I walked on stage, everyone stood up and they stayed up for the entire show. It was a great show. People just began weeping everywhere. Don't ask me why. I don't know what happened that night, but it was the most touching show I've ever done in my life. Afterwards, we had like two thousand people backstage. I was there for three hours just shaking hands. It was amazing."

FDC: "Your first major hit, 'Love to Love You Baby,' was so erotically charged, it caused a scandal."

DS: "'Love to Love You Baby' wasn't supposed to be my song. I mean, I cowrote the song, but I never really loved the lyrics. They released it to a record company, and it became a success."

FDC: "The explicitly sexual nature of the song made some people uncomfortable."

DS: "When I did the Johnny Carson show, he wouldn't listen to my record because it made him too nervous. I thought that was pretty funny. "

FDC: "Your career took off like a rocket after that song was released."

DS: "I was happy to go from zero to a hundred so fast. But I lost my own personal equilibrium. It takes a lot of energy—physically, emotionally, and spiritually—to sustain that kind of momentum. I'm a private person by nature. I don't like putting my relationship with my children or my husband in public. When people talk to me about success, I tell them that success means a lot of things. It means that people have a heightened awareness of you. They expect you to do great things."

FDC: "And you did! 'I Feel Love' came out not long after that and it's the best!"

DS: "I thought that song was really exceptional in its simplicity. There's just a vibe about it."

FDC: "When _Once Upon a Time_ was released in 1977, critics finally began to take disco seriously. That double album was seen as the genre's coming of age. Why do you think it worked so well?"

DS: "I came out of an acting background and every single song on that album has its own character. The songs told me who that character was, and I sang it that way, as opposed to applying my style to it and making it a Donna Summer song. I made my voice do whatever the song dictated."

FDC: "Your 1979 follow-up _Bad Girls_ got amazing reviews, too."

DS: "_Bad Girls_ honestly was a very transitional record for me. A lot of things happened around the time of that album. Everything seemed like it was in motion. I remember meeting Robert De Niro—platonically, nothing romantic—and he was a big fan of the music. He was working out to get in shape for _Raging Bull_, and he told me that he would jog in the morning near Casablanca Records. There was a huge poster of _Bad Girls_. He said he would listen to that album and that was his motivation to keep jogging. Things like that are kind of cool. When you realize that you can affect somebody else's life and encourage them in ways that you don't even know about."

FDC: "With so many hits, do you have a favorite Donna Summer song?"

DS: "'Last Dance,' for so many different reasons. The fact that it won an Oscar, the fact that Paul Jabara wrote it for me and then came to me like six hundred times asking me to record it. He trapped me in a bathroom, he wouldn't let me off a balcony, until finally, I said, 'OK, I'll do this.'"

FDC: "What was recording it like?"

DS: "I had been traveling and I don't think I was home a day and a half before Paul had me in the studio recording that song. I was there really late on the night that they mixed the song. Paul had gone home. I got a copy of it on a cassette, and I didn't go to sleep that night. I just stayed up, driving up and down Mulholland Drive playing it. I was waiting for Paul to get up at six o'clock in the morning and I pulled up to his house with the radio blasting 'Last Dance' to all of his neighbors. He came out in his jammies, and I jumped out of the car and grabbed him, and we just danced."

FDC: "You knew it was a hit that night and then the song won an Oscar! Did you get the award yourself?"

DS: "Paul got the Oscar. But I won that Oscar for him. We have pictures where we're fighting over the Oscar. He was a very funny person. I knew him for many, many years. The guy was nuts, out of his mind, but he was great."

FDC: "Do you ever watch yourself on TV?"

DS: "No, no, I never watch anything. Unless it's while I'm editing a video. I'm so critical of myself that I can't even look at myself. I'm thinking millions of people are going to see this and I can't change it."

FDC: "Do you read reviews?"

DS: "You couldn't pay me to read them. Right in the beginning of my career, I did a show at Roseland in New York. We had nothing but sound problems. There were way too many people in the room. I had worked so long on that show. The headline of one review was 'A ROSE THAT STINKS.' I could have died. I was mortified. It took me months to get over that. It was tough."

FDC: "Years ago, you were quoted saying 'God created Adam and Eve, not Adam and Steve' and your gay fans were really hurt, even after you apologized and said you'd been misquoted. Did that make you wary of the press?"

DS: "It's a scary thing. You never know what they're going to dredge up. Not that there is anything to dredge up. They'll print awful pictures of you. Everybody comes for celebrities. I have a problem when they take things out of context. It's so detrimental. You work your whole life and everything that you do, you hopefully do it with integrity. In one fell swoop, they can wipe that out, with something that doesn't even have validity. That's what frustrates me."

FDC: "How did it feel when America turned on disco?"

DS: "You know, it was just time. They wanted something different. It's like anything else. People's appetites change. It's the process of evolution, and it was bound to happen."

FDC: "Why do you think it was inevitable?"

DS: "Disco got so big so fast. It was as if it came out of nowhere and suddenly people were making zillions of dollars off it. Rock 'n' roll people who were making records didn't like it because they couldn't get on the radio. To them, this was synthetic music—it wasn't real. I understand the conflict. When you're out there struggling and someone comes along with the next new thing and you aren't it, it's hard. The audience determines what it wants. You have to sit back and wait until your turn comes again. Music does that constantly."

FDC: "What was it like when your megastardom receded a bit?"

DS: "People around me were probably way more disappointed than I was. I looked at it as God giving me time to take a break, which I needed. For me, it was just like, now I can swim in my pool for a minute. But when I wasn't working that much, I did begin to question whether I should just move on. The business side of everything is just so rough, and I found myself not knowing if my music really meant anything to anybody. But I grew up in church, and I always believed that God had a purpose in my life. I would get letters from people. They didn't know I was even going through all this. Those letters made me realize that it means something to somebody that I do this."

FDC: "How important is success to you?"

DS: "Believe me, I'm an A-type personality at the highest level. But in my life, joy isn't based on the success or failure of a record. Whatever happens with a record will happen. I'm happy whatever happens."

FDC: "When you sing your old songs, you're never a nostalgia act. Why is that?"

DS: "I try to do everything as if it's new that day. That's my whole perspective on everything. All I can do is go out and perform and be the person that I am and truly give it my all, even though there may be times that I want to sing other songs than my hits. But when I'm doing it, I'm in the moment. I don't give any less than I would have given at the time that that song came out as a single. When I do 'Last Dance,' it's just as powerful today as it ever was. I don't feel like it's dated. My songs apply to everybody—then, now, and in the future."

Must-Hear Disco Playlist:

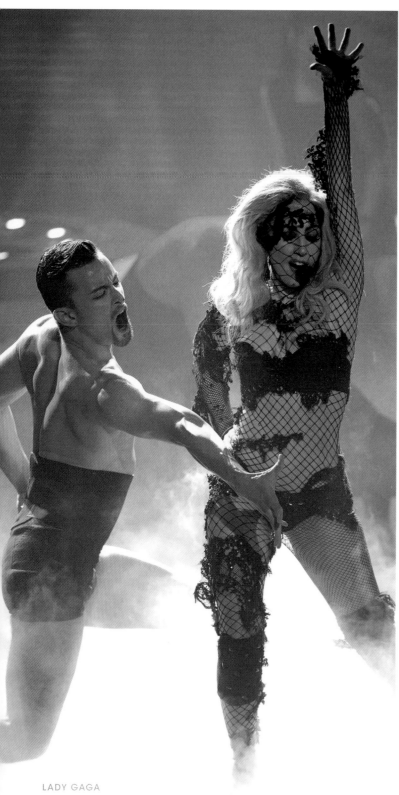

LADY GAGA

"CRYING AT THE DISCOTEQUE" by Alcazar, 2000

"YOUR DISCO NEEDS YOU" by Kylie Minogue, 2000

"MURDER ON THE DANCEFLOOR" by Sophie Ellis-Bextor, 2001

"DISCO SANTA" by Holiday Express, 2002

"SHINY DISCO BALLS" by Who Da Funk featuring Jessica Eve, 2002

"COMFORTABLY NUMB" by Scissor Sisters, 2004

"I JUST WANNA DANCE" by JSTO featuring Alison Jiear, 2004

"HUNG UP" by Madonna, 2005

"FASHIONISTA" by Jimmy James, 2006

"CLOSER" by Ne-Yo, 2008

"DISCO LIES" by Moby, 2008

"DISCO HEAVEN" by Lady Gaga, 2009

"I AM NOT A WHORE" by LMFAO, 2009

"PUT YOUR HANDS UP FOR DETROIT" by Fedde Le Grand, 2009

"BARBRA STREISAND" by Duck Sauce, 2010

"DANCING ON MY OWN" by Robyn, 2010

"DISCO FEVER" by Dual Minds, 2010

"INVISIBLE LIGHT" by Scissor Sisters, 2010

"TILL THE WORLD ENDS" by Britney Spears, 2010

"BORN THIS WAY" by Lady Gaga, 2011

"HOTEL NACIONAL" by Gloria Estefan, 2011

"WE FOUND LOVE" by Rihanna featuring Calvin Harris, 2011

"BOOGIE" by Dual Minds, 2012

"EVERYTHING THAT I GOT" by Kristine W and Bimbo Jones, 2012

"LET'S HAVE A KIKI" by Scissor Sisters, 2012

"RAINING AGAIN" by Betoko, 2012

"SCREAM & SHOUT" by will.i.am & Britney Spears, 2012

"GET LUCKY" by Daft Punk, 2013

"LET'S GO BACK TO THE DANCE FLOOR" by Village People, 2013

"A LITTLE PARTY NEVER KILLED NOBODY (ALL WE GOT)" by Fergie, 2013

"WORK BITCH" by Britney Spears, 2013

"SISSY THAT WALK" by RuPaul, 2014

"OPERATOR" by Lapsley, 2016

"CHAINED TO THE RHYTHM" by Katy Perry, 2017

"BATSHIT" by Sofi Tukker, 2018

"MY MY MY!" by Troye Sivan, 2018

"FIRE FOR YOU" by Cannons, 2019

"I FEEL LOVE" by Sam Smith, 2019

"SAY SO" by Doja Cat, 2019

"BOOM BOOM" by Teddi Gold, 2020

"DON'T START NOW" by Dua Lipa, 2020

"GOD, THIS FEELS GOOD" by Isaac Dunbar, 2020

"HOT STUFF" by Kygo X Donna Summer, 2020

2000-2024

"LEVITATING" by Dua Lipa, 2020

"COLD HEART" by Elton John & Dua Lipa, 2021

"DO IT TO IT" by Acraze featuring Cherish, 2021

"LOVE DON'T CARE" by Debbie Gibson, 2021

"ABOUT DAMN TIME" by Lizzo, 2022

"ALL SHE WANNA DO" by John Legend featuring Saweetie, 2022

"CHILL LIKE THAT" by Sunday Scaries X PiCKUPLiNES, 2022

"COME CHECK THIS" by Fetish, 2022

"DISCO INFERNO" by Syzz & Nora Van Elken, 2022

"MASSIVE" by Drake, 2022

"RENAISSANCE" by Cristobal Tapia De Veer, 2022

"SUMMER RENAISSANCE" by Beyoncé, 2022

"TIME TO GROOVE" by Majestic, 2022

"BABY DON'T HURT ME" by David Guetta with Anne-Marie and Coi Leray, 2023

"BETTER PLACE" by *NSYNC, 2023

"BLACK SOUL" by Disco Incorporated, 2023

"DANCE THE NIGHT" by Dua Lipa, 2023

"DJ PLAY A CHRISTMAS SONG" by Cher, 2023

"FLOWERS" by Miley Cyrus, 2023

"FREAK ME NOW" by Jessie Ware and Róisín Murphy, 2023

"FREE YOURSELF" by Jessie Ware, 2023

"HOUDINI" by Dua Lipa, 2023

"LOVING YOU" by Cannons, 2023

"MILLION DOLLAR BABY" by Ava Max, 2023

"NEVER GONNA NOT DANCE AGAIN" by P!NK, 2023

"NO MORE TEARS (ENOUGH IS ENOUGH)" by Claire Richards & Delta Goodrem, 2023

"PADAM PADAM" by Kylie Minogue, 2023

"SINGLE SOON" by Selena Gomez, 2023

"SHAKE IT" by INNDRIVE, 2023

"TRUSTFALL" by P!NK, 2023

"YOU MAKE ME FEEL (MIGHTY REAL)" by Adam Lambert X Sigala, 2023

"COLDER" by St. Paul, 2024

"DANCE ALONE" by Sia X Kylie Minogue, 2024

"ELECTRIC ENERGY" by Ariana DeBose, Boy George, and Nile Rodgers, 2024

"LONELINESS" by Pet Shop Boys, 2024

"ONE ON ONE (CERRONE REMIX)" by The Knocks & Sofi Tukker, 2024

"YES, AND?" by Ariana Grande, 2024

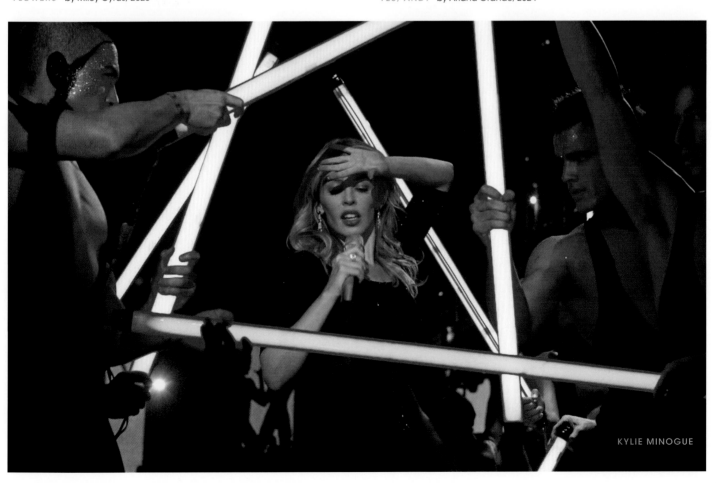

KYLIE MINOGUE

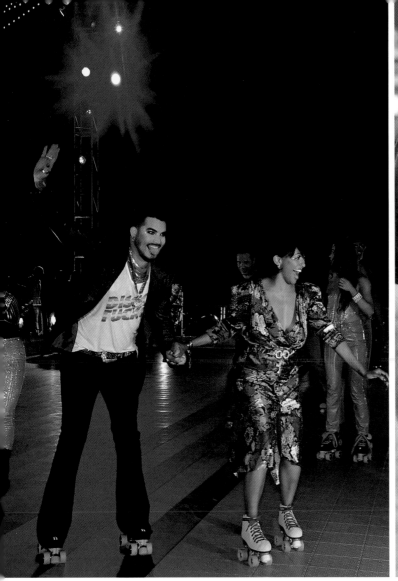

Singer Adam Lambert in a "Disco Fucks" T-shirt on skates at DiscOasis.
A "Disco Doesn't Suck" tee spreads the truth that dance music is forever.
Macho Macho Mugs by designer and potter Jonathan Adler.

It Takes A Village, People...

When it comes to writing a book about disco, to quote Village People, no man does it all by himself. Without my dearest friends—pop culture devotees, all—*Disco: Music, Movies, and Mania Under the Mirror Ball* would not have thump-thumped its way to life.

Thank you first to my enthusiast editor, Ellen Nidy, at Rizzoli, the book's talented designer, Sarah Chiarot, my delicious husband and idea bouncer-offer Jim Colucci, the smartest and funniest man I know, and our canine charges, the late great Gabby, and our mischievous pup Penny Puggleston.

My sincere appreciation goes out—in particular, and in alphabetical order—to:

Rica Allannic, Donna Marie Asbury, Erica Berger, Doria Biddle, Jay Blotcher, Joe Caparella, Jim Caruso, Jacqueline Cutler and Stephen Whitty, Norn Cutson, Mario Diaz, Lisa Donahey and Dexter Warren, Eric Drysdale, Richard Evans, Megan Feda, Stephen Ford, Greg Garry, Richard Gordon, Eric and Karen Herman, Julie Hinds, Andrew Hopf, Norma Kamali, Robert Kotonly, Paul Lavoie and Matt Severson, Michael Levitt and Marc Loren, Fern Mallis, Mark McCauslin, Patrick McDonald, Mister B Nation, Jennifer Niederhoffer, David Oriola, Robb Pearlman, Mike Pingel, Doug Prinzivalli and John Carrozza, Senor Amor, Rob Sidney, Sparrowboy, Joseph and Chris Titizian, Daniel Vaillancourt, and, of course, all those who agreed to be interviewed for this book and those who helped make that happen.

Each of you gave generous, significant contributions of time, talent, connections, and more.

Thank you, too, to all the wild and wonderful social media accounts dedicated to showbiz preservation. You revealed so many disco performances which I'd either never known or had forgotten. Many found their way into this book. I am gleeful and grateful for your daily madness.

My heart goes out to my long-lost childhood friends who accompanied me to the Strawberry Patch teen disco in Wayne, New Jersey, and that Bee Gees concert at Madison Square Garden in 1979. My ticket stub from that night is reproduced on page four. And my love is eternal for the members of the Northwestern Army who, with fake IDs in one hand and fifty-cent drink specials in the other, danced many nights away at the Bistro in Chicago in the early eighties.

One caveat: If you helped me with this book in some way and I've neglected to mention you by name here, I'm deeply sorry. I ask that you please remember that even Chic once was turned away from the doors of Studio 54 because Grace Jones had forgotten to put them on the list.

She didn't mean it either.

—FRANK DECARO, LOS ANGELES, APRIL 2024

Photo Credits:

Cover + Title Page	Photofest
Dedication	Collection of the author
Contents	Mario Casilli/mptv Images
P. 8	Pictorial Press/Alamy
P. 9	Collection of the author
P. 10-11	Chicago History Museum/Getty Images
P. 12-13	Nicky Siano Collection
P. 17	Left Photofest; right: collection of the author
P. 18	Nicky Siano Collection
P. 20-21	Keystone Press/Alamy; Photofest; Photofest
P. 22	Pictorial Press, Ltd/Alamy
P. 23	United Archives GmbH/Alamy
P. 24-25	Photofest
P. 26-27	Heinz Browers/United Archives GmbH/Alamy
P. 28	Photofest
P. 30	Ralf Liebhold/Alamy
P. 31	kpa/United Archives GmbH/Alamy
P. 32	Photofest
P. 34-35	Adam Scull/Photolink/Shutterstock
P. 37, 39	Adam Scull/Photolink/Shutterstock
P. 40-41	John Barrett/Shutterstock
P. 42-43	Adam Scull/Photolink/Shutterstock
P.44	Top, Adam Scull/Photolink/Shutterstock; bottom, Adam Scull/Photolink/Shutterstock
P. 46-47	Photofest
P. 48	Courtesy of the artist
P. 50	mptv Images
P. 51	Alamy; courtesy of the artist; Pictorial Press/Alamy
P. 52	Photo Media/ClassicStock/Alamy
P. 54	Pictorial Press/Alamy
P. 56-57, 59-60	Photofest
P. 62-63	Columbia/Kobal/Shutterstock
P. 64-65	Left, Columbia/Kobal/Shutterstock; right, Photofest
P. 66-69	Photofest
P. 70-71	Everett Collection/Alamy
P. 72	Top, Photofest; bottom, Photofest
P. 73	Film/Art Gallery
P. 74-77	Photofest
P. 78	Everett Collection/Alamy
P. 79-82	Photofest
P. 83-85	Universal/Kobal/Shutterstock
P. 86-87	Fran Drescher, Paramount/Kobal/Shutterstock; Donna Pescow, Photofest
P. 89	Curt Gunther/mptv Images
P. 90	Alamy
P. 92	Alan Davidson/Shutterstock
P. 94-95	Photofest
P. 96-97	Left, Sam Oaksey/Alamy; right, Photofest
P. 98-99	Robert Hammer
P. 101-102	Collection of the author
P. 103	Courtesy of Michael Koth
P. 104-105	Don Bierman/*Chicago Sun-Times* collection, Chicago History Museum
P. 106-108	Collection of the author
P. 109	Courtesy of Baskin-Robbins
P. 110-111	Erica Berger
P. 112-113	© *MAD*, used by permission
P. 114-115	Left, Frank DeCaro; right, Chris McHugh/Shutterstock
P. 117	Left, Photofest; right, courtesy of *Fire Island News*
P. 118-119	Photofest
P. 120-121	Grace Jones, courtesy of the artist; Alicia Bridges, Lynn McAfee Performing Arts Images/Alamy; Cheryl Lynn portrait, courtesy of the artist; Millie Jackson and Isaac Hayes, Photofest
P. 122-123,125	Photofest
P. 126	Shutterstock
P. 129	Left, collection of the author; right, Photofest
P. 130-131	Courtesy of Bob Mackie and Joe McFate
P. 132-133	Collection of the author
P. 135	Collection of the Museum of the City of New York
P. 137	Left, Photofest; above, Photo 12/Alamy, Erik Pendzich/Alamy; right, Funko
P. 138	Jack Mitchell/Getty Images
P. 140	Keystone Press/Alamy
P. 142-143	Photofest
P. 145	Helmut Reiss/United Archives GmbH/Alamy
P. 147-148	Photofest
P. 151-152, 154, 156	Photofest
P. 158-159	Ibl/Shutterstock
P. 160-161	Chic, Photofest; Cher, courtesy of the artist; Lipps album, Alamy
P. 162-163	Photofest
P. 165	MediaPunch/Shutterstock
P. 168	Collection of the author
P. 170	Photofest
P. 173	Walter Murphy Band, Alamy; Ann-Margret, courtesy of the artist; Elton John album, Popimages/Alamy
P. 174-175	Photofest
P. 176-177	Used by permission; all rights reserved, Playbill Inc.
P. 180	Collection of the author
P. 182-183	Photofest
P. 185	ABC Photo Archives/Disney General Entertainment Content/Getty Images
P. 186	Photofest
P. 188	Pictorial Press/Alamy
P. 190-191	Toby Melville/PA Images/Alamy
P. 192	Randy Duchaine/Alamy
P. 195	Photofest
P. 196	Studio Canal/Shutterstock
P. 198-199	Flemming Bo Jensen/Gonzales Photo/Alamy
P. 200	Courtesy of the artist
P. 202-203	dpa picture alliance/Alamy
P. 205	Brian J. Ritchie/Hot Sauce/Shutterstock
P. 208-209	Photofest
P. 210	David Fisher/Shutterstock
P. 212	JM Enternational/Shutterstock
P. 215	Pictorial Press/Alamy
P. 216	Photofest
P. 218-220	Courtesy of the artist
P. 222-223	Aviv Small/ZUMA Press/Alamy
P. 225	Hahn Lionel/ABACA/Shutterstock
P. 228-229	John Salangsang/Shutterstock
P. 230-231	Ceská editoriálni fotografie/Profimedia/Shutterstock.
P. 232-233	DiscOasis
P. 234	MediaPunch/Shutterstock
P. 236-237	Photofest
P. 238-239	Adam Lambert, DiscOasis; Macho Macho Mugs, Erica Berger; Disco Doesn't Suck, Kingsley Davis/Alamy

First published in the United States of America in 2024 by
Rizzoli International Publications, Inc.
300 Park Avenue South
New York, NY 10010
www.rizzoliusa.com

Copyright © Frank DeCaro

Publisher: Charles Miers
Editor: Ellen Nidy
Design: Sarah Chiarot
Production Manager: Colin Hough-Trapp
Managing Editor: Lynn Scrabis

Printed in Singapore

2024 2025 2026 2027 2028 / 10 9 8 7 6 5 4 3 2 1

ISBN: 978-0-8478-9961-6
Library of Congress Control Number: 2024983624

Visit us online:
Facebook.com / RizzoliNewYork
instagram.com/rizzolibooks
twitter.com/Rizzoli_Books
pinterest.com/rizzolibooks
youtube.com/user/RizzoliNY
issuu.com/rizzoli

FSC
www.fsc.org
MIX
Paper from
responsible sources
FSC® C167869